Sculpture of the Inuit

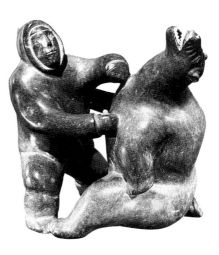

Sculpture

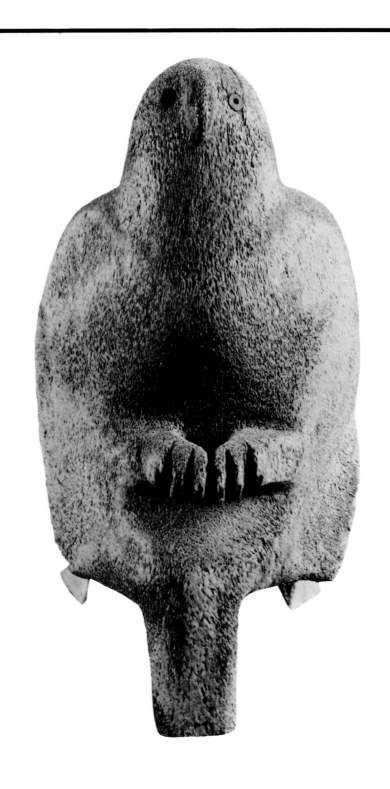

of the Inuit

Revised and updated edition

George Swinton

M&S

1 (HALF TITLE PAGE)/George Kopak Tayarak
(Kopak/Qupak)
Salluit (Sugluk) 1962
Stone and ivory height 10¼˝
WAG G-72-151
(Former front cover)

2/Iola Abraham Ikkidluak
(Iola)
Lake Harbour 1968
Whalebone height 9½”
WAG G-76-311
TITLE PAGE

3/Vital Makpaaq
(Makpa Arnasungnark)
Baker Lake 1965
Stone height 8½˝

Copyright © 1972 by George Swinton
Reprinted 1982
First published in paperback 1987
Revised edition published in hardcover 1992
Revised edition published in paperback 1994
3rd revised edition copyright © 1999 by George Swinton

Canadian Cataloguing in Publication Data

Swinton, George, 1917–
 Sculpture of the Inuit

3rd rev. ed.
First ed. published under title: Sculpture of the Eskimo.
Includes bibliographical references and index.
ISBN 0-7710-8366-1

1. Inuit sculpture – Canada. I. Title

E99.E7S942 1999 730'.89'9712071 C99-931848-9

We acknowledge the financial support of the
Government of Canada through the Book Publishing
Industry Development Program for our publishing activi-
ties. We further acknowledge the support of the Canada
Council for the Arts for our publishing program.

McClelland & Stewart Inc.
The Canadian Publishers
481 University Avenue
Toronto, Ontario
M5G 2E9

Printed and bound in Hong Kong

1 2 3 4 5 03 02 01 00 99

This new edition of *Sculpture of the Inuit*
is dedicated to all Inuit sculptors on the
occasion of Nunavut's birth as Canada's
newest Territory on April 1, 1999.

The following works are part of the
Bessie Bulman Collection at the
Winnipeg Art Gallery:
Plate numbers 66, 260, 294, 319, 343, 514,
519, 705

Grateful acknowledgement is made to:

George Braziller, Inc. Excerpts from *The
Structure of Art* by Jack Burnham; reprinted
with the permission of the publisher.
Copyright © 1971 by George Braziller, Inc.

Information Canada. Extract of "Arctic
Ecosystems" from the *1971 Canada Yearbook*
reprinted with permission of the publisher.

The Beaver and *artscanada* for permission to
reprint extracts from their magazines.

William E. Taylor, Jr., for permission to reprint
excerpts from his articles.

Dorothy Eber for her permission to quote
Pitseolak.

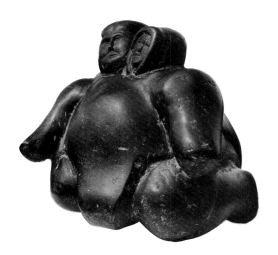

Contents

Foreword to the Updated Edition

4/Charlie Kalingoapik Angutigirk
Salluit (Sugluk) 1960
Stone length 9⅝″
WAG 3988-71

When it became evident that the revised and updated 1992 edition of *Sculpture of the Inuit* would soon be sold out, it also became evident that in revising the book for this new edition the new text and illustrations would have to be different in kind. They would have to indicate the real changes that have taken place in the last ten years.

As an illustration of these changes, the seal sculpture by Charlie Kalingoapik Angutigirk pictured here is, in its perfection, while being of the run-of-the-mill category, a characteristic product of "Eskimo Art" sculpture of the first decades. It would be difficult to find a more typical and popular example of Inuit art of that time. But there have since come into existence new parameters of looking at and describing the art of indigenous people. With a revision and reinforcement of the book's underlying ideas and information, however, combined with additional illustrations and new conclusions, this new edition of the book, with its still valid data base, does not require a great deal of further updating. The updated chapter, "Changes 1971-1999," suffices as the greatest part of this revision. In light of the new parameters for the discussion of Inuit art outlined in that updated chapter, I had at one time intended to change the title of the book to *Sculpture by the Inuit*, if publishing etiquette and traditions had permitted me to do that. Such a revised title would perhaps have best described my desire to truly update my notions of *Inuit art* and of *art* in general. For I had come to realize that some of the traditional Western methods had become largely inexpedient to describe – factually and historically – the work created by Inuit. I had wished to further distance myself and the book from prevailing popular notions – not to say misconceptions – about the Inuit in general and about the individuals who produce these works. The new text and illustrations follow on page 274.

Although this book was originally written some thirty years ago, I still am able to agree with most of its text. In fact, much of what I anticipated has become reality with the many changes in the past years in every aspect of Inuit art.

Since there are some four thousand Inuit who now carve – or have carved – doing justice to their enormous output in this new edition of *Sculpture of the Inuit* is not longer possible. Neither would it be possible merely to list, characterize, and illustrate the best of them. In order to produce an updated version of the image bank that constitutes the main body of the book, the time and expense of even assembling information and illustrations would be prohibitive.

In addition to the image bank, I have included personal interpretations, which have often led me to lucky, but generally useful, discoveries. While at times based on intuition, most of my speculations are based on experiences in the North and familiarity with Inuit life styles, myths, and traditions. The main purpose of the book, nevertheless, has always been, and still is, to provide the reader/viewer with a visual and informative overview.

It remains to explain why the word "Eskimo" appears in the portions of this book that have not required updating, while the title has become *Sculpture of the Inuit*. Uses of the term "Eskimo" have changed considerably. In fact, if used in common parlance (especially in Canada), that term suggests a certain lack of linguistic alacrity or, at least, a lack of ethnic cognizance. It also has some derogatory intimations because of its derivation from the Algonkian *esquimantsic* – "eaters of raw meat." Most of the Canadian Eskimo peoples have used for themselves the term *inuit* which, on one hand, simply translates as "people" but also implies "the ones who are (truly) human" (as opposed to almost all others who are not) or, in plain words, THE people (as most native peoples call themselves).

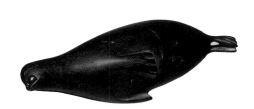

In this regard it is interesting to note that the younger people of Alaska and Greenland (and even of Siberia) have started to call themselves Inuit as a rapidly growing pan-Eskimoan movement (the "Inuit Circumpolar Conference"). The designation Inuit is in the process of becoming a universal term except in a generic sense where Eskimo and Eskimoan are still in use by social scientists. In order to conform with the above, the reader is asked to substitute "Inuit" for "Eskimo" in the introduction and the first ten chapters, except in generic references. It is important also to note the following orthographic changes: Kablunait is now spelled *qallunaat* (singular, *qallunak*, or, if anglicized, Kabloona or Kablunak); Povungnituk is now Puvirnituq; Spence Bay is now Taloyoak; Lake Harbour has become Kimmirut; and Baker Lake is occasionally called Qamanittuaq.

As to the captions throughout the book, it has become too difficult to locate the many sculptures that have been transferred to public institutions since 1991 and, consequently, to list their acquisition numbers.

In the context of this book, my concepts of acculturation include formal education and legislative and administrative responsibilities as intrinsic factors and, therefore, are not discussed separately.

Acknowledgements

This new edition is the second major revision of *Sculpture of the Inuit*. In the 1992 edition, I did not change the acknowledgements page except that I added a few lines with the names of those who aided me in putting together the revised text.

This time, however, due to lack of space, and for the historical record, I am retaining only a part of my original acknowledgements. I regret to have to omit certain names; some of the collectors and officials have died or are no longer active. As to those friends still living, they helped me out of the kindness of their hearts, and I again wish to express to them my gratitude for their support and friendship some thirty years ago. It is in no way possible to acknowledge all of them, or the many ways they have helped me during my research, my sorting and captioning of photographs, and other – often tedious – tasks in over three years of joys and labour. There are, however, a few I wish to single out for various reasons, because without them the book could never have come into existence.

For the original 1972 edition, my family, who had to put up with a very much absent and preoccupied father; Malvina Bolus, Shirlee Smith, and the late Cece Stewart of the Hudson's Bay Company, who supplied information and friendship; two passionate collectors, Budd Feheley and Jerry Twomey, who persistently and patiently goaded me into writing this book; Walter Yarwood, who understandingly supported these intentions; Brother Jacques Volant, OMI, Curator of the Eskimo Museum in Churchill, who always helped in many ways; Helga Goetz, Barbara Tyler, and Dr. William E. Taylor from the National Museum of Man, Diana Trafford Bissett and Sharon van Raalte from Ottawa, and Doris Shadbolt, Curator of the Vancouver Art Gallery, with whom I worked on the *Sculpture of the Inuit* exhibition and who gently forced me to face many problems of Eskimo art, as did Jack and Sheila Butler, Pat Furneaux, Gabriel Gély, Nelson Graburn, and Bob Williamson; Alma Houston and my colleagues on the Canadian Eskimo Arts Council; the University of Manitoba for its help through research grants from the Northern Studies Committee; my photographer friends, particularly Tom Prescott, Winnipeg Photo Limited, and Angus Murray, who made it possible for me to include so many photographs; all those who aided with captions and bibliography but particularly Evelyn Fieldhouse, who not only typed the manuscript several times but who helped me clarify many problems of meaning and sorted out the many intricacies necessary to achieve an accurate bibliographical listing; Jim Houston, who questioned many of my assumptions and forced me to take a broader look at every aspect of the contemporary art production in which he had played so important a role; and then, of course, the artists themselves, who not only created the work described in this book but who taught me new ways of seeing and thinking.

As to the 1999 revision, since most collectors wish to remain anonymous, and since pieces in private collections often change hands, no mention will be made of them. In the past two to three years, however, I have received help and encouragement from many people, mostly from my daughters, Moira and Nelda, and their husbands, also from Doug Gibson, Darlene Wight, Ernie Mayer, Heather Beecroft, Ingo Hessel, Louis Gagnon, Jean Blodgett, Norman Zepp, Cynthia Cook, Terry Ryan and Leslie Boyd, Faye Settler, the Marion Scott Gallery (Judy, Ed and Bob Kardosh), Lorraine Brandson, Bernard Murdoch, Canadian Arctic Producers, the North West Company, the Feheleys, Dr. Harry Winrob, Lorne Balshine, the Bayat Gallery, Glenn Wadsworth, the Ancestral Spirits Gallery, Denise Gagnon, and Dennis Hillman, all of them somehow involved with Inuit art. Many thanks to them and all the others, as well as the physicians and therapists who looked after me when my health demanded it.

Finally, I wish to express my gratitude to Alex Schultz, for taking on the challenge of editing this final revision of my book. Thank you Alex, and Doug Gibson, for seeing a fundamental rationale in my idiosyncratic ways of looking and seeing.

5/David Ikutaaq
(Ekoota)
Baker Lake 1965
Stone height 4¹/₄″
WAG G-76-72

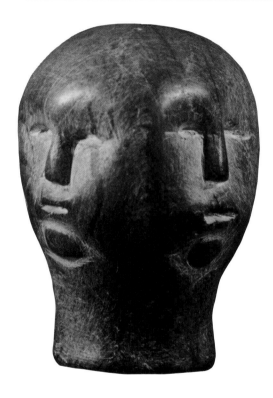

THE CARVED REALITY
Four small carvings –
 an owl by Tudlik in green stone
 spread wings yet still compact
 Tudlik by that time was almost blind
 his owl is totally tactile
 Ahlooloo's couple
 two whalebone people grown together
 forms interacting – space and volumes
 the porous whalebone
 more visually than physically tactile
the face by Tiktak
archaic stone, archaic forms
timeless
each indentation speaking volumes
 Jonanasii's creation tale
 man's relation to Nanook the bear
 or it is bear to man?
 small size yet monumental scale

All four carvings say "sananguaq" –
 things made or carved, realities created.
 Carved new realties are brought to life as
 images freed from confining stone and bone.
 Materials – now alive with form –
 were carved by hands and hearts of men,
 revealing life,
 releasing soul
 from formerly inert material.
 Art's essence always is a miracle
 transforming mass to life.

6/Tudlik
Cape Dorset 1959
Stone height 3⅞″
WAG G-76-134

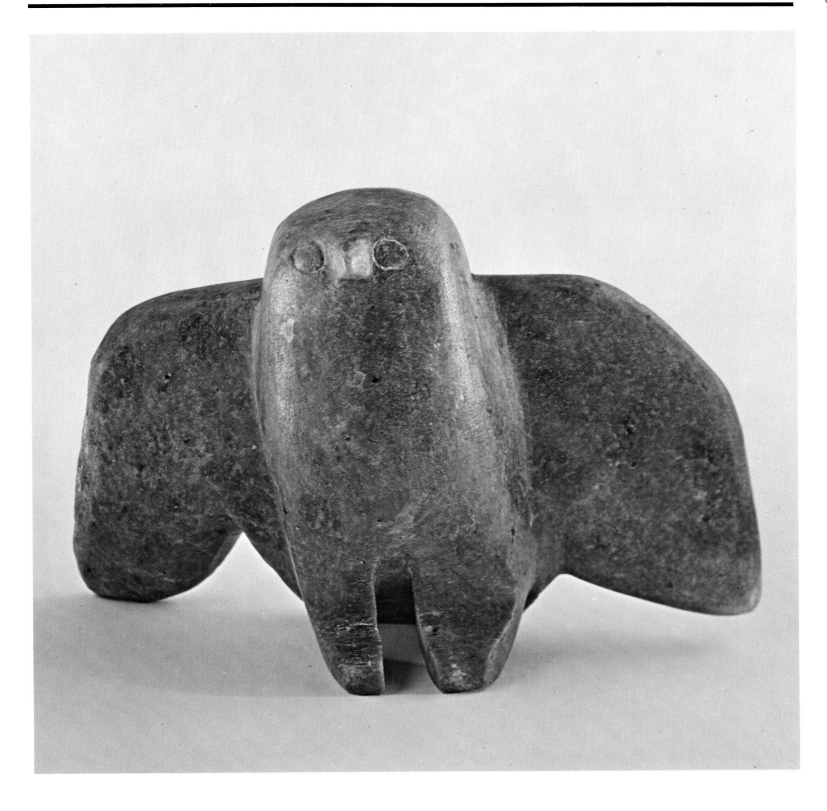

7/Peter Ahlooloo
Arctic Bay 1961
Whalebone height 5½″
WAG G-76-71

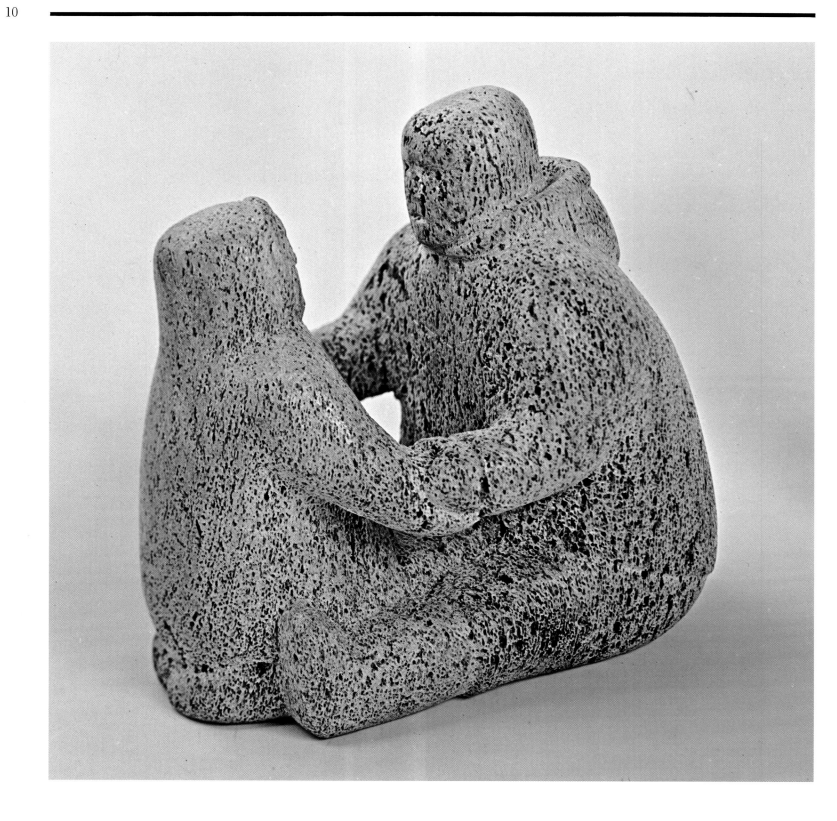

8/John Tiktak
Rankin Inlet 1965
Stone height 5¾"
WAG G-76-425

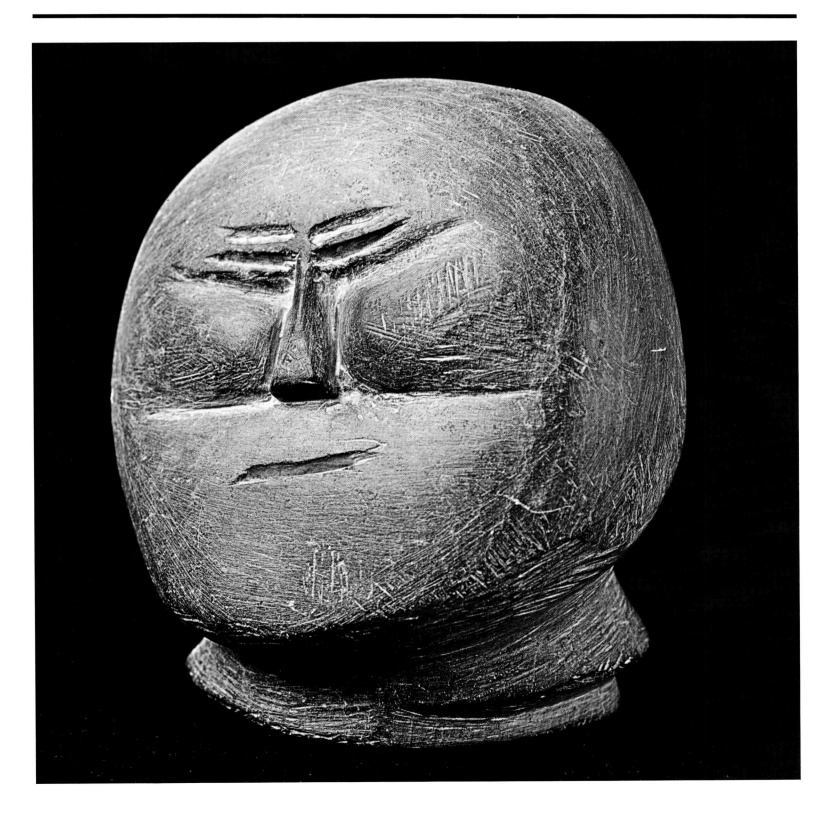

9/Jonassie Kudluk
(Jonanassi)
Kangirsuk (Payne Bay) 1963
Stone height 5¼″
WAG G-76-332

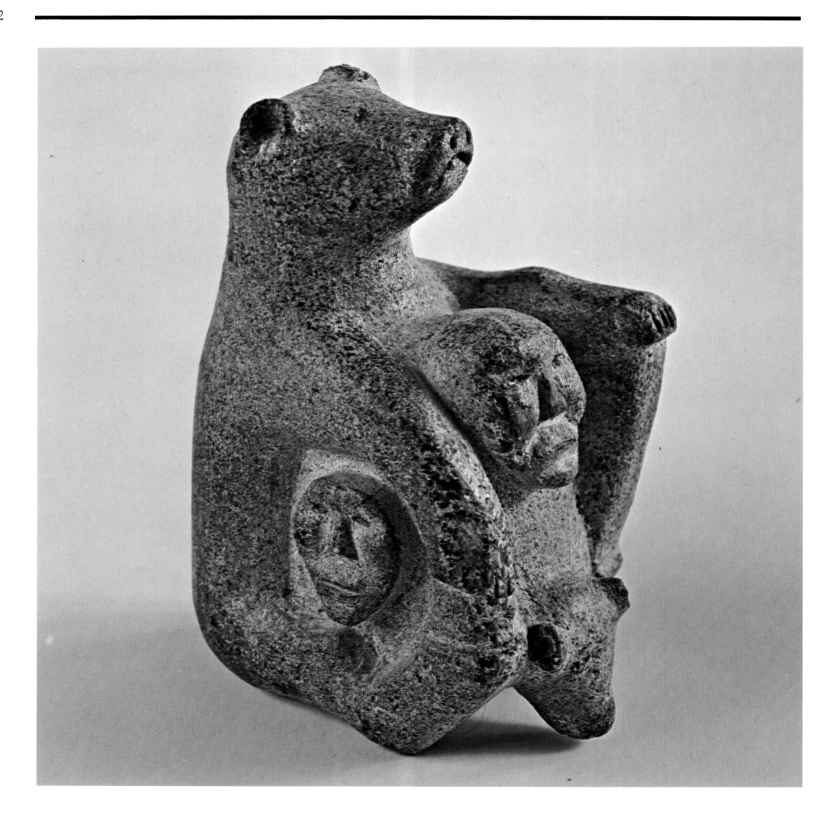

Introduction

Over thirty years ago Hermann Hesse realized the profound sense of weariness and irrelevancy which had overtaken the art impulse. He sensed that in the frantic attempts to glamorize and immortalize the products of art, society was unconsciously aware that a way of life was passing from existence.
JACK BURNHAM
The Structure of Art

We all know that art is not truth. Art is a lie that makes us realize truth, at least the truth that is given us to understand.
PABLO PICASSO

When used in official and commercial quarters, the term "Eskimo sculpture," or the more general label "Eskimo art," produces questionable undertones of never-ending streams of delightfully primitive art being produced by ever-smiling northern natives. While in Western civilizations we realize that not everyone who paints or sculpts is an artist, we lump all Eskimos and their art into one group and fail to make the necessary distinction between the talented and the indifferent. Our failure may be partially due to the initial promotion efforts of well-meaning government officials, distributors, and the media. Their intention was to establish the Eskimos' authenticity and to protect their art from imitation. But in our arrogance, we consider all natives in terms of collective characteristics and thereby establish meaningless generalizations concerning *all* Eskimos and *all* Eskimo sculpture.

The art historian also compartmentalizes Eskimo art in his attempt to place it in a variety of categories. Art history and art criticism do provide points of view that can bring the viewer closer to the work of art, but the historian and the critic tend to consider the art work in terms of its place in a larger scheme and thus turn it into something other than what it was meant to be.

The labels of the commercial, the official, and the academic worlds thus obscure the true relevance of the Eskimos' art and predispose us to certain aesthetic judgements. These judgements too frequently prevent deeper appreciation of the art form. And yet as abused as the term "Eskimo sculpture" is, it does locate and specify the activities and products coming from the Arctic. Unfortunately such labels also imply a characteristic and collective art style. The fact is contemporary Eskimo art is a widely practised activity carried out by many people who, though they are

often extremely sceptical about it, have miraculously retained a sense of directness of expression plus a strong relationship to their physical and cultural environments, old and new.

While carving and other techniques are practised by many Eskimos, art is by no means a collective activity, and the notion that all Eskimos carve or that all those who carve are artists is simply absurd. Still it is true that there is an extraordinarily high percentage of good artists among the contemporary Eskimos. This fact is even more extraordinary since these artists are able to create in the cultural vacuum resulting from the white man's intrusion on their land and culture, and since the alternative presented by the intruders is a culture that is technologically seductive, ecologically poisonous, and culturally ruinous.

The current carving activities were instituted in 1948/49 primarily in order to provide economic solutions to the problems of survival that had continually confronted the Canadian Eskimos (or *inuit*, as they call themselves) particularly on the east coast of the Hudson Bay. However, during the first few years, the commercial exploitation of what was then believed to be the Eskimo people's general ability to carve was only negligible in terms of both the number of artists and the amounts of money received.

Most of the carvings that appeared at the beginning of this phase were quite small (ill. 10 and 11) and sold for only a few dollars. They were originally produced as "whittles" (ill. 13), carvings made as toys, or barter goods, rather than as sculpture. However, when the whittles were first shown in Montreal their artistic merits were recognized at once. And, unavoidably, their commercial potential also became apparent. When the *inuit* were approached to produce carvings as a means of supplementing their livelihood,

the whittles were almost immediately changed into "art," and the casual carving activities were transformed into a cottage industry. It was only natural that under these circumstances more and more people became involved in producing carvings on a regular basis. However, after the initial impetus had spent itself, the harsh and relentless realities of a continuous art production brought about changes. On the one hand, the quantity of the small carvings on the southern markets greatly increased, with the concomitant deflation of the original artistic values through repetition and pseudo-sophistication. And on the other hand, a number of larger carvings that bore no resemblance to the former whittles started to appear.

But many of the Eskimos were able to do more than produce quaint curios for southern tastes. They did more than depict the subject matter of their environment; they gave their carvings content. And they did more than reproduce a successful style; they created their own personal styles – or forms. It is the extent to which these artists were able to go beyond the commercially successful subject matter and styles that their work became true art. And despite the many diverse ways in which works of contemporary Eskimo sculpture attain this classification, there are some characteristics that they have in common. Foremost among them, in addition to geographical origin, is the nature of the available materials, although today many new materials are being brought in from other regions.

For the past one hundred years it has become increasingly fashionable and almost mandatory to analyze the manipulation of materials in the production of works of art. It goes without saying that mastery of materials and techniques is an essential ingredient in an artist's work. Compared with Western theories and

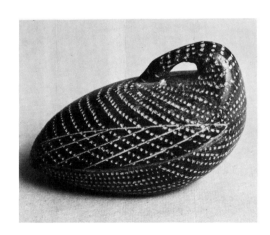

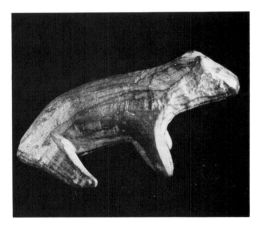

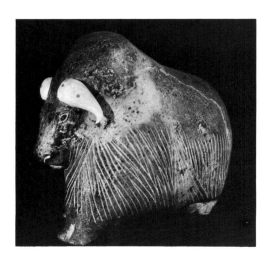

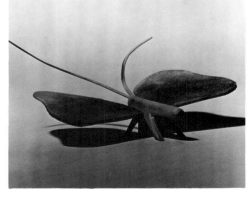

15/Davidialuk Alasua Amittu
(Davideealuk)
Povungnituk c. 1962
Stone width 9¹/₄″

16/Charlie Sivuarapik
(Charlie/Arnaituk/Sheeguapik)
Povungnituk 1954/5
Stone height c. 7″
WAG G-90-946

17/Eli Sallualu Qinuajua
(Eli Sallualuk)
Povungnituk 1967
Stone height c. 5″
UBCMA Na1359

practices, the Eskimo artists' responses to materials are much more sophisticated and complex. I am convinced that, with our kind of knowledge, we could not possibly have explored the range of subtleties within the limited materials available to the *inuit* and achieved their diversity of expressions and their technical accomplishments. Eskimo artists have been extraordinarily ingenious in overcoming the limitations of their materials and in extracting nuances and refinements hidden in the materials as we know them. It is as if the *inuit* artists were miraculously able to extend the materials and their properties. This faculty derives largely from their deeply implanted survival instinct which demanded the versatility and ingenuity to draw ever-new uses out of the most unexpected means and to be able to utilize fully whatever is available.

This in no way means that the *inuit* do not usually respond simply and directly to the intrinsic and surface qualities of the materials they use. However, they are able to perceive and utilize potentials that are almost inconceivable to most Western artists and critics. The point here is that the *inuit*, like all peoples close to nature and her mysteries, have deeper insights into and more highly developed intuitions about materials that to us are essentially inanimate. Their approach is more spiritual and organic – intrinsically animistic – whereas our approach is largely aesthetic, pragmatic, or functional. It is hard to imagine a Western sculptor listening to his stone to hear the image within *speak* its shape (cf. Pauta's woman, ill. 60).

Since the examples in this book illustrate the versatility of the Eskimo artists in the manipulation of materials, it seems unnecessary to add words to the visual evidence. However, the reader's sensory attention should be drawn to a few specific items which are particularly relevant to this point. For instance, the two family

groups by Kanayuk (ill. 61) and Makpa (ill. 62) show opposite ways of handling stone: Kanayuk delicately perforating a finely grained stone to the limit of its tensile strength as compared with Makpa's forceful exploitation of one of the hardest stones used anywhere in the Arctic. There is Oksokirtok's extremely intricate handling of a type of stone (ill. 87) that is usually carved in large simple volumes because of the stone's suitability for large masses and the grain's texture which accepts a high polish. And there is Ootnooyuk's apt use of beads and fox teeth as texture- and meaning-enriching elements (ill. 83) and Pauli's fascinating utilization of a rubber eraser as a significant texture for his bear's tongue (ill. 75).

Also, a straight comparison of Oshooweetook's massive but graceful musk ox (ill. 12) with Atok's humorous butterfly (ill. 14) indicates an intimate familiarity with materials, bringing out various unexpected textural and structural qualities, and all the other wonderful corporeal qualities of stone-musk-oxen and bone-butterflies.

Another characteristic common to Eskimo sculpture is the newness of the contemporary art form; that is, it is not part of a continuing tradition. In this regard, contemporary Eskimo sculpture of Canada differs sharply from that of Alaska and Greenland where traditions have been perpetuated and have unfortunately become largely sterile and commercialized. In Canada, too, many aspects of the contemporary development have stagnated, but these comprise only the large, run-of-the-mill souvenir production which exists wherever "art" is consciously produced for popular markets. On the other hand, the vital aspects of the contemporary art activities have a definite relevance to Eskimo existence, and in that sense, contemporary Eskimo art may well be one of the last remnants of the dis-

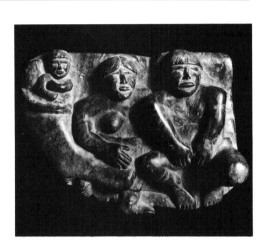

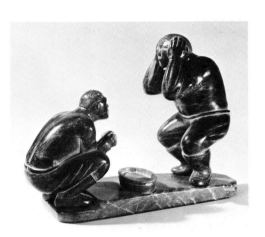

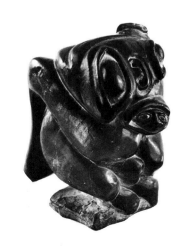

18/Johnny Inukpuk
Inukjuak (Port Harrison) 1962
Stone height 19″
TDB EC-82-600
(detail of 55)

appearing "art impulse" tradition.

One of the most important characteristics of contemporary Eskimo art – one which is still very much overlooked – is the compelling individuality of the artists. It is this characteristic that is most commonly ignored in the attempt to establish collective anthropological or commercial traits. Those artists who managed to preserve the "art impulse" tradition are those who are readily indentifiable and who have a marked individual style (see ill. 15, 16 and 17). Instead of the anticipated native charm, their works show authentic yet conceptually new Eskimo art forms.

When Picasso said, "we all know that art is not truth" but "a lie that makes us realize truth, at least the truth that is given us to understand," he took it for granted that search for truth was one of man's perennial concerns. He also realized that, though obviously an illusion, this search was nevertheless real or, at least, a game to be taken seriously because it provided a means for understanding what otherwise could not be understood. Art in that sense helps us to gain insights; it gives meaning to what otherwise might have no meaning. The territories where art gives meaning and helps us find meaning are the emotions, the senses, aesthetic perception, imagination and intuition, metaphors and dreams, interpretations and rationalizations. Within these territories, meaning is found in a variety of specific ways through stimulation received from works of art.

For instance, Johnnie Inukpuk's sculpture (ill. 18) shows a mother feeding her child. This ostensibly is the sculpture's subject matter. But then, suddenly, new meanings start to emanate, all of which are interdependent and cumulative. For example, there is a powerful image of feeding; not the fact of the mother and child, which is tacitly assumed, but instead the process of feeding; abundance, keeping alive, fostering; fostering mother; *alma*

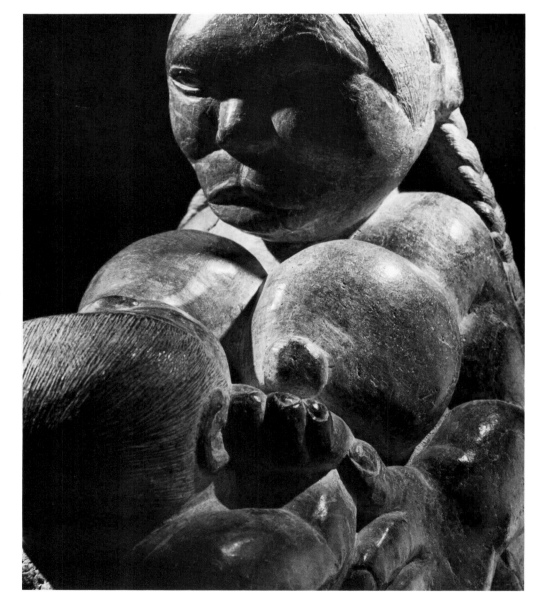

19/Unidentified artist
Inukjuak (Port Harrison) 1955
Stone and ivory inlay height c. 6"

20/Levi Qumaluk ? (re-a)
(Levi)
Povungnituk/Inukjuak 1954
Stone height 6"
Avataq NA-14

mater – source of knowledge – abundant, strong. Big hands, big back, big breasts; all very big. The head, the breasts, the other head; all are round. The ears, the eyes, the cheeks, the mouths, the fingers – touching, seeing, feeling.

The content is the product of all meanings; never static, never fully known. A work of art does not prove anything; it convinces. It is a truth which cannot be verified; a lie which reveals itself to be trustworthy; an illusion which is more real than perceived reality; a reality which is complete yet completely intangible; a statement that is explicit but never explainable. Art – like Shakespeare's midsummer night's happening –

*More witnesseth than fancy's images
And grows to something of great
 constancy;
But, howsoever, strange and admirable.*

This, of course, is precisely the life-quality of art and the element that eludes definition. Equally if not more elusive is the concept "form" on which not only the aesthetic but also the expressive and imagistic qualities of art depend.

The artist gives form to his ideas, i.e., he chooses, feels, discovers, uncovers the right or appropriate form to express what he thinks or feels. Form in that sense is the most essential ingredient in a work of art because only through the appropriateness of form does an image become art. And it is with regard to this very point that some of the contemporary developments of Eskimo sculpture have become so unequivocally valid as art.

Coming back once more to Johnnie Inukpuk's mother and child. This sculpture exemplifies form – form which transforms fact and expresses sensations and ideas. Every single part breathes life and strength, so that the meanings do not emanate as much from its imagery as from

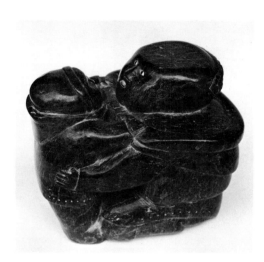

the abundant, excrescent shapes and the over-size, bulging volumes that are so closely related to each other, producing a fugue-like structure of roundnesses. These are Johnnie Inukpuk's personal style characteristics. The artist has found a unique form to express his emotions, impressions, and ideas. This personal form is achieved when the subject becomes trans-formed into a work of art. Form and art are inseparable.

Collective style, on the other hand, appears to me to be more on the surface, deriving from traditions or conventions and from the form accomplishments of other artists. In the carving (ill. 19) a Port Harrison artist, unknown to me, makes use of Johnnie Inukpuk's personal form by shaping the large head with the small inlaid eyes in a style that became common in Port Harrison between 1952 and 1954 (and, incidentally, was abandoned by Johnnie Inukpuk a few years later).† Similarly the dot pattern of the garment decorations is a traditional Port Harrison style (see ill. 20). The small hand, another Port Harrison style element, differs greatly from the huge hands which are so characteristic of Johnnie Inukpuk's form. It is, however, entirely possible for an individual artist to become attracted by and then to appropriate other artists' forms – or general styles – and make them into his own. The Italian Renaissance artists, for instance, believed in *invenzione*, not in originality – *invenzione* always implied the development of form and ideas, very much like variations on a theme or style.

†The "Woman with Ulu and Fish," by Pinnie Nuktialuk in the Art Gallery of Ontario (ill. 307), was formerly attributed to Johnnie Inukpuk, and was generally accepted to be his. But labels are often wrong, and, while assembling the *Sculpture/Inuit* exhibition, the true identity of the artist was discovered by Helga Goetz. Once known, the differences of style have become obvious.

22/Tuna Iquliq
(Donat/Toona/Erkolik/Erkoolik)
Baker Lake 1963
Stone height 12½″
WAG G-76-40

23/Tuna Iquliq
(Donat/Toona/Erkolik/Erkoolik)
Baker Lake 1963
Stone height 7″

21/Annie Niviaxie
Kuujjuaraapik (Great Whale River) 1966
Stone height 10⅛″
WAG 1627-71

18

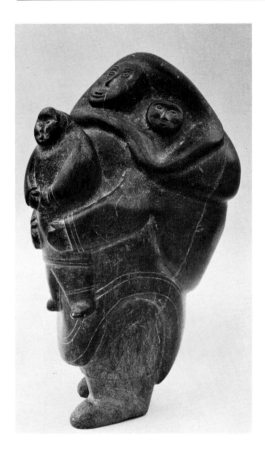

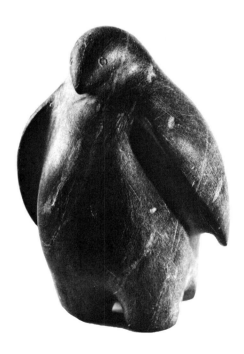

The third mother-and-child carving (ill. 21) by Annie Niviaxie illustrates various personal and collective aspects side by side. The lower half of the sculpture is made up entirely of strong, distinctive shapes which are general style elements used all along the east coast of Hudson Bay. The upper half, however, is completely unique in its great mass and sweep, with three faces unmistakably Annie Niviaxie's (cf. also ill. 222). The total feeling of the sculpture is highly personal, and it is an excellent example of what we call art. And when we speak of art in this sense, we always and unequivocally refer to the prime achievements rather than to lesser examples. These prime achievements conspicuously define art. In that sense, art is obviously more than "any embellishment of ordinary living that is achieved with competence and has describable form."[†]

The uniqueness of form is well illustrated by the four carvings (two each, ill. 22, 23, and 24, 25) by Erkoolik and his brother Tikeayak, produced when these two artists were at the height of their creative abilities a few years ago. Curiously enough, at that time they worked in two different settlements some 140 miles apart – Erkoolik in Baker Lake and Tikeayak in Rankin Inlet. Yet their attitudes towards the human figure and their attitudes towards animals, particularly birds and even more specifically ptarmigans, were similar. However, their personal styles were quite different. In their carvings of figures each was highly expressionistic, revealing the severity of the human condition. In contrast, their carvings of ptarmigans were elegant abstractions of pleasingly plump birds not only good to eat but also beautiful to see. Yet in spite of their differences, Erkoolik's two

[†]Melville Herskovits, *Cultural Anthropology* (New York: Alfred A. Knopf, 1955), p. 235.

24/Eli Tikeayak
Rankin Inlet 1963
Stone height 6″

25/Eli Tikeayak
Rankin Inlet 1964
Stone height 4¹/₂″

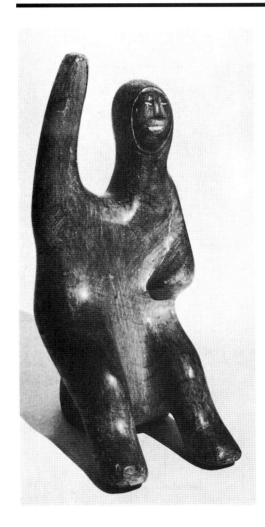

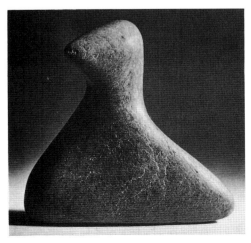

carvings have a common crispness of form, with well-defined edges and clearly incised or raised features. Tikeayak's carvings also have their own personal style characteristics. In contrast to Erkoolik's crispness, Tikeayak's form is soft and smoothly round and, where they exist at all, the linear features are merely gently grooved.

Once one has become aware of these nuances, the individualities of the two artists begin to emerge. And the factor that enables us to speak of the unique qualities of the artists is their personal form rather than a collective style. This point of distinction is not peculiar to Eskimo artists alone but applies to all artists; in fact, even the so-called anonymity of "primitive artists" is purely mythical and has arisen only because of our lack of intimate knowledge of their work and our unfamiliarity with artists of non-Western cultures. To local populations their artists were never anonymous. Even when the subject matter and content are similar, personal styles can create individuality in art.

The next four carvings have the same theme – "togetherness." To the Eskimos this always has been a significant aspect of their fight for survival and hence their ethic of existence. This ethic is gradually losing its significance for the younger Eskimo population but remains firmly implanted in the older people. Its current state of decline is a grim indicator of the effects of acculturation which are threatening the cultural survival of the *inuit*. It is with regard to this threat that the four images of togetherness have become important symbols of cultural affirmation. They accomplish much more than merely illustrating formal arrangements of human figures for the sake of achieving aesthetic and harmonious design units. In the Pelly Bay piece (ill. 26) the elemental male and female heads sternly arise from a common volume as out of one single

body. Pangnark's elegant shape (ill. 27) – reminiscent of Brancusi – is another unified configuration, a family that has grown together. The other groupings (ill. 28 and 29), each different in each artist's own form and concept, achieve the same kind of content in their own particular or, if you will, in their own original way. What makes them superficially appear to be alike is their common theme, their common content, their essential Eskimo-ness, and, of course, their use of similar materials and techniques.

The sources for the originality of Eskimo artists are varied. Davideealuk (ill. 15) and Joe Talirunili are "real old-timers" – story tellers *par excellence*. Their attitudes to form developed more in relation to their visual than their prodigious verbal expressiveness. Their form is truly Expressionist rather than illustrative. Charlie Sivuarapik (this spelling is the closest to the actual sound of his name), on the other hand, carves in an illustrative mode with special emphasis on anatomical trueness which he achieved through constant reference to his own body by touching it, rather than from visual observations (ill. 16). His naturalism influenced most of the carvers in Povungnituk; however, only few were as skilful as he. Nevertheless, out of the respect for skill itself there developed a totally new theme in Povungnituk, as in Cape Dorset a few years earlier – fantasy and spirit carvings.

In Eli Sallualuk's carvings (see ill. 17) the mixture of skill and fantasy leads to a daliesque surrealism – a highly descriptive yet fantastically abstract supernaturalism. Everything is defined as if it were absolutely real, like detailed photographic representations of seen monsters and not of creatures of the imagination. This specific, physical portrayal of invisible apparitions and legendary subject matter is characteristic of Eskimo art and folklore.

26/Unidentified artist
Pelly Bay no date
Stone height 2³/₄"
WAG G-76-355

27/John Pangnark
Arviat (Eskimo Point) 1967
Stone height c. 4¹/₂"
WAG 1238-71

28/Deleted

29/Sheokjuk Oqutaq
(Sheeookjuk)
Cape Dorset 1952
Stone and ivory length 6¹/₂"
CGCM 123.

30/Davidee Mannumi
(Munamee)
Cape Dorset/Iqaluit 1961 ?
Stone height 9"

31/Kiawak Ashoona
(Kiawak)
Cape Dorset 1963 ?
Stone height 8¹/₄"
(same as 482)

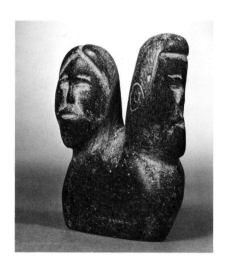

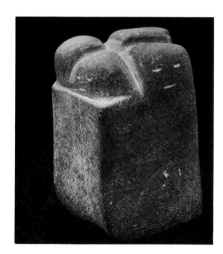

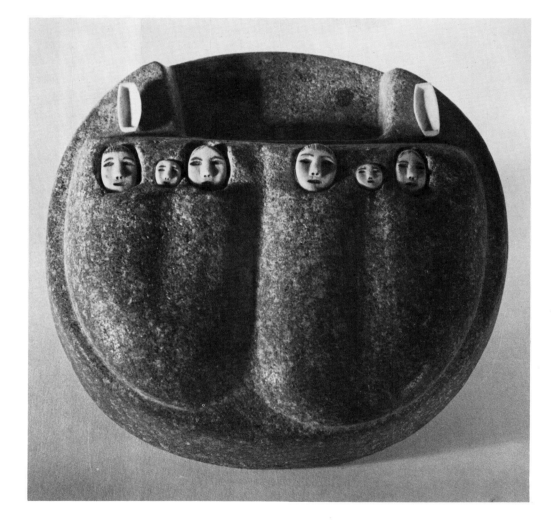

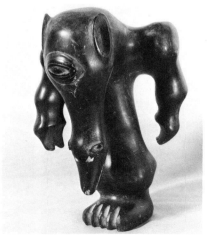

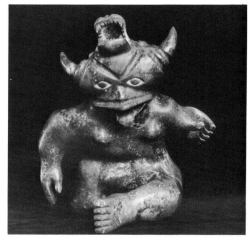

32/Kaka Ashoona
(Kaka/Hakkak)
Cape Dorset 1953
Stone height 5³/₄″
CMC IV-C-3362

33/Noah Koughajuke
(Koojuajuk)
Lake Harbour 1966
Stone length c. 13″
(also 516)

34/Letia Koonoo Tagornak
(Kunuk)
Repulse Bay 1968
Stone and ivory height 3″

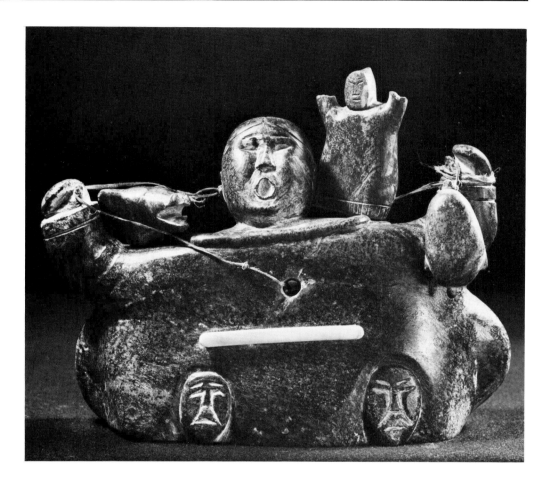

Both Munamee's and Aggiak's spirit carvings (ill. 30 and 31) are less detailed, more baroque than the Povungnituk style. They are typical of the extravagant and dynamic fantasy style of Cape Dorset carvings and prints. In fact, this baroque flamboyance has spread to many other parts of Baffin Island.

Closely related to the fantasy carvings are the formerly rare but now increasingly popular motifs taken from folklore and mythology. Kaka's great carving of a female shaman (ill. 32), though very small in actual size, is a powerful image that has retained its force despite the many descriptive details and appendages of various materials. It is a classic example of purely illustrative content which became magically transformed through its Expressionist form into an archetypal image of *the* metaphysical sorcerer-healer, adorned with all the paraphernalia of her calling.

The next three carvings (ill. 33, 34, and 35) have purely mythological themes. They are shown here in order to make two points of comparison. First, they come from widely different areas – Lake Harbour, Repulse Bay, and Povungnituk – and hence indicate the wide distribution of mythological carvings. Second, such carvings are usually executed with greater care and knowledge than most other work. In general, only the more accomplished artists "tackle" such sculptures. Their magic or spiritual qualities still evoke respect. Whether their appeal will commercialize them, or whether their culturally significant content will protect them against exploitation, is still uncertain. But they are appearing more frequently on southern markets.

The final theme of contemporary carving that I would like to discuss is the role of sexuality. As in our society and art, sexual references are becoming more frequent in Eskimo sculpture and have

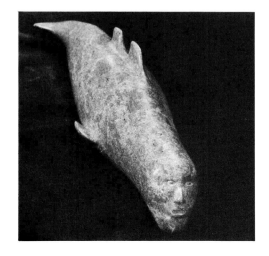

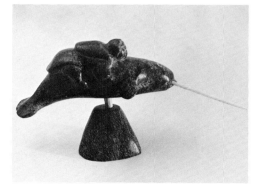

22

changed from a concern with animal
propagation to human eroticism. This
change in attitude is said to be due to
the prodding of whites, particularly in
Povungnituk during the late 1950's, and
there exist references which substantiate
this hypothesis and identify some of the
participants. However, it is wrong to say
as many purists do – that such carvings
are frivolous or have nothing to do with
Eskimo ethos. Propagation and sexuality
are very much part of Eskimo life, and
their appearance in art is a reflection of the
whole contemporary scene in which the
inuit are participating in a perfectly
normal and healthy way, and that includes
tongue-in-cheek art.

Three carvings which, for the sake of
identification, I have entitled "Bear and
Walrus Theme" need one further
comment. These carvings by Aupilarjuk
from Repulse Bay (ill. 38), Peter from
Payne Bay (ill. 39), and an unidentified
artist from Port Harrison (ill. 40), show
both directly and symbolically, copulation
between two very powerful animals. I have
not been able to obtain information on
this theme other than, "there are all kinds
of things happening in nature for which
man cannot find explanations," or "which
man must not seek to explain." On the
other hand, I have found a few carvings
on the same specific theme from Great
Whale River, Belcher Islands, Cape
Dorset, and Arctic Bay. A clue to its prob-
able nature symbolism may be found in
the Payne Bay carving with its emerging
human heads. Might it belong to a
creation myth, might it be the marriage
between two powerful but different forces
in nature, or might it be a typical *inuit*
animal fable with the ubiquitous mixed-
union content?

Until very recent times, only little was
known about the *inuit* artists' attitudes to
their art. In fact, adverse criticism and
patronizing news releases created

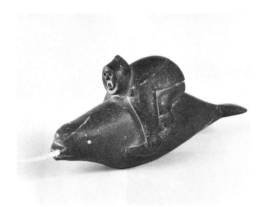

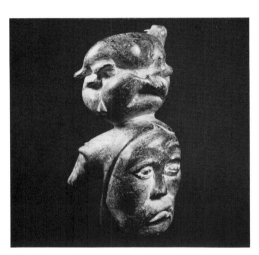

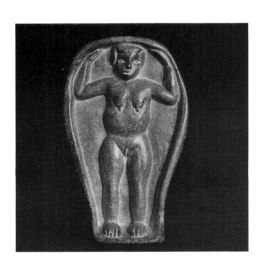

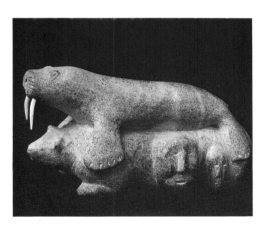

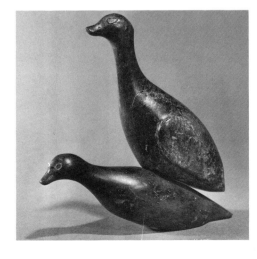

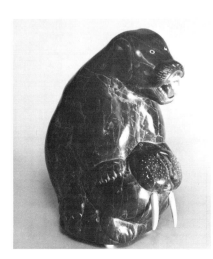

41/Donat Anawak
(Anaruak)

42/John Tiktak

suspicions that the artists' motives in producing their art precluded any degree of sincerity and that no art would have been created if it were not profitable. The facts contradict these assumptions. Obviously, the overt motivations are always commercial. Yet in the last eight years I have come to know many artists, some of them very well. They do not deny their commercial motivations, but the financial rewards are not their only reasons for their choice of work. They prefer carving or printmaking to hunting or putting up fish.

Pitseolak is a committed artist. She enjoys the money she receives, but also insists:

"To make prints is not easy. You must think first and this is hard to do. But I am happy making prints. After my husband died I felt alone and unwanted; making prints is what has made me happiest since he died. I am going to keep on doing them until they tell me to stop. If no one tells me to stop, I shall make them as long as I am well. If I can, I'll make them even after I am dead."

Anaruak, an outstanding artist and supervisor of the Rankin Inlet ceramics project, vice-chairman of the Rankin Inlet Community Council, and a widely respected *inuit* leader in the Keewatin district, spoke in this regard during an interview with members of the Canadian Eskimo Arts Council.† Asked whether or not people are happy working on arts and crafts, Anaruak replied:

"The making of works of art could be more a source of happiness if the people were not so completely dependent on it. I have

† John K. B. Robertson, Robert G. Williamson, and myself, at the Rankin Inlet Crafts Centre on August, 25, 1971.

many children at home, and in the past I lived by hunting and trapping. When I think back, I know that I was sometimes happy doing that, but not always because I was often worried about being able to provide enough for my family. Why should anybody be expected to love what they're doing all the time? A lot of the time, we have cause for worry – sometimes we worry about knowing what to make and how to make it. Some people are no more constantly happy making than I was constantly happy hunting and trapping, but sometimes the art work is a source of great joy."

Asked about the social position of the worker in the craft shop and the independent artist he replied:

"There are people who are working in the craft shop and others who are working occasionally on art and crafts but are otherwise working outside. There are some who would like to come to the shop full-time. Others would only come if there were better materials to work with.

"There are some people who are art and crafts people and are known in the community as art workers. They're known to be good as artists and they are becoming respected in the same way as good hunters are respected. *I* prefer to work in the craft shop because I feel happy with myself.

"At one time I was employed by the hunting and fishing officer and I was supposed to be in charge of a boat. I should have felt happy as the boss of a boat but, once ashore, I was pushed around and treated as a child. Now I can live with myself because I use my own mind, and because with my greater knowledge I can show other people what to do and I feel respected by the people I work *with*.

"In fact, some of the people who work at the craft shop are a source of envy because of our working conditions. Many people

are less independent than the artists who are able to work as their minds tell them. Many people are happy to have the opportunity to make works of art. Almost any Eskimo can benefit by the project whatever their condition.

"Look at Kavik, he is an old, old man who cannot hunt and fish very much any more and he cannot have a regular job with the white people, but he can make money for himself and enjoy himself very much. He enjoys making what the white people also enjoy having. Without the art and crafts project Kavik would not be the happy man he is now.

"Look also at Kamimmak – who has only half a lung. Look at Samgusak and Tikeayak who are deaf mutes and could not get white men's work because it would not be safe. Look at Tiktak who was badly hurt when the mine was here, who is deaf, weak, and elderly. Without the arts program he would have nothing and be nobody, but everybody knows him through his work.

"I have always been happy that I have been self-supporting. There was just a little time after the mine closed that I wasn't and I was very unhappy. But all the time since I have been self-supporting. What worries me now is that there are young people who seem to be content to stay at home and draw relief. I do not want that for our people. Does the Government want us to have no thoughts but only be part of the white man's money-making, or would they like us to have our own thoughts, to be respected by other people and to stand on our own feet in our working and living?"

There are, of course, many people who are unhappy being artists because being an artist frustrates them. But then, many artists everywhere are frustrated, and being an artist, as Pitseolak said is not always easy.

Two more illustrations of the artist's problems are very revealing. One is a pencil drawing which I collected at Povungnituk in 1957 from the then young Isa Sivuarapik. The drawing shows a man and a boy. The boy is looking at a rock, and the man is hacking away at a seal-shaped rock. Here is a translation of the caption.

BOY: "Eskimos and white people are not the same – they are not hunting, that's it – they have to try to get around [i.e., the Eskimo's not hunting anymore]. That's him there thinking about something: What can the Eskimo make out of rock? He doesn't think he can get anything out of this piece that he has got – because it is big – Sometimes it is no wonder that it is hard to know how to make it [a carving] – He is trying to think what would be the easiest way to carve it without breaking it."

MAN: "He† is very glad because he has got something out of this piece – because it didn't break – He is working on it so that it may not break – for he would be sorry –"

The other illustraton is the letter already quoted in my first book but this time the people are identified. In May, 1963, Samisa Paqsauraaluk – a formerly excellent wild-life artist who now no longer carves – wrote from Povungnituk to the Winnipeg collector J. F. Twomey:

"It is still winter. In July I will have good stone. The stone used now by Eskimos here is not good. I do not enjoy working poor stone. Do not get tired of waiting for my work. The white people will soon refuse our carvings if we use poor stone. I

†Since Isa Sivuarapik made the drawing he expresses the thoughts of the other man in the third person rather than the first person. The boy, of course, is a self-portrait.

am not doing much carving now, also I am a slow worker. I like to think of something that would please the buyer. . ."

This letter continues to be a remarkable and moving document of that period. Samisa no longer carves. He works as a building superintendent for the local school at Povungnituk. One day, maybe, he might carve again. He was an excellent hunter; I know, I went hunting with him. Now he hunts only occasionally. The anxieties he expressed in his letter still exist: the concern for high standards, the anxiousness to please, the interest in good craftsmanship. But there are things that have changed. If a man does not really want to carve he can find a job, although often only with difficulty. And then, of course, many people now carve or draw or make prints with a definite pride and have become the best-known and the most respected members within their communities. Art for many has not only become a means of livelihood but also a source of pride and joy, even though it does involve hard work. And they can say with Pitseolak: "I became an artist to earn money but I think I am a real artist." Tiktak does not leave any doubt about his professional pride. At a press conference he once said:

"As long as I am able, I like to be a sculptor, this is what I like best. I would also like my son to live where I live. Maybe he too could become a sculptor and find happiness as I found. That's what I wish for him."

How is it possible to explain the emergence of these new forms, new themes, and new attitudes in the art of a culture that seems to be on the point of disappearing? In the past, in most cultures, art was created not so much for purely aesthetic reasons but for purposes of communicating ideas and

producing symbolic or decorative images. This does not mean that aesthetic considerations did not count. In fact, it became obvious that through aesthetic considerations more effective results could be achieved. It is at the very moment of that realization that art and artist become unique instruments of communication. The artist instead of merely making images or producing decoration becomes the one who can make the most effective images or the most significant (and hence beautiful) decoration. The key idea here is that beauty arises out of efficiency and significance. It would be entirely wrong to assume that this implies a kind of Bauhaus philosophy of "form follows function." In fact, the opposite is meant: beauty enhances function and produces or increases effectiveness.

Furthermore, it is important to realize that, while some art is produced for the sheer joy of it, art and aesthetics are not always ends in themselves, but also powerful means. The impulse to use art in the production of ends is contingent on collective social, cultural, or religious goals. In today's Western art, artists are increasingly concerning themselves with trying to find meaning in life and have turned to the processes of living as the only significant art forms. To them, life and random activities have replaced the processes of art.

Contemporary Eskimo artists, fascinatingly enough, work in the opposite direction. While producing in the cultural vacuum created through the replacement of traditional Eskimo values by the attitudes of Western technology, the Eskimo artists – at first producing for non-Eskimo consumers – gradually found in art a means of cultural and ethnic self-affirmation. That meant that art production no longer was valid only for the satisfaction of economic needs but instead could become a factor in affirming spiritual,

43/John Tiktak
Rankin Inlet 1963/4
Stone height 7"
WAG G-76-443

44/Joe Talirunili
Povungnituk 1965
Stone length 10"

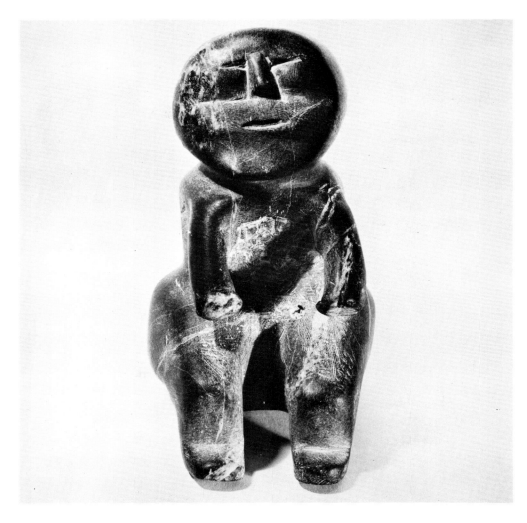

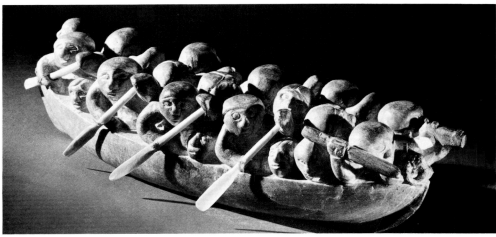

cultural, and ethnic ends. Through his art, the Eskimo became capable of overcoming the very weariness and irrelevance that seems to have overtaken much of the Western art impulse.

This dual achievement of meaning – art and cultural self-affirmation – is a fundamental necessity if the contemporary Eskimo is to survive as "Eskimo." In his long and arduous history of survival during the past five thousand years, the Eskimo has changed so much that it is safe to challenge any categorical definition of the term "Eskimo." Culturally, and even physically, the people of today are different from what they were in the past. The characteristics most common to Eskimo people across time are geographical distribution (although it too has changed a great deal) and the ability to adapt with an amazing degree of skill and inventiveness. Because of their need and their ability to adapt so successfully, and because of the effective natural selection that took place over the centuries, Eskimos developed a great pride in their ability to survive and to be. No wonder that, as other proud pre-literate people, they call themselves *inuit* – the human beings, THE people.†

To the Eskimo, in order to continue to be the *inuit*, the need for cultural self-affirmation is obvious. Without their Eskimo-ness the name *inuit*, THE people, would be ludicrous. One means toward this end is language, *inuktut* or *inuktitut* (literally "to be an Eskimo" or "in Eskimo") for there simply is no chance for the Eskimo's survival without his language.

Art is another means, but at the commercial level of souvenir production it obviously constrains more than it nourishes. Since there exists a definite

†*Inuit* is the plural of *inuk* (meaning man, total man) implying the humanity rather than species of the creature.

45/Ennutsiak
(Inuksiak)
Iqaluit/Frobisher Bay 1963
Stone and ivory width 9¹/₂″
EMC C 69.27-1
(also 521)

46/Thomas Ugjuk
(Udjuk)
Rankin Inlet 1967
Stone height c. 5″
PWNH 970.3.62

26

momentum of pride in much of their new art production, the question now arises: can art – as Eskimo art – survive? The answer depends partially on whether the Eskimo themselves will be able to survive, that is, whether they will be able to function as the *inuit* within the new, urbanized, acculturated, white-technology sphere of influences. Another determining factor will be the extent to which the Eskimos will wish to retain their Eskimo-ness and whether, under present conditions, they will have available sufficient strength and options to make such a decision.

Currently there exists a growing degree of Eskimo ethnocentricity, and the political pressures are such that the governmental agencies – more so the federal than the territorial – are vitally interested in supporting the *inuit*'s cultural aspirations. On the other hand, economic pressures and so-called "purely commercial" pragmatism are posing an almost irresistible threat. In spite of good intentions, our white culture together with our educational system (which is at best inadequate and at worst corrosive), plus the increasing influx of transient and inherently parasitical whites, further menace the Eskimos' chances of continued existence and identity.

Against this background of threats, the phenomenon of contemporary Eskimo art – particularly sculpture and the two graphic media of prints and drawing – is achieving a new significance. Aside from the subject matter which is taken from the physical environment and the daily life, past and present, the major content is Eskimo-ness itself and not the charming description or illustration of Eskimo activities.

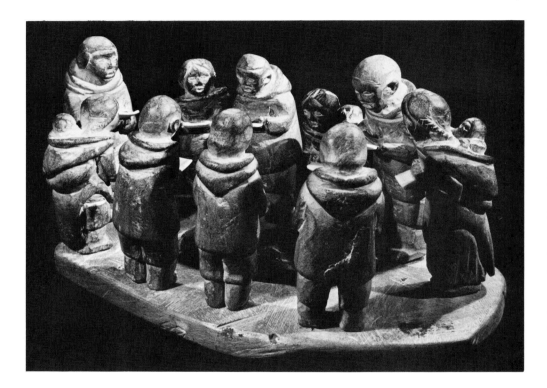

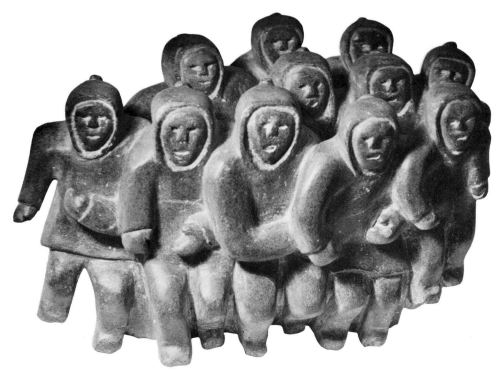

The Varieties of Inuit Sculpture

The following pictures form a small museum without walls, not showing all there is, but pointing to the themes, ranges, different directions and apparent contradictions that might be found in Eskimo sculpture. This great variety is the living quality of any art form that is not yet defined because it is still in the making.

The absence of a formalized tradition creates certain cataloguing problems. For example, the use of titles would be either obvious or misleading, for the Eskimo artists prefer to avoid titling their works. I consider this a virtue and have therefore not presumed to impose my own titles.

And for reasons mentioned in Chapter 9, I have referred to the various materials used for the carvings only by such simple terms as stone, bone, ivory, etc.

When it comes to the spelling of *inuit* names, the problems of doing justice to their pronunciation are practically insurmountable. Local dialects and various orthographies make it impossible to arrive at a consensus as to the transcription of the sounds. (The government is now completing the task of cryptographically formalizing all names in consultation with the entire *inuit* population.) The spellings used in this book are based on descriptive sounds that were acceptable to the artists and also were in as much accordance as possible with familiar spellings and established local practices. Yet discrepancies in spelling are inevitable; therefore, conspicuous alternative spellings are given in parentheses. For example, Sivuarapik has been spelled Sheeguapik, Seeguapik, Segooapik, and Sheruapik; and Kavik has become Kagvik, Kabvik, Kabvirk, and Kaviq, all depending on where the name is found and who is spelling it.

Postscript 1992

During the past fifteen years the promised formalization of spelling of first and last names has gradually taken place. Lists of artists and biographies have been published by Canadian Arctic Producers and, lately, by the Inuit Art Section of the Department of Indian and Northern Affairs. While discrepancies still occur, they will no longer be the major orthographic problems they once were. Still I wish to mention the case of one particular artist whose different spellings exemplify some of the cataloguing difficulties: Osuitok IPEELEE, surely one of the best known Inuit artists. In the previous editions of this book he was listed as Oshooweetook "B" as in the then official Cape Dorset records (with his disk number E7-1154). In several publications, however, he was – and still is – listed as Ipeelee OSUITOK, that is with the same surname as that of his wife and children. He also has been variously called (and spelled) Aipellie, Ipellie, Oshaweetuk, Oshewetok, and Osoetuk. May his name never be changed again.

I have kept the old or alternate names in brackets for art historical reasons and I have cross-indexed them and new ones according to the *Inuit Artist Alternate Name Index* published by the Inuit Art Section in 1990. Wherever necessary the new names and spellings of localities are listed with their former names in brackets. When names of *two different localities are listed in one caption*, the first one indicates the artists' domiciles (but not necessarily their birthplaces) and the second the sites where the carvings were produced.

New and old public repositories are recorded by names (abbreviations are listed on page 146) and by catalogue or accession numbers. The names of private collectors have been omitted because of security risks. Most of the carvings probably will end up in public collections as has already been the case with many of them.

In order to help readers to visualize the actual size of carvings, measurements are given in inches with which North Americans are still more familiar than with centimeters.

Finally, a few titles have been added to the *Bibliography*. Only the most important new publications, most of which are still available, are listed.

47/Joe Emiqutailaq
(Emikotialuk)
Sanikiluaq (Belcher Islands) 1970
Stone height 7³/₄"
WAG 929-71

48/John Tiktak ▶
Rankin Inlet 1967
Stone height 6"
WAG G-76-446

49/Amonomjak ? ▶
(as per identification tag)
Arctic Bay 1961
Whalebone, ivory, black inlay &
graphite height 3¹/₄"
NGC 30073

29

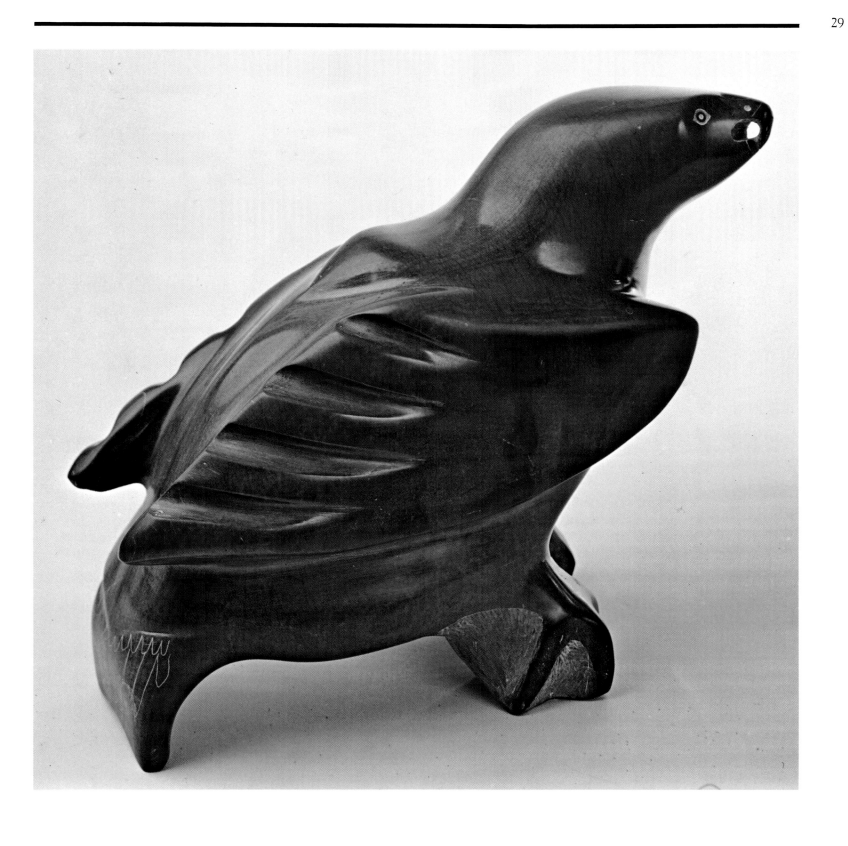

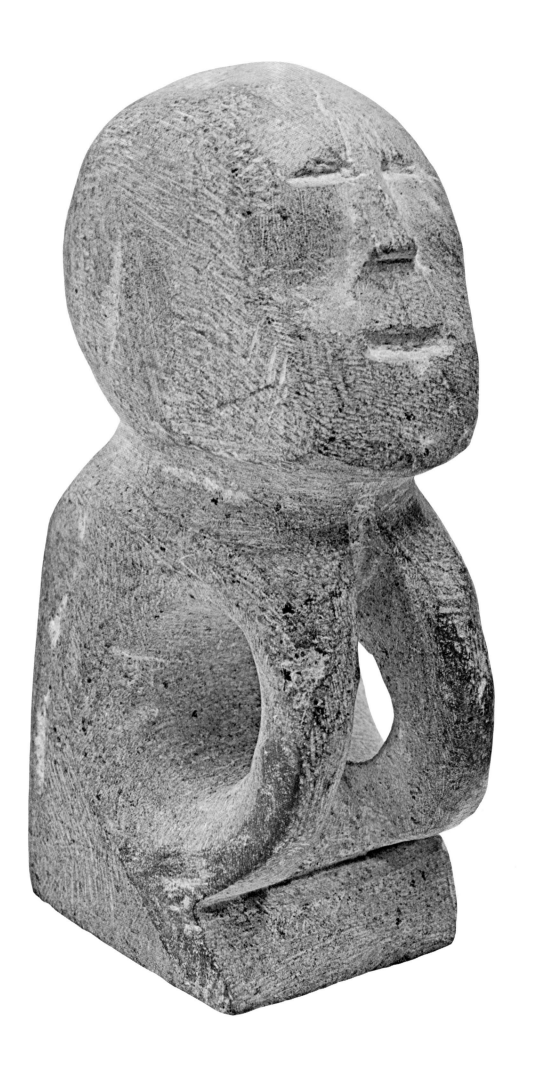

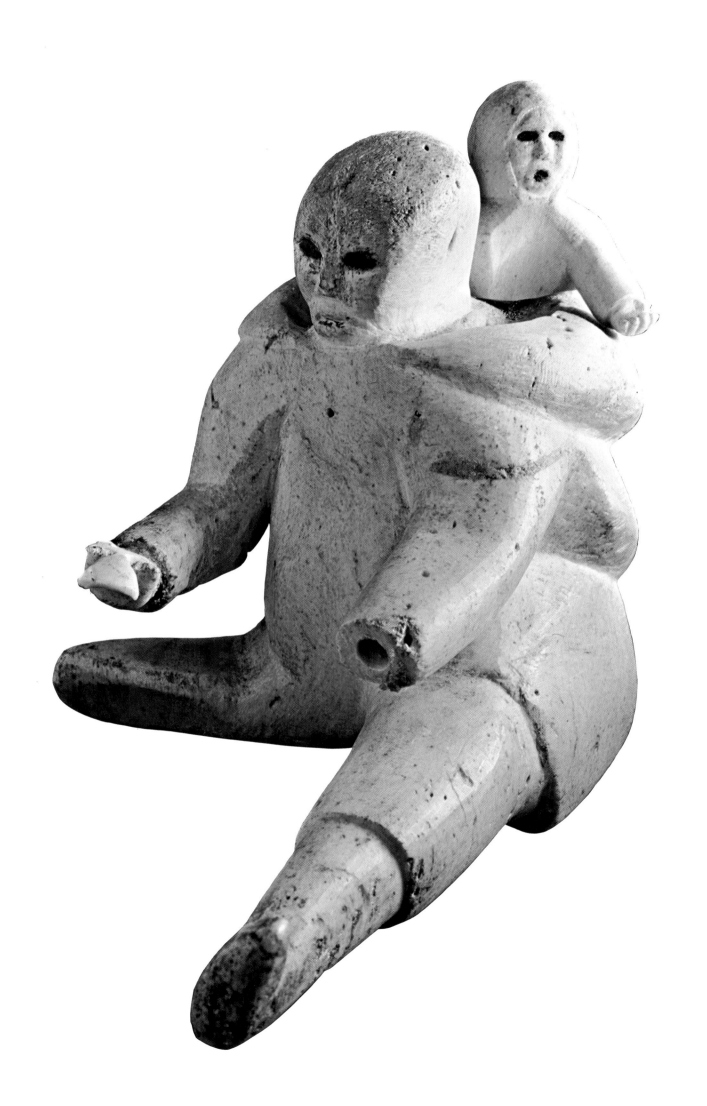

50/Unidentified artist
Inukjuak (Port Harrison) 1949
Stone and various inlaid materials
length 5½"

51/Johnnie Tukallak
(Tukaluk)
Sanikiluaq (Belcher Islands) 1966
Stone length 8"

52/Unidentified artist
Cape Dorset c. 1950
Whalebone and hair height 11"
TDB EC-82-652

32

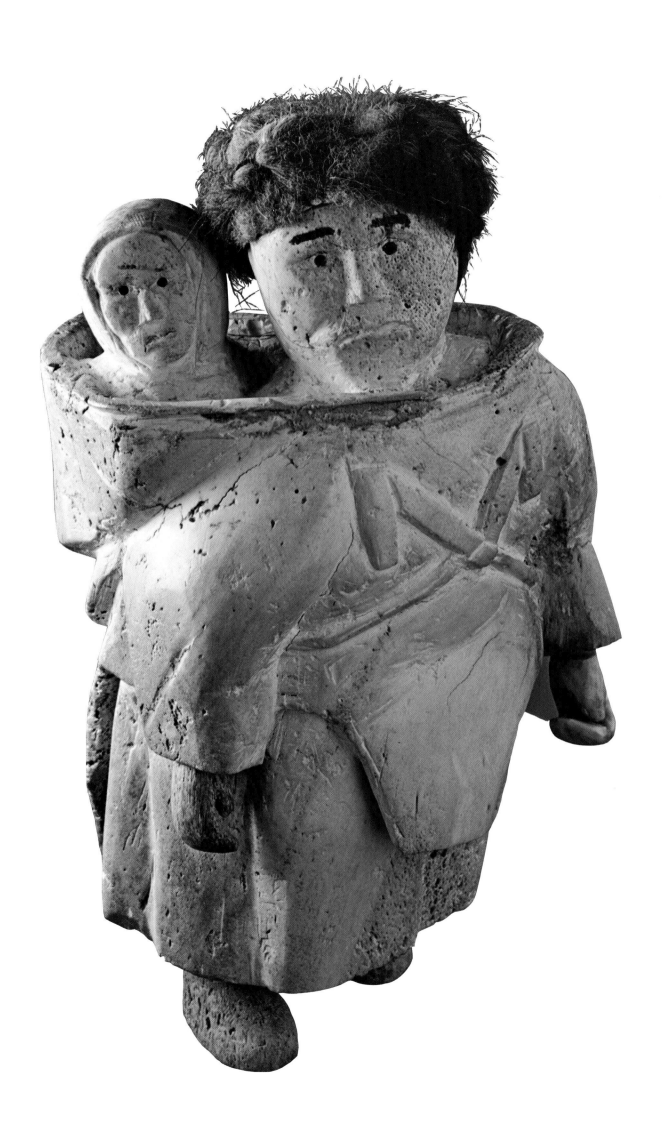

53/Josephee Kakkik
Pangnirtung 1970
Whalebone and ivory height 11″
WAG 1721-71

54/Joanni Kaviok
Arviat (Eskimo Point) 1968
Stone height 6¹/₈″

▶

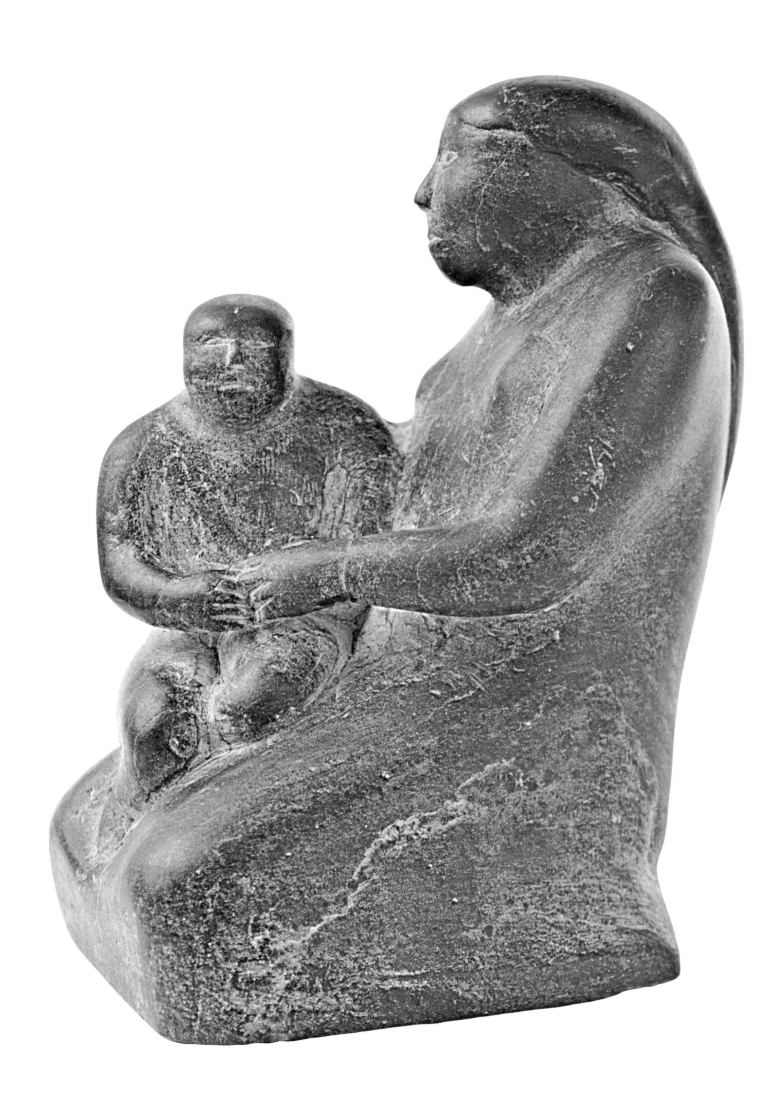

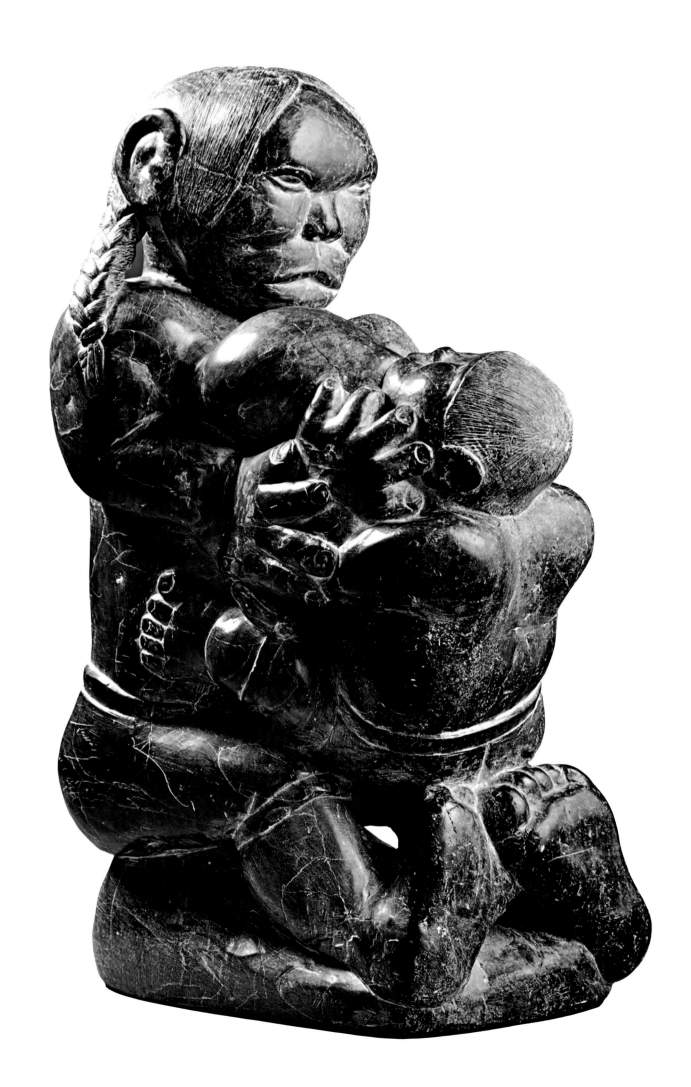

55/Johnny Inukpuk
Inukjuak (Port Harrison) 1962
Stone height 19″
TDB EC-82-600
(cf. detail p. 16)

56/John Pangnark
Arviat (Eskimo Point) 1968
Stone height 4¼″
CMC IV-C-3823

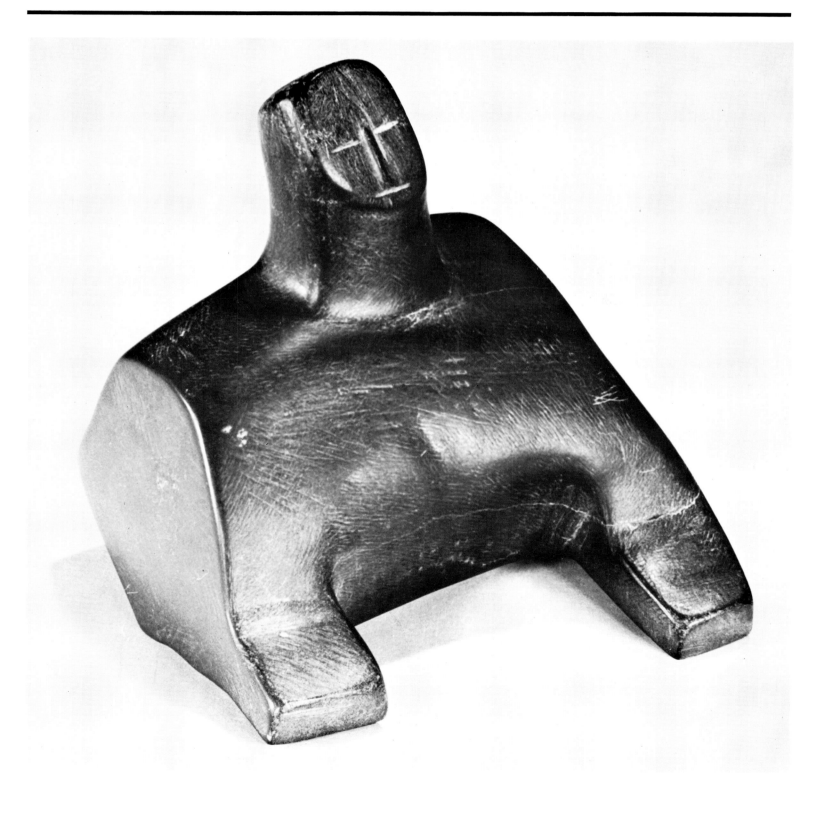

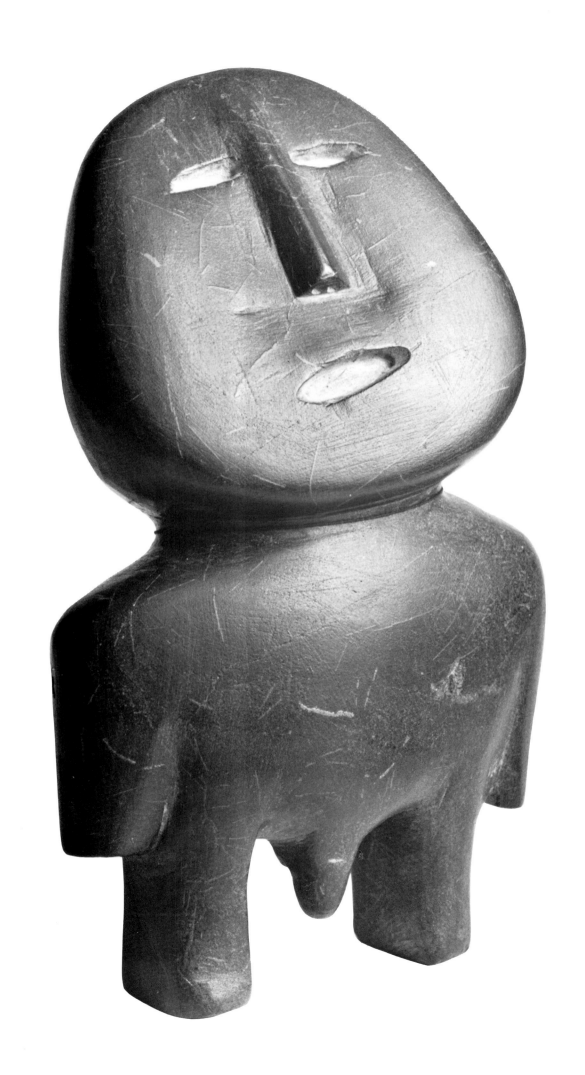

57/Peter Inukshuk
Baker Lake 1969
Stone height 8¹/₂″

58/Lucy Tasseor Tutsweetok
(Tasseor)
Arviat (Eskimo Point) 1968
Stone height c. 4″
WAG G-68-90

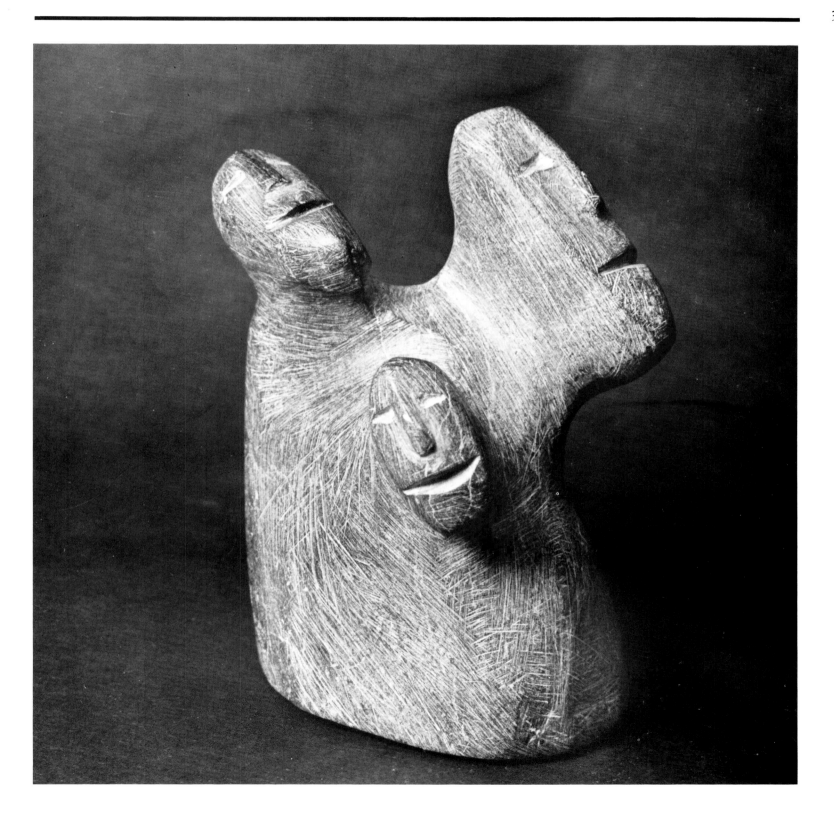

61/Yvonne Kanayuk Arnakyuinak
(Kanayuk)
Baker Lake 1970
Stone height 3¹/₄"
WAG G-76-31

42

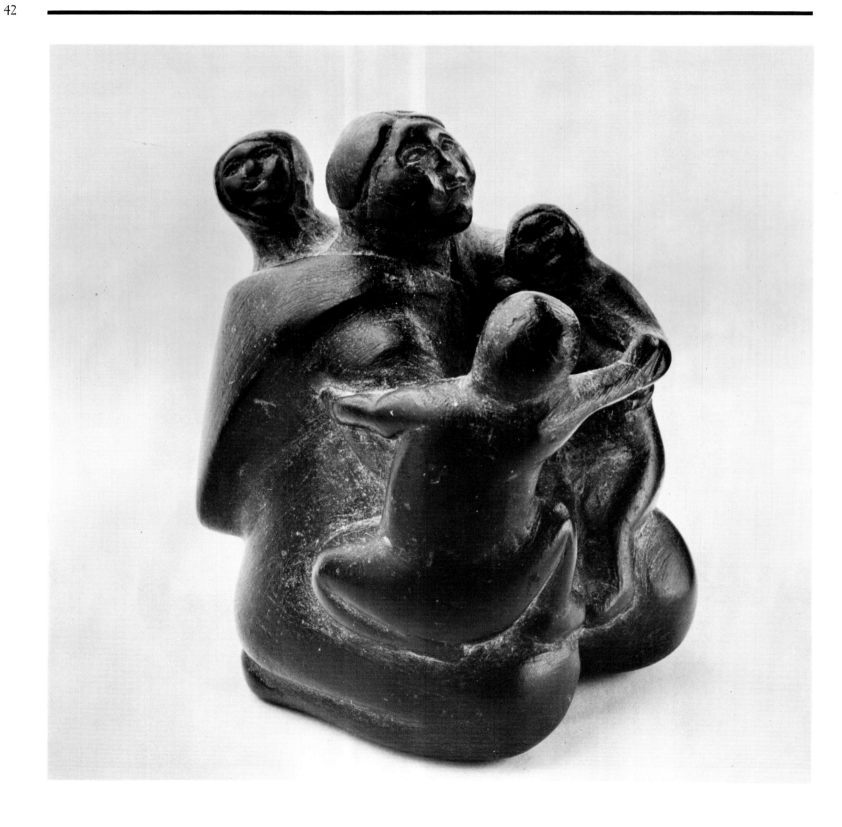

57/Peter Inukshuk
Baker Lake 1969
Stone height 8½"

58/Lucy Tasseor Tutsweetok
(Tasseor)
Arviat (Eskimo Point) 1968
Stone height c. 4"
WAG G-68-90

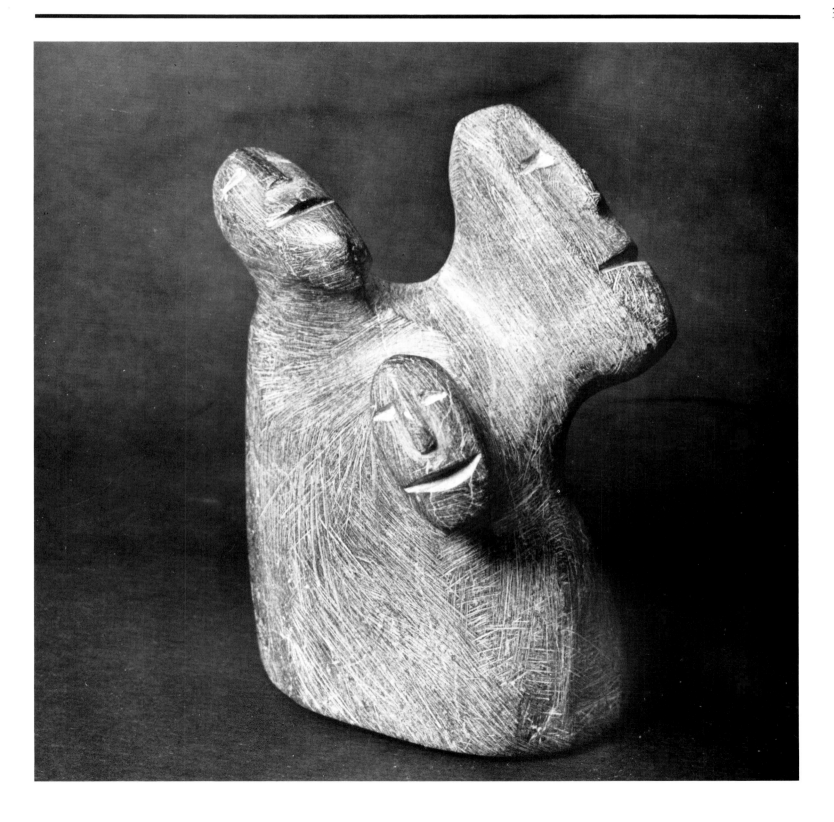

59/Bernadette Iguptark Tongelik
(Iguptark)
Repulse Bay 1963
Stone and bone height 3³/₄″
WAG 3685-71

60/Pudlo Pootogook (re-a)
(Pudlat "A")
Cape Dorset 1967
Stone height 13¹/₄″
(also 468, formerly attributed to Pauta)

▶

40

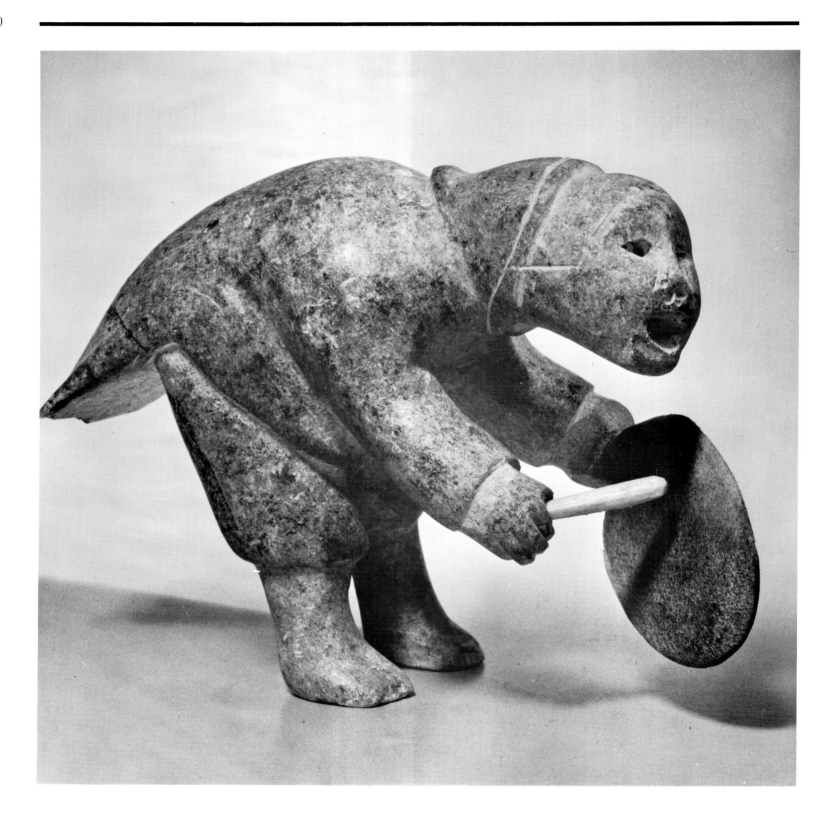

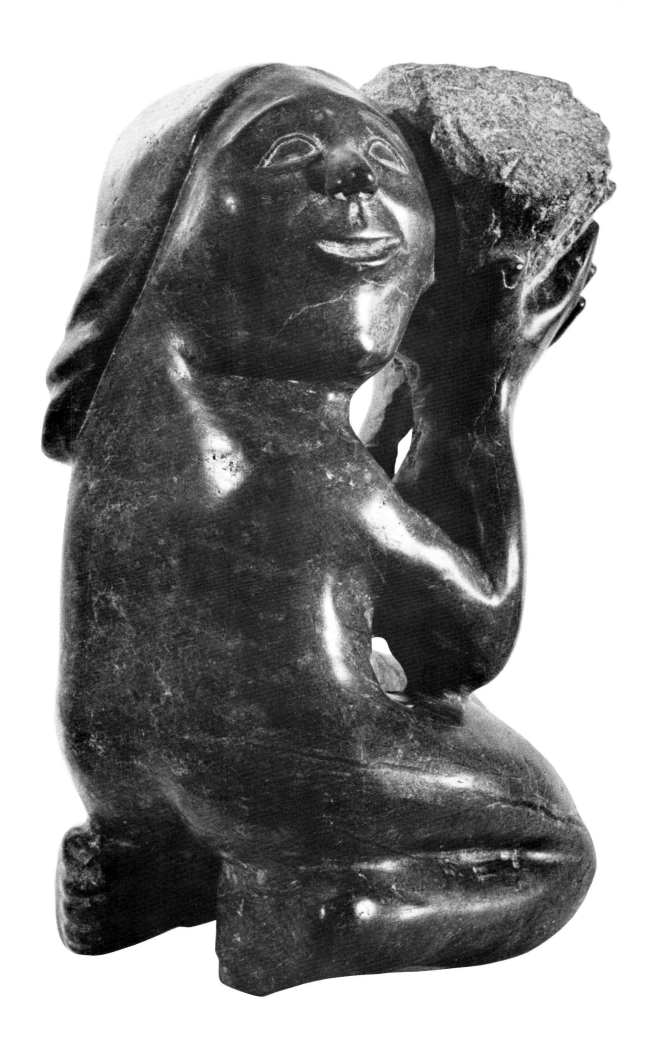

61/Yvonne Kanayuk Arnakyuinak
(Kanayuk)
Baker Lake 1970
Stone height 3¼"
WAG G-76-31

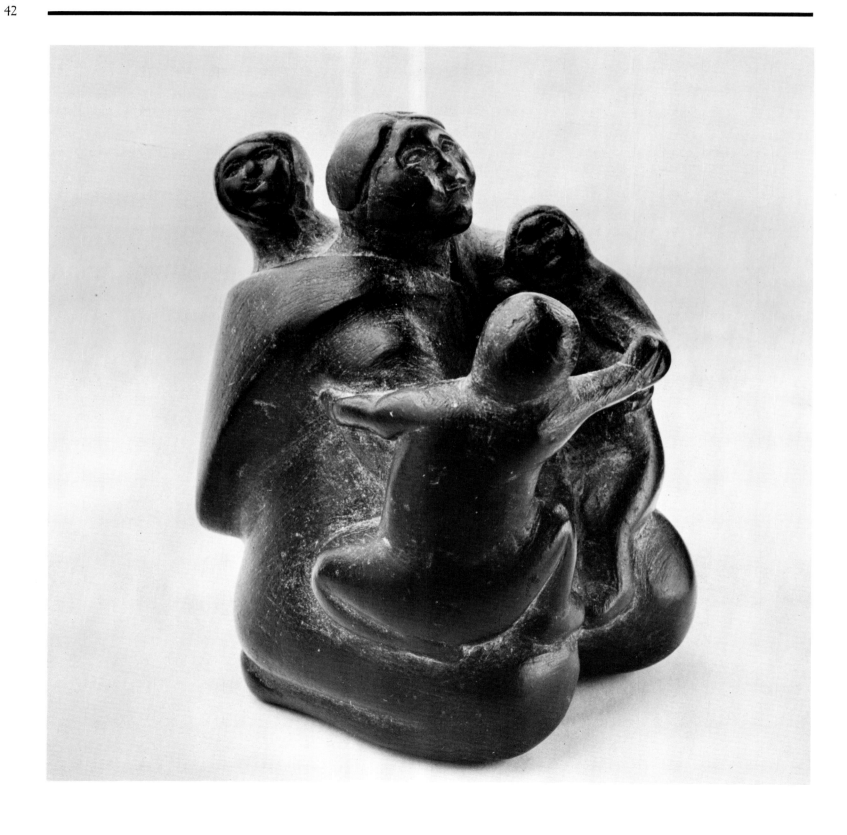

62/Vital Makpaaq
(Makpa Arnasungnark)
Baker Lake 1963
Stone height 13⁵/₈"
WAG G-64-79

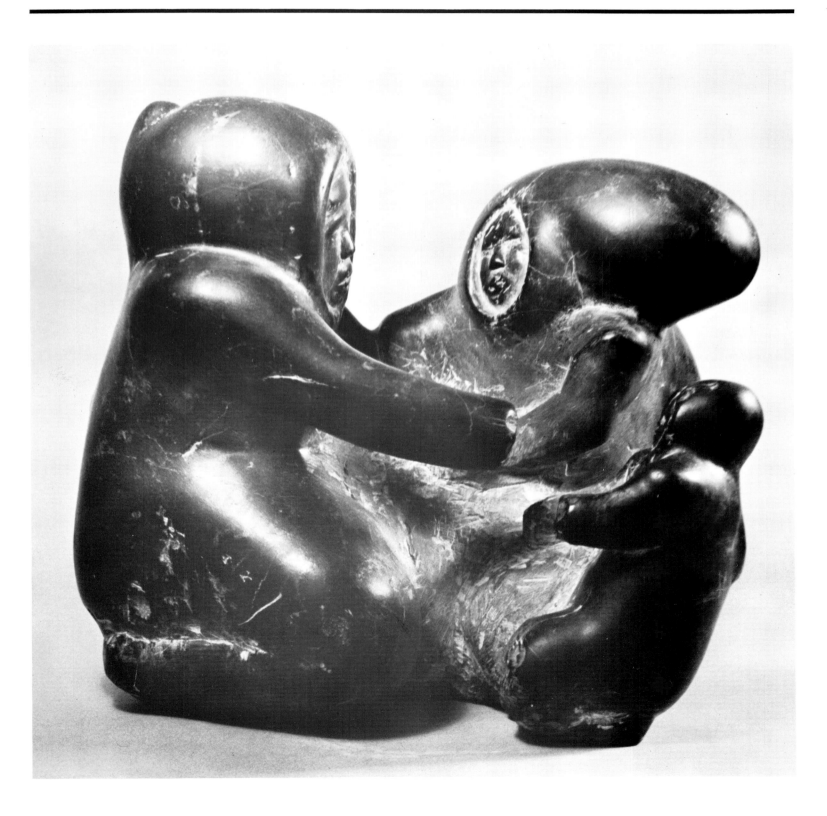

63/Simon Kutuaq
(Kutuak)
Arviat (Eskimo Point) 1968
Stone and ivory height 6⅝″
WAG 1326-71

64/Etirayagyuaq Pee
(Etugeeyakjuak)
Cape Dorset 1967
Stone height 10¾″

44

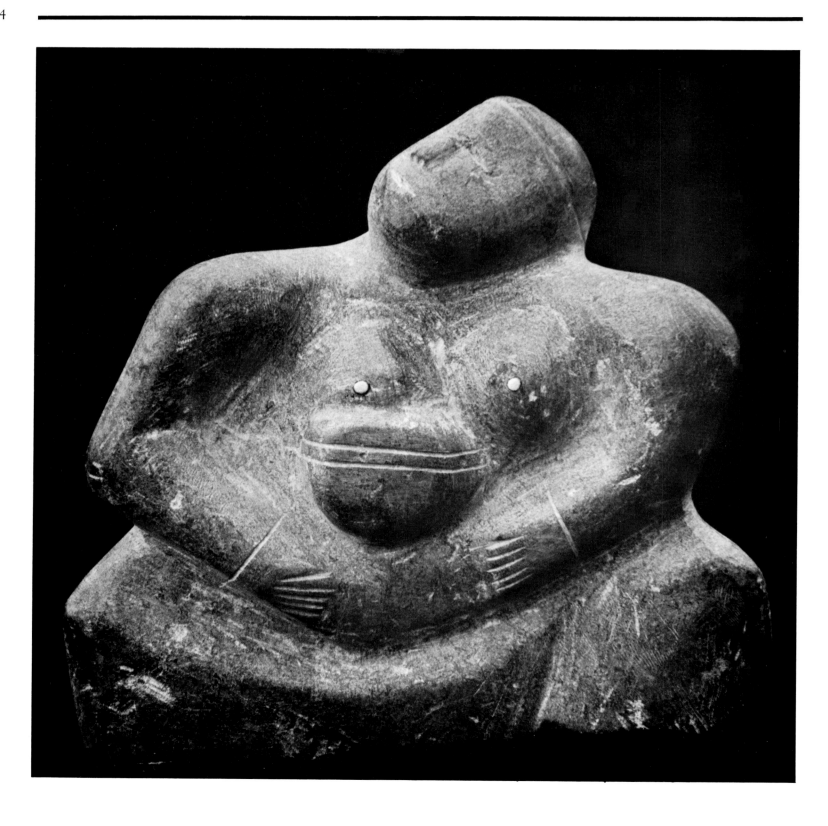

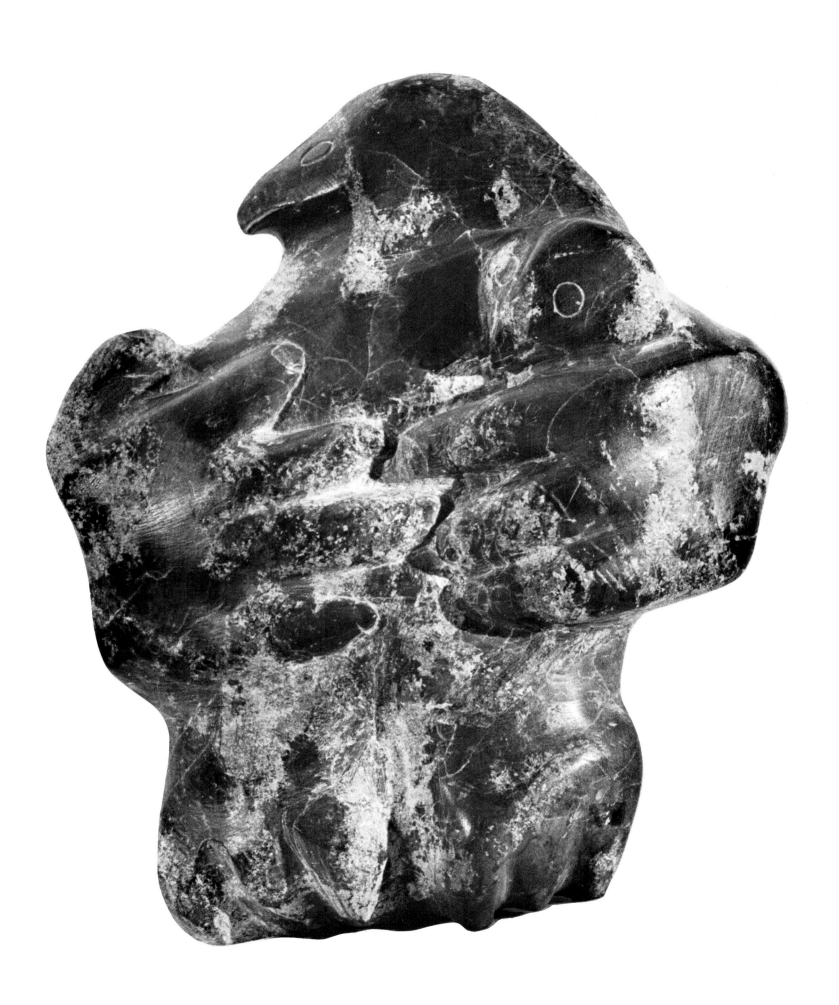

65/John Attok
(Atok)
Arviat (Eskimo Point) 1967
Stone height 7¹/₂″
AGO 90/118

66/Felicite Kuwianartok Kaunak
(Tartok)
Repulse Bay 1964
Stone height 4″
WAG G-72-245

▶

46

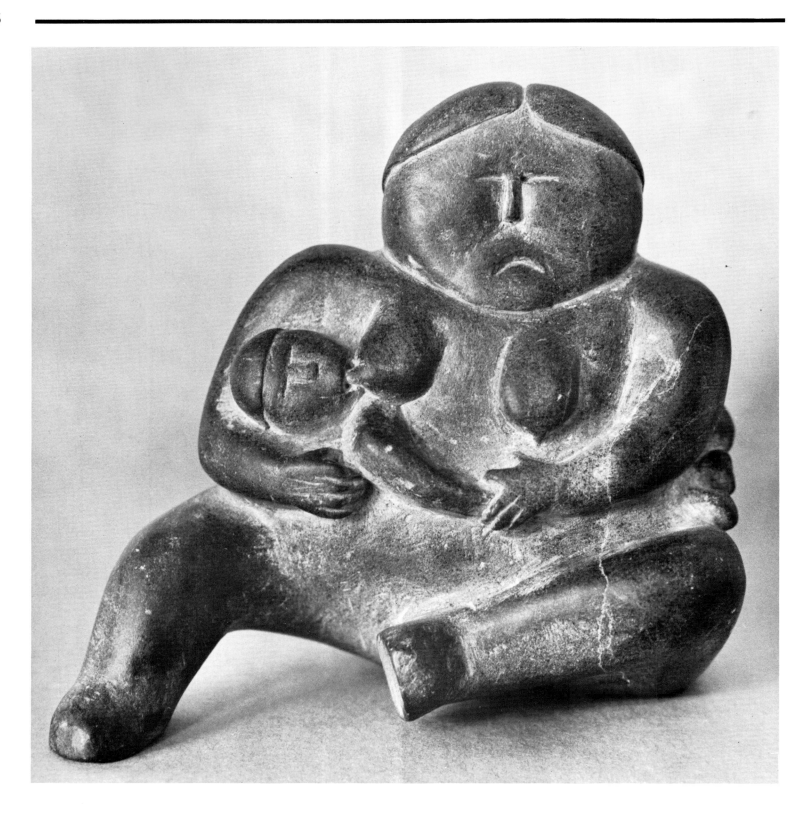

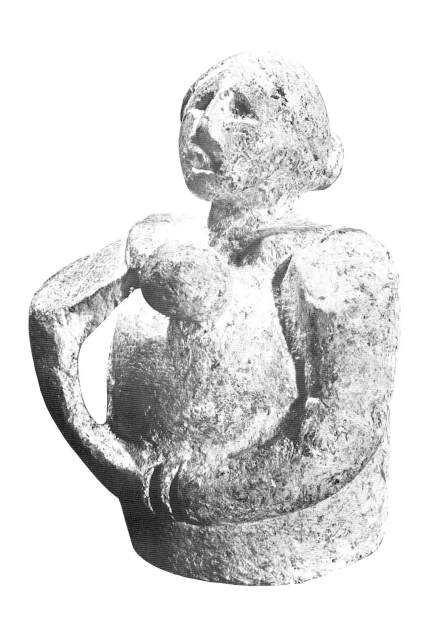

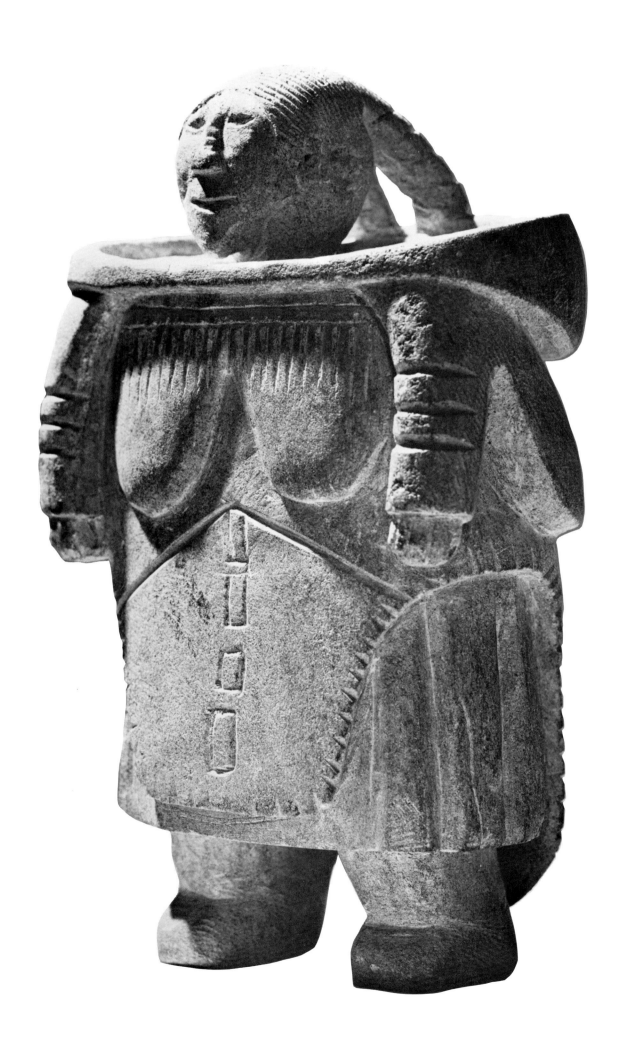

67/Unidentified artist
Salluit (Sugluk) 1955
Stone height c. 10″

68/Aqjangajuk Shaa
(Axangayuk)
Cape Dorset 1965 ?
Stone height 12½″

69/Pudlo Pudlat
(Pudlo)
Cape Dorset 1962
Stone length c. 9″

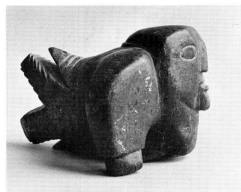

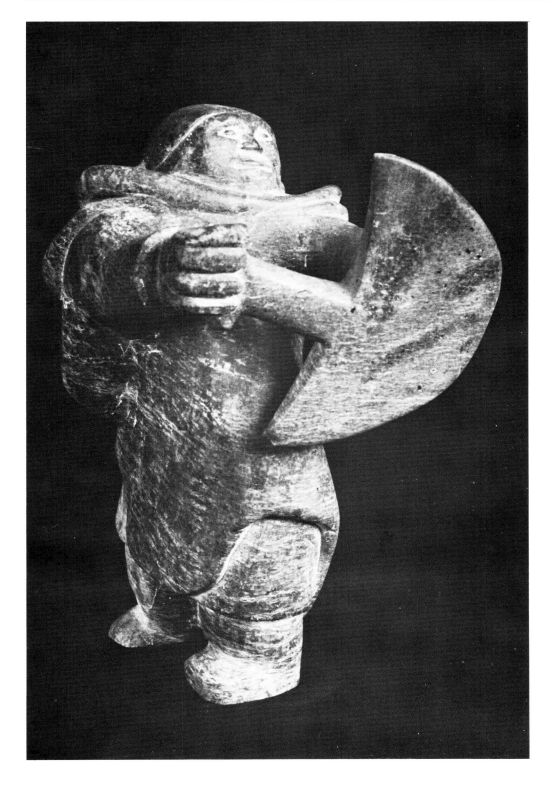

70/Johnny Inukpuk
Inukjuak (Port Harrison) 1955 ?
Stone and inlaid ivory height 6″
CMC IV-B-1164
(also 289)

71/Isaaci Qurqaq Padlayat
(Aisaki Qaqapulik)
Salluit (Sugluk) 1956
Stone height 7³/s″

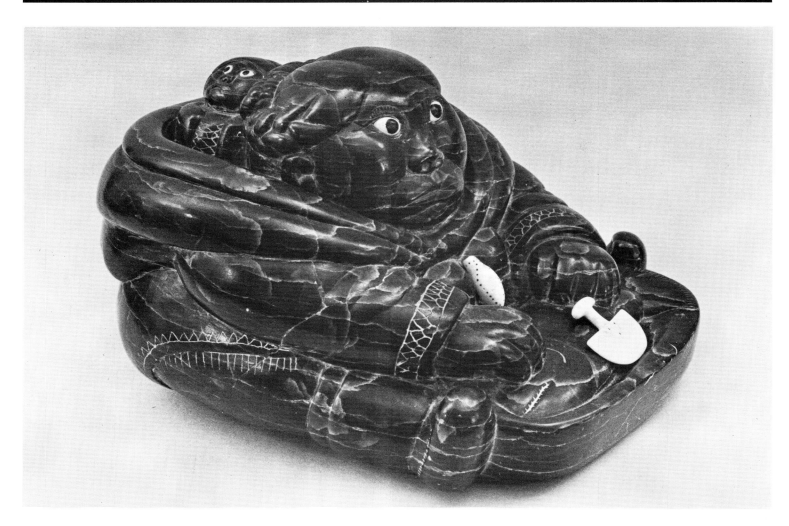

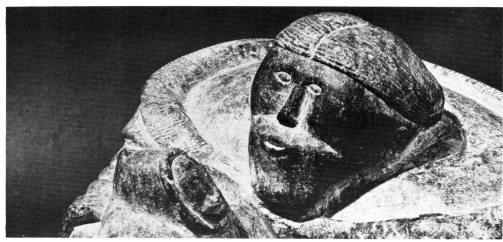

72/Akeeaktashook ?
Inukjuak/Port Harrison 1953 ?
Stone height 9³/₄"
WAG G-60-42

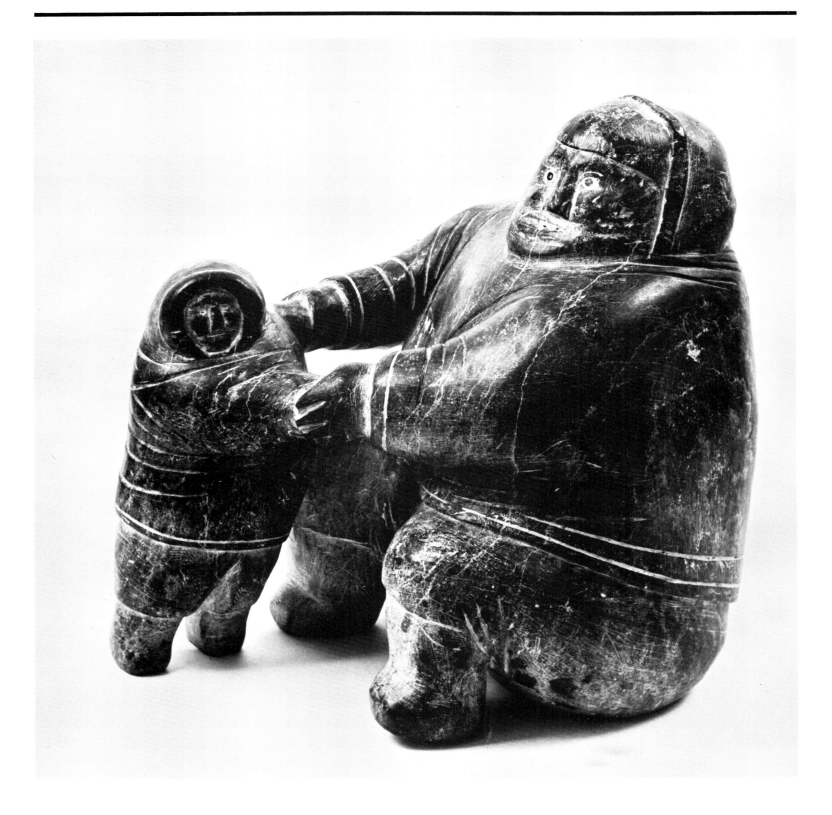

73/John Tiktak
Rankin Inlet 1963
Stone height 7"
TDB EC-75-366

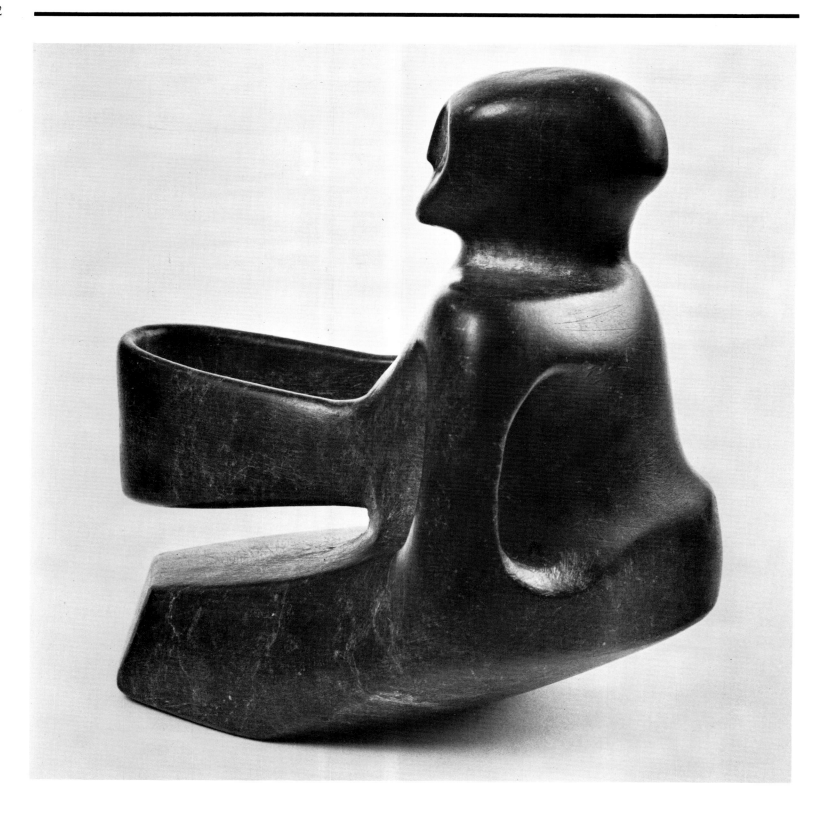

74/Joanasee Kakkik (re-a)
Pangnirtung 1970
Stone height 8½″
WAG 1058-71

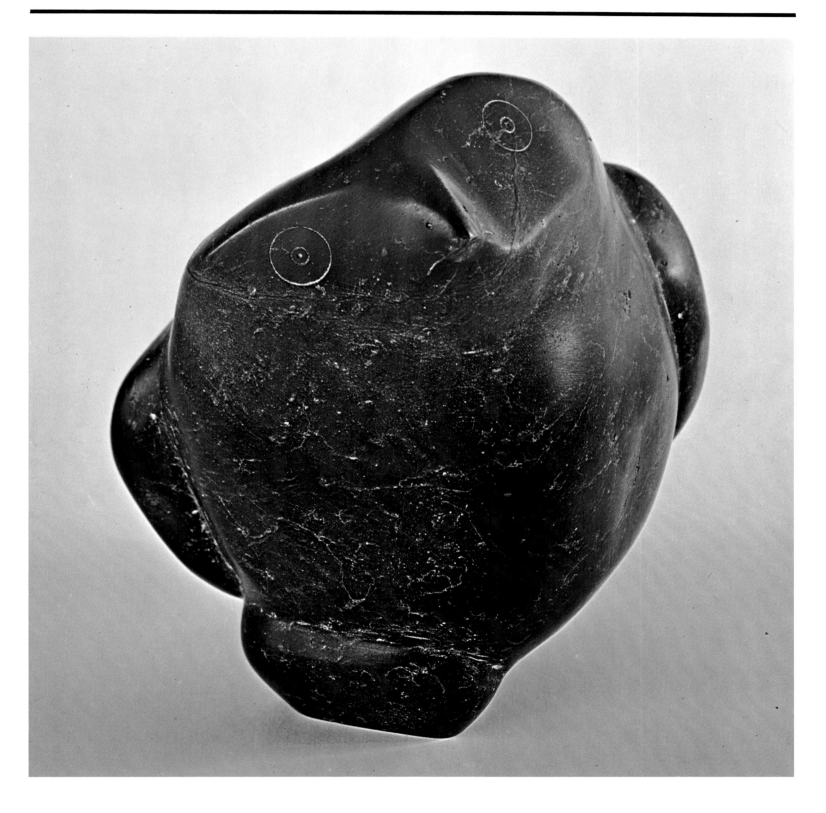

75/Pauli Uqitiuq
Kangiqsujuaq (Wakeham Bay) 1965
Stone, ivory, antler, and rubber length 5⁵/₈″

76/George Arluk
(Arlu)
Arviat/Rankin Inlet 1967
Stone and felt marker length 8″
WAG G-76-131

77/Tikituk Qinnuayak
(Tikkitoo)
Cape Dorset 1970
Stone height 14³/₄″
WAG 1082-71

▶

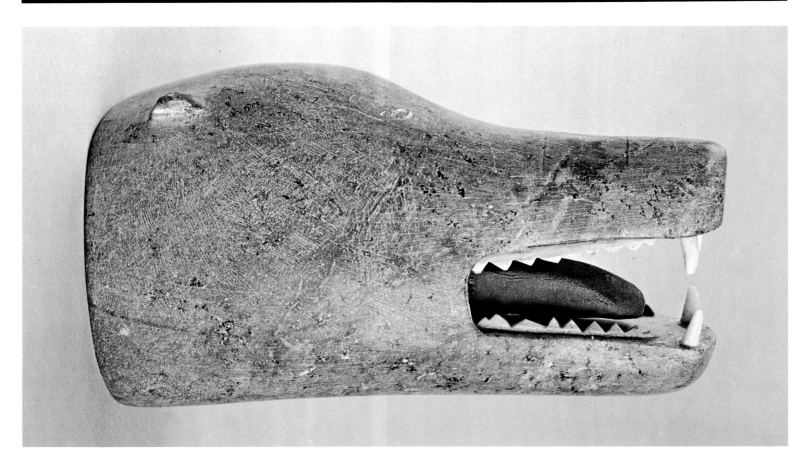

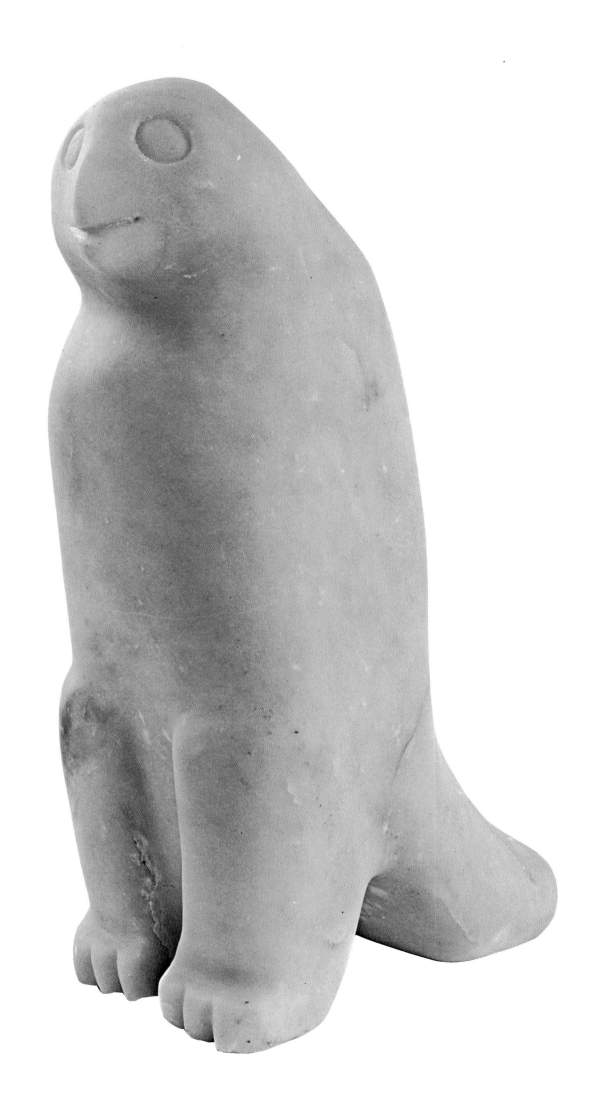

78/Pauta Saila
(Pauta)
Cape Dorset 1964
Stone height c. 17″
TDB EC-82-604

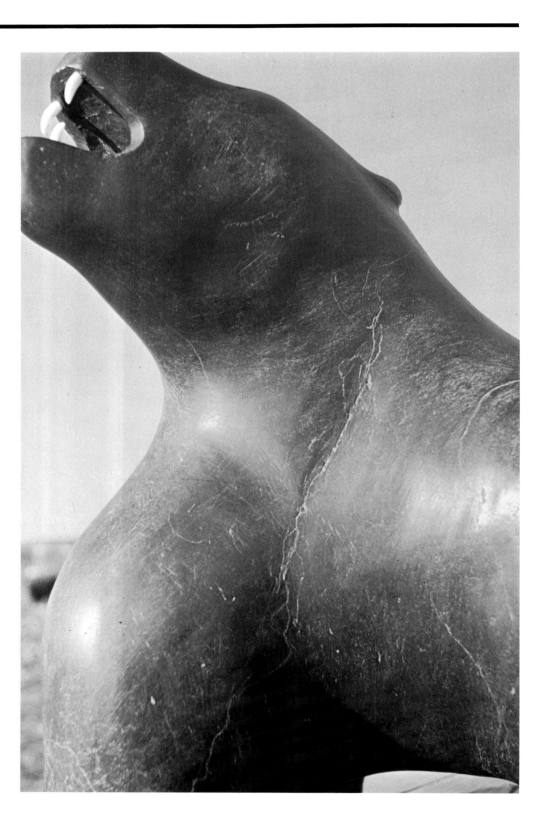

79/Unidentified artist
Rankin Inlet 1966
Stone and antler height 2³/₄"
WAG G-76-420

80/John Attok
(Atok)
Arviat (Eskimo Point) 1969
Stone height 4⁵/₈"

58

81/Unidentified artist
Inukjuak (Port Harrison) 1951
Stone and ivory height 6½″
TDB EC-75-350

82/Nutaralaq Akulukjuk
Pangnirtung c. 1950
Stone and inlaid ivory height 3½″
TDB EC-82-664

83/Susan Ootnooyuk
Arviat (Eskimo Point) 1968
Stone, beads, and fox teeth
height 4¼″
WAG G-76-179

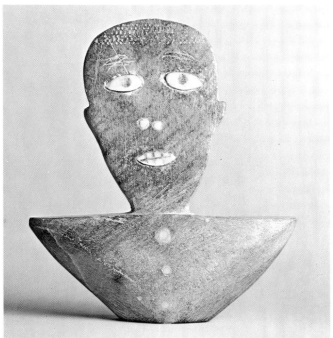

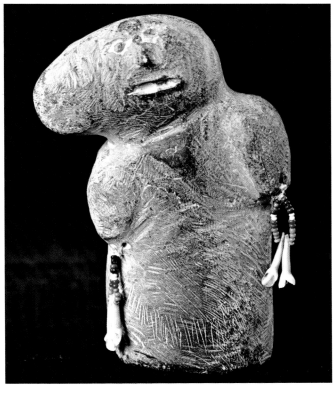

84/Latcholassie Akesuk
(Lassaulaasi)
Cape Dorset 1962
Stone height 7³/₄″
WAG G-76-137

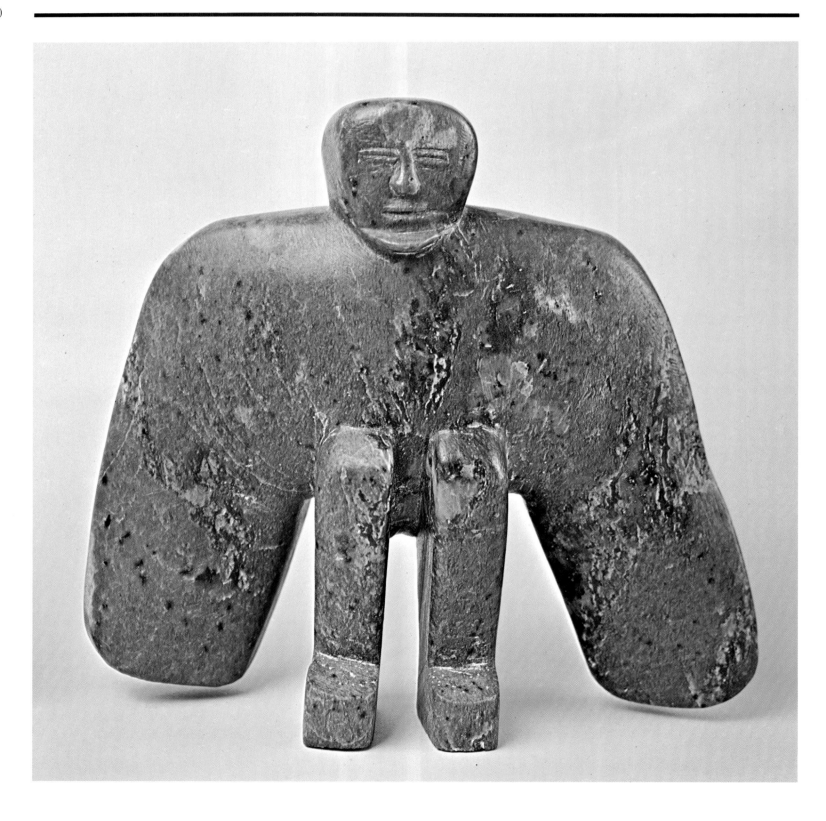

85/Enuya Shooyook
(Eenooya)
Arctic Bay 1969
Stone height 4³/₄″
WAG G-76-8

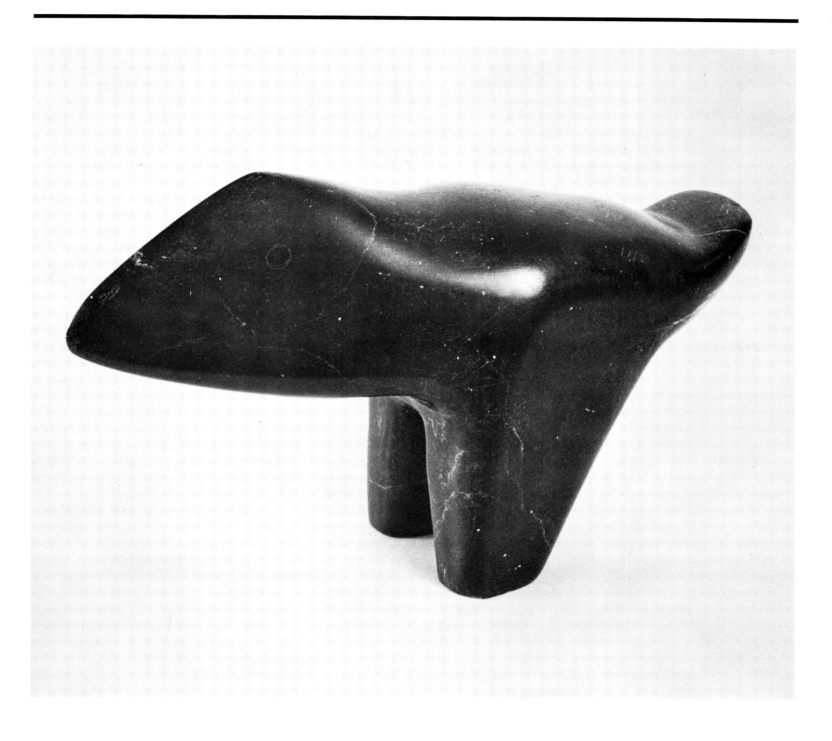

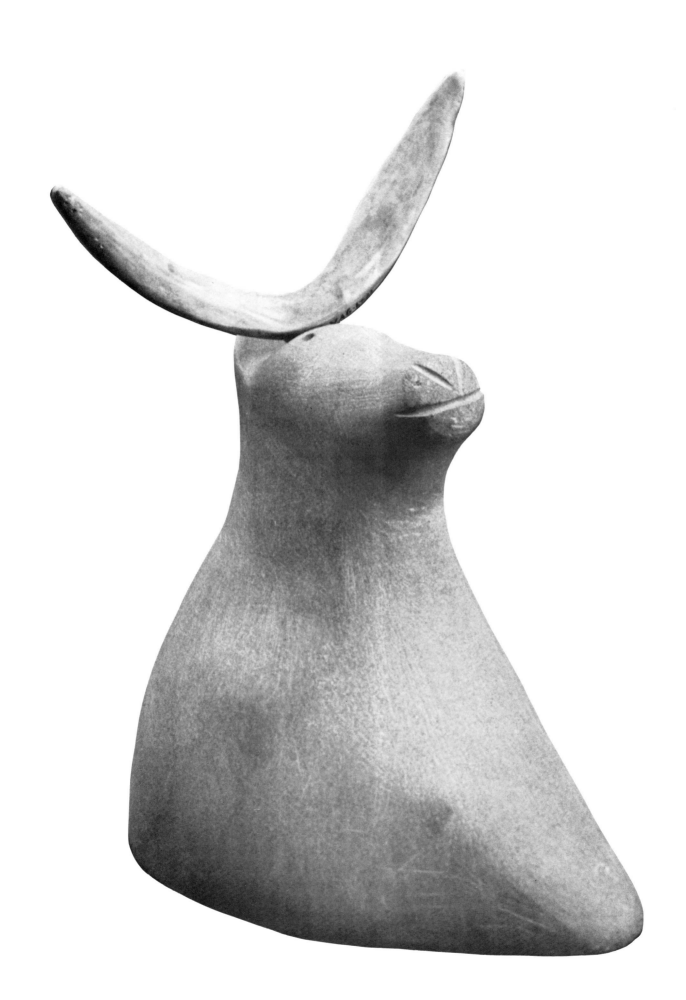

86/Andy Miki
Arviat/Whale Cove 1965/6
Stone and bone height 11½"
VAG 67.63

87/Louis Oksokirtok
Repulse Bay 1966/7
Stone and ivory height 7"
EMC C67.21-1
(cf. 727)

63

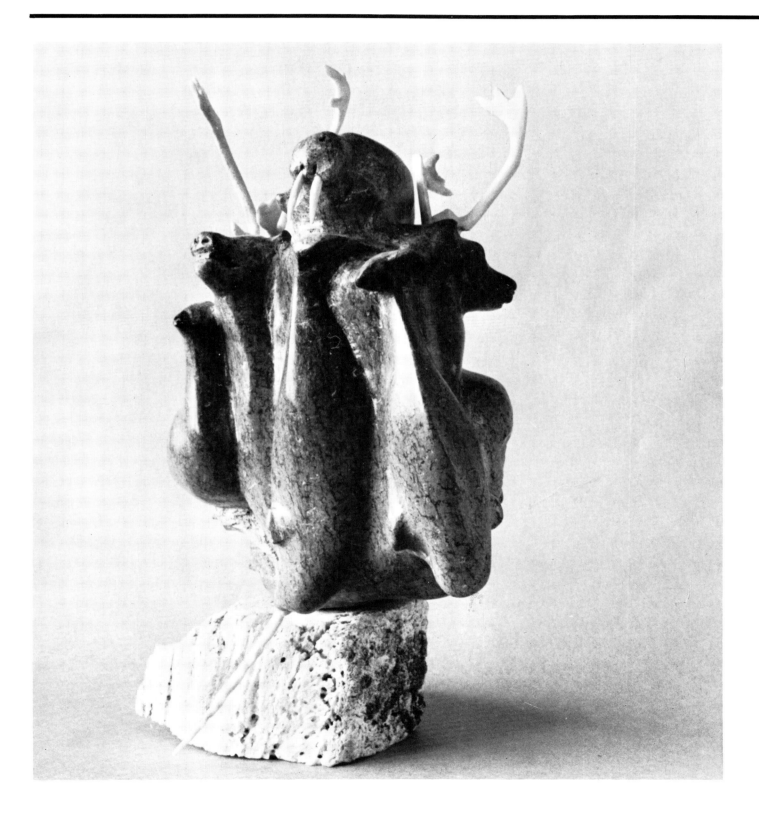

88/Charlie Qittusuk
(Kittosuk)
Sanikiluaq (Belcher Islands) 1967
Stone height 6³/₄″
WAG G-90-943

89/Lucassie Oqaituq
(Ohaytook)
Sanikiluaq (Belcher Islands) 1966
Stone height 4¹/₂″
MCQ G6-310

64

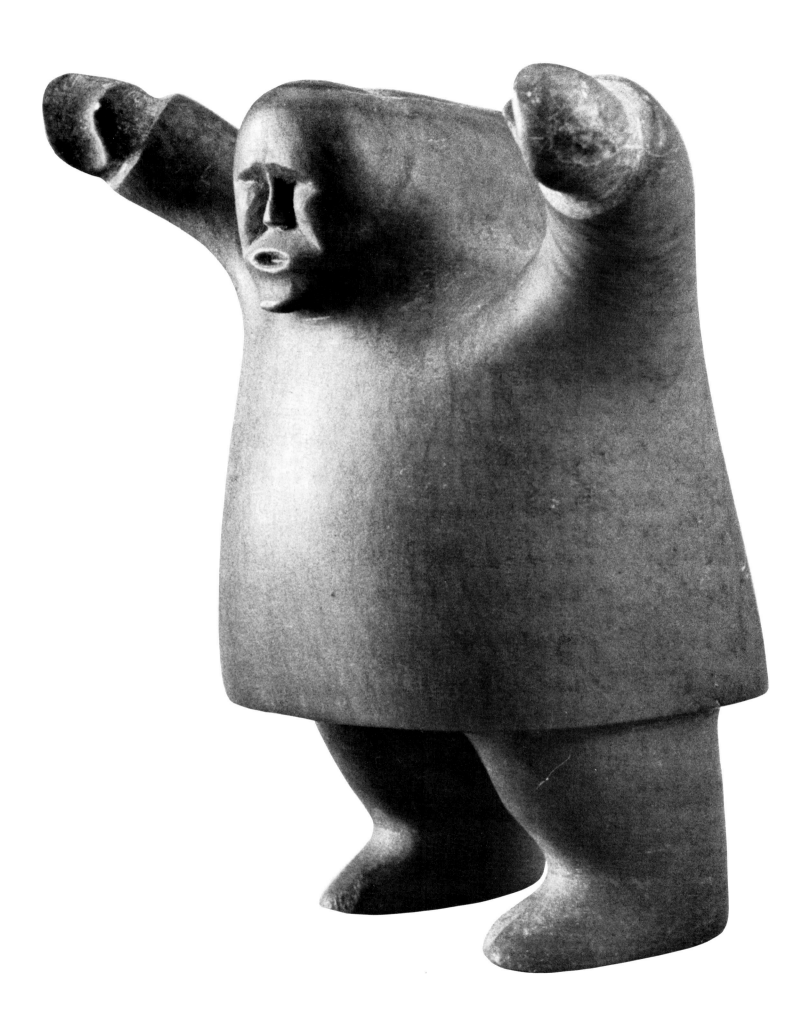

90/John Kaunak
Repulse Bay 1969
Stone and bone height 5⁷/₈"
WAG G-90-928

91/Charlie Inukpuk
Inukjuak (Port Harrison) 1961
Stone height 12¹/₄"
WAG G-62-102

66

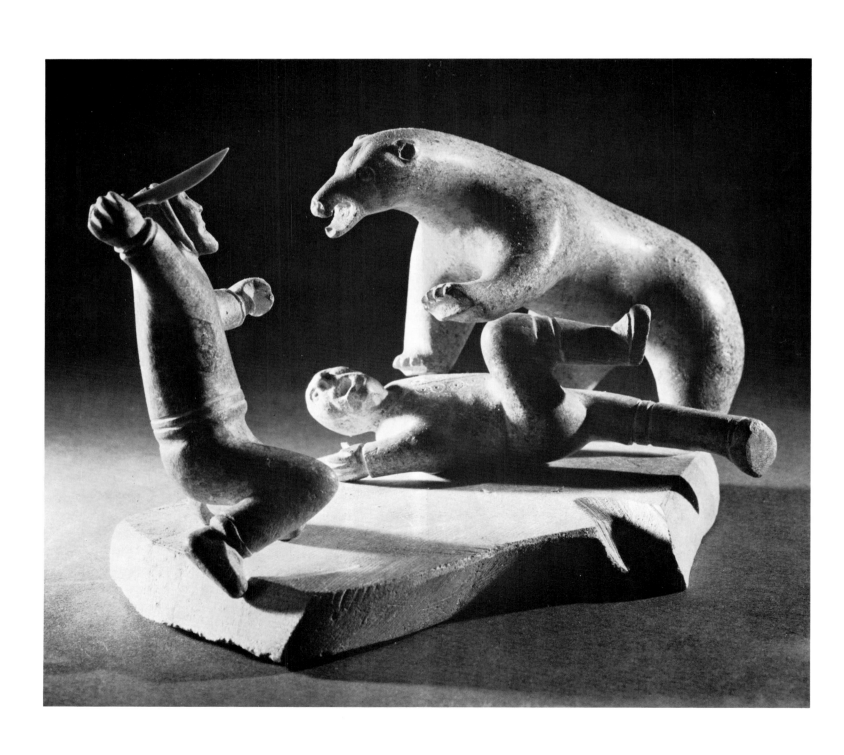

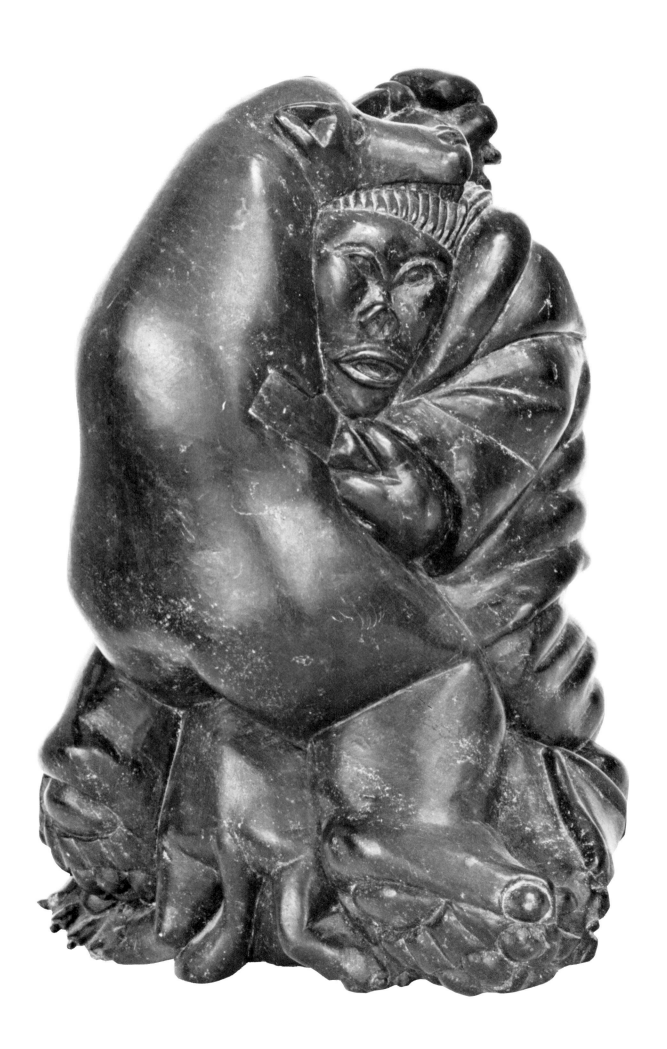

92/Eric Niuqtuk
(Irenee Neeooktook)
Baker Lake 1963
Stone height 7⅞"

93/Samuellie Tunnillie
(Tuniluk)
Cape Dorset 1960
Stone height 2½"
WAG G-62-102

94/Osuitok Ipeelee
(Oshooweetook "B")
Cape Dorset 1968
Stone height 19¼"
McMB

68

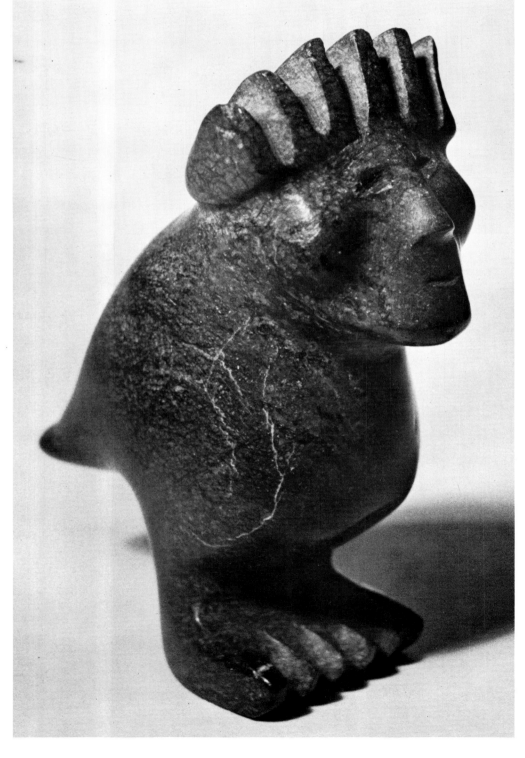

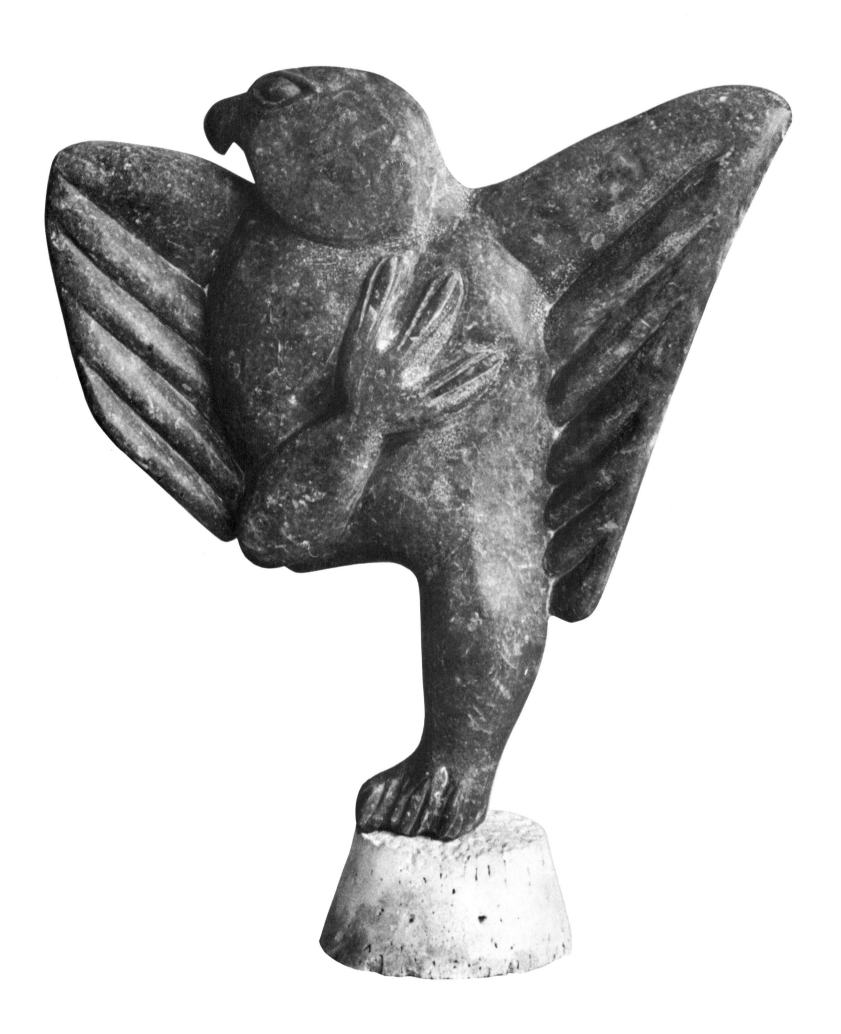

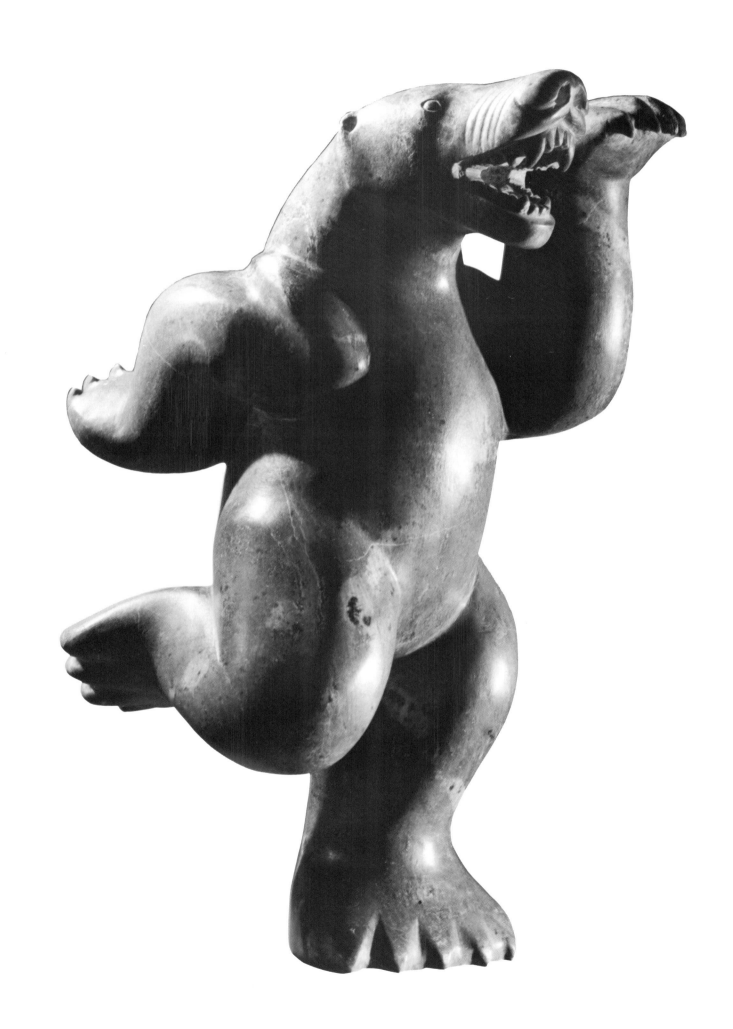

◄ 95/Iyola Kingwatsiak
(Iola/Aiulaa)
Cape Dorset 1966
Stone height 22"

96/Timothy Naralik
(Narlik)
Sanikiluaq (Belcher Islands) 1968/9
Stone height 5¹/₈"
AGO S693
(also 227)

97/Eli Sallualu Qinuajua
(Eli Sallualuk)
Povungnituk 1968
Stone height 8³/₄"
AGO GS309

98/Levi Qumaluk
Povungnituk 1968
Stone height 4³/₄"
WAG G-76-399
(also 379)

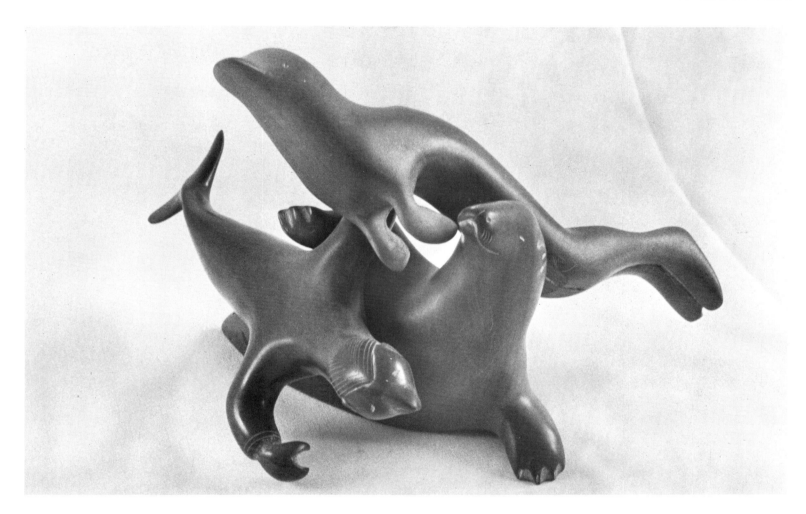

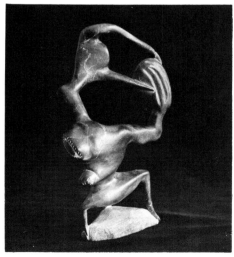

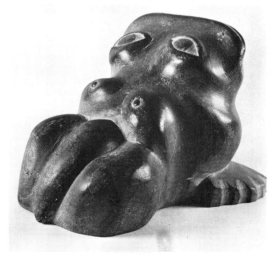

99/Jobie Saumik Inukpuk (re-a)
Inukjuak (Port Harrison) 1952/3
Stone height 8¼″
CMC IV-B-1212

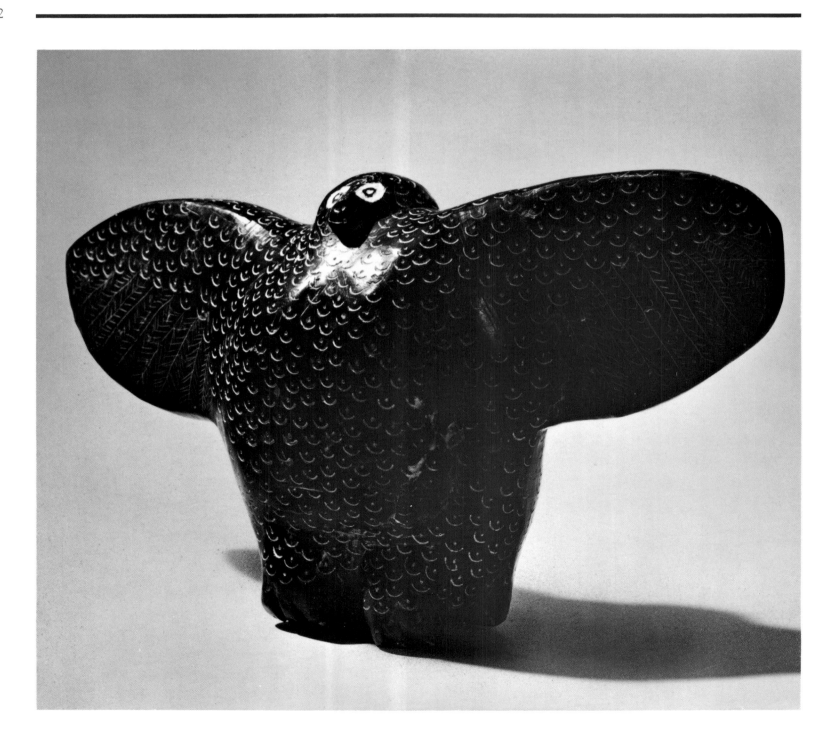

100/Qaqasiralaq Kullualik
(Kakasilala Koodluarlik)
Pangnirtung 1967/8
Whalebone height 6"

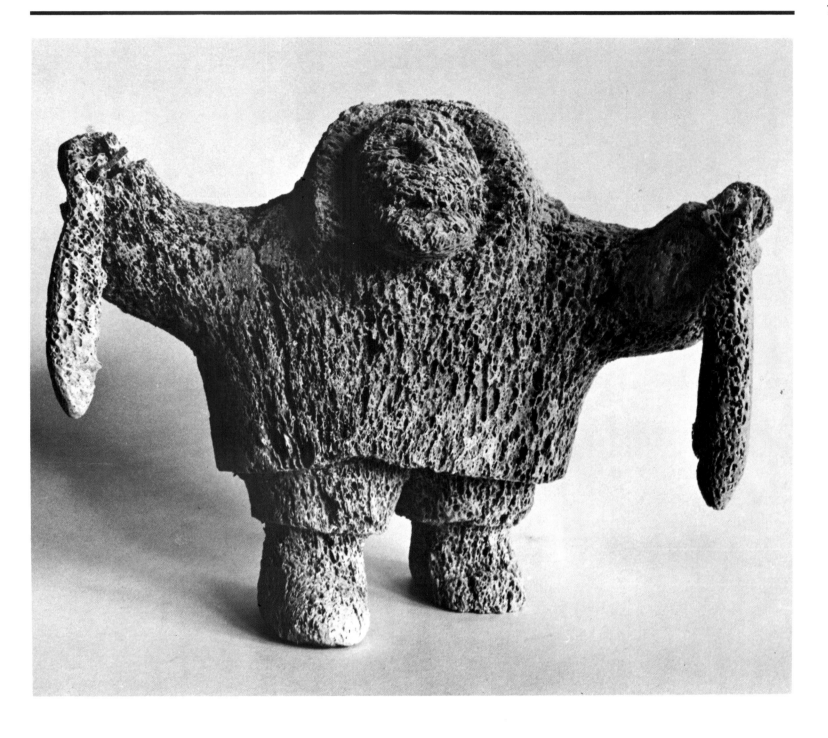

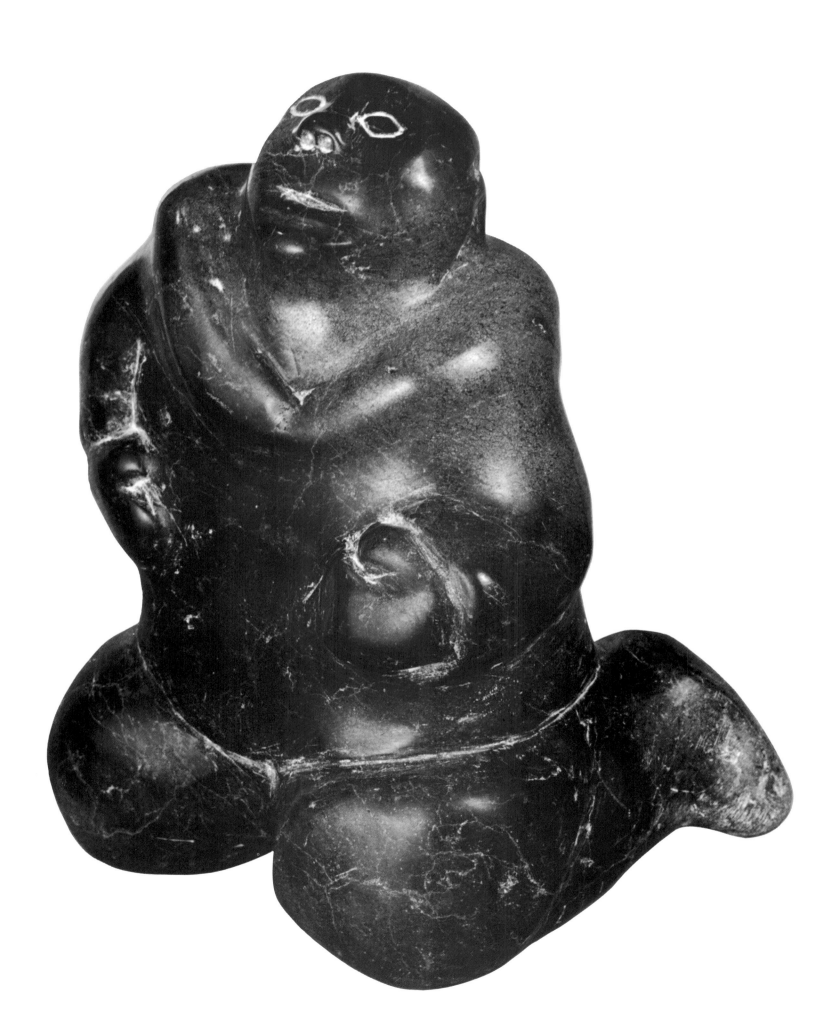

101/Samuellie Tunnillie?
(Tuniluk)
Cape Dorset 1966
Stone height 11½"

102/Paul Toolooktook
Baker Lake 1964
Stone length 12¼"
WAG 636-71
(also 696)

103/John Kavik
(Qavirq)
Rankin Inlet 1965
Stone height 7"
AGO 89/240

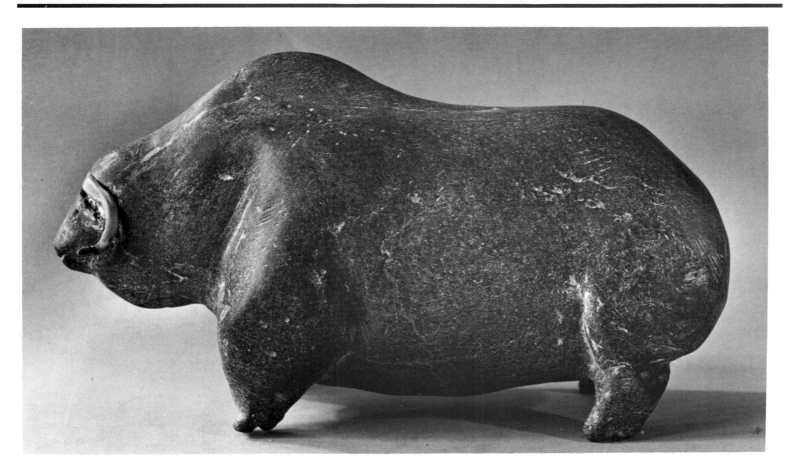

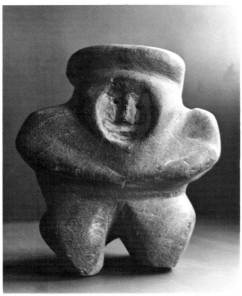

104/Moses Nagyugalik
(Nugyugalik)
Baker Lake 1968
Stone and bone height 7³/₄"

76

105/Elisapee Kanagnaq Ahlooloo
(Elisapee Kanagna)
Arctic Bay 1960/1
Whalebone height 3³/₄″
TDB EC-82-667

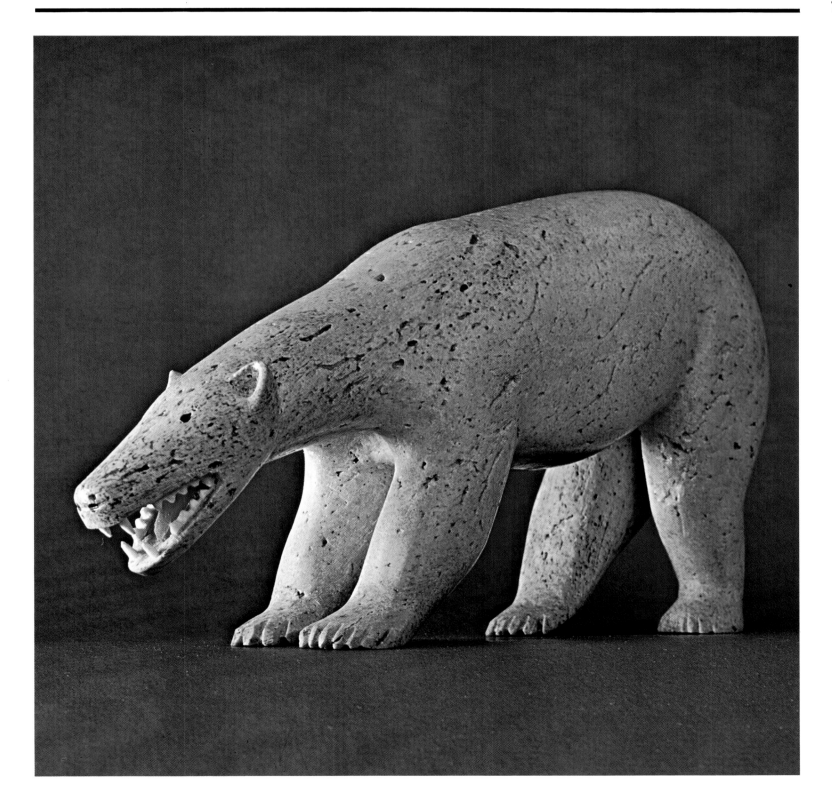

106/Unidentified artist
Arctic Bay c. 1965
Whalebone, ivory, and paint
length 10¾″
TDB EC-82-665

107/Aoudla Pee
(Audla/Aullaq)
Cape Dorset 1965
Stone length 13″
TDB EC-82-610

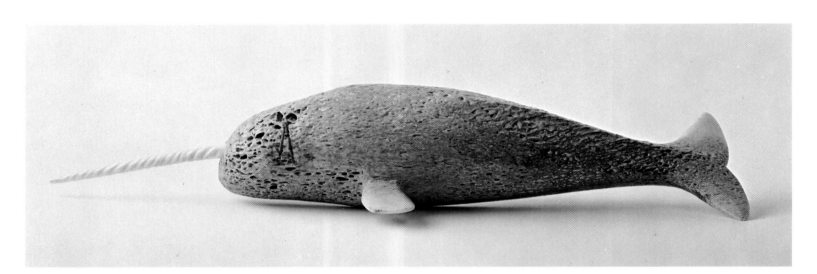

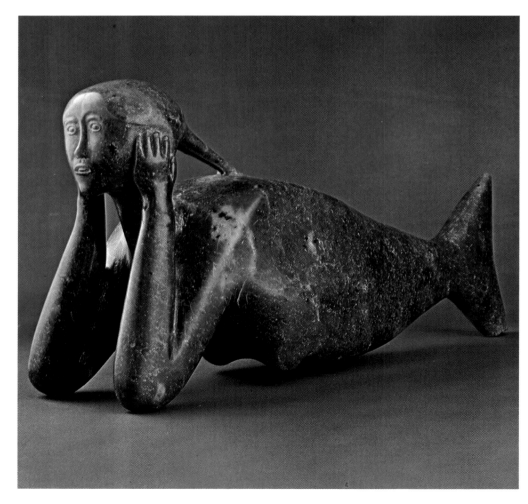

108/Etidlooie Etidlooie
(Eeteedlooee)
Cape Dorset 1960
Stone height 8″
NGC 29279

109/Mariano Aupillardjuk
(Aupilarjuk)
Repulse Bay 1962/3
Stone height 6³/₈″
WAG G-76-551 ▶

110/Tuna Iquliq
(Donat/Toona, Erkolik/Erkoolik)
Baker Lake 1963
Stone height 7³/₄″
WAG G-76-4 ▶

79

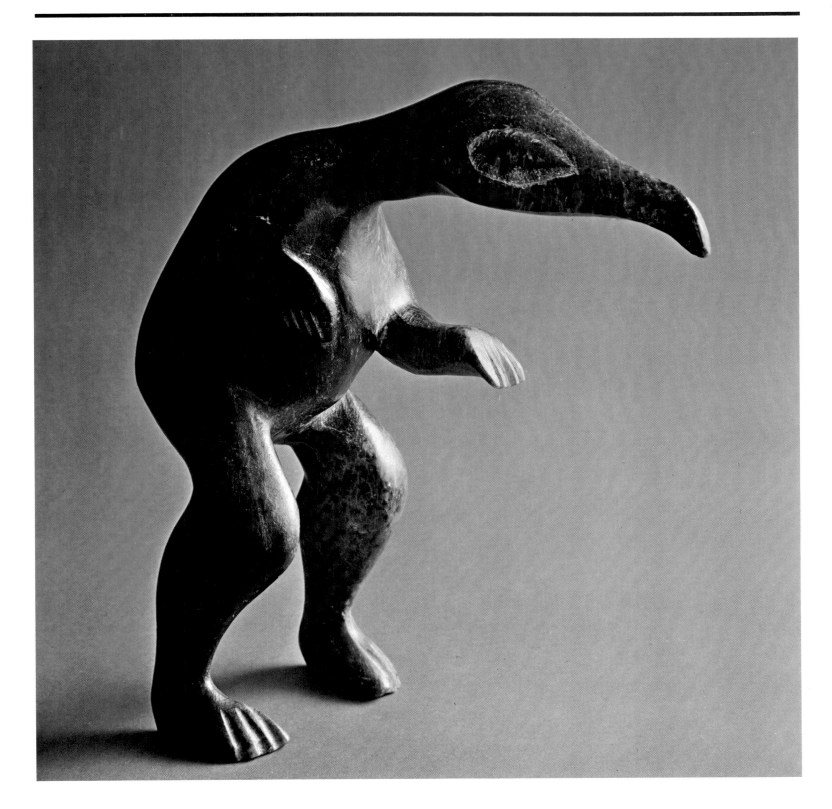

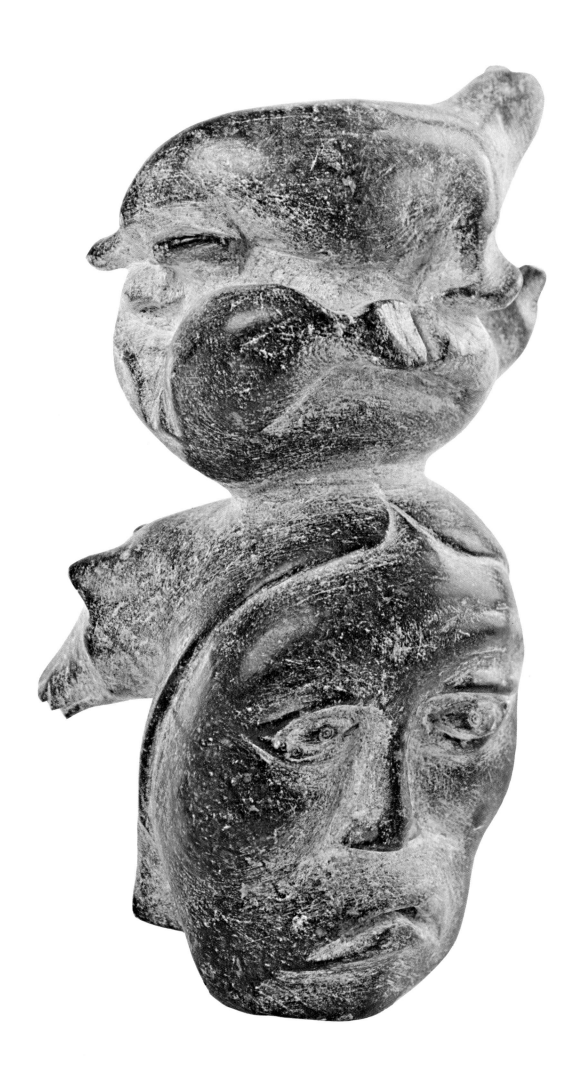

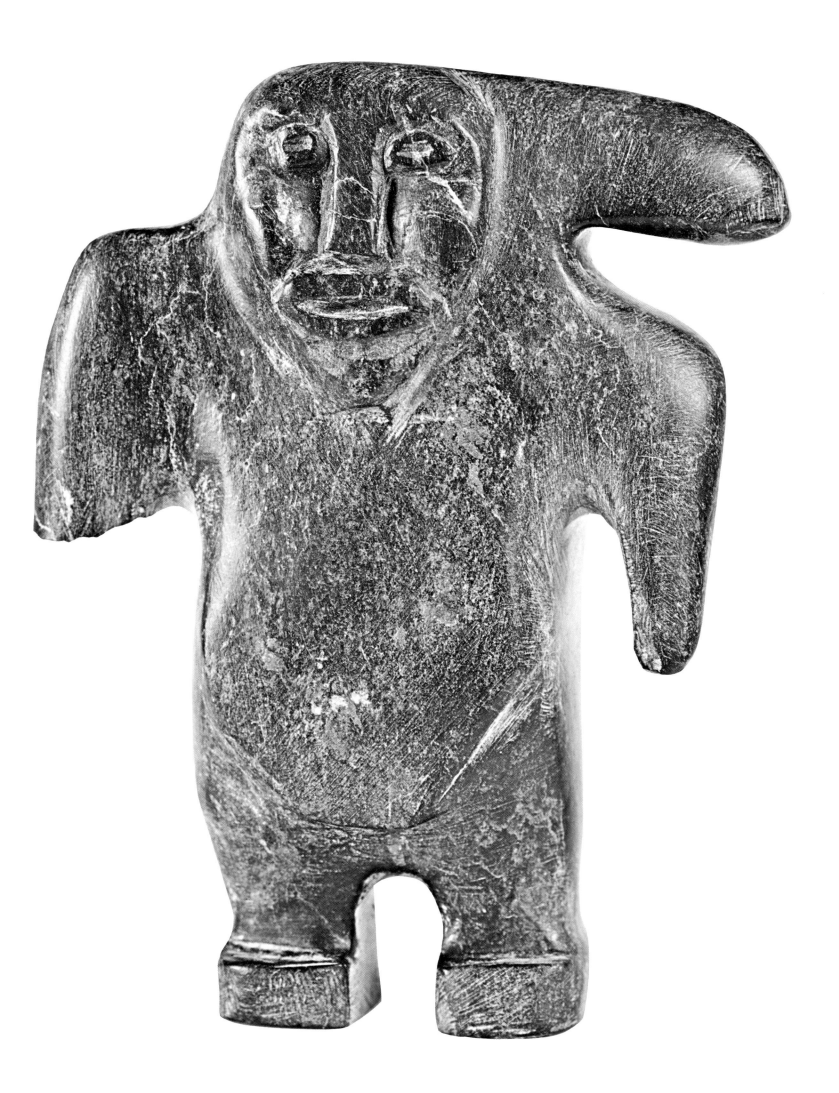

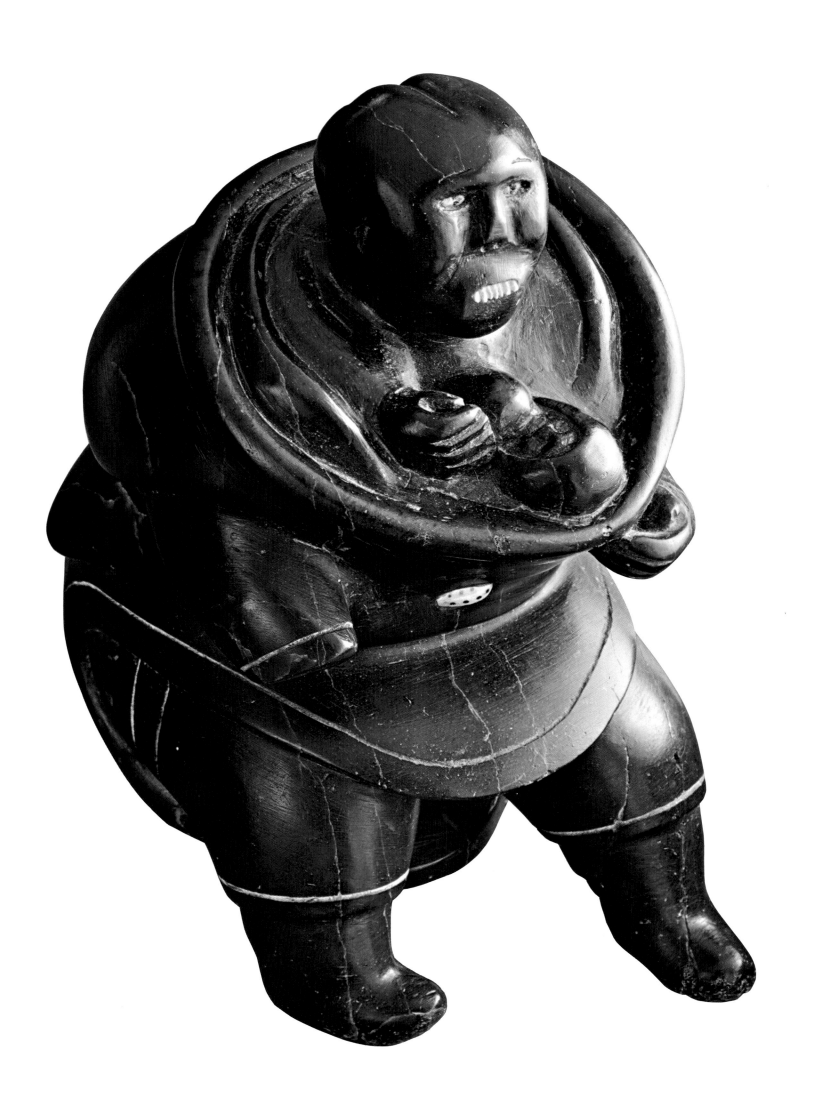

◀ 111/Unidentified artist
Inukjuak (Port Harrison) 1952/3
Stone and ivory inlay height 7³/₄"
TDB EC-82-614

112/Aoudla Pee
(Audla/Aullaq)
Cape Dorset 1965
Stone and ivory height 7"
WAG 1071-71

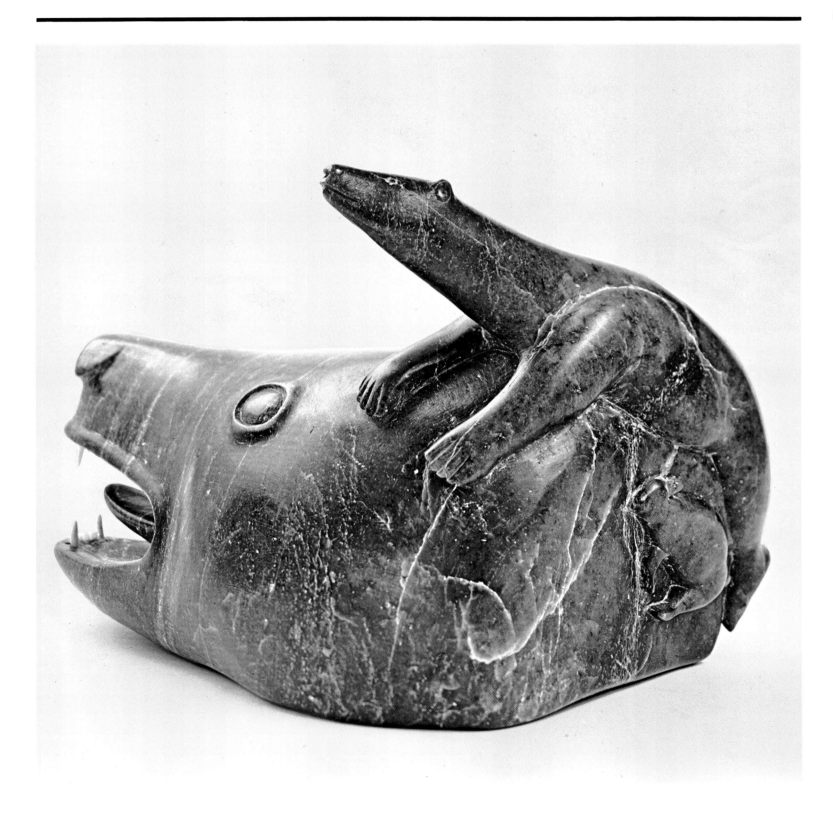

113/Noah Koughajuke
(Koojuakjuk)
Lake Harbour 1969
Stone length 7³/₄"
AGO 90/109

114/Thomas Arnayuinak
(Arnayuinnar)
Arviat (Eskimo Point) 1969
Whalebone height 5¹/₄"
WAG G-76-191

84

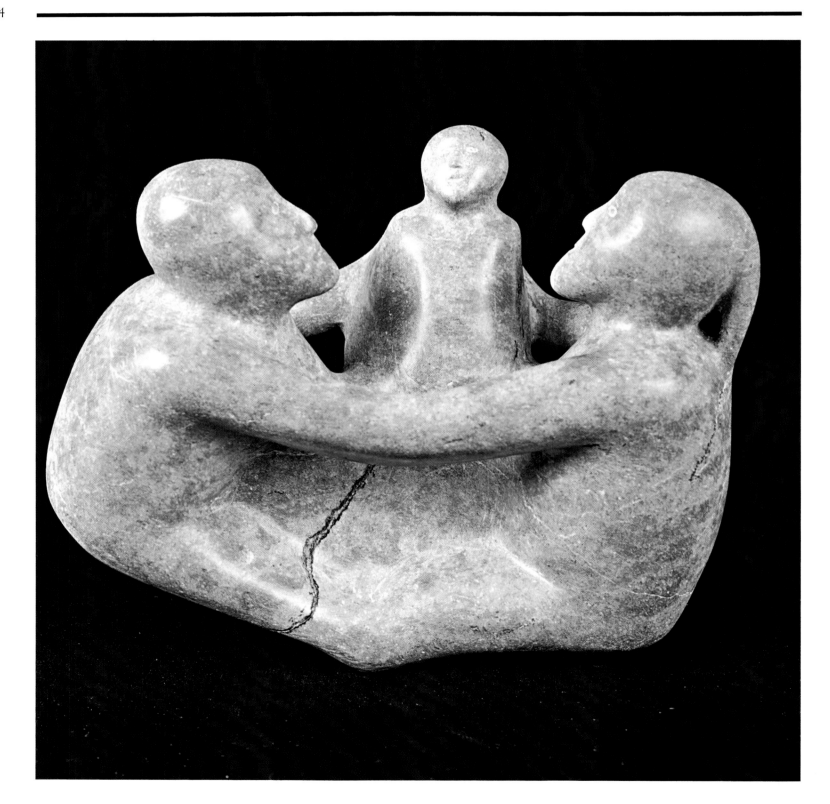

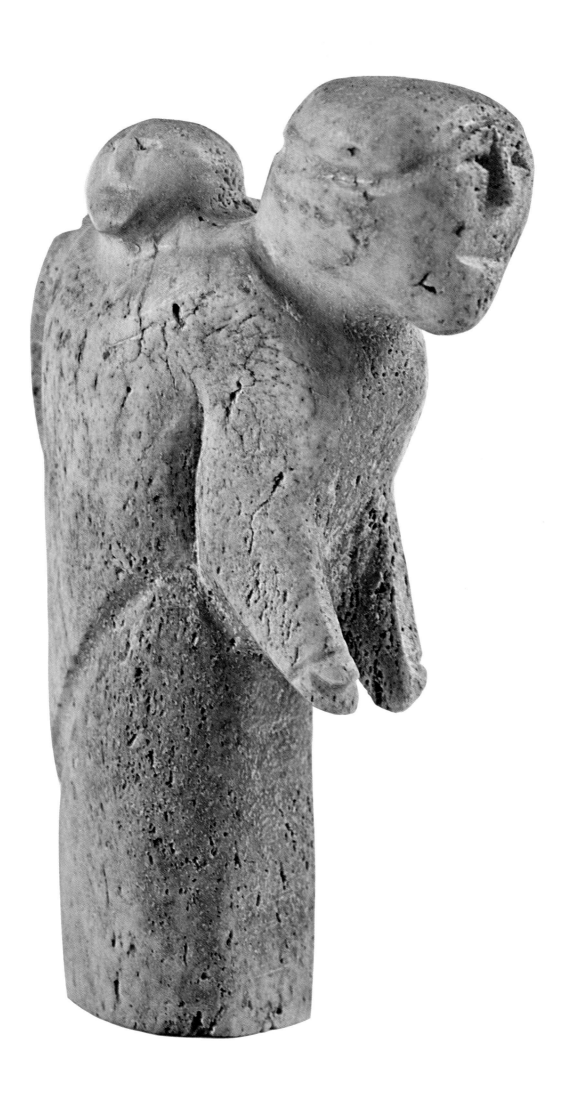

◀ 115/Thomas Udjuk
(Ugjuk)
Whale Cove 1965
Whalebone and antler height 18¹/₃"
AGO 90/280

116/Luke Iksitaaryuk
(Ikseetarkyuk)
Baker Lake 1968
Caribou antler total height 8³/₈"
AGO 90/115 (detail of 689)

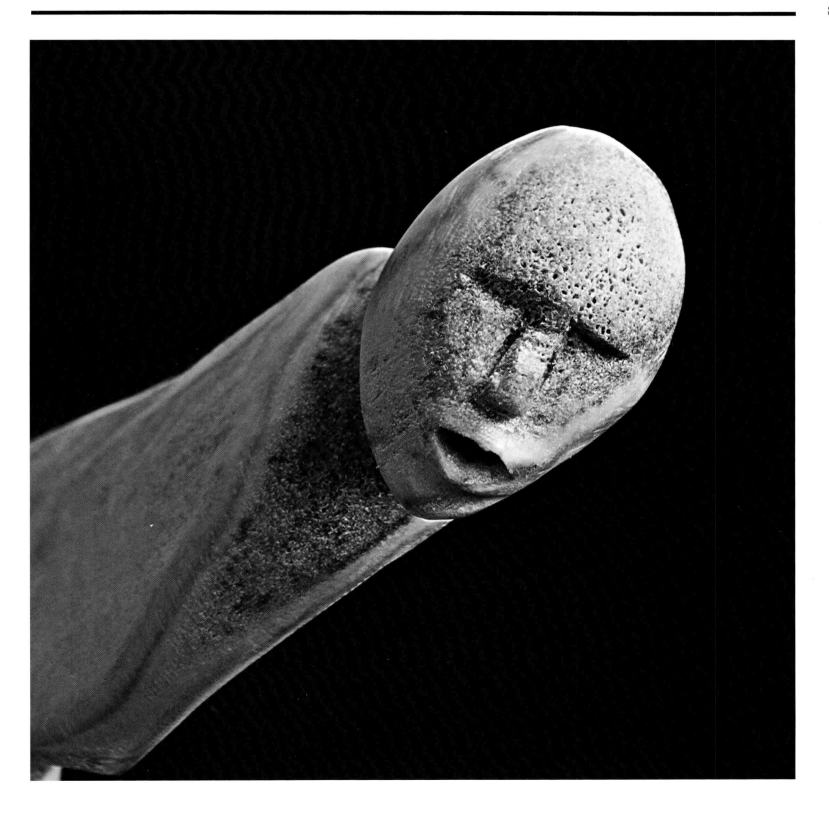

117/Thomas Saumik
Rankin Inlet 1969
Stone height 8″

118/Lucy Tasseor Tutsweetok
(Lucy Tasseor)
Arviat (Eskimo Point) 1967
Stone height 11³/₈″
WAG G-68-91
(also 608)

88

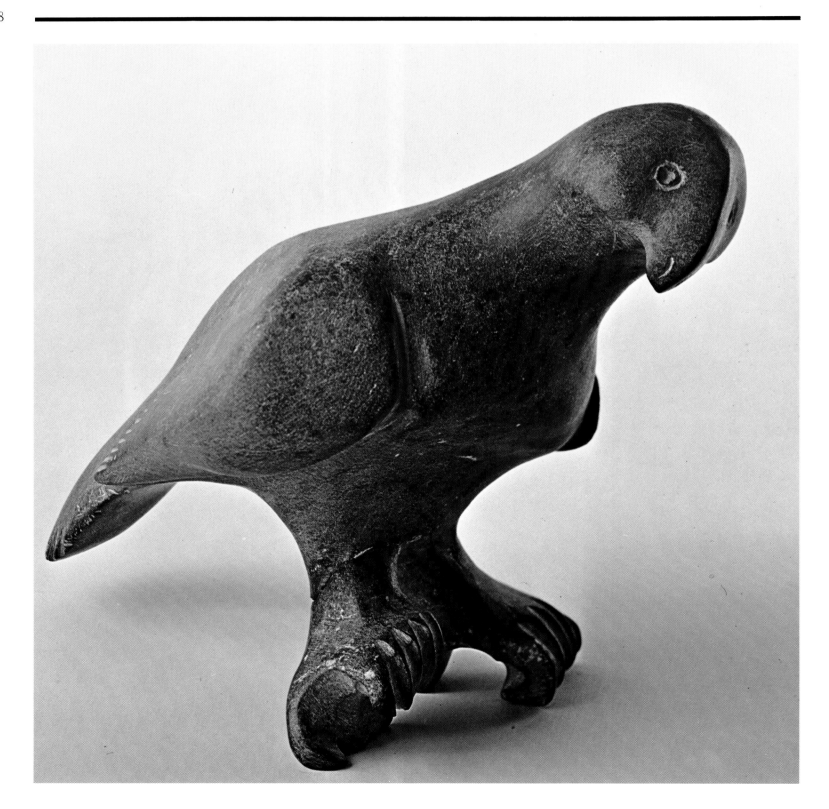

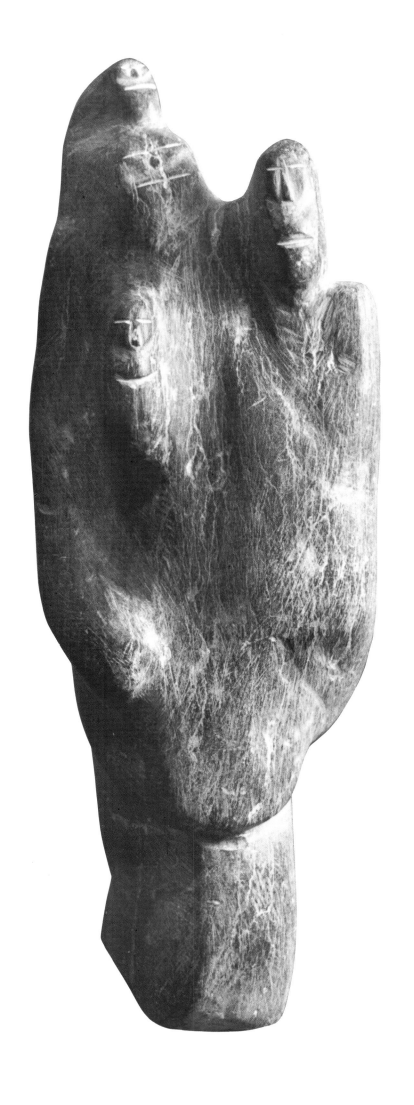

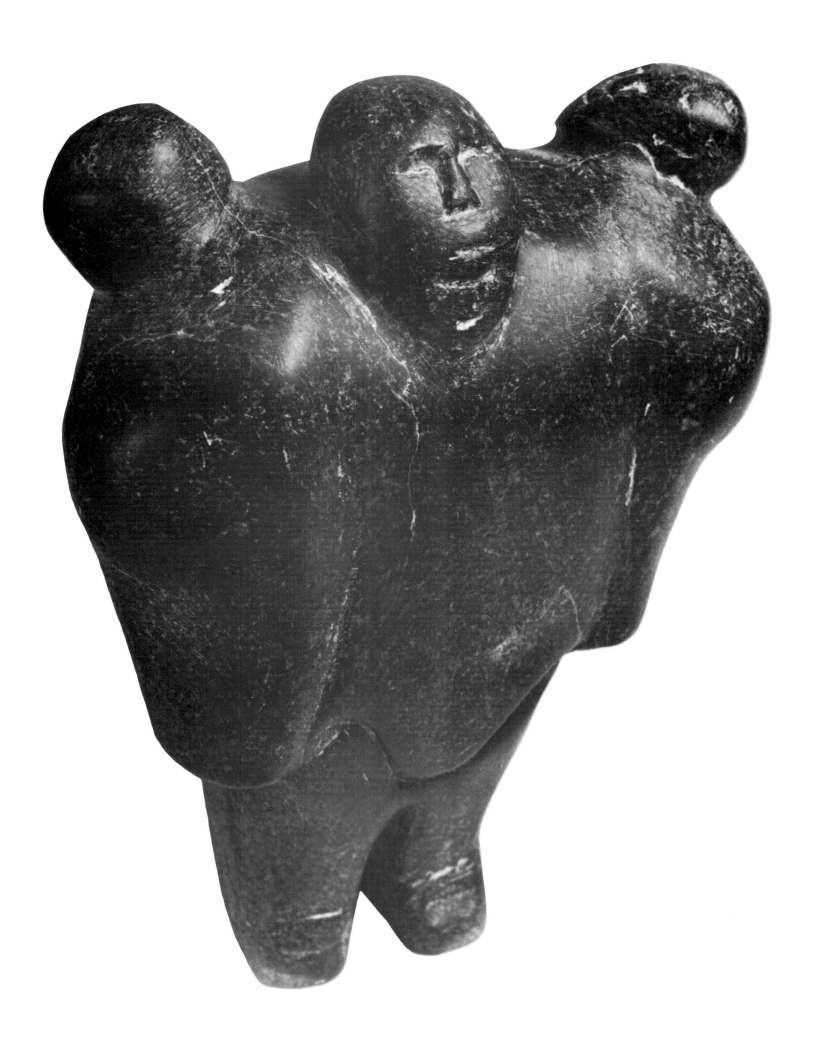

119/David Ikqutaaq
(Ekoota)
Baker Lake 1962
Stone height 9½"
WAG G-64-84

120/Margaret Uyauperq Aniksak
(Uyaoperk)
Arviat (Eskimo Point) 1968
Stone height 9½"
WAG G-68-93

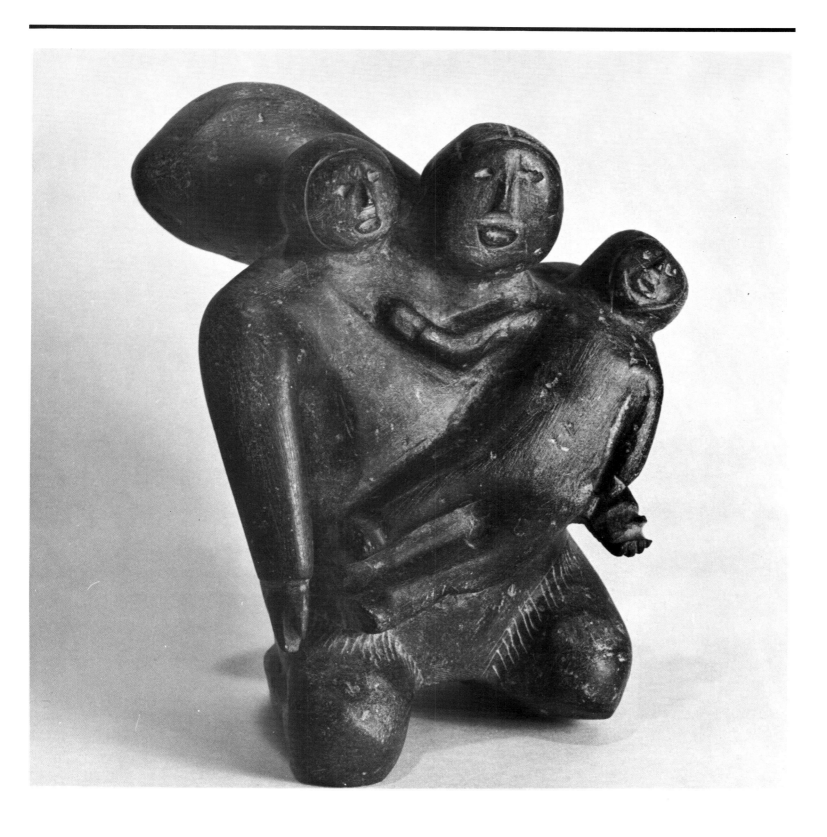

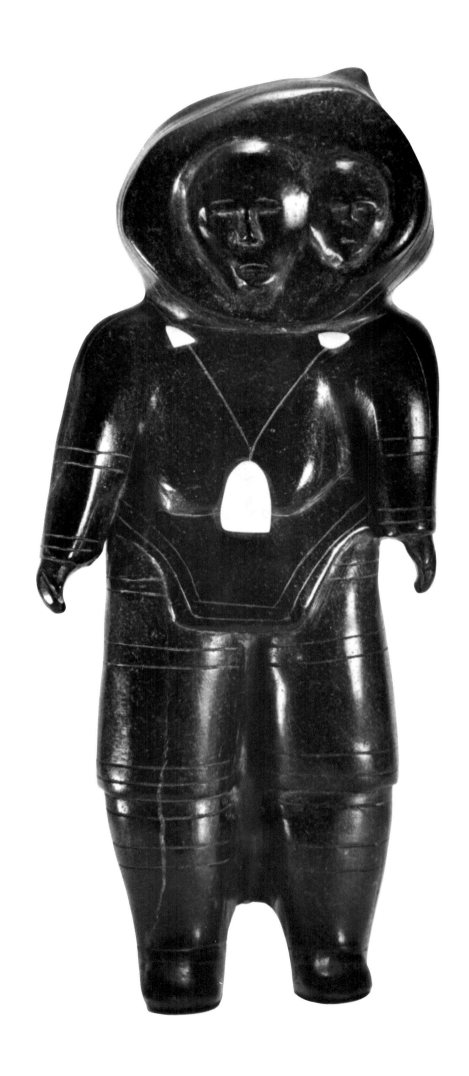

121/Josephee Angnako
(Agnako)
Pangnirtung 1955/6
Stone and ivory height 13³/₈"

122/Annie Niviaxie
(Sala)
Kuujjuaraapik (Great Whale River) 1967
Stone height 6"
(also 233/4)

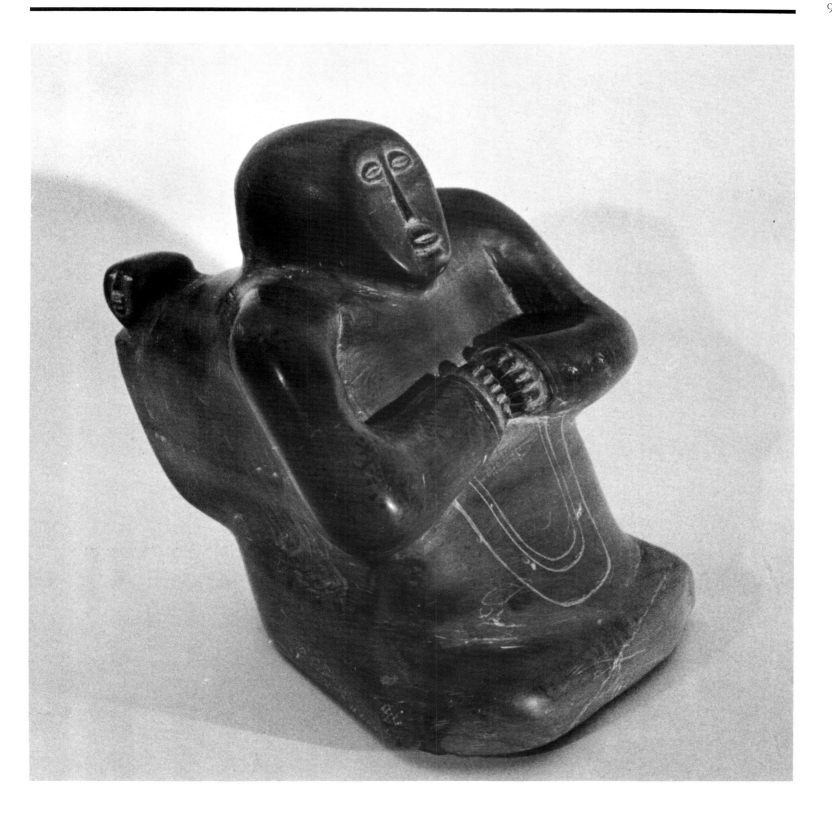

123/Unidentified artist
Arviat (Eskimo Point) 1968
Stone height 5″

124/Kaka Ashoona
(Kaka/Hakkak)
Cape Dorset 1967
Stone height 21¹/₂″
York 70.11

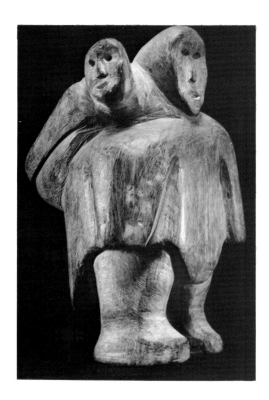

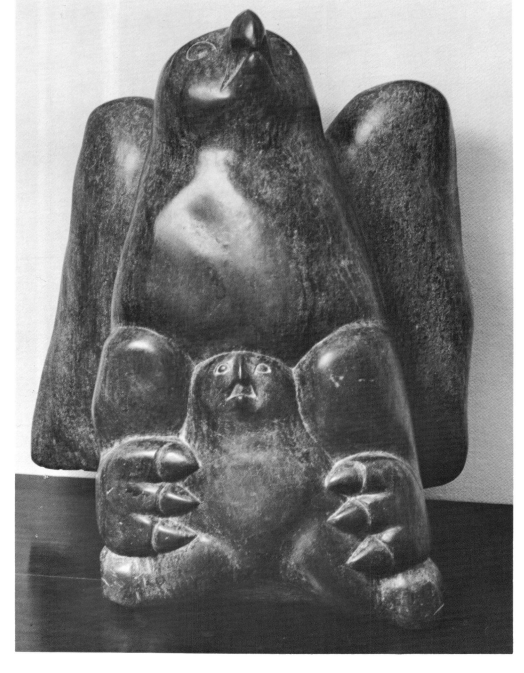

125/Unidentified artist
Repulse Bay 1955
Stone height 4³⁄₄″
WAG G-76-536

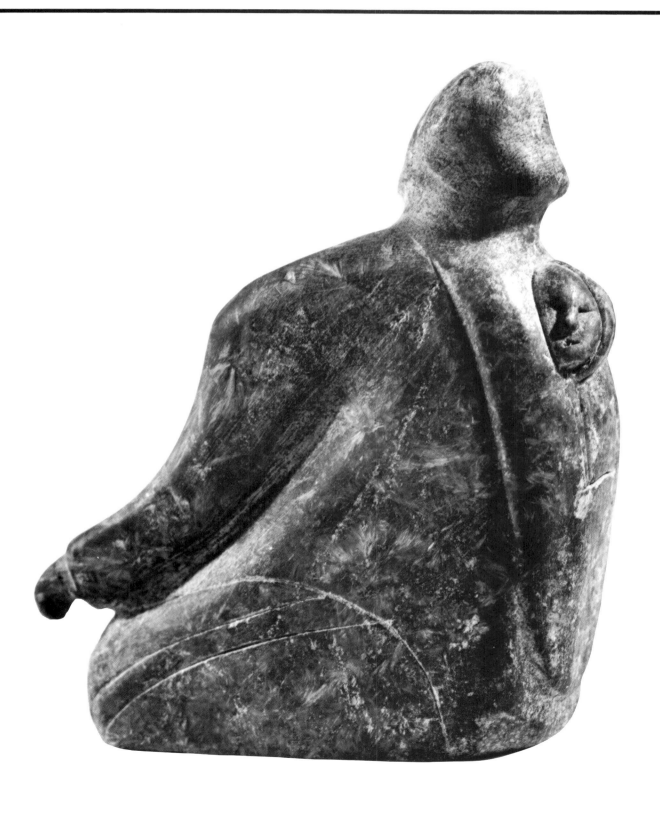

126/Abraham Pov
Inukjuak (Port Harrison) c. 1959
Stone height 7″

127/Unidentified artist
Inukjuak (Port Harrison) 1953/4
Stone and ivory inlay height 14½″
WAG G-90-947

96

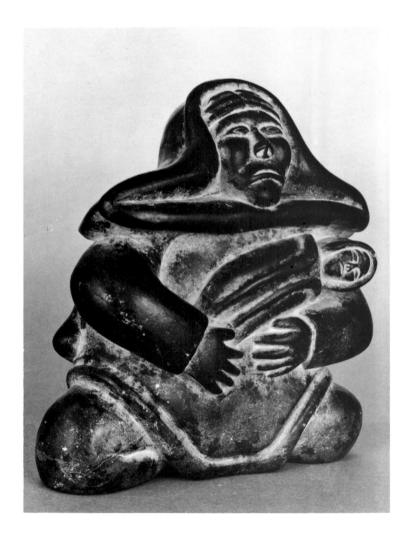

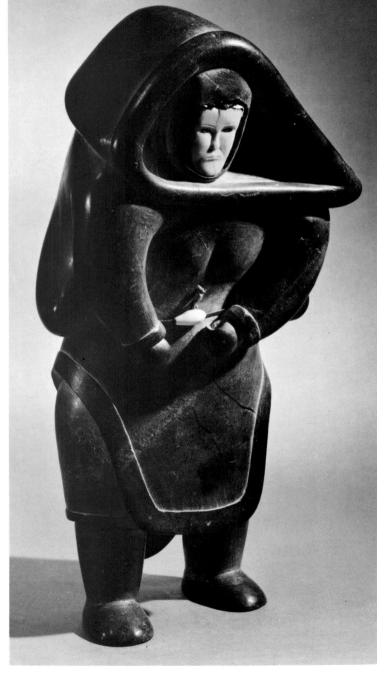

128/Johnassie Mannuk
Sanikiluaq (Belcher Islands) 1965
Stone height 5⅛″
WAG G-76-86

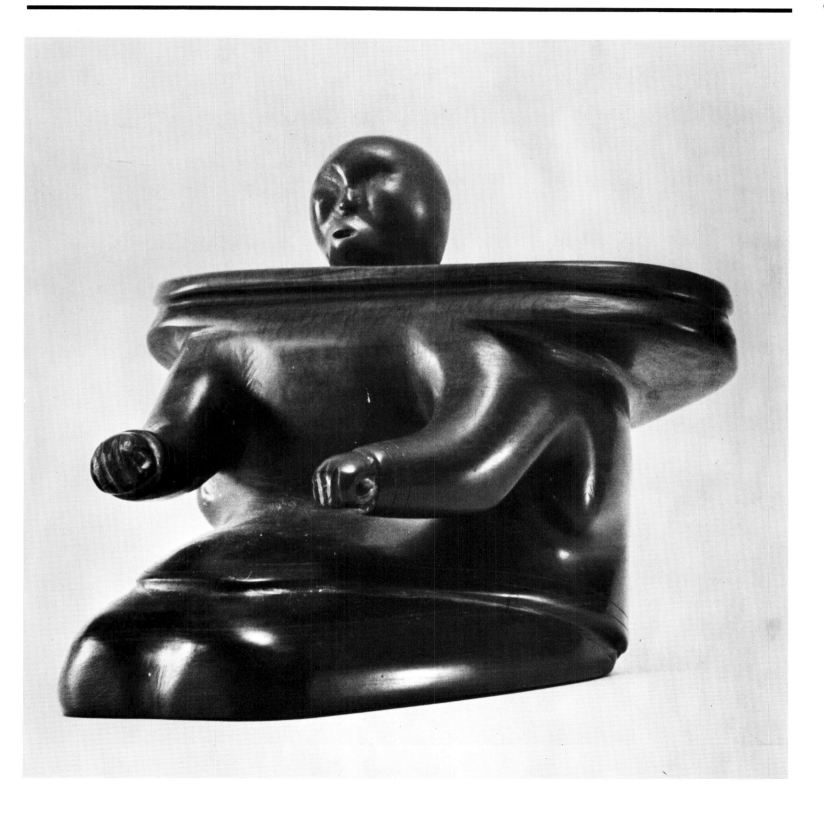

129/Davidialuk Alasua Amittu
(Davideealuk)
Povungnituk 1959
Stone height 4³/₄"
TDB EC-82-624

130/Unidentified artist
Baffin Island 1951 ?
Stone height 6"

131/Unidentified artist
Cape Dorset 1955 ?
Stone height 13¹/₄"
NGC 28733

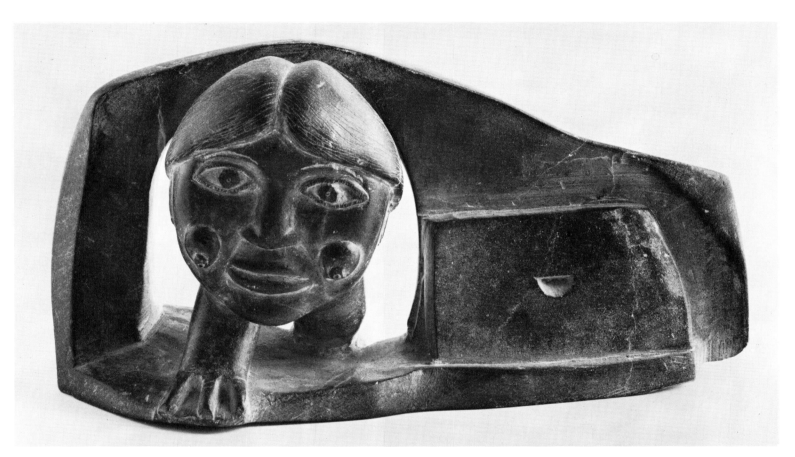

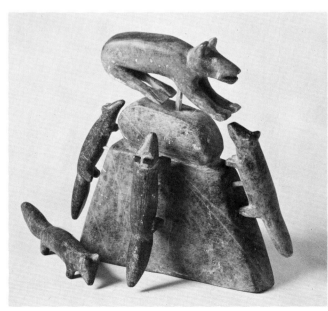

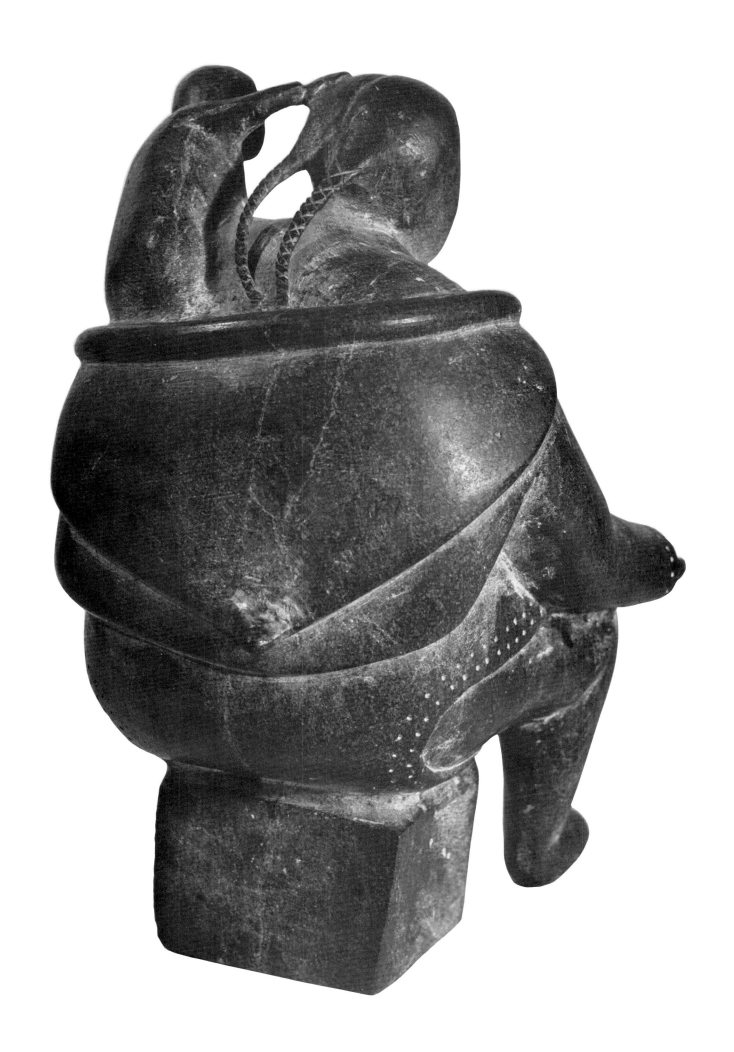

132/Daniel Simaotik
(Shimoutic)
Inukjuak (Port Harrison) 1959
Stone height 7½"

133/Ennutsiak
(Inuksiak)
Iqaluit (Frobisher Bay) 1967
Stone height 4¾"

134/Guy Kakiarniut
(Kakiarniuk)
Pelly Bay 1967
Stone height 7⅝"
EMC C65.35-1

135/Gina Sala
Kuujjuaraapik (Great Whale River) 1962 ?
Stone height 7¾"

100

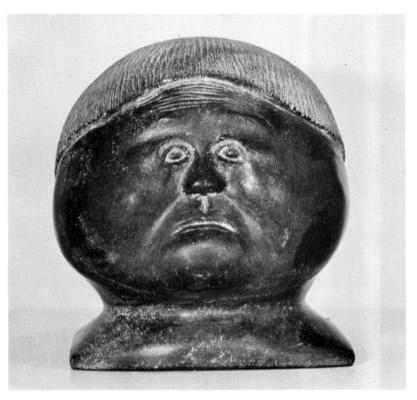

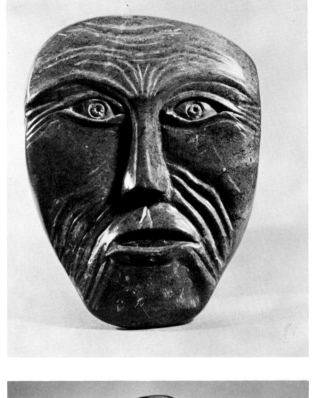

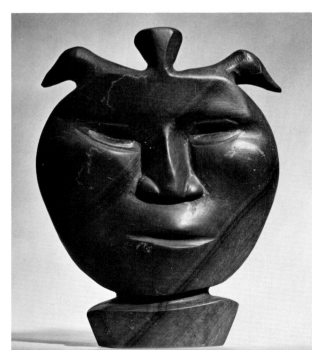

136/Johnny Inukpuk
Inukjuak (Port Harrison) 1958 ?
Stone and ivory height 24″
TDB EC-82-608
(detail)

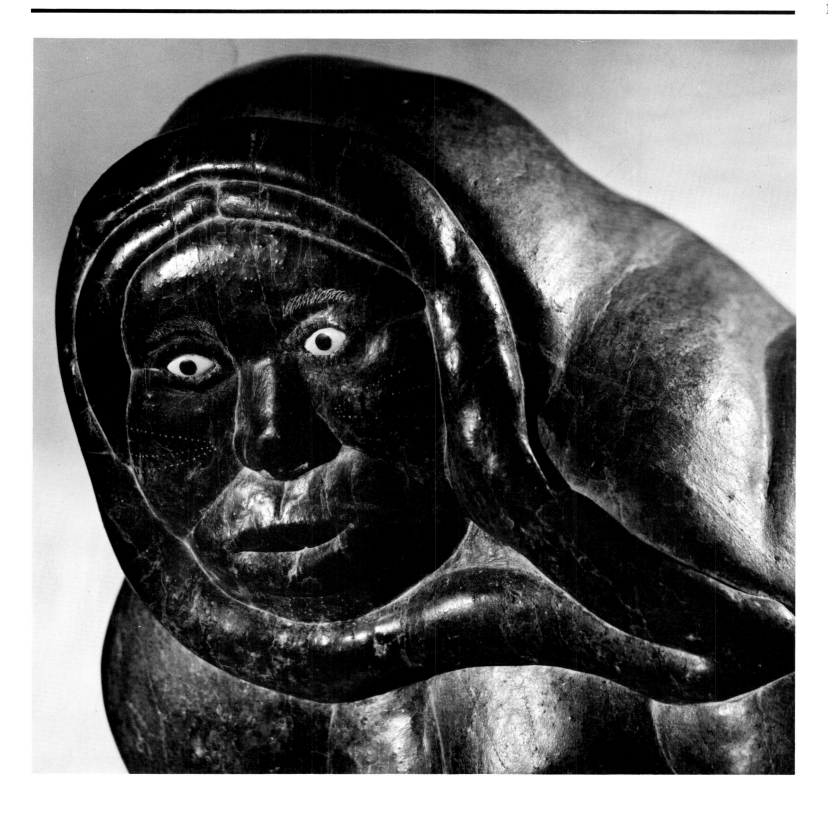

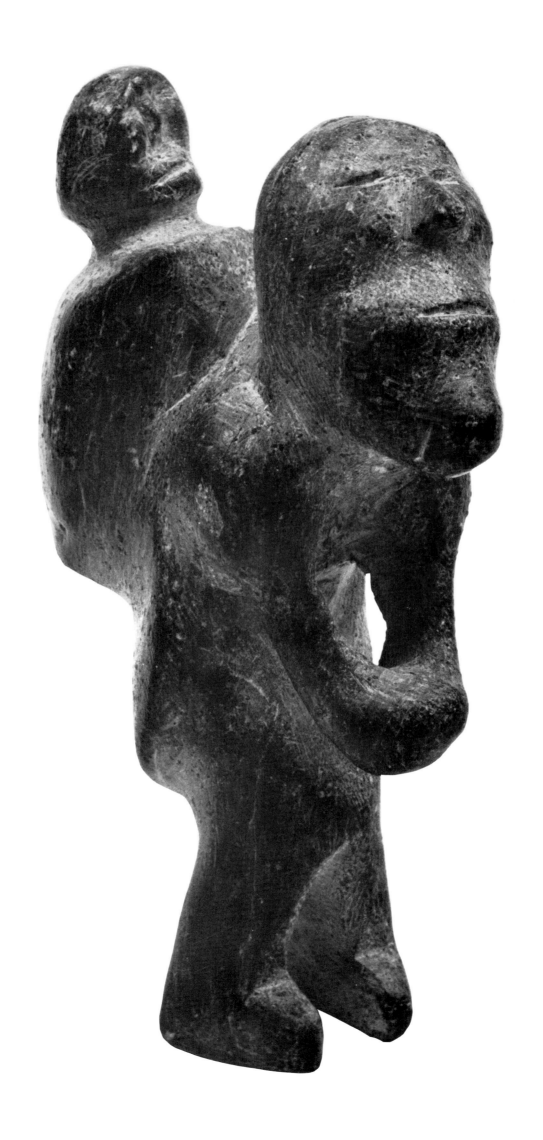

138/Juniapi Angutigulu Uqaitu
(Johnnieapik)
Povungnituk 1959
Stone length 8³/₄"
WAG G-76-394

139/Joe Adlaka Aculiak
(Adlikit)
Inukjuak (Port Harrison) 1967
Stone length 12"

◄ 137/John Tiktak
Rankin Inlet 1963
Stone height 7"
WAG 2060-71

140/Quvianatuliak Takpungai
(Kovinaktilliak "C")
Cape Dorset 1966
Stone height 6¹/₂"

141/Mary Ayaq Anowtalik
(Akjar)
Arviat (Eskimo Point) 1969
Stone height 11" ►

103

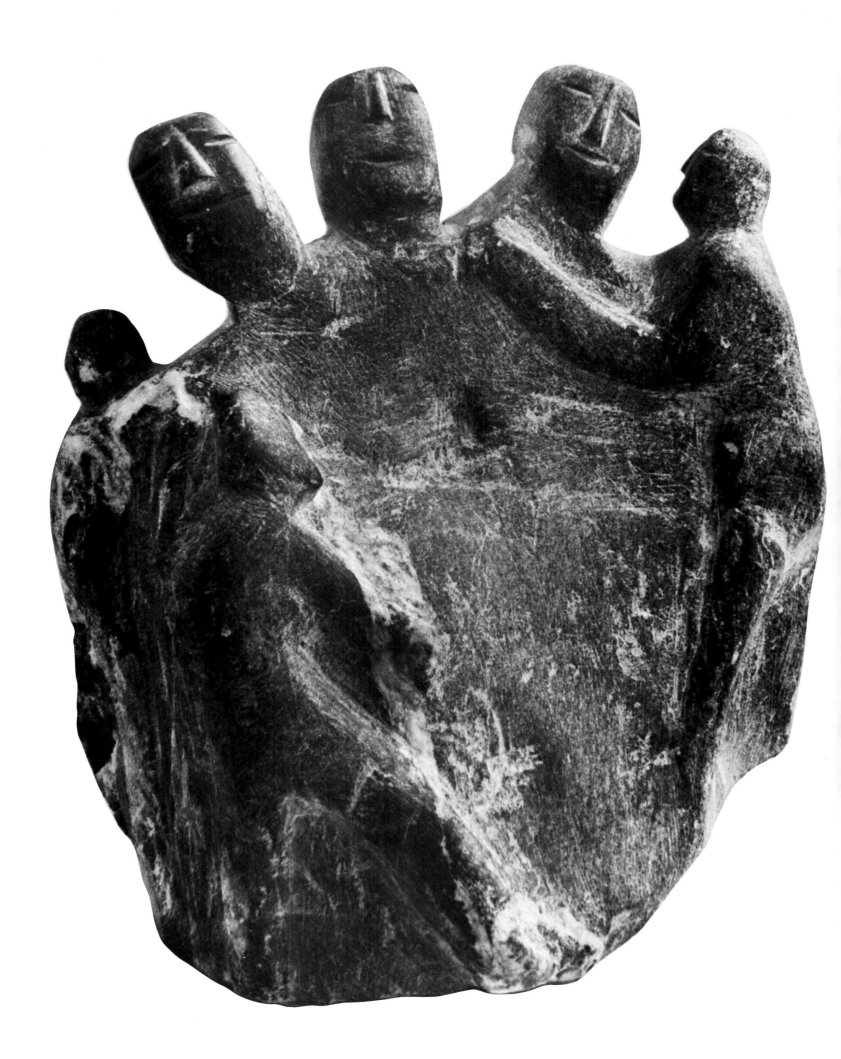

The Sananguaq-Art Concept

Sweet are the uses of adversity;
Which, like the toad, ugly and venomous,
Wears yet a precious jewel in his head:
And this our life exempt from public haunt
Finds tongues in trees, books in the
* running brooks,*
Sermons in stones and good in every thing.

William Shakespeare
As You Like It, Act II, scene i

I/ The Environment

In 1957, several people predicted the end of Eskimo art "within this generation" or perhaps "within ten to fifteen years." I was one of them. We were wrong. We looked into the future and said, "How would it be possible for one's art to survive when one's culture is dying?" Little did we know about the nature of Eskimo culture. We looked at what we thought were its essential factors, and we saw that they were gradually disappearing. New factors had come into existence. We thought – and said – "these are not Eskimo." Little indeed did we know about what was "Eskimo." We thought the factors that we knew – the data by which we "defined" the *inuit* – were definitive. The only factor that we now know to be definite is change. Change as a tradition, change as a way of life, change as a way of being alive. But more about that later.

We also thought that the environment was permanent or, at least, recurring. Well, recurring it may be in the succession of seasons, but static it never is; for any environment exists in relation to one's awareness, attitudes, and experiences. It may shape our awareness and sensory experiences, but, in turn, new, non-environmental experiences and attitudes change our concepts of the environment and our relations to it. These new awarenesses are in turn reflected in new ways of experiencing. The environment in a tradition of change is a changing environment, although the rocks may not change much, nor the weather, nor the macrocosm. But when we try to control the environment in order to escape it rather than to live with it, we actually create new and artificial environments.

One of the aspects of the Eskimo's natural environment is the Arctic itself. Physically it is best defined as being above the tree line, one million square miles of land masses, more than half of it the Arctic Archipelago. Actual estimates of the Arctic's exact size vary; some sources say less, some say more. Be this as it may, it does lie north of the tree line, mostly north of the Arctic Circle, but one-third extends south to Churchill, Manitoba; into James Bay, Ontario; covers most of Nouveau Québec; and moves far into Labrador. On the other hand, as in Alaska, the tree line in Canada creeps north of the Circle at the Mackenzie Delta, at the Anderson River and at Coppermine, reaching toward the Arctic Ocean.

An excellent description of the Arctic appeared in the annual handbook of the Dominion Bureau of Statistics, *Canada 1971*. It is well worth quoting for its to-the-point illustration of the Arctic Tundra:

"Permanently frozen ground allows only a small biomass to develop. Most plant-communities, except under the most barren conditions, are very unstable. Animal populations likewise fluctuate greatly: small rodents (lemmings) are virtually absent some years and then rise to swarming invasions.

"The abrupt fiord lands of Baffin Island, with their cliffs and screes, their vast gravelly outwash, their low domed hills, their coastal strands and marshes, and their permanent ice-caps fringed with yearly-melting snow patches have a varied repertory of ecosystems: the sedge and grass marshes are teeming with bird life in the summer as are some of the island cliffs whose dwellers feed on sea-creatures. The rocky shores and ice-shelves have an abundant sea-mammal population.

"The more dry and flat lands support a patchy tundra of dwarf willows, bilberries, rosebays, and crowberries interspersed with the flowering saxifrages, buttercups, sandworts, louseworts, and tufts of wood-rush and sedge. Herds of caribou graze and browse upon these plants and upon the ever-present caribou lichen (*Cladonia*).

"The low plains of the Mackenzie River, on the other hand, show a vast expanse of wet meadow, interrupted by moss-chocked bogs and reticulated with streams that are bordered with willow screens.

"The greater part of this territory is nearly primeval, but it reveals itself extremely vulnerable to man's impact: irreversible destruction of some permanently frozen soils and oil pollution in the waters."

To which needs to be added that the winter is long and cold, and though daylight is scarce at that time the darkness is not necessarily deep. When February comes, the sun comes too, and gradually all life is influenced by its arrival. By mid-July, when the "break-up" is complete, the Arctic becomes a carpet of flowers that continually changes for six weeks. September is the harbinger of winter and all creatures brace themselves for its inexorable return. As the Arctic Archipelago is one of the driest regions in the world, snowfall is relatively light. In fact, if it were not for the moisture-conserving long winters, the Arctic might well have become a desert.

This is the Arctic in the raw. To the Eskimo it is *nunassiaq* – The Beautiful Land.† And it is here where they and their ancestors have lived for five thousand years. This is their land and to them it is their home. Today the majority of the close to seventeen thousand Canadian Eskimos reside in the Northwest Territories, but thirty-two hundred inhabit Arctic Quebec, twelve hundred still live in Labrador, and slightly less than four hundred in Manitoba.

The *inuit* have the highest birth rate in Canada – fifty-five per thousand, as

† In 1962, *Nunassiaq* was the name voted to be given to the Eastern Arctic when the Northwest Territories were to be divided into two separate administrative regions. More recently, the name of the future territory became *Nunavut*.

compared with the Canadian average of just eighteen. This statistic is significant; it reveals a complete reversal of the pre-Second World War population trend created by newly improved health standards and a much reduced infant mortality rate (which, incidentally, still is four to five times as high as the Canadian average). However, the major point of importance here is the vastly improved chance for the *inuit*'s physical survival. This improvement is not due to changes in the natural physical environment itself, but has been brought about by changes in living conditions, predominantly by the move from the former camp life into quasi-permanent housing in fewer but larger urbanized settlements. These new settlement patterns in turn have affected, and continue to radically change, the structure of relationships between the *inuit* and the natural environment.

The Arctic today is very different from what it was even ten years ago. For the white men, the *kablunait* (the people with the heavy eyebrows), have come in growing numbers and have imposed changes on the environment in the name of progress, commerce, and God. And the *inuit* no longer live in harmony with their land but, as they have learned from the white man, are trying to use it and to master the many dangers it still holds. In doing so they are changing their environment and their concepts of it.

2/Two principles of Inuit survival: Adaptation and Change

It is possible to explain Eskimo existence in the Arctic on a variety of grounds. Perhaps the most commonly projected arguments are that Eskimos were stone-age hunters and nomads following the trails of the caribou, or that they were coastal hunters finding a plentiful supply of sea mammals on the extensive and intricate sea shores of the Arctic Archipelago and the many inlets and bays of the mainland. But these arguments are only half truths, implying continuous, highly specialized hunting economies which, in fact, are very rare, as has been convincingly demonstrated and described by Dr. William E. Taylor. Archaeological and ethnological evidence suggests mixed hunting economies with wide local variations in the different cultural sequences. "Seen everywhere in the Eskimo world is an economy that is omnivorous or tending to be so by which the band exploits a wide range of faunal resources – even man, if starving. Fundamentally, Eskimo economy is neither inland nor coastal adapted but arctic adapted (and to some degree, occasionally sub-arctic adapted), and the degree to which different species are exploited reflects primarily the environment, the faunal resources, and only secondarily an economic heritage." (TAYLOR 1966)

Obviously, omnivorousness requires flexibility as a companion in order to successfully exploit specific environments and changing circumstances. Thus Taylor affirms that the "economies adjust to regional variations in the environment."

Flexibility in adaptation to the environment is an essential aspect of Eskimo history, at least, from what little we can reconstruct from archaeology. And at present this is pathetically little indeed, considering that archaeology and, to a certain extent, ethnology are almost the only possible means that can provide or substantiate clues to the Eskimo past, and

in that sense to Eskimo history.† From the evidence there is, it appears that change and adaptation are the major principles of Eskimo history and survival. But at the same time one should also note that, as inevitably as these two principles operate, they function only as slow processes, often taking hundreds of years and spreading over tens of thousands of square miles, and always involving merely a handful of people relative to the immensities of spatial and temporal dimensions.

Contrary to our culture, which encourages constant change and which accepts and even glorifies swiftness of change as a desirable social criterion, Eskimo ethics – similar to ethics of most non-Western cultures and also of pre-industrial-revolution Western culture – presuppose the opposite: life patterns and traditions are almost sacred and change comes only as the result of forcing necessities. The recent rise of Indian and Eskimo self-awareness in both Canada and the United States is based on the recognition of the validity of these tradition ethics. Knowledgeable whites in both countries have recognized the cogency of that argument not only in relation to the cultural survival of Indians and Eskimos but also as a valid attitude to life *per se*. It is important to underline this point for it might help us to explain a conspicuous paradox in current acculturation problems in the North, particularly in art and education.

Whenever we think of flexibility and adaptation in connection with Eskimo history and life-patterns we are inclined to forget that these characteristics differ from our concepts of change and that they

† Considering that Canada is one of the wealthiest nations in the world, our general lack of interest in and the almost complete absence of substantial support for archaeological and ethnological research are somewhat of a national disgrace. Surely this is one stigma of which we could free ourselves quite easily!

coexist with the above-mentioned tradition ethics. Thus, while the *inuit* are technologically and materially moving from a relatively simple hunting and trapping economy to a highly complex and technologically sophisticated money economy, their basic ethos patterns (i.e. their way of thinking and their reactions to new events and experiences) are changing only slowly. This paradoxical pattern is a great source of strength to the Eskimo, and I suspect that as long as they can maintain these ways against the ever-increasing onslaught of our technological intrusion they will be able to survive as *inuit*.

Their most formidable opponents in this battle, therefore, are not the technological means and practices themselves nor the inevitable dangers of various types of pollution to the environment, but rather the driving forces behind them: our industrial and economic-growth philosophies, our belief in the virtue and dignity of institutions and organizations, the assumptions of the superiority of Euro-Canadian values, and the patronizing acceptance of native quaintness, charm, and naiveté. In such a context, predominantly Euro-Canadian values and knowledges are propagated, officially or more often unwittingly, and *inuit* values are practically neglected if not ignored, although they are theoretically and rhetorically acknowledged. What is even worse is that the communication media and the cultural values of most resident whites are part of the growing mass-culture syndrome, which includes such phenomena as: swinging Bach and rock Beethoven; the philosophies of John Wayne and Hugh Hefner; the literary values of Li'l Abner, Blondie, and Tarzan, the art forms of comic strips and record covers; the historicities of Farley Mowat and Irving Stone; quite apart from French Provincial and Spanish Colonial TV sets, or Astrodome record players, and the ultimate Virtue, Truth, and Beauty of

Johnny Cash. No wonder that in such an environment the changes from the traditional and homespun values of the recent Eskimos to the currently vulgar acculturation values have become only too conspicuous. Yet whenever the support of the traditional values inherent in language, folklore, music, and handicrafts is advocated by progressive educators, administrators, or cultural groups, they are attacked as being reactionary and unrealistic because, after all, the Eskimos must accept the realities of the English language and the virtues of our ways of life and not the extravagant fantasies of high-browed outsiders.

One of the continuing miracles of the current art renaissance is that the *inuit* artists are flexible enough to reject as much as to accept what we have to offer. There are several factors accounting for this phenomenon, but to list them at this moment would confuse rather than simplify the discussion. However, one point is certain: while the contemporary *inuit* art forms are not stylistically related to the past, the strong connections the *inuit* have with the past reappear today as vivid echoes which have been blended together with completely new reflections of the changed environment. In illustration 153, the traditions of the past have survived in the image of a Dorset-like shamanistic bear, complete with joint marks, which floats through the air, while the contemporary environment is reflected in the aesthetically detached, almost abstract carvings by Pangnark and in the surreal fantasy carvings by Eli Sallualuk.

For historical reasons we have left this map as it was in 1972. See the new map, pp. 146-47 for current place names and added localities where Inuit art is produced now.

1/Belcher Islands	10/Arctic Bay
2/Great Whale River	11/Eskimo Point
3/Port Harrison	12/Rankin Inlet
4/Povungnituk	13/Baker Lake
5/Sugluk	14/Repulse Bay
6/Cape Dorset	15/Pelly Bay
7/Lake Harbour	16/Spence Bay
8/Frobisher Bay	17/Coppermine
9/Pangnirtung	18/Bathurst Inlet

3/Culture Patterns

In Canada, the history of Eskimo cultures is quite straightforward especially when compared with that of Alaska. Quite apart from the contemporary co-existence of three basically Eskimoid languages in Alaska – *inupik, yupik,* and *aleut* – which indicate the complexities of Alaskan cultural developments not only in temporal but also in spatial and linguistic boundaries, there also exist highly complex patterns of change, diffusion, and remarkable continuities within given neighbouring and distant areas.

In Alaska, frequently occurring stylistic changes can be clearly observed and defined. These developments differ widely over the various areas (South Alaska, Kodiak Island, Aleutian Islands, Southwest Alaska, Bering Strait, Northwest Alaska, North Alaska, and Central Alaska) with some thirty differing culture traits. In the Canadian Arctic, which is almost four times the size of Alaska, only five distinct periods of cultural developments can be discerned: Pre-Dorset, Dorset, Thule, Historic, and Contemporary. In fact, most anthropologists and archaeologists distinguish only four cultures, lumping the Historic and Contemporary phases into one. Because of many changes in the material culture I have to insist on five.

Art styles and attitudes in these cultures are completely distinct; each period can be distinguished by its own clearly definable stylistic characteristics. These characteristics enable us to identify all objects by virtue of their form as belonging uniquely to one period and to no other.† The rare exceptions that exist (as for instance the Manitunik culture of the Belcher Islands and the Sadlermiut of Southampton Island) are isolated cases of cultural retardation in which earlier cultures

†Currently at least one computer study is under way to group and classify stylistic components into useful diagnostic data.

continued to exist into relatively recent eras. But otherwise, despite our still scant knowledge, definite cultural sequences can be established with a reasonable amount of certitude. Our knowledge concerning them must be, and I hope will be, confirmed and expanded through much needed archaeological research.†

Pre-Dorset culture derived from ancestral sources in Alaska which have not as yet been uncovered but which go back at least five thousand years. The first known proto-Eskimos – that is, people living in treeless regions and adapted to mixed hunting economies, inland and coastal – were the people of the Denbigh Flint Complex of Western Alaska dating back to between 3000 and 2000 BC. At the same time a related group of Eskimoid people, who must have shared the same parental culture, moved eastward along the Arctic coast, reaching Canada by 2500 BC and Greenland, via the Hudson Strait, some five hundred years later. These people, the Pre-Dorsets, occupied areas in Canada until around 800 BC and went as far south as Churchill, Manitoba.

Dorset culture (or Cape Dorset Culture as Diamond Jenness originally named it) evolved locally, *in situ*, out of the Pre-Dorset in the central areas of the Canadian Arctic between 1000 and 800 BC. It lasted for two thousand years, and went through at least five distinct phases which seemed to occur in different areas of the Canadian and Greenlandic Arctic at differing periods. (There is, however, ample evidence that the nineteenth-century Angmassalik Eskimos of eastern Green-

†In the descriptions of the Canadian Eskimo cultures that follow I have drawn heavily on Dr. William E. Taylor's work (TAYLOR 1966, 1967, and 1968) and on several articles of mine (SWINTON 1967 and 1971-a). I also wish to refer the reader to other publications (COLLINS 1961, MARTIJN 1964 and 1967, MELDGAARD 1960-b, and TAYLOR 1969) which give a good overview of Eskimo prehistory in relation to art.

land were direct descendants of the Dorsets, if not their last surviving vestiges living relics from the distant past.) Dorset culture extended from Melville Island and Bernard Harbour in the west to Greenland in the east, and as far south as Cape Ray on the southwestern tip of Newfoundland, Great Whale River on the east coast and Chesterfield Inlet on the west coast of Hudson Bay. Though similar in some ways to Pre-Dorset, most of Dorset culture's traits were characteristically its own. Among them were soapstone lamps, beautifully shaped harpoon heads and fish spears and, most important of all to me, art works of great strength and beauty, small in size, highly three-dimensional in concept, and vigorously incised and excaved.

Thule culture, which replaced Dorset between 1000 and 1300 AD, swept eastward from Alaska around 900 AD, reaching Greenland by 1100. While Thule art, as we shall see, differs considerably from Dorset, some exchange of cultural traits took place between the two – the Dorset snow house, for instance, is a "Canadian invention," adopted by the Alaskan Thule Eskimos. And some of the Dorset art objects and artifacts were reworked with Thule tools, such as the bow drill, which did not exist in Dorset times. Thule culture also "imported" to Canada the dog team and equipment for efficient whale hunting, including the *umiak* (woman's boat). In fact, Thule culture with its baleen and whalebone artifacts centred around whale hunting, which became its most distinctive feature. After only five hundred years of existence Thule and Eskimo whaling started to decline. By 1600 it disintegrated as a unified culture. The Thule people, ethnically and physically, were the direct ancestors of the contemporary Canadian Eskimo. Many of their traits, techniques, beliefs, and probably their language

143/Dorset Culture
Abverdjar, Igloolik
Antler length c. 8″
CUMAA 1950.411A

144/Dorset Culture
Igloolik area (c. 1000 AD)
Caribou antler height 4½″
EMC C45.1-325

112

survived until today, although their superficial material culture, for example their housing and their dress, underwent considerable changes.

The Historic period begins with the decline of Thule culture and the coming of white men – the *kablunait*,† the people with the heavy eyebrows. At first the *kablunait* came slowly, but by the end of the eighteenth century and the beginning of the nineteenth their arrivals increased with steady frequency. All came in search of something or other: whalers for baleen, traders for fur, explorers for the Northwest Passage, searchers for the lost explorers, missionaries for souls, and scientists for knowledge. And many wrote about their searches and adventures. And more *kablunait* came. And more was written. And the Arctic was romanticized. And so were its natives, who became the very symbols of courage, friendliness, happiness, and inventiveness. But, with the coming of all the searchers and the many gifts and ills they brought, the *inuit* population started to decline at the beginning of the nineteenth century and never quite recovered, reaching an all time low of 8000 before the Second World War.‡ After the war, things started to change again and a new type of *kablunait* arrived on the scene in great droves to mark the beginning of a new epoch.

The Contemporary period is marked by many events which changed the Eskimos and their environment. Perhaps most significant of these events is the increased and intensified contact with white men – at first mostly government people, but later an increasing number of industrial officials, researchers, and tradesmen. It is

†Plural of *kablunak*, just as *inuit*, the name the Canadian and only the Canadian Eskimos have given themselves is the plural of *inuk* – a man.

‡For an excellent account of this period see Diamond Jenness' five volumes, *Eskimo Administration*.

145/Mary Ayaq Anowtalik
(Akjar)
Arviat (Eskimo Point) 1969
Stone height 6³/₄″
(also 601)

146/John Tiktak
Rankin Inlet 1968
Stone length 27″
CMC IV-C-3771
(also 655)

147/Miriam Marealik Qiyuk
(Marealik)
Baker Lake 1971
Stone width 8″
WAG G-76-61

a period of complete cultural and technological change: from dog team to motor toboggan; from Peterhead boat to regularly scheduled air flights; from disposable architecture (snow house and tent) in over seven hundred camps to permanent housing in some forty-odd urbanized (slum) settlements; from a barter and subsistence economy, in which every family lived off the land, to a mixed welfare and money economy, in which families sell their services or the products of the land in order to obtain money with which to sustain themselves. Failing this and in some areas as much as eighty per cent of the population are unable to support themselves – money is supplied by the *kablunait* who have come to administer the land. Another event which initiated this period was the building of the DEW line with its science-fiction radar structures. And there also was the discovery of Eskimo art. That was in 1948. And the man of the hour was James A. Houston.

4/The development of prehistoric Inuit art

Although Pre-Dorset and Dorset cultures had many common traits, art was not one. In fact, there is hardly any object from the Pre-Dorset period that can be called art.

The famous Tyara "mask" (ill. 149), discovered by Taylor on Sugluk Island, has been carbon-dated around 700 BC. I would not be surprised, however, if this exquisite mask were eventually proved – by Meldgaard, Taylor, or some as yet unknown archaeologist or art historian – to be a remnant of the Pre-Dorset or even its ancestral period, handed down to, or found by, an early Dorset shaman and buried with him some 2700 or 2800 years ago. This stark yet elegantly formalized mask appears to be stylistically unrelated to Dorset art, especially to early Dorset art. It is such a highly accomplished piece that it could stand at the end or even at the height of a period rather than at its beginning. It is, however, similar to a Pre-Dorset fragment unearthed by Meldgaard and mentioned by Martijn (1964, p. 550). What is more, its form and structure are highly reminiscent of Pre-Dorset or very early Dorset harpoon heads (ill. 150).

The Tyara mask might well provide us with a key to Pre-Dorset art and also to Pre-Dorset attitudes to form giving. Similarities of motifs, styles, and attitudes link various early art forms all the way from the Aleutians to Newfoundland and to eastern Greenland. These similarities may also be attributed to transmitted attitudes or, as I would call them, form codes. An example of such a form code is the use of the "skeleton motif" on, and in, the surface of animal effigies (ill. 151 and 152). Such motifs are more than *design* patterns; they are essential form and content concepts. They represent actual skeletons, indicating the reduction of the animals to an ultimate physical form. Whether the Tyara mask with its Pre-Dorset harpoon-head forms is also an example of such a form code remains, as yet, conjecture.

Among the many thousands of objects that so far have been excavated from Dorset times, there are not more than six hundred that can be called art in the conventional sense. It is quite possible that art objects may have been destroyed or that most of them were made of organic materials which did not survive. A few sites (notably Button Point on Bylot Island) have yielded some wooden objects and fragments. Almost the same paucity of art objects prevails on Thule sites and, likewise, on excavations from the Historic period (where wooden dolls appear with a certain degree of frequency).

In 1586, during his second Arctic voyage, John Davis observed Thule culture tents "made with seale skinnes *set up upon timber* [as well as] *many little images cut in wood*." He also noted that the people "are *idolaters* and *have images great store*, which they weare about them and in their boats, which we suppose they worship...." (A. H. MARKHAM 1880, pp. 293-295 – italics mine)

From the few Dorset art specimens that are known, one is immediately impressed with their great vitality and originality and their extraordinary craftsmanship which steadily declines in Thule culture and is almost absent in the Historic period. This point is particularly curious in view of the trade-art tradition of good craftsmanship that developed during the second half of the nineteenth century and the early part of the twentieth.

In Dorset times, art seems to have been a highly specialized activity. In fact, the pieces are so highly developed and so exquisitely carved that they are difficult to imagine as the work of occasional carvers, or mere whittle activity,[†] but are more likely the work of specialists (artists, or

shaman-artists) who practised a well-known and carefully handed-down tradition of craftsmanship and image making.

Despite the scarcity of Dorset art objects, a great many "artifacts" have been found from this period. In an analysis of Dorset and indeed all Eskimo art, it is necessary to consider just why we call one object art and not another. For instance, does surface decoration make an object art and the absence of it an artifact? Or does decoration present merely a different point of view? As an analogy here, one might compare the richly ornamented objects of the Polynesian Archipelago with the spartanically pure forms of Micronesia, or perhaps rococo with Shaker furniture. Since form manifests itself in many ways, but is always a quality that an artist applies to an object, trans-forming it into art, it is quite possible to speak of qualitative distinctions among similar objects, but it is not always feasible to make the traditional imagistic/functional division of objects into art and artifacts.

The difficulty here is not only one of value judgements. Today I think of art as predominantly the process of form giving and/or image making and as the visual communication of experience and concepts.[†] But contrary to many of my colleagues, I also think of art as an achievement that implies the realization of the process and the idea (action and thought completed) in a product (the image or art object). In any case, I recognize that different products need not necessarily be compared with each other in terms of final value judgements but that the intrinsic quality of any art object lies in the successful application of the process

[†] The notion that the carvings of the "genuine" Eskimos were discarded once they had been completed is apocryphal, romantic, and out-dated.

[†] I wish to declare myself on this subject without having to give a definition of what art is and is not (cf. my discussion of this subject in my previous book, pp. 11-26).

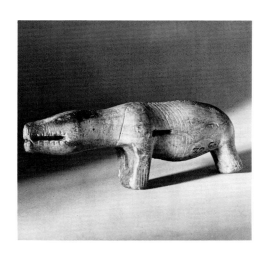

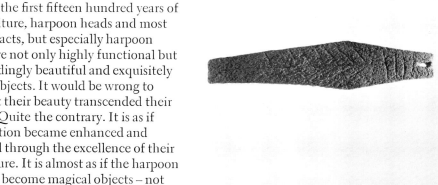

of form giving and/or image making to an idea, and that it can be measured only in terms of its own achievements.

During the first fifteen hundred years of Dorset culture, harpoon heads and most other artifacts, but especially harpoon heads, were not only highly functional but also exceedingly beautiful and exquisitely sculpted objects. It would be wrong to imply that their beauty transcended their function. Quite the contrary. It is as if their function became enhanced and multiplied through the excellence of their manufacture. It is almost as if the harpoon heads had become magical objects – not merely instruments to be used but initiators of their own action. It is as if each hunter through his love and care would obtain increased skill from the fitness built into the instrument of his attention. As if through a reverent attitude toward his work – his carving action – he could transform the object into a carrier of magic and thus achieve an effective measure of control. It is as if the form were magic achieved through art.

The Dorset harpoon head was produced in quantity, and as mentioned earlier, many art objects resembled its shape and structure. This was true not only of bird and bear figurines with their magical connotations (cf. TAYLOR 1967 and SWINTON 1967) but also of face forms, human figures, and objects with inverted double meanings. In addition to the very strongly felt three-dimensional handling of the shapes, the Dorset artists also made deep incisions in their carvings to express skeletal structures and magic marks (x-es on heads and faces, crosses on joints).

When Dorset culture began to be replaced by Thule culture, the changeover was only gradual (taking place over a span of three hundred years), but it may have been not as peaceful as we imagine Eskimo activities to be. Many *Tunit* legends (*Tunit* seems to have been the

154/Face carvings
Dorset Culture
Ivory/stone heights 2³/₈″ and 2″
(l) CMC IX-C: 1106
(r) EMC C45.124

155/Dorset Culture
Igloolik area
Ivory height 1¹/₂″
EMC C45.1-214

156/Dorset Culture
Igloolik area
Ivory length 1⁵/₈″
EMC C45.1-260

157/Abstracted bears (upside down: faces)
Dorset Culture
Button Point
Ivory heights 3″ and 2¹/₂″
CMC PfFm-1:413 & 1:414

158/Dorset Culture
Mansel Island
Ivory length 2³/₈″
CMC JlGu-2:156

159/Dorset Culture
Igloolik area
Ivory length 1⁵/₈″
EMC C45.1-264

116

Thule word for Dorset people) are gruesome and bloody, and judging from the differences in their art, not only their material but also their intellectual cultures must have been vastly different. Although the Dorset people were definitely Eskimoid, they had their own local (Canadian) traits as compared with the Thule people, whose attributes were definitely Bering Strait (i.e., Alaskan and perhaps partly Asian).

When Thule culture took over from Dorset, a few of the Dorset art objects were reworked; that is, they were adapted and changed with Thule tools and Thule concepts. Thus there are two instances where parts of Dorset tubular containers (shaman's tubes?) were converted to combs. We know that the Dorsets had no combs, and we also know that the original designs of these combs are unequivocally Dorset and are, in fact, fragments of (shamanic) tubes. There also are other examples. And it seems that in these few cases spiritual Dorset pieces have been reworked to become secular Thule implements. The aesthetic adaptation of formerly sacred objects may be typical of hedonistic Thule attitudes; there are several points supporting this hypothesis.

The Thule culture that displaced Dorset did so because it brought into Canada more efficient hunting and living technologies, which completely changed the Dorset way of life. Whaling technologies were already mentioned, as was the importation of the dog team and the bow drill. The latter permitted certain aspects of shaping and drilling of holes (which in Dorset times were cut – one of the most typical Dorset identification traits). At the same time, Thule people imported the use of decorative motifs which were incised[†]

[†]Here the term "etched" is often used but this is a misnomer. The designs are either engraved or incised. Etching is done with acid and obviously was not used by the Eskimos.

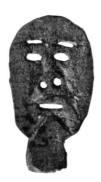
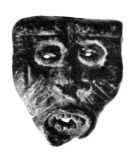

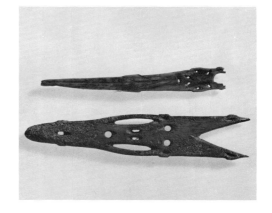

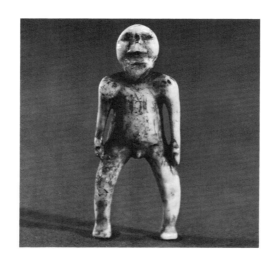

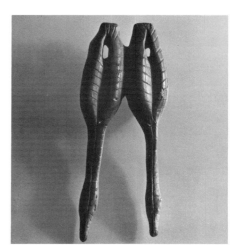

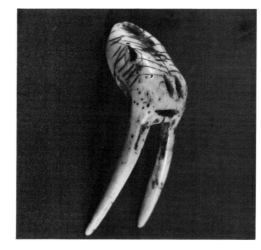

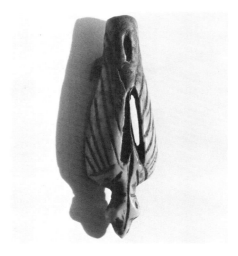

160/Shaman's tube
Dorset Culture
Ivory length 3⁵/₈″
CMC NiHf-4:115

161/Shaman's utensil tube
Dorset Culture
Button Point
Ivory length 4¹/₈″
CMC PfFm-1:405

162/Dorset Shaman's tube/Thule comb
Dorset culture recarved in Thule times
Ivory length 2¹/₂″
CMC IX-C:2827

163/Dragline handle
Dorset effigy recarved in Thule times
Ivory length 2¹/₂″
CMC IX-C:5283

164/Female figurines
Thule Culture
Igloolik area
Ivory lengths 1¹/₂″ to 2″
EMC C45.1-559, C45.1-270, C45.1-361

165/Bird figurines
Thule Culture
Igloolik area
Ivory lengths 1¹/₂″ to 2″
EMC C45.1-453, -330, -333, -560, -331, -329

117

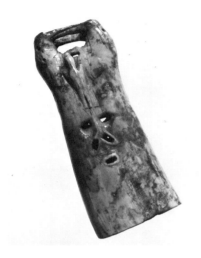

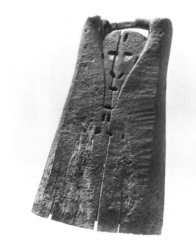

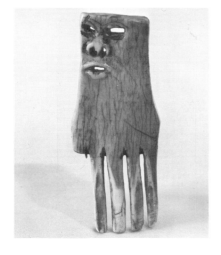

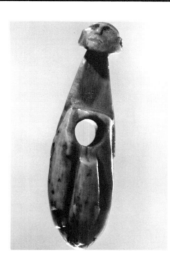

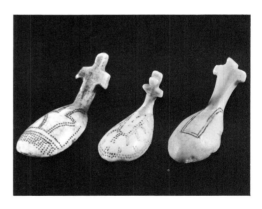

by knife or else applied as a dot pattern by means of the bow drill. (By "decorative" is meant the use of geometric or figurative designs or elements, which might have no other purpose than to enrich the surfaces to which they are applied, but which often have functional or magical origins and motives that have become stylized, forgotten, or have no other relevance than to please.) Such decorative Thule ornamentation is very different from the severe designs of Dorset carvings with their magico-religious implications.

The most frequent Thule art objects are "swimming" figurines – mostly women and birds (ill. 164 and 165) – elegantly shaped and often decorated, but almost always faceless. They may have been used as amulets or decoration, but not likely, as is so often assumed, as gambling pieces (for which, however, they were the prototype). The use of such carvings as gambling pieces probably did not occur until after the demise of Thule culture. Carved or incised faces such as on the comb from the Eskimo Museum at Churchill (ill. 166) are very rare; that particular face might very well be a Dorset carving too, although the material does not show any signs of having been reworked. It could, however, be a transitional piece showing elements of both cultures. In any case the featureless Thule faces, in comparison with the striking faces of Dorset art, suggest essential differences between these two cultures. It goes without saying that any such ideas have to be speculative but they are worth projecting in view of the possible understanding one might gain. To me, Dorset people appear to have been fearful, intense, severe, moody, mystical, and highly credulous and superstitious; Thule people appear less fearful, even easy-going, gregarious, exuberant, even luxurious.

Furthermore, Dorset art is made with

118

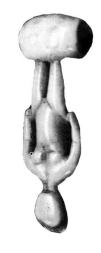

greater care and dedication, more thoroughly "invented" and considered. Thule art is more elegant, more casual, more purely aesthetic, less invented, more routine. Dorset human figures are predominantly male, Thule predominantly female. Thule more playful, smooth, and round; Dorset almost never playful but agonizing, gnarly, and hard. Dorset surface patterns are incised with short but deep strokes, powerfully furrowed and grooved in sharp vertical, diagonal, and perpendicular relationships: decisive, aggressive, and male. Thule patterns are rounded, subtle, peaceful, serene; even the engraved zig-zag lines are gay: most motives and patterns are applied in a dotted manner, giving gentle form-following curves, very opposite to the energetic and harsh Dorset incisions. Dorset magic seems to deal with propitiation of evil spirits, control of supernatural forces, and securing efficiency in hunt and survival. Thule art, when magic (as probably in the archetypal swimming female figurines and birds and spooky, rounded creatures, and as in the upside-down pendants), seems largely concerned with abundance, fertility, and the good life. In a highly polarized way, male Dorset art seems power and death oriented, female Thule art more oriented toward nature and life.

In Dorset art there are, however, also some wonderfully and exquisitely shaped carvings with gentle curves, but they are frequently accompanied by incisions and deformities. In Thule art, too, there are straight lines and incisions, but these are more in the nature of technical matters: they usually refer to engraved representations which require straight lines rather than being symbolic or expressionistic marks. In all, the male/female, power/nature, death/life argument of Dorset/Thule signification is still only tentative. Hopefully, it will be substantiated, or disproved, by future research.

5/The development of art in historic times

The disintegration of Thule whale hunting as a single cohesive culture trait in the sixteenth and seventeenth centuries is paralleled by a conspicuous decline of craftsmanship and quality in art. This decline may have been due to the stresses imposed by a change from the whale-hunting-oriented economy to other ways of harvesting food, and to the extra energy required to battle the inclement climate when more effort had to be expended in satisfying the increased demands for survival. These changes seem to correspond to a decline of spiritual values or, at least, to a decreasing concern for aesthetic considerations in whatever needed to be done. It was as if a general sense of urgent crudeness seemed to have pervaded all aspects of Eskimo life.

The term "urgent crudeness" needs some explanation. "Crude" and "primitive" are often used as convenient handles in popular and professional art criticism to denote an absence of refinement or sophistication, particularly with regard to craftsmanship or to the refined and intellectual "high culture" art forms of Western Europe, India, and China. But, as already remarked earlier, such "linear" value comparisons are no longer tenable. In actuality, most so-called "primitive art" forms (relating to the art of societies that have not yet become acculturated) are usually highly complex, intellectually or symbolically sophisticated, and are often carefully and ingeniously executed (e.g., Northwest Coast Indian or African tribal art). As to "crudeness," while it may refer to a lack of refinement, apparent carelessness, or lack of complex structuring, these attributes need in no way interfere with the content of an art object and may, as a matter of fact, enhance it. In that sense, "crude" may imply qualities of primordial strength and vigour (like Dubuffet's *art brût* and the outbursts of the COBRA group)

or of disarmingly pure directness and lack of gimmickry (like Leadbelly's anguished sounds and Bob Dylan's angry litanies). In our time we have become attuned to the subtleties of crudeness especially when, as in so much Eskimo work, the emphasis is placed on functional rather than aesthetic excellence. And this was exactly what occurred with Eskimo art and artifacts during the Historic period.

Those humble pieces, though crudely executed, were most ingeniously put together out of broken fragments or out of a wide range of seemingly unrelated materials. One is moved by their touchingly human mystique which, in retrospect, becomes an essential feature of *inuit* aesthetics that still survives. It is a warm and sincere feeling, a kind of unashamed homeliness, where things are put together for the sake of adequacy and economy without regard for elegance or superficial beauty. Yet it is this very disregard for outside appearance combined with knowledge of and respect for all the materials used in the process of manufacture – form-giving, image-making, use-providing – that creates a highly aesthetic sensation. It is both a totally functional and a joyfully sensuous, tactile aesthetic experience.

Toward the end of the eighteenth century, there occurred a decline of the former traditional values in art and life, followed, at the beginning of the nineteenth century, by the steadily increasing contacts with the *kablunait* – whalers, traders, explorers, missionaries, and what not. A great many new attitudes towards art and trade came into existence as a result of these contacts and the changed circumstances of life. The gradual establishment of an at least partial barter economy strongly influenced the former subsistence economy and further despiritualized Eskimo existence. Within this barter relationship the *inuit* started to

produce art objects for the sole purpose of trading with the *kablunait*. Hence it is possible to pinpoint the beginnings of the "commercial production of art" as occurring in the first two decades of the nineteenth century and not, as is so often assumed, in the middle of the twentieth century – the post-Second-World-War period or, even more precisely, to the years subsequent to James A. Houston's first Arctic visit in 1948/49.†

In his article in *Anthropos* ("Canadian Eskimo Carving in Historical Perspective," still an essential resource in the study of contemporary Eskimo art), Dr. Charles A. Martijn has pointed out that

"as early as 1812, while stopping at Upper Savage Island in the Hudson Strait . . . [Thomas M'Keevor] watched how the natives. . . .no sooner got alongside than they began to traffic. . . [among] the articles which they offered for sale were . . . toys of various kinds, as models of their canoes . . .' During his stay up north . . . [Captain G. F. Lyon] bartered for carvings at Repulse Bay, Salisbury Island, and also at the Savage Islands where he recorded that . . . 'from the children were produced small toys and models, their parents directing them in their bargains.'"

On September 25, 1824, Lyon made an entry in his journal for *A Brief Narrative of an Unsuccessful Attempt to Reach Repulse Bay*. He wrote:

"Nothing new was seen at this visit, if I except a most ingenious piece of carving from the grinder of a walrus; this was a very spirited little figure of a dog lying down and gnawing a bone; and although not much above an inch in length, the

†These events are also documented and discussed in my book of 1965 (now out of print); also I again wish to refer the reader to Dr. Charles A. Martijn's excellent articles (MARTIJN 1964 and 1967) and one of my own (SWINTON 1958).

120

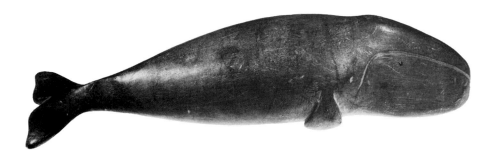

animal's general expression was admirable.
I should, however, mention that we also
procured a few little ivory bears of the
same description, and *far better executed
than any we had purchased before.*"
(italics mine)

W. E. Parry in the same year and Richard
King twelve years later were less impressed
with Eskimo art and skills, but neverthe-
less King did not abstain from acquiring
some "rude carvings of bone."

In an interesting passage of his book
*Narrative of Two Voyages to Hudson's
Bay,* Dr. J. B. Nevins comments on his
visit to the Savage Islands in 1843:

"*They had brought a number of little
figures carved in bone or ivory, and
representing the different kinds of animals
and birds* which are met with in the
Straits; as the walrus, or sea-horse, the
seal, the white bear, and the various birds
which swim upon the water. They had
also *little ivory figures of men and women,*
which were very well executed, and give
an admirable notion of the style of people,
and of their dress. I bought one figure of
a man which had perhaps been a *favourite
doll* with one of them." (NEVINS 1847
– italics mine)

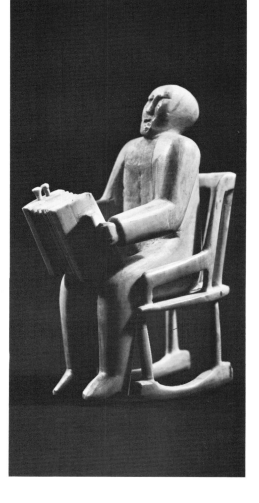

The first report that dealt more fully
with Eskimo art was John Murdoch's
*Ethnological Results of the Point Barrow
Expedition of 1881-83.* He devoted twenty
pages and over forty illustrations to the
specific heading "Art." A large part of his
report describes and illustrates the tools,
weapons, utensils, games, toys, amulets,
hunting scores, masks, clothing, ornamen-
tation, and so on, all of which are essential
parts of a total concept of traditional
Eskimo art.

"The artistic sense appears to be much
more highly developed among the western

173/Unidentified artist
Keewatin District before 1950
Antler, ivory and sinew lengths 9″ and 6″

174/Unidentified artist
Baffin Island c. 1965
Antler and sinew length c. 4¹/₂″

175/Unidentified artist
Labrador before 1914
Bone and sinew length c. 5¹/₂″
CMC (Number inaccessible)

121

Eskimo than among those of the east. Among the latter, decoration appears to be applied almost solely to the clothing, while tools and utensils are usually left plain, and if ornamented are only adorned with carving or incised lines. West of the Mackenzie River, and especially south of Bering Strait, Eskimo decorative art reaches its highest development, as shown by the collections in the National Museum. Not only is everything finished with the most extreme care, but all wooden objects are gaily painted with various pigments, and all articles of bone and ivory are covered with ornamental carvings and incised lines forming conventional patterns. . . .

"We brought home a series of seventy-nine objects which may be considered as purely works of art without reference to decoration. Some of the older objects in this series perhaps also served the purpose of amulets or charms, but *a number of the new ones were made simply as works of fancy for sale to us.* These objects are all carvings of various materials, sometimes very rude and sometimes very neatly finished, but in most cases even when rudely made highly characteristic of the object represented. Walrus ivory, usually from the tusks, but sometimes from the teeth, is the commonest material for these carvings. Thirty-six of the series are made of this material, which is very well suited for the purpose, being worked with tolerable ease, and capable of receiving a high finish. Soapstone, from the ease with which it can be cut, is also rather a favourite material. . . ." (italics mine)

Interestingly enough, some of Murdoch's carvings not only resemble the early carvings of the Contemporary phase but, in their general stylizations, they also show a relation to Thule art, thus establishing a faint, but perhaps still significant link. One must be cautious

with such a diagnosis, since Eskimo cultures of Alaska had a more continuous development than those of the Central and Eastern Arctic. Also, stylistic resemblances often stem from the nature of tools and materials used and not necessarily from common cultural origins. This latter point is particularly relevant here. The greatest "stylistic" resemblances can be found in "crude" carvings; the carvings that are less concerned with style than with the process of effigy making. Here again, we find evidence of conceptual rather than stylistic continuities.

In this connection it might be interesting to compare some nineteenth-century carvings of whales, from various areas in the Arctic, with their contemporary equivalents. Although the visual comparisons speak for themselves, it should be underlined that the widely held belief that *all* Eskimo carvings before 1949 were uniformly small is a myth. The large Aivilik soapstone whale measuring close to seventeen inches, which was collected by Captain George Comer in 1899, is much larger than most contemporary carvings and is by no means unique.

As far as the contemporary developments are concerned, one of the noteworthy common features of the reports by Lyon, King, and Murdoch is the repeated reference to the "commercial" nature of the production and disposal of individual carvings, some of them made in soapstone. Two more recent quotations will lead us directly to the Contemporary phase.

In 1912, S. K. Hutton wrote about the Eskimo of Labrador that

"ivory carving is practically a lost art among the Eskimos. For one thing, walrus tusks are too scarce since the walruses have been scared away northward, and the people need all they can get for making harpoon heads; for another thing time is too precious nowadays and *there is not a good enough market for the quaint little figures* of men and sledges and birds, and all the animals that an Eskimo knows; so it comes about that the modern Eskimo young man does not bother to learn ivory carving." (italics mine)

And Diamond Jenness comments that

"the missionaries advised the artists to substitute soapstone and even wood, but their counsel fell on deaf ears . . . the *curio market had weakened* and the few articles of ivory the natives still sold to the missionaries, and the missionaries sent on to London, brought very low prices . . . the younger Eskimos no longer interested in working ivory . . . the art of carving vanished from the coast with the passing of the 19th century." (italics mine)

The grim picture was probably only accurate for Labrador. In the rest of the Arctic, trade-art activities continued almost everywhere.

In the preceding descriptions of nineteenth- and early-twentieth-century carving activities, economic motivations were stressed for three reasons:

First, in terms of art history there is the need to underline that there actually exist continuities and relationships between the contemporary art form and the past, and what precisely these continuities are: in this particular case, the nature of economic motivations.

Second, there is the need to counteract the widely held belief that the absence of magico-religious motivations is a twentieth-century phenomenon and untypical of all Eskimo art that preceded the period of the Second World War. In fact there is the need to counteract the spurious insistence that magico-religious content (besides whittling) is almost the only acceptable motivation for the production of Eskimo art and that therefore any other motivation (except whittling) completely invalidates the *inuit* content of the contemporary art objects. Or in other words, there exists the need to establish the concept of a historical tradition of secular Eskimo art that is documented and that is continuous for more than one hundred and fifty years.

Third, it is important to underline the qualities that do emerge from secular motives in the production of art as opposed to sacred origins. We shall come back to this point later, after the beginnings of the Contemporary phase have been discussed.

6/The development of art since 1948/49

The Eskimo has been a carver for thousands of years. He has had to be in order to survive. He made his own tools, weapons, and utensils. He carved them from whatever materials were available, mostly from ivory, bone, antlers, and sometimes from driftwood and soapstone.

Ivory, bone, and antler were used much more frequently than soapstone because of their greater strength, durability, and lighter weight. Even today there is a great respect for the strength and hardness of any material used. Generally speaking, the harder the stone, the better the carving. Strangely enough, it was work in soapstone, rather than the more widely used ivory, that caught the attention and imagination of a young Ontario artist, James A. Houston, on that fateful first visit to Port Harrison in the fall of 1948.

During the next ten years Houston gave many accounts of this venture; the most informative are those in *The Beaver* of June, 1951, and in *Canadian Art* of Spring, 1952. These articles give an excellent insight into the circumstances and events surrounding the beginning of the new carving activities, and are therefore quoted quite fully.

In the 1951 *Beaver*, Houston wrote:

"The Eskimo project of the Canadian Handicrafts Guild began with a test purchase in the Port Harrison-Povungnetuk areas in the summer of 1949. I had visited Harrison while on a painting trip the previous summer, and on my return to Montreal, the few small carvings I had been able to collect were shown to members of the Guild. They were impressed by the artistic importance of the articles, immediately became interested in the potentialities of the Eskimo work, and so decided upon the test purchase, requesting that I return to the Arctic and carry out the project.

"Having learned at Port Harrison during my previous visit that the natives in that area were in need of additional means of making a living, I was glad of the opportunity to begin there. Povungnetuk and Cape Smith were also, as it later proved, excellent places for the introduction of the Handicrafts endeavour.

"The Hudson's Bay Company gave fullest co-operation to the plan, providing food and much valuable information. Norm Ross helped immensely with the payment to the Eskimos by evolving the system of chits, which they trade in the store for their necessities. His understanding and enthusiasm were important factors in establishing with the natives the idea that we were prepared to buy a considerable quantity of their handicrafts. Once the Eskimo fully understood that, the place became a veritable hive of activity. Summer is always a time when they have little or nothing to trade, and they gladly devoted much of their time and interest to their new industry.

"From the outset, the project progressed favourably, and the Eskimos in all three of the places visited were enthusiastically creating before the trip had ended. My headquarters, the Anglican Mission at Harrison, was most satisfactory. The Anglican Arctic Diocese had kindly given me their permission to use the building, which was not being used at that time.

"During the trip, about a thousand articles were bought, and were arranged for a November sale at the Peel Street shop of the Canadian Handicrafts Guild in Montreal. The Guild had advertised the sale, scheduled to last a full week. It was over, however, in three days. All the articles had been sold!

"A representative of the Department of Mines and Resources had visited the Harrison area during the summer, and had seen the test purchase as a definite aid to the Eskimo economy. Later, the decision was made in Ottawa that a grant from the Department would be offered the Guild, to extend their Arctic project and to offset travelling and shipping expenses. On receipt of this encouraging help, the Guild's second Arctic operation was planned.

"The plan was to visit Chesterfield Inlet, in the spring of 1950. This trip was postponed, due to reports received that the Harrison-Povungnetuk area had suffered an extremely poor fox year. At the government's request, the east coast of Hudson Bay was revisited in 1950.

"During that period the Eskimos produced handicrafts at the purchase cost of a thousand dollars a month – in the Harrison area alone.

"As well as this increase in production, the quality of the pieces greatly improved. After July, when I returned to Montreal to prepare for the Chesterfield trip, Norm Ross at Harrison and Irvine Gardiner at Povungnetuk continued purchases throughout the summer.... With co-operation of this kind, the venture will continue to succeed.

"Repulse Bay was the next place to be visited for the development of handicrafts, and a satisfactory beginning was made. The culture of the Repulse [Bay] Eskimos differs considerably from that of the east coast natives, though they are as anxious to create. A number of interesting pieces were purchased, one of the differences being the larger percentage of ivory work. Here also the HBC post manager, Alex Spalding, is continuing purchases for the Guild.

"At this date [1951], more than eleven thousand pieces have been purchased. The Eskimos' desire for originality is clearly illustrated in that of all these, no two are really alike."

In a 1952 *Canadian Art* article, Houston made some additional comments about the initial test-purchase:

176/Pilipusi Tukai
(Pillipussie)
Povungnituk 1949
Stone and paint height 3⅝″
WAG G-76-386

177/Unidentified artist
Povungnituk 1949
Stone with inset bone face height 2″

178/Unidentified artist
Povungnituk 1949
Stone length 4½″

124

"The object was to find out whether the Eskimos on the east coast of the Bay could produce carvings in quantity and of a quality that would be saleable.

"Once the Eskimos fully understood that we wanted to trade for all their work, they went at this new industry excitedly....

"The Department of Resources and Development became interested in the project, and asked the Guild to extend its search for such material even further north. They stressed the need for work in areas that were depressed because of a scarcity of game and offered the Guild a small grant to cover my salary and travelling expenses.

"Five trips have been made thus far. Points on the east and west coasts of Hudson Bay have been visited. Hudson's Bay Company post managers are continuing to purchase Eskimo handicrafts at those places where I have spent some time on behalf of the Guild.

"Over twenty thousand pieces have been brought out, and sold by the Guild to the Canadian public. The supply has not begun to meet the demand."

Before Houston's successful venture there were several other experiments to promote "Eskimo work," but none succeeded. In the thirties, the Hudson's Bay Company had attempted to stimulate a market for Eskimo handicrafts but in spite of the efforts of the HBC Development Department this project petered out during the great depression. Yet trading activities in Eskimo handicrafts have gone on since the days when trading posts were first established. In particular, the ivories of Lake Harbour were highly treasured and usually made on special commission rather than for general sale. Every trader and visitor to the North saw, and sometimes collected, ivory carvings, but these were always considered curios and souvenirs rather than art.

Thus, when the Canadian Handicrafts Guild made inquiries about the carvings that Houston had brought out, it was only natural that the Hudson's Bay Company people thought ivory carvings were involved. And so, on January 12, 1949, C. P. Wilson, then editor of *The Beaver*, wrote to C. J. G. Molson, Chairman of the Guild, that

"the carved ivory is not particularly good, nor particularly plentiful. The soapstone you speak of would, presumably, be little models of stone lamps, and so forth."

On further inquiry from Molson, Wilson answered on February 11:

"The soapstone models of implements and animals are inclined to be crude because the material is so breakable. The ivory carving is much inferior to that done farther north."

Wilson's opinion reflected the prevailing thinking of almost all the people then concerned with the North; even today there are many who hold this view. It was one of Houston's many great accomplishments to have recognized and promoted the carvings as art. In a letter of July 19, 1950, to Wilson, Houston's sincere enthusiasm is evident:

"The Eskimo Handicrafts from that area [Port Harrison, Povungnituk, and Cape Smith] are truly remarkable and I was able to purchase over $3,000 worth for the Canadian Handicrafts Guild."

Originating out of the Women's Art Association formed in 1902, the Guild began to show an interest in Eskimo art in 1910, when they started to collect "every now and then, when anything drifted our way." The Guild arranged "specialized exhibitions of the general

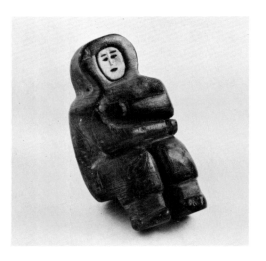

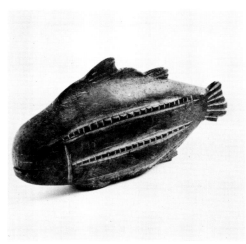

native crafts of Canada" and, on one occasion in 1930, arranged an exhibit of Eskimo objects, including carvings. Most of these were collected by Diamond Jenness and Vilhjalmur Stefànsson, but some came from private collectors in Montreal, notably from Mrs. James Peck. *The New York Times* of December 14, 1930, carried a report of this exhibit which is worth quoting in full, not only because it refers to the first show of Eskimo art, but also because it gives such a good idea of what was then considered to be "Eskimo Art."

ESKIMO ART SHOWN –

MONTREAL SEES CRUDE PENCIL DRAWINGS AND IVORY CARVINGS

"An unusual exhibition of the art and handicrafts of the Eskimos, Canada's primitives of the Northland, attracted a great deal of interest here when it was shown in the McCord National Museum of McGill University. There were specimens of tools, implements and weapons, and in addition a large number of pencil drawings of Eskimo life done by one Enooesweetok of Baffinland. They were crude efforts, but accurate in detail and a graphic illustration of life in the sub-Arctic.

"Articles made of walrus ivory were shown in great abundance and variety. There were snow glasses made of wood with small slits for vision; curious drills which the Eskimo holds in his teeth while he presses the point into the ground or the ice; a leather belt with an ivory buckle; fine combs delicately carved out of ivory; ivory needles and toys; carved miniatures of bears, walrus and seals; ivory rattles and draughts.

"In another department were several model boats made by the Eskimo of sealskin. There were fine specimens of the Eskimo spear, which has a detachable tip of steel. Bows and arrows were skillfully made. An Eskimo whip thirty-one feet

long was the sort used by the driver of a large dog-team. There were specimens of deerskin underwear worn with the fur inside, and the skins of two huge white polar bears."

No new developments occurred until 1940 when Major David McKeand, of the Northwest Territories Administration of the Department of Resources and Development (now the Department of Indian Affairs and Northern Development), asked the Guild to find an outlet for Eskimo handicrafts. He hoped that the money received from the sale of the handicrafts would counteract the losses in trapping and hunting which then, as later in 1948, posed a severe threat to the northern people.

Miss Alice M. S. Lighthall, chairman of the Guild's Indian Committee (now the Indian-Eskimo Committee), remembers how Major McKeand "pulled out of his valise bits of things of basketry [including] a teapot with spout, an oil lamp and an igloo." Miss Lighthall suggested that the Eskimo women should make actual baskets instead of replicas.†

Diamond Jenness was then consulted, and a meeting was called to consider what could be done to help the Eskimo and how their crafts could be developed. Jenness reported that there were "mostly ivory carvings and one or two insignificant little stone carvings." A complete record was prepared and recommendations issued in leaflet form, to be taken by Major McKeand for distribution to "the white ladies then resident in the Arctic" wherever the HBC supply ship *Nascopie* stopped on her annual tour of northern trading posts. But the next year, 1941, the report from the North indicated a good fur year. The Eskimos were, therefore, not interested in handicrafts. The following year

†See pp. 129-130 for a discussion of the concept behind the making of replicas.

the leaflets were sent out again, and the response was the same. Afterwards, with "time passing by quickly," and the war coming to an end, nothing further was undertaken.

In 1947, Major J. D. Cleghorn informed the Canadian Handicrafts Guild of the existence of Eskimo carvings that he had seen while on the Canadian Army Exercise Muskox; he suggested that the Eskimos should be encouraged in this activity. At that time, Colonel P. D. Baird, commander of Exercise Muskox, became a member of the now re-named Indian-Eskimo Committee as a delegate from the Arctic Institute. He "provided a list of white women" who might be interested in supporting a homecrafts program, and the 1941 leaflet was reissued to them. The main idea was that these ladies would "gather around them neighbouring Eskimo men and women and encourage basket weaving, parka sewing, carving, etc.; the ladies would also provide a list of what the Eskimos might produce and the Guild would see how to market these articles."

Thus, in the fall of 1948, when Houston returned from Port Harrison with his carvings and "was sent to the Guild, recommended by neighbours of his at Grand Mère," the stage was well set for the beginning of the new phase of Eskimo art in general, and of soapstone carving in particular.

A meeting was set up at the Ethnological Museum in the Medical Building at McGill University to confer with Houston. He showed the beautiful, small carvings he had collected and related his experiences. When Houston asked for backing and for the Guild to sponsor him, the Guild was ready to consent. C. J. G. Molson thought it all "too good to be true" and made arrangements with the Hudson's Bay Company to take care of Houston's expenses and to open an account on behalf of the Handicrafts

126

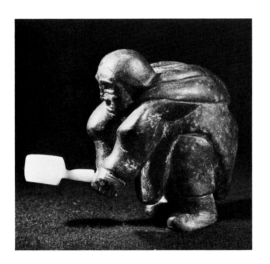

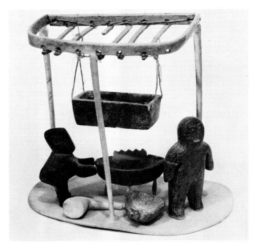

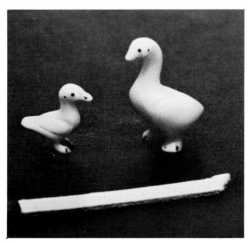

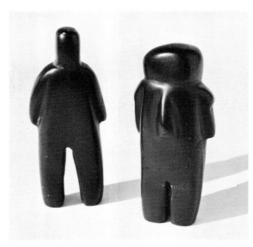

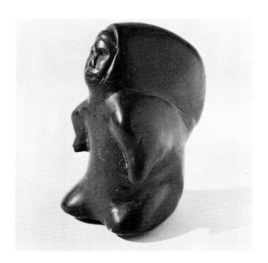

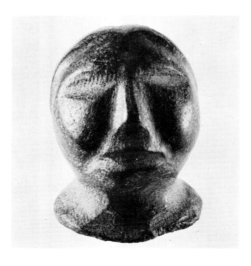

Guild to the extent of fifteen hundred dollars in 1949 and twice that amount in 1950.

Miss Lighthall subsequently went to Ottawa to enlist the support of the government. During the next four years, government grants covered Houston's living and travelling expenses for the promotion and collection of Eskimo art. The Hudson's Bay Company entered into an agreement with the Guild, dividing equally the expenses, the carvings, and the outlets. For suddenly, after many attempts and failures, Eskimo carving had become not only an artistic but also a financial success.

Before closing this section on the early days of the Contemporary phase of Eskimo art it is important that some credit be given to the late Dr. Jacques Rousseau of the Centre d'Etudes nordiques at Laval University. During 1947 and 1948 he did field work in Ungava and started to collect "Eskimo art" not as souvenirs but as an art form. In the summer of 1948 he met James Houston in Povungnituk and showed him carvings which Qupirqualuk had casually carved – "avec une lime et un couteau, il s'amuse à sculpter des pièces de stéatite, d'une allure extraordinaire." Some of these pieces were shown at that famous first sale at the Guild in Montreal; and later through Houston's writings, Qupirqualuk became one of the very first individual artists to be known.

I wish to add carvings 323 and 324 were the carvings shown by Dr. Rousseau to Houston. Qupirqualuk actually had signed these carvings "Koper" and had given them to Dr. Rousseau in gratitude – and in typically Inuit expression of polite embarrassment – for two sacks of provisions which Dr. Rousseau had presented to him as a parting gift. They are indeed the first documented carvings of the Contemporary Period.

7/Differences in culture and motivation

It is perhaps impossible to have an objective view of one's own time and its events. Even when one hopes to view the past objectively one suffers from elusive aspirations. Still, we feel more secure with the past since we feel we are at least able to distinguish between what has been significant and what has not. Thus the study of art and culture seems to be most successful when carried out in terms of the processes of changing cultures and concepts — more in terms of comparisons and explorations of meanings and processes than value judgements. For obviously the study of culture and the criticism of art are meant to reveal the qualities of art and life and not to judge them.

But many social scientists and art critics – as well as large segments of the population who feel that they are – often judge, or feel it their responsibility to make pronouncements on art and culture. These judgements are based on concepts that they hold with sincerity but that do not correspond to what, for lack of a better phrase, I call the facts of life. When it comes to the contemporary Eskimo the facts of life include acculturation.

For many social scientists, art critics, journalists, purists, and all the many gullible and not so gullible followers of Edmund Carpenter, Farley Mowat, and similar bearers of the-glories-of-the-past Eskimo flags, any aspect of acculturation is a dirty word. For Carpenter, today's Eskimos are simply no longer Eskimos, and past Eskimos (or "true" Eskimos) and whatever they did or produced exemplified the highest values of life, art, and wisdom. Carpenter is truly inspiring, writes beautifully, thinks even more beautifully; but his conclusions and his arguments are romantic and rarely valid. I wish they were. They are so beautiful. With Farley Mowat, who sounds even more knowledgeable and convincing, "truth" is always divorced from fact. Or, as he himself says: "I won't let facts interfere with truth."

While both these men succeeded in arousing world-wide interest in and sympathy for the Eskimo, they have given a completely distorted picture to a cause which I too espouse but which is dedicated to the problems of the living and not to the idealized glories of the past. To Carpenter, Mowat, and many others, the horrors of the present are worse than the dangers and fears of the past. But they are merely romanticizing the past and are not facing the facts of the present which, though often ugly, are no more so than those of the past.

The objectives of their attacks is the Western influence on formerly "unspoiled cultures" by means of acculturative processes. The major meaning of acculturation is the adoption by an individual, or a group, of the culture or cultural elements of a differing group; it is a process of social change induced by the interaction of the significantly diverse cultural elements. The intrinsically dangerous component of all acculturation experiences is that a dominant culture will impose its values rather than exchange them. This is, of course, what happened when the dominant white Western culture came in contact with the Indians. Now the *kablunait* have started to encroach on the *inuit* in an equally decisive manner with irreparable consequences. But sentimentally romanticizing the past will not remedy this now irreversible situation.

Incidentally, the rapid acculturation processes in today's North do not only include the obvious aspects of urbanization, such as the previously mentioned abandonment of camp-life in favour of centralized prefabricated settlements with built-in slum conditions, and the shift from subsistence economy to the money economy of labourers and wage-earners; from dog teams to ski-doos; from hunters to carvers, office workers, and dump-truck operators. The acculturation processes also generate new institutions such as government administration (with ever-changing civil servants), schools (with ever-changing teachers), cooperatives and occasionally some small enterprises (sometimes with problems and sometimes with happy endings). Yet, intrinsically and insidiously, northern acculturation implies the gradual replacement of the Eskimo language and the juggernaut-like incursion of the vulgar *kablunait* values as expressed in the mass media and in the visual environments imported to the North by white institutions, residents, and transients.

Perhaps most insidious of all is the seediness of our total cultural values which, together with our overwhelming technological persuasiveness, disrupt most phases of Eskimo existence, particularly the relationships between the old and the young. Given this situation, it seems to be a miracle that so much of the contemporary art production is of such high quality. Or could it perhaps be that the opposite pertains? That the good comes because of the adversities – as an exceedingly strong assertion of inherent strength: "Sweet are the uses of adversity."

The ability to achieve good results despite – or because of – adversity seems to be one of the real traditions of Eskimo art and manifests itself with or without commercialism. In Dorset and Thule times, the art efforts seem to have been directed towards achieving more favourable conditions with adverse forces in the universe or, perhaps, towards ensuring that such forces would not operate. In the Historic and Contemporary periods different adversities have had to be overcome.

After the gradual disappearance of Thule culture, carving became a predominantly casual activity, producing functional, decorative objects as well as

128

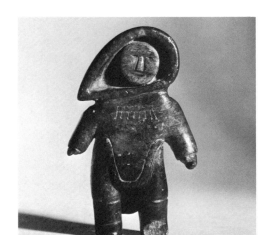

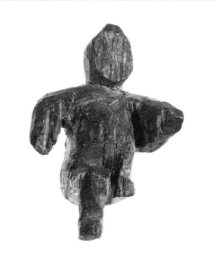

toys and "whittles," made for self-entertainment. In fact, many of the amulet carvings (particularly the type we know from Dorset times – animals and birds, or characteristic details of them, like caribou hoofs, bear heads, sea-mammal skulls or parts, or bird beaks) were replaced by the actual animals parts, natural or real objects, rather than carved effigies. And instead of magical objects needed for one's spiritual survival, more objects for secular gratifications came into use.

Professor R. G. Williamson has pointed out that the secularization of all aspects of life came about because hunting, on which all Eskimo life depended, had lost a great deal of its sacred content (WILLIAMSON 1968). Hunting was in itself a spiritual activity, an inseparable part of the *inuit*'s spiritual existence in which every Eskimo participated in personal and communal ways. But more than that, because of the hunter's mystical and sacred relationships with the animal world, animals and their soul-spirits and spirit-bodies were integral components of Eskimo life, kin-like and directly affiliated with one's existence. These relationships are evident in almost every aspect of Eskimo mythology and legends. With the coming of the whalers and traders eager to exploit the rich fur-resources of the North (especially the Arctic fox, which of all the tundra's animals had the lowest spiritual esteem in the minds of the *inuit* hunters), hunting and trapping of fur-bearing animals for barter purposes was initiated. This commercialization of the hunt broke the sacred bonds between animal and man, and led to the secularization not only of the hunt but of Eskimo life itself.

At that very time and for the very same reason (i.e., trade which, compared to hunting, is a vicarious way of providing for one's livelihood), the *inuit* discovered the potential of making likenesses (*sananguaq*) as means for barter. The contact with the whites engendered the secularization of art as well as the hunt. Thus, as noted before, the origins of the economic motivations of art are to be found in the nineteenth and not in the twentieth century.

There are other aspects of cultural (rather than stylistic) similarities between the arts of the past two centuries, especially when compared with prehistoric art forms. The points of similarity in craftsmanship and motifs are probably the most significant.

The appeal and meaning of the "crude" carvings and artifacts made after the disintegration of the Thule culture were described in Chapter 5. It would be wrong to assume, however, that the style of the nineteenth-century carvings made for barter was equally unsophisticated. It may have been at the beginning, but soon the carvers found out that more highly finished products were more eagerly collected by the *kablunait*. And so, quite logically, the skill applied to the barter carvings – or trade art as it was later called – grew steadily and developed its own, albeit imported, aesthetics. Still, it was utterly Eskimo in manufacture and accurately reflected the state of Eskimo existence – the beginning of acculturation, and the secularization of the hunting economy and of *inuit* life.

In the same manner, today's art reflects the changed conditions of Eskimo life but, instead of the mere negative aspects of acculturation, there has emerged a defiant spirit of self-affirmation which is no longer merely immanent as in the fifties and early sixties but has now come into the open not only in art but also in social action (co-operatives, settlement councils, territorial government, national associations, etc.). Before discussing this development and the new art forms, one final theoretical digression has to be made: the nature of Eskimo aesthetics.

Ever since the emergence of the contemporary Eskimo art forms in 1948/49, two major criticisms have been levelled against them: first, that they are based on Western (Euro-Canadian) and not Eskimo values; and second, that the criteria for evaluating this art are definitely *kablunait* and not *inuit*.

The reason for the first criticism was that most art which appeared on the southern markets seemed to bear no resemblance to Eskimo life other than anecdotal content of Eskimo activities or quaint illustrations of Arctic fauna. Such carvings were, of course, part of the preceding nineteenth-century trade-art tradition, but many critics of the contemporary art looked for art objects that were part of and had ritualistic meaning in the daily lives of the "true" Eskimos. Art "produced for the white man" only – regardless of asethetic values – was therefore considered foreign, un-Eskimoan, and white-polluted.

Although several people could have contributed to this subject in some objective fashion very little has been published.[†] It was therefore felt that what

was needed were statements and autobiographical material from *inuit* artists who could give much needed insights and first-hand information about the basis of their art and their evaluation of it.[‡]

However, artists are notorious for not being able to judge their own work (although there are some exceptions), and they are far less able to be objective about other artists' work. They do give an insight into art but not necessarily into their own. Some artists are very erudite and expressive about their work, others are not. Obviously, no universally valid statements about artists evaluating their art can be made, just as I feel no universally valid statements about art can be made that would give insights into the work of individual artists.

Eskimo artists and perhaps artists of other non-Western cultures differ from Western artists with regard to verbalizations about themselves. It just is not part of the *inuit* ethic to put forth unequivocal views (though in recent years I have heard several Eskimo leaders speak out clearly for others when they are speaking either as representatives of others or when they speak on matters of their own community or calling). And very often, out of sheer politeness, when Eskimo people talk to you they will not reveal their thoughts and

opinions unless they know you very well.

The question becomes further complicated when one realizes that there is no Eskimo word for art and that accordingly the criteria for judgement are based less on aesthetics than on a kind of functional effectiveness that relates to both message and medium or, if you prefer, to content and technique. In any case, the Eskimo concept of art is process-and-meaning oriented rather than directed towards the product or to a concept of beauty.

Since this book deals with Eskimo sculpture, I shall restrict myself to sculpture, although printmaking and drawing have become very major and highly creative – albeit acculturated – art activities of international significance.

Today the word that is used for carving is *sananguaq* or *sananguagaq*[†] which has a significant etymological derivation: *sana* refers to "making" and *-nguaq* to the idea of "model, imitation or likeness." In Alaska, by the way, *-nguaq* refers to "play pretending," and in Greenland it signifies "little" in the sense of diminutive. Indeed, there are several related words which use the suffix *-nguaq* to express the diminutive-likeness-imitation-model-play connotation. They are *inunguaq* – doll, " a little man-likeness"; *pinguaq* – toy, "a little pretending-toying"; and *atjinguaq*, which means " a likeness like a replica" and is hence used as an Eskimo word for picture or even photograph. The carving-*sananguaq* idea refers then to a likeness that is made or carved.

When the great Cape Dorset artist Kenojuak was once asked what the word for art is, she answered: "There is no word for art," *sananguatavut* – "we say it is from the real to the unreal," which unfortunately is not too happy a translation, although it sounds fascinating. For *sananguatavut* deals not so much with the

[†]Houston has not yet recorded or documented his experiences and observations in a way that they need and deserve – an omission he hopefully will rectify. Dorothy Jean Ray has a few well-documented observations on the aesthetics of Alaskan Eskimos (RAY 1961 and 1967-a), as has Meldgaard on the Greenlanders (MELDGAARD 1960-a and 1967-b). Martijn has faithfully and accurately analyzed whatever has been said, and has indicated some of the work that needs to be done (MARTIJN 1964 and 1967). Carpenter has taken a definitely biased viewpoint against the contemporary art and has often over-romaticized the "pre-Houston" art phase (CARPENTER 1955-a, 1958, 1959, and 1964-b). Graburn, I expect, will soon come out with some important contribution; after some initial misunderstandings (GRABURN 1966 and 1967-a), he has carried out extensive field work in the North (GRABURN 1967-b, 1969-b, and 1969-d), and he, more than anybody else, has tried to come to grips with Eskimo aesthetics. Since he has not published in final form I, unfortunately, have to refrain from mak-

ing use of his material and have to rely on my own research and observations which are not as scientific as his but which are based on my being an artist rather than a social scientist.

Williamson has a vast knowledge of the Eskimo and his way of life; he is a great collector and a poet, and his insight into Eskimo aesthetics is outstanding (WILLIAMSON 1965); unfortunately he publishes too little. Others – particularly Jack and Sheila Butler, Gabriel Gély, and Terry Ryan – who live and work with Eskimo artists and have artistic insights could also contribute to this field.

[‡]Dorothy Eber has edited tape recordings of Pitseolak, a great Cape Dorset artist (PITSEOLAK 1971), and I have notes and tape recordings from as far back as 1957. I have quoted from both these sources.

[†]Pronounced *sha-na-ngu-ak* and *sha-na-ngu-a'-gak*. (See SWINTON 1971-a.)

188/Charlie Sivuarapik
(Arnaituk/Argnaituq/Sheeguapik)
Povungnituk 1958
Stone and ivory heights 6⁵/₈" and 9¹/₂"
WAG 2006/7-71
(also 322)

189/Philip Qamanirq
(Kominerk/Kaminerk)
Arctic Bay 1964
Stone height 4¹/₂"
WAG G-76-6

130

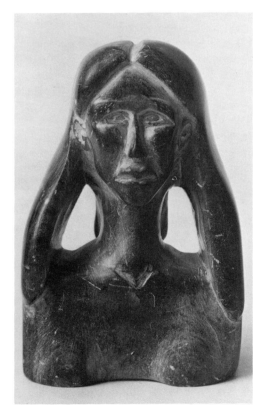

idea of the real and the unreal as with the idea of having succeeded in making a likeness; "we have taken, i.e., made or carved it, a likeness" – "a little likeness we have achieved by carving it." The imitation is not unreal but actually a little replica – "a little likeness-reality that we have achieved."

This point needs much emphasis because it leads to an understanding of the basis of contemporary Eskimo art, which is essentially the achievement of "making" likenesses – real or imagined – that have their own small-size reality rather than beauty. An idea not unlike our own contemporary concepts of art! A work of art is then an object that is well made rather than beautiful. This is the essential criterion for judgement: how well it is made rather than how pleasant it is; or in other words, the success of the artist in having worked the stone well, in having reacted sensitively and intelligently to the material from which the carving is made, and in capturing the imitation, the likeness it was intended to be. The contemporary Eskimo aesthetic is clearly contained in the word *sananguaq;* the emphasis is on making and the achieving of a likeness that becomes its own reality.

Furthermore, since the Eskimo language has no exact equivalent to an aesthetic concept of beauty,† *sananguaq* now carries with it some aesthetic connotations, which imply the successful achievement of that which is made.

An additional point of great importance to the *sananguaq*-art concept lies in the problem of subject matter itself, since that is what the Eskimos would consider to be the focal point of all their art activities. While in contemporary Western aesthetics, the major emphasis is placed on form,

in *inuit* aesthetics the *conscious* emphasis is always on subject matter.

In Western aesthetics, the quality of a work of art – from crucifixion to abstraction, from miniature to mural, from sculpture to stitchery – is determined by its aesthetic excellence. Judgement of quality is essential to Western aesthetics, and since time immemorial the emphasis on aesthetic excellence of form has influenced all judgements. In fact, this emphasis has been accepted even in courts of law, where aesthetic excellence is admitted as almost "sanctifying" any subject matter – if it's art it can't be censored – and, correspondingly, in the courts of art – if anything is made by an artist, it automatically is art. I shall not comment further on the implications of this argument within the state of health of contemporary art but merely wish to point to the syndrome.

Eskimos, on the other hand, have not yet determined what the criteria of excellence are, but rely largely on the *sananguaq*-art notion: art as reality, art as truth, art as effective communication. Graburn has pointed out that in Ungava, that is, in Arctic Quebec, this concept – which he calls realism – arises from the phrase *sulijuk,* which actually means true or honest, as perhaps opposed to *takusurngnaituk* (or *takusurnaituk*), meaning imaginative "replicas" that have never been seen. However, this distinction is made only in terms of the subject matter's actual visibility: whether it has been or can be seen, or whether it is from the realm of fantasy and therefore cannot be seen. But even here, the point of Eskimo aesthetics that "truth is beauty" precedes all other considerations in the process of art making. For to be beautiful means to succeed in being real, and art is that which succeeds most. So also with fantasy art: that which makes the unseen, or the fantasy, most real and turns the fantasy,

†*Pitsiark! maitsiak! ânana!* are expressions or exclamations of visual pleasure; *takuminaktuk* (or *takuminartoq*) means good to see or beautiful to see.

190/Levi Alasua Pirti Smith
(Levi Smith)
Povungnituk 1968
Stone height 9″
(also 386)

191/Isah Qumalu Sivuarapi
(Isa Sivuarapik/Isah Sheeg)
Povungnituk 1968
Stone height 2³/₄″
WAG G-76-393
(also 383)

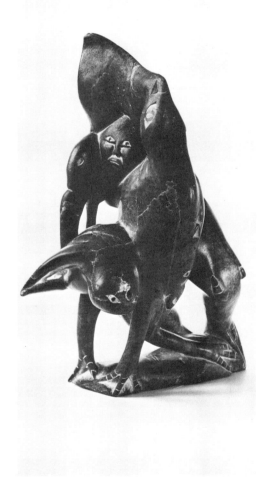

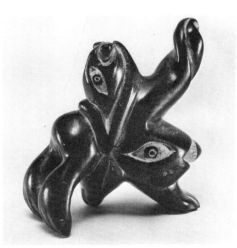

or the unseen, into actual existence, into visual reality, is the most significant and is in fact art.

As to the question what is real or what is most real, the Eskimo retains his pragmatic (or existential) ambiguity. The real cannot be known beforehand; reality is what is honest and convincing. It is what a man sees and experiences. Truth and reality are subjective; they are experiences not universal laws. The truly amazing aspect of Eskimo reality is the genuine respect that many people seem to have for other points of view. And as a result of this ethic the realness of art, the *sulijuk*, accounts for the many varieties of individual expression. In that sense, the absence of limiting art criteria has been a real blessing to the contemporary *inuit* artists, a nightmare to art-studying anthropologists and an odious bone of contention to traditionalists.

One more point in this regard. It is often said that white men and white values have changed and corrupted Eskimo art. Changed – I agree, but corrupted – definitely not. Changed, because white influences stimulated the production of art at a time when it was necessary, at a time when art was almost dead. And it is here where lies the greatest achievement of the much maligned James Houston. It was his insight, his enthusiasm, and his promotional talent that sparked the entire development.† There were others too; many in fact. But Houston was the prime mover. Pitseolak says of him that he was "the first man to help Eskimos." He made it all possible; "ever since he came [in 1951], the Eskimo people have been able to find work, here in Cape Dorset they call him 'The Man.'" (PITSEOLAK 1971)

As to the corruption aspect, much detrimental evidence can be cited. The culturally destructive *kablunait* traits have

†But his promotional enthusiasm unfortunately also endangered his credibility.

already been mentioned, particularly the inane visual and intellectual environments that so unfortunately had taken firm root in the North. There also were economic influences on aesthetics and, of course, the plethora of "good advice," commercial directives, and aesthetic pronouncements. For a multitude of reasons relating to Eskimo ethics and aesthetics, and to their straight common sense, there was actually very little corruption. Obviously, it is the corruptible who are always corrupted, whereas those who are resistant to it are so by nature and can be corrupted only with difficulty.

Even a booklet, prepared by Houston in 1951 to instruct the Eskimos in arts and crafts and in the anticipated demands of the market, had more good than bad influences, if any influences at all. The beneficial effects were that more carving was done with greater care, that people were reminded of their responsibility to carve as only they and not the white man could, and that in fact the white man wanted to buy their carvings because they were something that the Eskimo could do well. However, the booklet also led the Eskimos to believe that the *kablunait* wanted specifically those carvings which were illustrated and no others. And here, by ill fortune, Houston's instructions, which were meant to permit as much leeway as possible, had the opposite effect. But generally speaking, the booklet was largely ignored by the "good" carvers and only affected the marginal carvers who anyway could do no better than to produce for the souvenir market. And that was precisely the pamphlet's purpose, for it was issued in order to provide some sort of economic base, other than welfare, in those areas that were economically depressed. The book never reached far beyond Ungava. I could find traces of it only in Port Harrison, Povungnituk, and Ottawa – and it was withdrawn from circulation

192/Allie Appaqaq
(Apawakak)
Sanikiluaq (Belcher Islands) 1967
Stone lengths 3″ to 5″

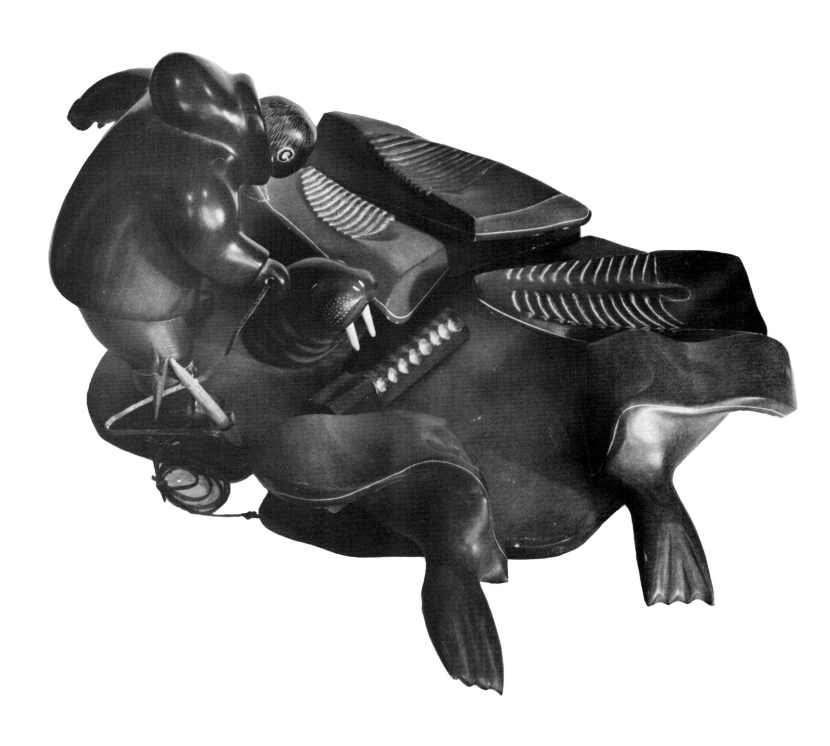

193/Simon Natak
(Naattaq)
Hall Beach 1970
Stone height 11¹/₈″
CMC IV-C-4132

195/Paniluk Qamanirq
(Paneloo)
Arctic Bay 1970
Stone height 5″

194/Henry Napartuk
Kuujjuaraapik (Great Whale River) 1968
Stone length 2³/₄″

and even office use before the middle fifties. One should add perhaps that nobody gets upset about how-to books, TV programs, or "art" demonstrations in the South, but when it comes to "natives" everything not simon-pure is always shameful. It is this patronizing attitude that is so objectionable to me. Eskimos can and will take care of themselves but we must let them do it; they have to make their own choices, including mistakes.

Finally, the true differences between *inuit* and Western aesthetics can only be found in evaluations and attitudes and not in styles. Eskimo aesthetics appear to be non-linear, process-and-content oriented; Western aesthetics predominantly linear, product-and-form oriented. As a practical application of this hypothesis I shall contrast three carvings from these two different points of view, but first I have to pose several caveats. All interpretations of works of art are subjective and conditioned by personal experiences and tastes; all research, regardless how thorough, merely increases or influences one's data and never leads to an objective understanding of art; both artists and public may read more, or less, into a work than there actually is; art has to be apprehended through the senses and not through the intellect; intelligent "understanding" of a work of art does not lead to liking it, and, vice versa, one does not need to like a work in order to understand it; it is ridiculous to assume that any work of art can be liked or understood by all; trying to understand a work of art means trying to find out what the artist wanted to say and what he did say, at best this can become a good guess (educated and/or intuitive), and it is here where factual data seem most helpful; most works of art always remain a mystery and their creation miracles; not all works of art need to be conspicuous, not all works of art need to be great. Having said all this, the task of making my comparisons

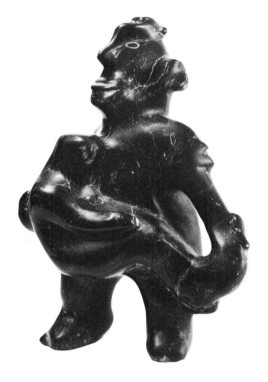

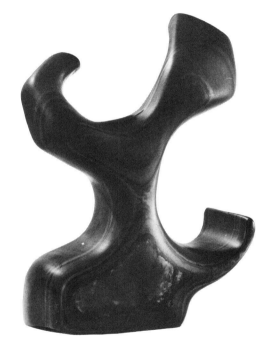

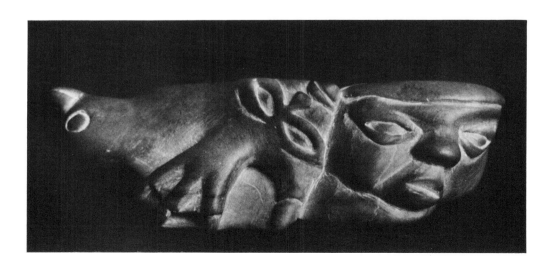

134

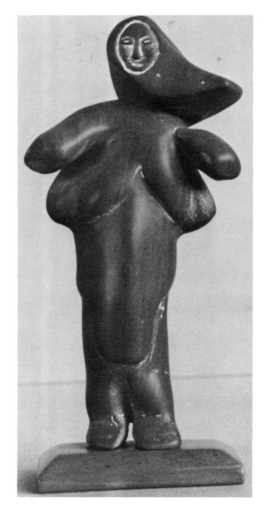

becomes somewhat formidable; still, it might lead to some insights which in turn might lead to some understanding or enjoyment, or to both.

To make the comparisons, or the contrasts, more meaningful I have chosen three carvings from roughly the same region (Great Whale River and the Belcher Islands) and produced from the same fairly hard greyish-green stone that some geologists call Belcher Island argillite. In evaluating the carvings it is important to consider their sizes, which are an essential aspect of their total form.

In Eskimo terms, the tiny pendant by Henry Napartuk (ill. 194) is "a very real carving explaining the 'mysterious co-existence' – the being together that cannot be explained – of many real-life and imagined-life forms in the stone; very well carved, amazing detail – only Henry Napartuk would see such a thing and make it." In Western terms, "this amazing little Netsuke-like carving is also reminiscent of West Coast scrimshaw work; stylistically it certainly is not typical of any other Eskimo work, except in the scrambled mythological imagery of mixed human-animal relationships carefully fitted into the tiny stone. In its size and multi-figured form it contains echoes from Dorset times, but its form is thoroughly modern and not related to any personal or ritualistic use. (Those few who know Henry Napartuk would also say that it is typical of his style in the late sixties.)" My opinion: "I love this beautiful carving although I don't know what it means."

As to the "Man Butchering a Walrus" (ill. 192), an Eskimo might say "Now, there is a real carving for you. Everything is here: the man; the harpoon with the line; all the meat parts, each is carved separately and just right for the stone that takes such a high polish; it is good when a carver can do it so well, and all parts are fitted together right, only Allie Apawakak

can do this, a carving such as this will please the *kablunait*."

A white art critic: "A typical slick Belcher Island carving; too many fiddley parts although each part is beautifully carved; great abstract shapes; but why the cute hunter and the corny walrus? The carver should have left them out. It is too bad that he spoiled it, but it will make a great gift for a retiring executive."

A white non-art-collector: "Oh honey, that's beautiful! So real and so smooth! And all the parts too! I wonder whether they will break? Let's buy it. It will make a great conversation piece!"

My opinion: "Great conversation piece, a bit gimmicky perhaps, but that doesn't matter. It is beautifully carved, and I love the tactile experience of those meat chunks. What great shapes they are!"

The final carving (ill. 196) is a bit difficult to interpret. I might say: "I love this carving, simply gorgeous in its bulging shapes, like a Picasso flower, or a fertility symbol, or some female idol. I shall liberate it from its base." An Eskimo might say: "This must have been a very hard rock or she would have carved that woman smoother. Maybe she felt these forms like that because she did not see them. Caroline Kittosuk is blind." General white reactions would differ, especially once it was known that the carver is blind. The blindness of the artist would, however, be a definite additional attraction; for souvenir collectors (and also for some doctors) perhaps the only one.

9/ The new art form

Contemporary Eskimo art has indeed become a new art form. It is the art of the new Eskimo. That Eskimo is still in the process of change. So is his art. And yet we are able to think of and categorize them only in terms of the past. We have typecast them in a role and into a frame of reference in which they no longer exist and in which they certainly do not wish to exist.

Still, although they have changed, the Eskimo and his art are intrinsically and uniquely Eskimoan. The same could be said of the contemporary Greeks, Japanese, or Africans, or any group whose ethnic attributes, although changed, are still uniquely theirs. However, within the context of the rapidly expanding art scene, the Eskimos have manifestly retained a specific and highly ethnic art form of their own, much more so than any other acculturated or national group. While nationalism in art can hardly ever become respectable or commendable, art that is deeply rooted in the culture or geography of a particular location derives strength and nourishment from the very qualifications that its specific location imposes on it. In this way, attachments to one's physical and psychological environments are affirmed – despite the emergence of the global village and its insistence on the universality of form.

The essential aspect of newness of the contemporary Eskimo art form is the paradoxical coexistence of acculturated and indigenous traits. This paradoxical nature pervades every aspect of the new "production" and, while I personally am suspicious about the credibility of analyzing highly specific art expressions and classifying them into broad categories, I will attempt to show some of the individual characteristics of the new Eskimo art and the paradoxes they imply or create.

Materials & Techniques

To the purists all new materials used by "formerly pre-literate" cultures are evil aspects of their cultural degradation. To the Eskimo, new materials have inevitably been a source of stimulation and enrichment. One of the most exciting facets of all Eskimoan cultures is their fertile ingenuity in exploring and exploiting materials and in extending their uses beyond the obvious characteristics of the materials whenever the needs for such extensions arise. So it always has been and so it still is.

The traditional materials for art objects were many: ivory and bone, antler and wood, stone and leather. Stone was perhaps the least used because of its weight and fragility. However little it was used for art, stone played a major role in utility carving. The entire earlier economy depended on the use of stone cooking pots (*okkosik* or *ukusirk*) and stone lamps (the *kudlirk* or *qullik*). In fact, in many areas the Eskimo name for the "soapstone" used in carving is *qullisajak* or *qullisak*, named after the oil lamp; in many areas the somewhat harder stone is called *ukusiksak*, named after the material used in making cooking vessels (cf. GRABURN 1969). Since every family produced its own utensils, tools, and weapons, most *inuit* probably carved, though I have not been able to find out to what extent women were involved in the carving activities. I suspect that weapons might have been made chiefly by men, and that other functional objects were produced by both. In any case, it is impossible to formulate any definitive statements or even to avoid misleading generalisations.

In Povungnituk, for example, in 1957, all but two of the artists were male. In the neighbouring Port Harrison camps at that same time, the percentage of women artists was a bit larger, whereas in Sugluk only few of the carvers were men, and most of the good carvers were women. In Port Harrison one wife always carved for her husband and it would therefore not surprise me at all if most of his best carvings were made by her.

Also, since weapons used to be made largely of ivory, bone, or antler (but mostly of ivory), the carvings made of such harder materials have frequently been ascribed to male artists, yet in Repulse Bay and Pelly Bay where most of the ivory carvers were male some of the best ivory carvers were female. The same point applies to size; large carvings are often associated with men, and in many areas are made by men. But in Eskimo Point, Baker Lake, and Cape Dorset, some of the best large carvings are made by women. However, size is another matter; more about it later.

The subject of materials is an important criterion, inasmuch as stone carving, while existing before, was not a "traditional" art technique. Yet it was primarily carving in stone, and stone inlaid with ivory, that caught Houston's initial attention and that he encouraged, since ivory was not readily available.[†] I know many people who still associate Eskimo art with ivory carvings and "etchings"[‡] and who deny the validity of stone carving as a legitimate *inuit* art activity. Actually, stone carving has become so definite a tradition that today many artists and collectors think mainly of stone carving as the most legitimate Eskimo art form. Carving in stone certainly is typical of the past twenty years; however, other materials and techniques, such as drawing and print-making, and to a lesser extent oil and

†Oddly enough, attempts to make use of elephant tusks were completely unsuccessful, yet in Alaska some artists did some excellent work with prehistoric, often fossilized, mastodon ivory.
‡Really engraved – scrimshaw-like – carvings or highly polished tusks.

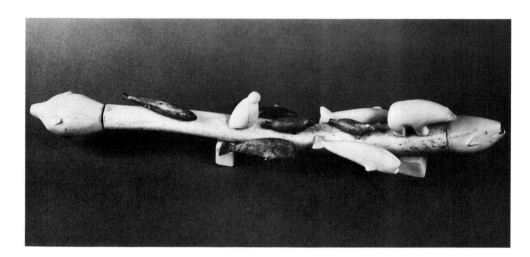

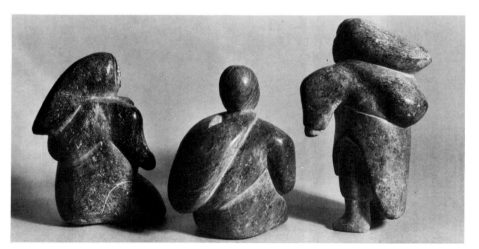

water-colour painting as well as ceramics, are rapidly absorbed into the new Eskimo art ethic and transformed into new, unequivocally *inuit* expressions.

It is at this point where subtle distinctions between genuine and not-genuine *inuit* expressions and techniques must be made. Summarized into one sentence, it all amounts to whether foreign materials and techniques taken from one culture into another can become reworked and adapted so that they are no longer foreign. In such a case – and there are many in the history of art, industry, and ideas – one should not speak in negative terms of cultural domination but in positive terms of sensitive responsiveness; drawing and printmaking certainly are not Eskimoan art techniques, nor are paints and crayons indigenous materials, yet the drawings and prints of Angosaglo, Kenojuak, Oonark, Parr, and Pitseolak are so thoroughly Eskimoan that the formerly foreign materials and techniques are now part of the new *inuit* traditions, just as is syllabic writing which was introduced to the *inuit* by an Anglican missionary only some seventy years ago.†

Soapstone carving, or more correctly carving in stone, is then part of the contemporary Eskimo culture even though its forms and its widespread uses as art material and technique are of only recent vintage.

To apply the term "soapstone" generally is incorrect and confusing, as less than half of the stone used is soapstone. Only the before-mentioned *qullisak* – the stone used in the production of oil lamps – can be classified as soapstone, which is high-grade

†In 1876 the Rev. E. J. Peck moved to Little Whale River and *transcribed* the New Testament into Eskimo, using the syllabic system invented around 1839 for the Crees by the Manitoban Methodist missionary James Evans. In 1894 Peck moved to Baffin Island and, by 1903, syllabic writing had diffused over most parts of the Eastern Arctic (cf. JENNESS 1964).

201/Unidentified artist
Inukjuak (Port Harrison) 1956
Stone with inlay height 8″

202/Lucassie Echalook
(Lukassie)
Inukjuak (Port Harrison) 1952
Stone height 4¼″
WAG G-76-277

203/Eelee Shuvigar
(Shoovagar)
Iqaluit (Frobisher Bay) 1971
Stone height 3¾″
WAG G-76-371

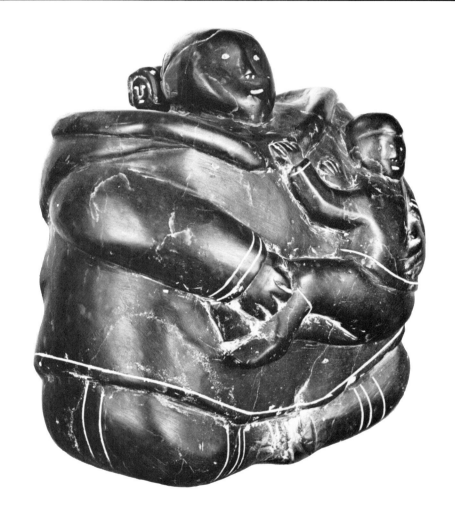

massive talc or steatite, one of the softest minerals known, with a hardness of 1 to 1.5 on the Mohs scale. Related but harder minerals used in carving are chrysotile, olivine (H. 6.5 to 7), chlorite (H. 2 to 2.5), serpentine (H. 2.5 to 4), peridotite (which alters into serpentine); other basic rocks, such as limestone, gypsum, quartz, and the previously mentioned argillite, are also used. Since the exact geological terms would be highly technical, as would be the specific names of bones and other materials, all captions in this book are confined to such simple terms as stone, bone, ivory, antler, wood, etc.; also I am extremely doubtful whether it would be possible to obtain exact descriptions of the materials used in each carving. These might have implications for better understanding of certain works such as the walrus baculum in Ainaluk's symbolic fertility carving (*baculum* is the physiological term for the penis bone) but these instances would be rare exceptions.

One final point concerns the importation of rocks which are not indigenous to some regions. Here too the raised eyebrows are not quite justified (although I often used to raise mine), but occasional criticism and continuous surveillance are still necessary. However, the reason for objections does not inhere in the fact of importation itself but in the quality and the condition of the rocks.† Some of the prettiest Quebec soapstone is simply too soft whereas the most interesting and harder serpentine permits excellent results in such areas as Arctic Bay, Clyde, Frobisher Bay, and Hall Beach. By the way, the typical stones of many areas are not always indigenous: Baker Lake, Cape

† The same type of criticism would apply to other imported material, e.g., the fussy, long-fibered mulberry paper used in some of the Cape Dorset prints; the extremely fugitive (non-resistant to light) dyes of the brilliant felt pens which fade rapidly; poor and inappropriate glazes, etc.

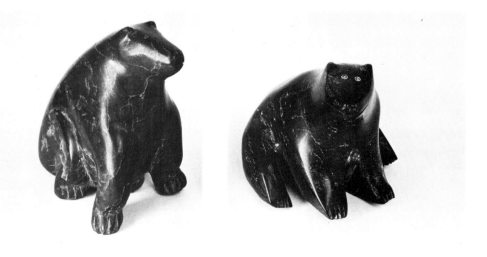

204/Davidialuk Alasua Amittu
(Davideealuk/Davidialu)
Povungnituk 1969/70
Stone height 3¹/₄"
MCQ 76-396
(cf. 370)

205/Eli Sallualu Qinuajua
(Eli Sallualuk)
Povungnituk 1967/8
Stone height 2³/₄"
CMC IV-B-1417

206/Josie Pamiutu Papialuk
(Josie Paperk/Poppy)
Povungnituk 1967
Stone width 4⁵/₈"
(also 318)

138

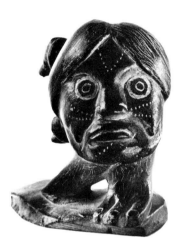

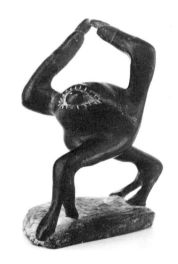

Dorset, Eskimo Point, and other settlements have to mine their best rock far away and often with great difficulty. And while it was once possible to identify the exact locality of each carving area by the appearance of its materials rather than by the intrinsic style, this is no longer possible, although the rocks of some areas do have unique characteristics. Today, such rocks are used regionally rather than merely locally.

As to techniques, the mystique of the handmade tool vs. the imported tool – or even worse the mechanical or power tools – also holds implications of value judgements which I do not share. Every artist must choose the tools he likes and that is all there is to it. The "damage" done by electric tools is not due to the implements' mechanical characteristics but to the lack of sensitivity, guidance, and restraint on the part of those who introduced them. The artists' lack of familiarity with such tools leads to inappropriate or unmotivated mechanical uses. But as we are introducing mechanical implements to the North and are educating many young people to become mechanics, the eventual adoption of power tools in art processes is inevitable.

Meanings, Styles, & Traditions

The meaning of a work of art lies within itself; although obviously it may also refer to the outside world, it does not need to do so in either form or content. The fact that contemporary Eskimo art is capable of existing as an experience in itself eludes most of its critics. In fact, one of the most disturbing criteria to those critics – apart from, and as a part of, the acculturation patterns – is the alleged absence of meaning that the contemporary art processes and products have for the artists. It is further hypothesized that art therefore has no meaning in contemporary Eskimo culture.

During the past fifteen years I have had the good fortune to discuss this topic with many artists across the Arctic. Their responses (see pp. 22-24) not only confute these theories, but also indicate their perceptive insight into the creative processes and their ideas about art as a thing-in-the-world and not just as a commentary on the world. Yet they often cannot and do not express themselves about this any better – or any worse – than artists elsewhere in the world, for it requires them to look at themselves in relation to their private and social experiences, their changing values and tastes, their continually challenged concepts and ideas, and their mysterious and unaccountable manners of and reasons for "making" art. Instead of verbalizing these experiences and pains, they turn them, consciously or subconsciously, into art that defies rationalization.

The same verbal reticence and justifiable uncommunicativeness apply to the emergence and interpretations of regional, local, and personal styles which are based on the talents and sensitivities of individuals and only partially on traditions. At a news conference in Winnipeg on March 4, 1970, held in connection with his retrospective exhibition at the University of Manitoba (SWINTON 1970), the great Rankin Inlet sculptor Tiktak, when asked what a group of faces carved in stone actually meant, answered, "Can't you see? Faces!" When then asked why, he answered, "I like to carve faces. Round ones when the stone is soft and flat ones when when the material is hard." Tiktak's carvings are highly personal, very physical and cannot be intellectually rationalized; yet they can be understood in the *sananguaq*-art context (see pages 216-218) as sensitive and talented responses to the nature and the topography of the materials he uses.

However, once their form achievements

207/Manasee Manniapik
(Manasie Maniapik)
Pangnirtung 1971
Whalebone width 17″

208/Thomas Arnayuinak
(Arnayuinnar)
Arviat (Eskimo Point) 1969
Stone and antler height c. 9″
WAG G-76-155

209/Francis Kaluraq
(Kallooar)
Baker Lake 1964
Bone height 4″
WAG G-76-60
(also 711)

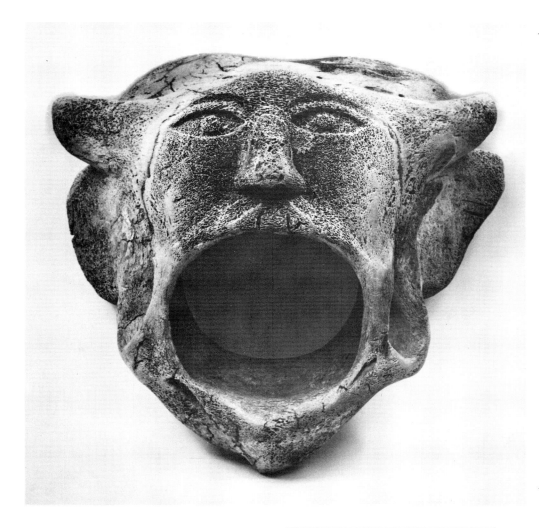

– which means their "success" within the *sananguaq*-art concept – become known and appreciated, the insights and achievements of individuals might become consciously or subconsciously adopted by other artists.† The diffusion of such style ideas could easily become the subject for another book, by, I would hope, an art historian. All I have done in this book is to record visually the relationships of styles and subject matters within the better-known areas of the Arctic (see pp. 143-243) as an initial step in that very important field of Arctic research. I might add that even today much irretrievable information has already been lost but, as with Canadian archaeology, very little is being done to remedy this situation.

Finally, traditions still exist. Some are obscure; some come through hearsay or faint memories; some come – and increasingly so – through the media (books, magazines, newspapers, photos, and films). But Eskimo traditions were chiefly oral and never clearly categorized. And in their diffusion across the Arctic (this subject, too, would make a fascinating study) they often became garbled.

In their fascinating book *eskimo stories – unikkaatuat*, Nungak and Arima describe how "in 1958-59, under the active encouragement of Reverend Father André P. Steinmann, OMI, the Povungnituk carvers depicted some of their oral traditions in soapstone." In addition to the carvings, most of the stories were also collected in syllabic writing and on magnetic tape with the assistance of Dr. Asen Balikci of the Université de Montréal. Arima also recorded additional versions of the stories while visiting Povungnituk in 1963 and 1964.

"Often a story was collected two or . . .

†In recent years, for instance, George Arlu and Angutaguak (now in Baker Lake) very definitely have become "influenced" by Tiktak.

210/Unidentified artist
Inukjuak (Port Harrison) 1951/2
Stone height 7″

211/Anthanese Ullikatar
(Ullikatark/Ulikatar)
Repulse Bay 1969
Stone and antler width 8″
WAG G-76-527

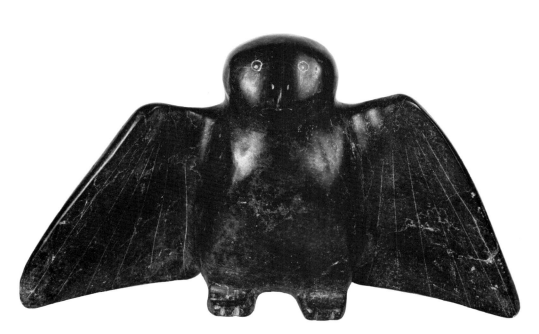

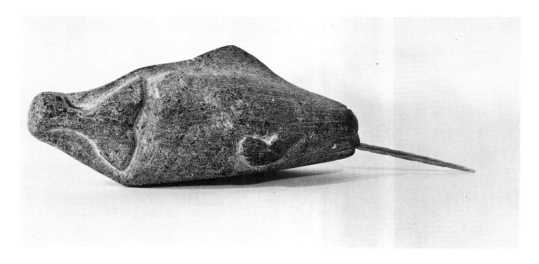

more times, from different individuals
or as different renditions by the same
person. The resulting wealth of versions
was embarrassing in a way, as one might
contain something another lacked, and
the other might have something else again
not in the first. . . . Preference [in their
book] was given to syllabic texts because
these were generally written while the
carver was at work. The syllabic texts tend
to be more concise than the tape-recorded
accounts, which are often a bit disorgan-
ized, repetitious, and at times, even
'ungrammatical.' . . .The syllabic texts
have certain drawbacks on their own in
that they are sometimes ambiguous, the
syllabary in use being underdifferentiated,
and in that they are sometimes overly
condensed to the point of sketchiness.
Whether texts or recordings, the accounts
are often poorly presented or fragmentary.
To start with, not everyone is a good story-
teller, and today the traditions and their
telling have deteriorated greatly under
acculturation." (NUNGAK AND ARIMA 1969,
pp. v and vi)

The many versions, the disorganized
and repetitious accounts are not at all
surprising. Neither are ambiguities nor
poor or fragmentary presentations. These
hazards would not be encountered only
by an Eskimo ethnologist; to me, they are
part of the entire Eskimo system of life
and aesthetics. The strength and vitality
of Eskimo art, and one might also speak
here of philosophy and thinking (both as
process and product), lie in an undifferen-
tiated, syncretistic approach in which
details can be repeated, omitted, or even
added without affecting the whole
meaning. In this regard Eskimo art and
thoughts are very much like television
programs or serials with interruptions from
commercials, distorted reception, and
added living-room conversations, but
which – interruptions and distractions

212/Fabien Oogaaq
(Oogark)
Pelly Bay 1964
Ivory height 3½"

214/Unidentified artist
Sanikiluaq (Belcher Islands) 1958
Stone and ivory height 6¾"
WAG G-60-76
(also 225)

213/Aggeak Petaulassie
(Aggiak)
Cape Dorset 1963
Stone length 19"
MMFA 1963.aa.3
(also 483)

215/Mina Tooktoo (as per signature)
Kuujjuaraapik (Great Whale River) 1967
Stone height 6"
AGO 90/338

notwithstanding – can be readily understood almost in spite of themselves. It is this very casualness of communication, combined with the capacity to draw attention sufficient for understanding without learned commentaries, that is typical of Eskimo art and traditions.

Size, Complexity, & Extremes

Still further extensions of the conscious and subconscious aspects of the *sananguaq*-art concept become manifest in a closer examination of the multi-faceted interactions between styles, materials, and techniques.

The most conspicuous of these paradoxes concerns size and its relations to traditions old and new. In prehistoric art, small size – remember the "diminutive" side-meaning of the suffix -*nguaq* in *sananguaq* (cf. p. 129)? – was not only a visual characteristic but also a cultural necessity for nomadic hunters. Today, within the cultural environment of trade art and permanent settlements, the traditional size limitation is meaningless. In fact, from the financial point of view alone, large-size carvings are obviously preferable because of the higher monetary returns they yield. But quite apart from this advantage within the contemporary economy, there comes into play the well-known Eskimo fondness for extremes. The Eskimo delights in the impressively large as well as in the surprisingly small – in the very special and unusual as well as in the expected – as long as they are impressive, surprising, special, or exactly according to expectations and are well done.

Today, the Eskimo's admiration for the very small is associated with those objects that are charmingly delightful rather than magically powerful, whereas the appeal of the large resides in the impressiveness and the physical power of the carvings. The *kablunak*

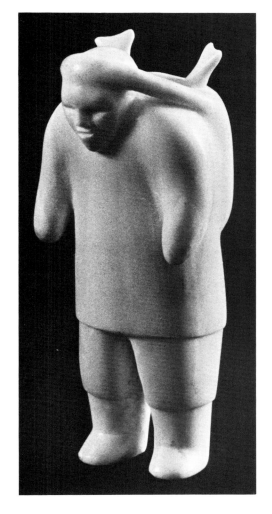

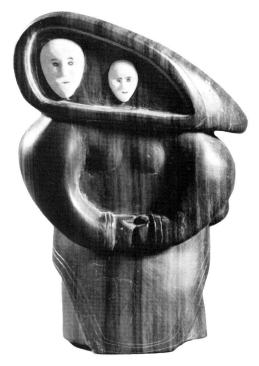

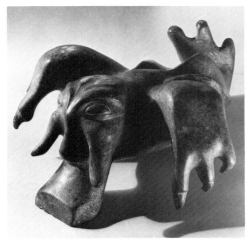

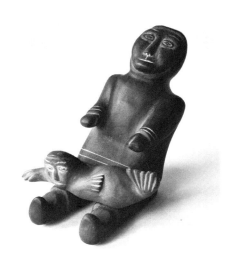

preference for the prehistoric smallness resides in an admiration for the skill in handling the difficulties of such diminutive carvings, for their "monumental" scale, and for their power of expressiveness. Large carvings are often discounted because of the "un-Eskimoan" large size and also because of their unjustified dimensions. Still, the highest prices (up to several thousand dollars) are paid by both collectors and museums for the larger and often very impressive pieces.

As to scale, the so-called monumentality of Eskimo art inheres predominantly in two factors: their extreme simplicity (when simple) and their emphasis on the massive body in comparison with the relatively small head. The massiveness of the body is further enlarged by the heavy appearance of Eskimo clothing, particularly the bulging form of the parkas and *amautik* (the pouch in the woman's parka hood that holds the child).

However, Eskimo carvings are not always massive or simple; in Povungnituk, for example, the major criterion of excellence is delicacy and complexity, ranging from objectively faithful wildlife art (like that of Samisa and Isapik) to highly complex hunting scenes (ill. 340) and even more complex and detailed fantasy carvings (Eli Sallualuk and Isapik Smith, ill. 205 and 386). At the same time two individualistic carvers who for a long time were considered too crude are now accepted in Povungnituk because of their outside recognition by specialists; I am referring here to Davideealuk and Joe Talirunili.

There are many polarities which coexist as style characteristics in contemporary Eskimo carving. They too derive from the Eskimo penchant for well-expressed extremes. Among them are symmetry and asymmetry, flatness and roundness, balance by weight and balance by gravitational forces, roughness and smoothness, stylization and naturalism, observation and invention, expression and abstraction, etc. All these are equally typical of contemporary carving or, perhaps more realistically, of the form and style characteristics of individual artists and specific localities.

The proper interpretation of these characteristics (if at all justifiable) may come from a detailed study of styles and style diffusions. As indicated earlier such work can and needs to be done now while many of the artists and the prime movers and manipulators still live and remember. Yet "objective" analysis in itself cannot yield much more than classifications, chronologies, and what James Joyce called "factifications." Such systems are good for building models, creating order, or compiling catalogues. As such they are means, even valuable means for practical and useful ends. But are the ends of art practical? Is art to be used?

An artist's carvings are responses to the material which he works. In the *sananguaq*-art context his responses are physical, sensuous, tactile, and intuitive. The material suggests the subject matter which in turn suggests the form. The response is the content found in the form. Tiktak has said: "I do not think out what I will do. My thought comes out while I work. My work expresses my thought."

We must, therefore, beware of systems that try to contain thoughts in statements of facts. Tiktak's work *is* his message.† His work does not *contain* messages. Art is not merely *about* something; it *is* something. Hence my misgivings about the ultimate value of "analyzing art" as a means to appreciate or experience it. Analysis is, however, a valid and relevant means to build a platform from which to leap into the airy region of experience. Especially when it is supported by biographical and autobiographical material (which is never objective), by iconographical and iconological studies (which are sparked by the intuitive and inductive powers of perceptiveness), and most of all, by the intimate, tactile presence of the works.

†The work is contained in its form. That which is form (cf. pp. 17-19) is the work as it is experienced. It does not prove anything, but it convinces. It is a cyclical argument: the form of a work of art is its content; the content of a work of art resides in its form; the subject matter is given form and becomes content; the subject matter can never be the content; when it is, then the work is not art. The subject matter can be analyzed; the content and the form can only be experienced.

10/ The place of Inuit art

It now remains to assess contemporary Eskimo art within the framework of art and art history. But one must avoid entombment, labels, eulogies, and flowery phrases. To "place" Eskimo art into a new framework might mean to liberate it from one pigeonhole only to encase it in another. Even "assessment" entails dangers. "Negative assessment" might be more appropriate – to say what it is not, rather than what it is.

First of all, the phrase "Eskimo Art"! As a label, this term implies anonymity. However, as we have seen, individuality is the foremost characteristic of Eskimo art. But the myth of the universal and anonymous primitive artist is an old one. In view of our increasing understanding of all the wonderful and exquisite art objects which, with our typical Western culture megalomania, we used to call primitive, this myth no longer holds true yet still continues to persist in even those quarters where one would expect to find greater enlightenment and insight. Many so-called "native" or "primitive" artists[†] know that they are neither primitive nor usual. In fact they feel "chosen," and the people in their community either accept them as being chosen or reject them as "being crazy" (cf. my earlier book, *Eskimo Sculpture*, pp. 62-65). Among the Haida Indians of the Northwest Coast,

[†]Oto Bihalji-Merin, in his book *Modern Primitives*, suggests that the term "insite art" proposed by the founders of the Triennial Exhibitions of Naive Art at Bratislava, Czechoslovakia, is not acceptable for use to describe naive art. "Insite" derives from the Latin *insitus* (innate) and might well be used for many of the contemporary *inuit* artists. What we have to do is stop using the terms native and primitive when we speak of the art forms of non-Western cultures. We also must stop making hieratic judgements by speaking of "high cultures" as contrasted with "pre-literate cultures." These are linear concepts of art, culture, and history which are no longer valid, not even in a taxonomic sense.

artists were highly valued professionals some of whom were even kidnapped by rivalling chiefs in order to secure their professional services (cf. B. HOLM 1965). In any case, while we may use the term "Eskimo art" in order to designate the ethnic origin of the artists producing the work discussed in this book, the term itself has no other connotations, least of all collective content and anonymity of artists.

There are, however, exceptions. Within the entire art-and-craft production by Eskimos an increasingly large percentage does have collective content and almost anonymity of form. These are the souvenir carvings. They are classifiable and predictable, but I am opposed to calling them art. Yet in the jargon of the ever-categorizing social pseudo-scientists, and of most gift-shop operators, they may be called "typical" Eskimo Art with a capital A, because they are typical, identifiable, ethnic commodities. The objects I call art are characteristic and identifiable only in terms of individual artists.

Where does this leave Eskimo art (with a small a) in relation to other art forms of today? In kind, it does relate to many of the art expressions in many of the so-called "developing countries" all over the world. These are now gradually being accepted as new arts. For instance, the scholarly magazine *african arts* (issued by the African Studies Center of the University of California at Los Angeles) continuously publishes information on the traditional and the new arts and artists of Africa. The Africans are acculturating, so are the aboriginal Australians, the West Indians, and all the other peoples of the world who, after the Second World War, gained new freedoms. They, like the Eskimos, had old and complex traditions. Some continue with their rituals but many do not. They, like the Eskimos, have Western-culture-oriented education. Only recently did they take cognizance of their

past culture and traditions within their education processes, and so now do the Eskimos.

Currently their art forms are transitional – partly ethnic, partly acculturated – but there are signs that these transitional art phases, including those of the Eskimo, will gradually disappear. Yet there are other indications that they will retain at least some of their ethnic character, a cultural heritage that will continue to exist as long as at least some form of cultural communication continues to exist.

For the Canadian Eskimo – the *inuit* – two major communication forms still prevail: the old language and the new art. But new forms are developing. In the Mackenzie Delta most of the young people speak English better than Eskimo, if they speak Eskimo at all; the written or printed word – as opposed to oral tradition – has become a powerful factor in every aspect of communication; the language of education, commerce, administration, and job opportunity is largely English; almost all the means for and the implements of transportation and daily living are imported; visual stimulation comes largely from crime and cowboy movies, comic books and comic strips, illustrated magazines and cheap calendars, etc., etc. – products of our popular mass culture. All of this sounds very negative. But I feel and have always felt that the good often develops in spite of the bad; that the good always wants to affirm itself; that art can be as much an assertion against its time as a reflection of it.

Art always is an assertion, an affirmation, an act of faith. As such it always changes and, as long as it is able to change, it lives. Today its greatest danger comes from commercialism which resists change or at least corrupts the artist into producing, or rather into reproducing, a proven product. Commercialism is a state of mind that exists as much in the mind of the

216/Aisa Amaruali Tuluga
(Isah Tool/Toologak)
Povungnituk 1969
Stone height 12¾"

217/Simon Natak
(Naattak)
Hall Beach 1970
Stone height 9½"

144

producer as in the mind of the distributor.
It is a sickness of our century and it
pervades most of our activities, our
motives, and our institutions. Since it
promises pleasant rewards, great strength
and convictions are required to resist it.
With the growth of commercialism in the
North much of the current art produc-
tivity will disappear. But again there will
be assertions against it. For the time being
the visual arts are still powerful and lively;
they also have received a potent boost from
the two-dimensional media. But in a world
of words, the future of Eskimo art may
well become more verbal than visual. And
if and when that change will come, it will
be a continuation of the *inuit* tradition of
flexibility and adaptation. If the *inuit*
could not change, they would no longer be.

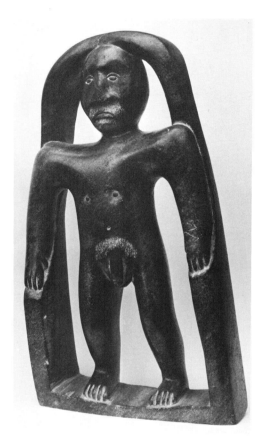

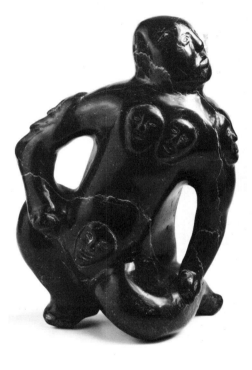

Catalogue of Artists by Area

The purpose of this catalogue is to provide a visual reference to the work done in the various Arctic regions. The selection of illustrations approximates the numerical and thematic distribution of work done in these areas, and in no way aspires to give complete coverage of any area. It does, however, include those artists who have received outside rather than mere local recognition.

In order to indicate the stylistic changes of some of the highly productive artists, specifically Johnnie Inukpuk, Joe Talirunili, Davidialuk, Eli Sallualu, Pauta, Latcholassie, Aqjangajuk, Tasseor, Pangnark, Kavik, Tiktak, Iquliq, Ikutaaq, and Christine Aaluk, they have received complete sections of their own. Other equally important artists have been listed within thematic categories.

Unfortunately, there are a great many excellent pieces by artists who as yet have not been identified. It is quite likely that most of them never will be, since in the first five to ten years of the contemporary development, the preservation of the anonymity of artists was a standard practice in keeping with the then prevailing concepts of "primitive authenticity." Any information that would help to remedy this injustice would be welcomed. By the time of updating this book a number of artists have been identified in a variety of ways. New records have been found, forgotten names have been remembered, new stylistic attributions and re-attributions have become plausible, and misinformations have been rectified. Whenever this was possible, revisions have been made accordingly. Furthermore, the new orthographic spellings of names of artists and localities – followed by alternate or former names in brackets – are used.

In order to accommodate the catalogue or accession numbers of works in public collections it has become necessary to use abbreviations instead of full names. Several sculptures have been transferred to other institutions while others have been de-accessed. In case of the latter the names of those repositories have been deleted.

AEF – Amway Environmental Foundation, Aka, Mich.
AGO – Art Gallery of Ontario, Toronto
AMNH – American Museum of Natural History, New York
Avataq – Avataq Society of Nunavik, Inukjuak
CAG – Confederation Art Gallery and Museum, Charlottetown
CGCM – Canadian Guild of Crafts, Montreal
CMC – Canadian Museum of Civilization, Hull
CUMAA – Cambridge University Museum of Archaeology and Anthropology
EAG – Edmonton Art Gallery
EMC – Eskimo Museum, Churchill
ICI – Inuit Cultural Institute, Rankin Inlet
MCQ – Musée de la civilisation, Québec
McM – McMichael Canadian Art Collection, Kleinburg
McMB – MacMillan Bloedel Coll., Vancouver
MMFA – Montreal Museum of Fine Arts
NGC – National Gallery of Canada, Ottawa
PWNH – Prince of Wales Northern Heritage Centre, Yellowknife
ROM – Royal Ontario Museum, Toronto
TDB – Toronto-Dominion Bank Collection, Toronto
UBC – University of B.C. Museum of Anthropology
U of M – University of Manitoba, Winnipeg
VAG – Vancouver Art Gallery
WAG – Winnipeg Art Gallery
YORK – York University Gallery of Art, Toronto
"?" – *attributions* made by local informants, colleagues, or myself
"(re-a)" – *re-attributions* according to recent catalogues or new information
slash "/" – *between alternate names* (in brackets) indicates names used in earlier records or publications and in previous editions of this book
slash "/" – *between two localities* indicates the place of artist's domicile and the place where the particular work was produced (cf. #236 "Inukjuak/Kuujjuaraapik" (not Port Harrison/Great Whale River) and #626 Arviat/Rankin Inlet (no longer Eskimo Point/but still Rankin Inlet)

Notes to New Map

In the new map we have used the latest official names but some of them may be changed again in the future as has been the case with Arviat (Eskimo Point) and Iqaluit (Frobisher Bay). Most of the Ungava Peninsula settlements have now been renamed (with the original names in brackets). The peninsula itself is diversely identified as Nouveau-Québec or Arctic Quebec, but is referred to as Nunavik by Inuit and even by Quebeckers.

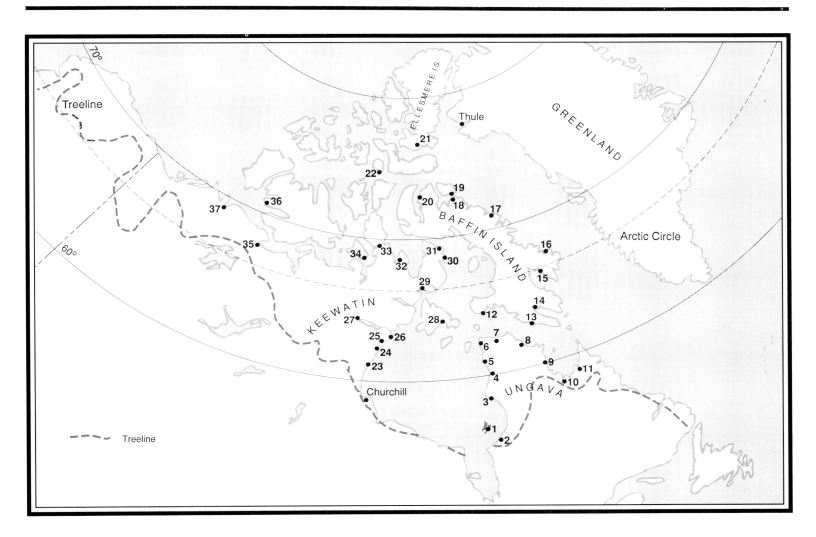

1/ SANIKILUAQ (Belcher Islands)
2/ KUUJJUARAAPIK (Great Whale River/Poste de la Baleine)
3/ INUKJUAK (Port Harrison)
4/ PUVIRNITUQ (Povungnituk)
5/ AKULIVIK (Cape Smith)
6/ IVUJIVIK (Ivugivik)
7/ SALLUIT (Sugluk/Saglouc)
8/ KANGIQSUJUAQ (Wakeham Bay/Maricourt)
9/ KANGIRSUK (Payne Bay/Bellin)
10/ KUUJJUAQ (Fort Chimo)
11/ KANGIQSUALUJJUAQ (George River, Port-Nouveau-Québec)
12/ CAPE DORSET
13/ KIMMIRUT (Lake Harbour)
14/ IQALUIT (Frobisher Bay)
15/ PANGNIRTUNG
16/ BROUGHTON ISLAND
17/ CLYDE RIVER
18/ POND INLET
19/ BUTTON POINT (Bylot Island)
20/ ARCTIC BAY
21/ GRISE FIORD (Craig Harbour)
22/ RESOLUTE
23/ ARVIAT (Eskimo Point)
24/ WHALE COVE
25/ RANKIN INLET
26/ CHESTERFIELD INLET
27/ BAKER LAKE (Qamanittuaq)
28/ CORAL HARBOUR (Southampton Island)
29/ REPULSE BAY (Naujat)
30/ HALL BEACH
31/ IGLOOLIK
32/ PELLY BAY
33/ TALOYOAK (Spence Bay)
34/ GJOA HAVEN
35/ COPPERMINE
36/ HOLMAN
37/ PAULATUK

218/Noah Kudluk
(Noakudluk)
Sanikiluaq (Belcher Islands) 1954
Stone and ivory height 8¹/₂"
CMC Na-3

219/Sarah Qittusuk
(Kittosuk)
Sanikiluaq (Belcher Islands) 1966
Stone length 5¹/₂"
MCQ 66-290

220/Johnassie Kavik
Sanikiluaq (Belcher Islands) 1965
Stone height 5³/₈"
WAG G-76-84

221/Johnassie Mannuk
Sanikiluaq (Belcher Islands) 1964 ?
Stone and ivory height c. 4"

222/Annie Niviaxie
Sanikiluaq/Kuujjuaraapik 1968
Stone height c. 4¹/₂"

223/Johnassie Kavik
Sanikiluaq (Belcher Islands) 1964
Stone length 7"
WAG 892-71

224/Johnassie Kavik
Sanikiluaq (Belcher Islands) 1961
Stone height 5¹/₂"
WAG 894-71

225/Unidentified artist
Sanikiluaq (Belcher Islands) 1958
Stone and ivory height 6³/₄"
WAG G-60-76
(also 214)

148

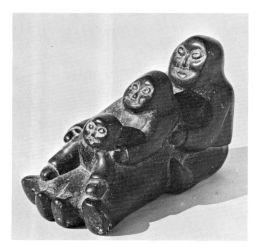
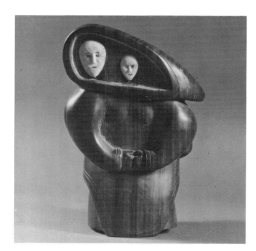
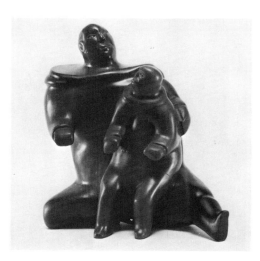
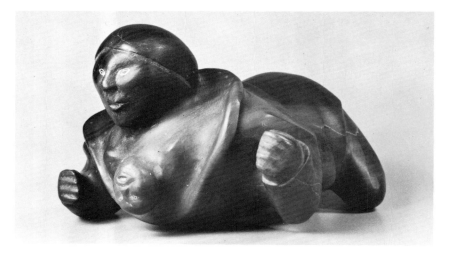

226/Johnnie Tukallak
(Tukaluk)
Sanikiluaq (Belcher Islands) 1963
Stone height 6″

227/Timothy Naralik
(Timothy Narlik)
Sanikiluaq (Belcher Islands) 1968/9
Stone height 5¹⁄₈″
AGO S693
(also 96)

228/Josie Oonan ?
Sanikiluaq (Belcher Islands) 1966
Stone length 4¹⁄₂″

229/Unidentified artist
Sanikiluaq (Belcher Islands) 1955
Stone height 3¹⁄₂″
CMC IV-C-3379

230/Paulassie Eqilaq
(Ekidlak)
Sanikiluaq (Belcher Islands) 1968
Stone length 11³⁄₈″

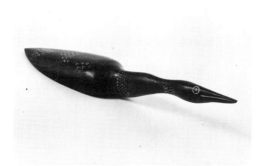

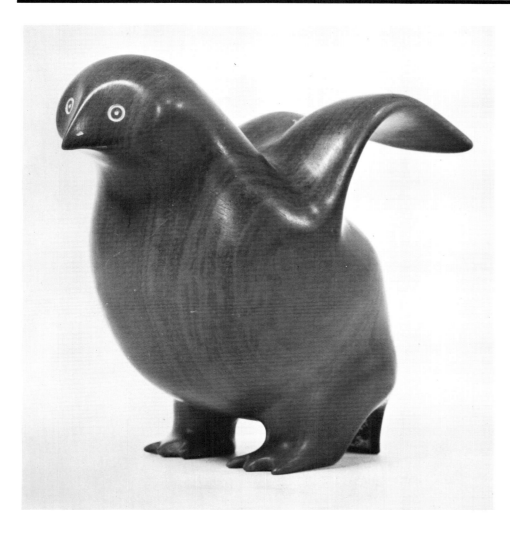

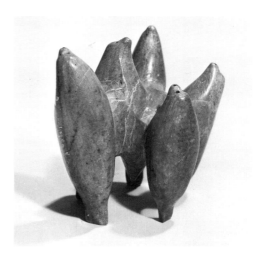

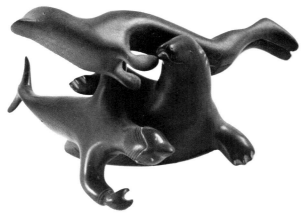

231/Unidentified artist
Sanikiluaq (Belcher Islands) 1955/6
Stone height c. 2″

232/Samwillie Iqaluq
(Ekalook)
Sanikiluaq (Belcher Islands) 1965
Stone height 10½″

233/Annie Niviaxie
(Sala)
Kuujjuaraapik (Great Whale River) 1967 ?
Stone height 6″
(also 122)

234/Another view of 233

235/Lucassie Qittusuk
(Kittosuk)
Sanikiluaq (Belcher Islands) c. 1964
Stone length 4½″
WAG G-76-95

236/Conlucy Niviaxie
(Cooneeloosie)
Inukjuak/Kuujjuaraapik 1959 ?
Stone height 4¼″

150

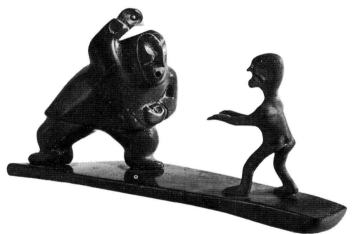

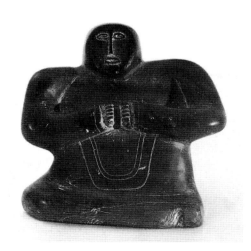

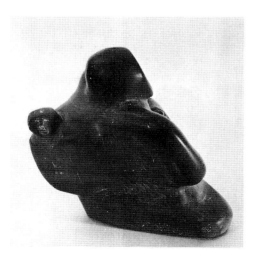

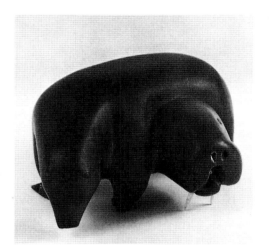

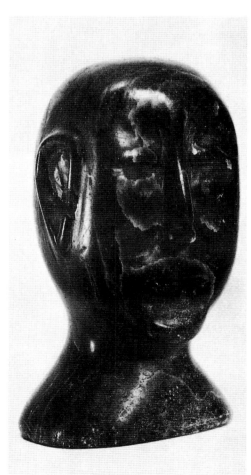

237/Davidee Kavik
(Kagvik)
Kuujjuaraapik (Great Whale River) 1966
Stone, wood, and ivory height 11″

238/Davidee Kavik
(Kagvik)
Kuujjuaraapik (Great Whale River) 1968
Stone height 13³/₄″
MCQ 69-350

239/Samwillie Iqaluq
(Ekalook)
Sanikiluaq (Belcher Islands) 1961
Stone length 4³/₄″

240/Paulassie Eqilaq
(Ekidlak)
Sanikiluaq (Belcher Islands) 1967
Stone heights 4¹/₂″ and 5¹/₂″

241/Henry Napartuk
Kuujjuaraapik/Great Whale River no date
Stone height 4″

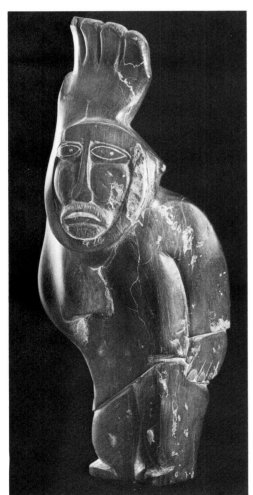

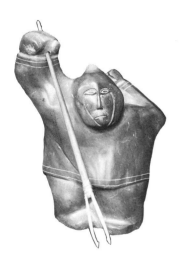

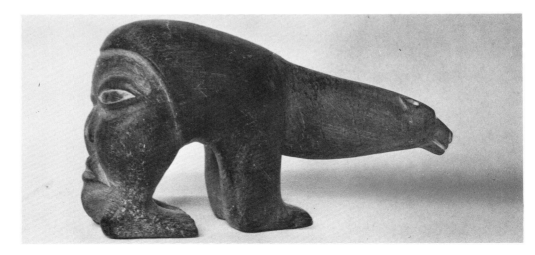

242/Levi Amidlak ?
(Amidilak)
Inukjuak (Port Harrison) 1952
Stone and inlaid ivory height 5³/₄″
CGCM 197.

243/Jobie Inukpuk
Inukjuak (Port Harrison) 1958
Stone height 5³/₄″
CMC IV-B-1322

244/Unidentified artist
(Samwillie Amidlak ?)
Inukjuak (Port Harrison) 1949/50
Stone and ivory height 2³/₄″
TDB EC-82-660

245/Lucassie Nuktialuk
Inukjuak (Port Harrison) 1957
Stone length 5¹/₂″
WAG G-60-124

246/Paulosie Weetaluktuk
(Pauloosie)
Inukjuak (Port Harrison) 1967
Stone height 3³/₈″
TDB EC-82-676

247/Daniel Inukpuk
Inukjuak (Port Harrison) 1964
Stone height 6³/₄″
WAG 1795-71

248/Timothy Kutchaka
Inukjuak (Port Harrison) 1957
Stone with incised lines length 7¹/₂″
WAG G-60-120

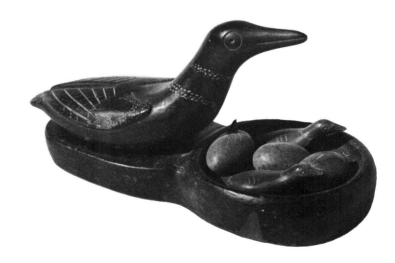

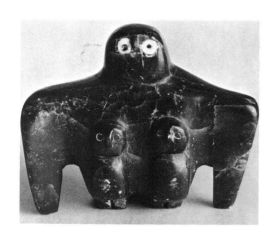

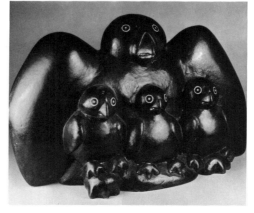

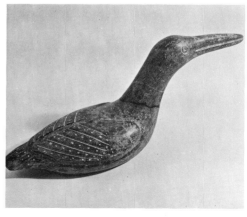

249/Unidentified artist
Inukjuak (Port Harrison) 1956
Stone length 8¹/₂″

250/Eli Elijassiapik
Inukjuak (Port Harrison) 1954/5
Stone and inlaid ivory height 9″

251/Sima Tuki
Inukjuak (Port Harrison) 1958
Stone height 7″
CMC NA-700

252/Levi Amidlak
(Amidilak)
Inukjuak (Port Harrison) 1958
Stone length 5¹/₄″

253/Mathewsie Amidlak
(Mathewsie Amidilak)
Inukjuak (Port Harrison) 1957/8
Stone height 6¹/₄″

254/Samwillie Amidlak
(Samwillie/Samuel)
Inukjuak (Port Harrison) 1954
Stone height 7¹/₈″
Avataq NA-9

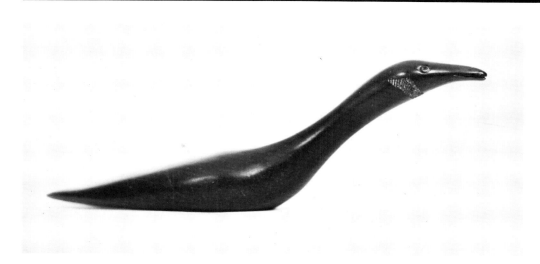

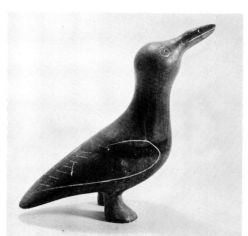

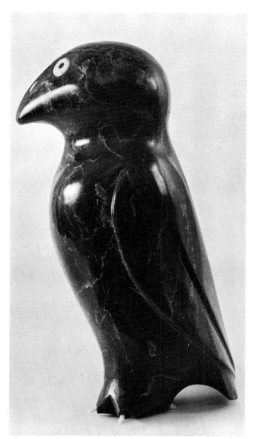

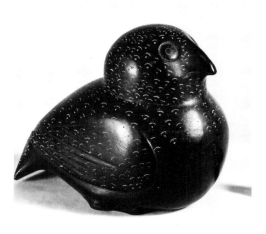

255/Isa Smiler (re-a)
Inukjuak (Port Harrison) 1954
Stone and inlaid ivory height 6³/₄"
CMC IV-B-1175

256/Unidentified artist
Inukjuak (Port Harrison) 1954
Stone length 10¹/₄"
WAG G-60-147

257/Unidentified artist
Inukjuak (Port Harrison) 1954/5
Stone length 9"
CMC IV-B-1213

258/Philiposie Napartuk
(Pillapusee/Pillipussy)
Inukjuak (Port Harrison) 1953
Stone height 5¹/₂"
CMC IV-B-1155
(formerly attributed to Akeeaktashook)

259/Philliposie Napartuk (re-a)
(Pillapusee/Pillipussy)
Inukjuak (Port Harrison) 1953 ?
Stone length 5³/₄"
WAG G-60-93

260/Charlie Epoo
Inukjuak (Port Harrison) c. 1960
Stone height 10¹/₂"
WAG G-76-236

261/Thomassie Tuki
Inukjuak (Port Harrison) 1969
Stone and ivory height 7"

262/Isa Smiler
Inukjuak (Port Harrison) 1956/7
Stone and ivory height 5¹/₂"

263/Unidentified artist
Inukjuak (Port Harrison) 1951 ?
Stone and ivory length 4¹/₄"

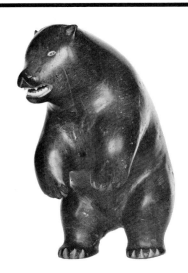

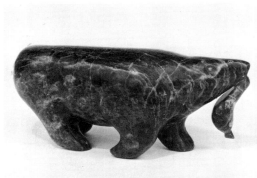

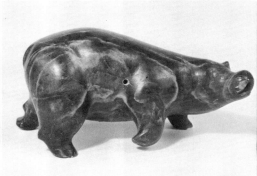

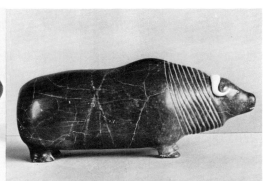

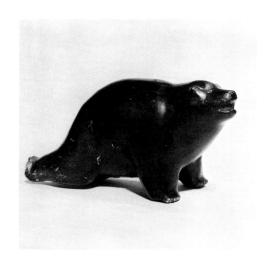

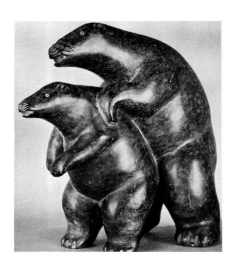

264/Syolee Weetaluktuk
(Syollie)
Inukjuak (Port Harrison) 1953
Stone and bone length 10″
WAG G-60-103

265/Unidentified artist
Inukjuak (Port Harrison) 1954
Stone and ivory length c. 19″
CMC NA-240

266/Adamie Niviaxie
Inukjuak (Port Harrison) 1955/6
Stone length 8¹/₈″
WAG G-60-87

267/Joe Adlaka Aculiak
(Adlikit)
Inukjuak (Port Harrison) 1958
Stone with inlay length 6³/₄″
WAG G-59-15

268/Johnnie Epoo
Inukjuak (Port Harrison) 1962
Stone length 12¹/₂″
WAG 1858-71

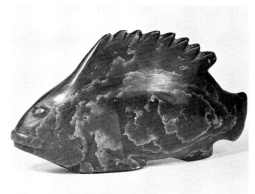

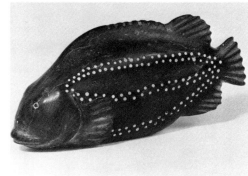

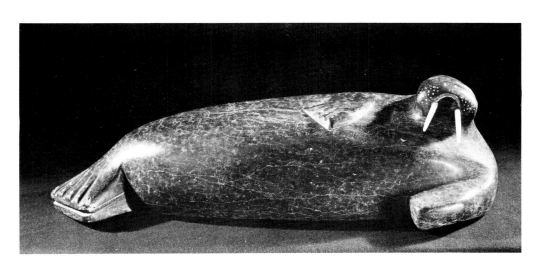

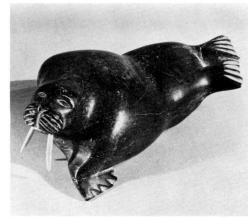

269/Pilipusi Tukai (re-a)
(Pillipussie)
Povungnituk 1950
Stone height 4⁵/₈"

270/Timothy Kutchaka
Inukjuak (Port Harrison) 1958
Stone, wood, and bone height 11⁷/₈"
WAG 1773-71

271/Unidentified artist
Inukjuak (Port Harrison) 1954 ?
Stone height 8¹/₂"

272/Levi Amidlak
(Amidilak)
Inukjuak (Port Harrison) 1955
Stone and ivory height 6³/₄"

273/Unidentified artist
Inukjuak (Port Harrison) 1956/7
Stone and ivory height c. 7¹/₂"

274/Akeeaktashook
Inukjuak (Port Harrison) 1951/2
Stone height 10"
Avataq NA-752

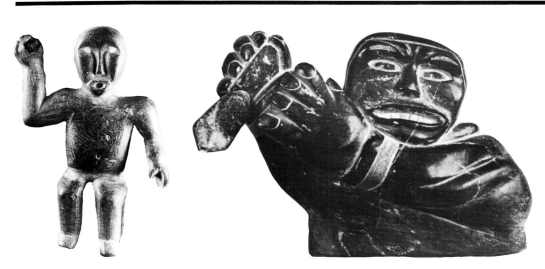

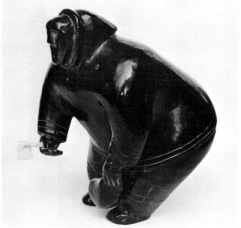

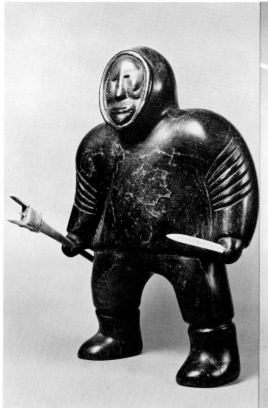

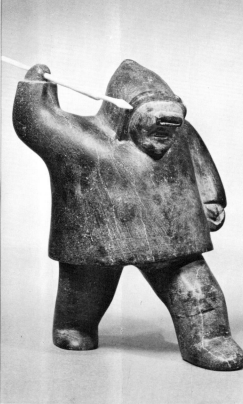

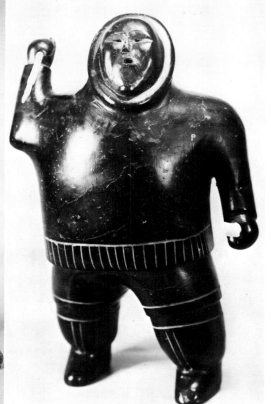

275/Unidentified artist
Inukjuak (Port Harrison) 1956
Stone and leather height 5"

276/Samwillie Amidlak
(Samwillie/Samuel)
Inukjuak (Port Harrison) 1950 ?
Stone and ivory height c. 6"
WAG G-85-354

277/Syollie Weetaluktuk
(Sarollie)
Inukjuak (Port Harrison) 1957
Stone height 3³/₄"

278/Timothy Kutchaka (?)
Inukjuak (Port Harrison) 1955
Stone with inlaid lines height 9¹/₄"
WAG G-60-139 a, b, c

279/Makusi Qalingu Angutikirq
(Kalingo)
Povungnituk 1955
Stone height 6¹/₂"
WAG G-60-100

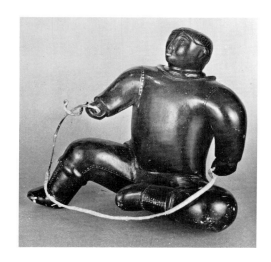

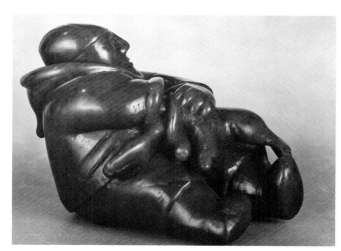

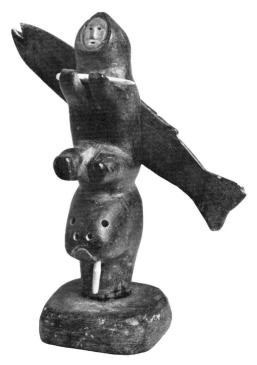

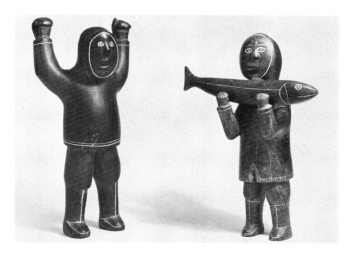

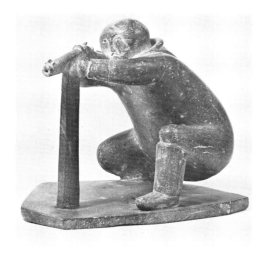

280/Paulosie Paulosie ?
Inukjuak (Port Harrison) 1957
Stone height 7⁷⁄₈"
CMC IV-B-1265

281/Unidentified artist
Inukjuak (Port Harrison) 1953/4
Stone height 4³⁄₄"
WAG G-60-126

282/Levi Echalook
Inukjuak (Port Harrison) 1954 ?
Stone height 7"
CGCM 198.

283/Unidentified artist
Inukjuak (Port Harrison) 1949/50
Stone height 6³⁄₄"

284/Abraham POV ?
Inukjuak (Port Harrison) 1957
Stone length 16"
CMC IV-B-1234 a, b

285/Sharky Nuna (re-a)
(Sarkee)
Cape Dorset 1951/2
Stone and ivory height 3³⁄₈"

286/Simon POV
Inukjuak (Port Harrison) 1959
Stone height 5³⁄₄"

287/Simon Mukimuk
Inukjuak (Port Harrison) 1959
Stone length 13³⁄₄"
WAG G-76-383

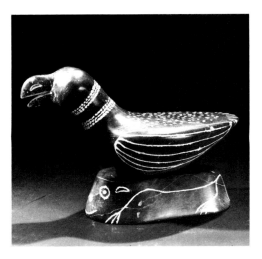
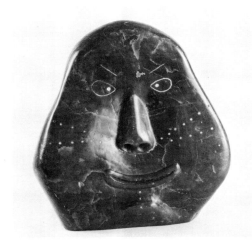
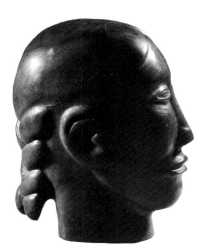
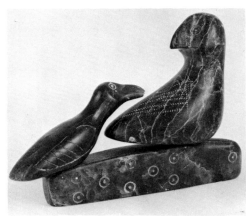
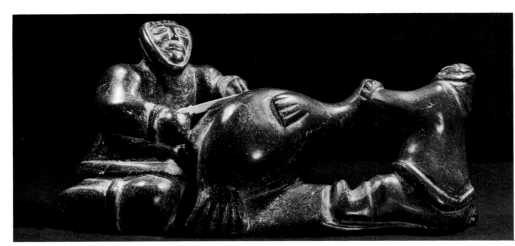
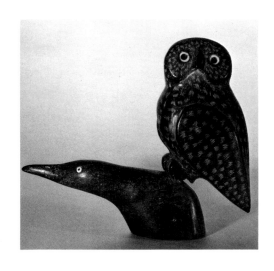
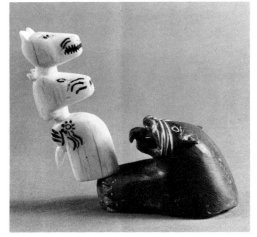
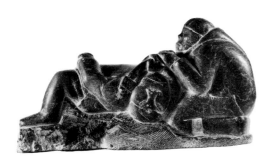

288/Johnny Inukpuk
Inukjuak (Port Harrison) 1954
Stone height c. 11″
Avataq NA-29

289/Johnny Inukpuk
Inukjuak (Port Harrison) 1955 ?
Stone and ivory height 6″
CMC IV-B-1164
(same as 70)

290/Unidentified artist
(formerly attributed to Johnny Inukpuk)
Inukjuak (Port Harrison) 1952/3
Stone and ivory height 12³/₄″
CMC NA-454
(cf. "Canadian Eskimo Art" 1954)

291/Unidentified artist
(formerly identified as Johnny Inukpuk)
Inukjuak (Port Harrison) 1951/2
Stone and inlay height 9³/₄″
WAG G-60-69
(now attributed to Philiposie Napartuk)

292/Johnny Inukpuk
Inukjuak (Port Harrison) c. 1965
Stone height 17″
TDB EC-72-7

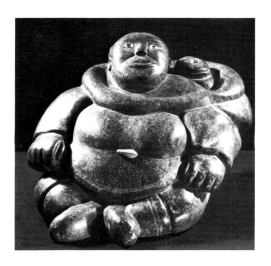

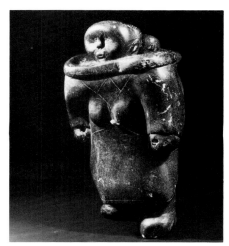

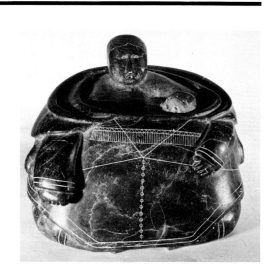

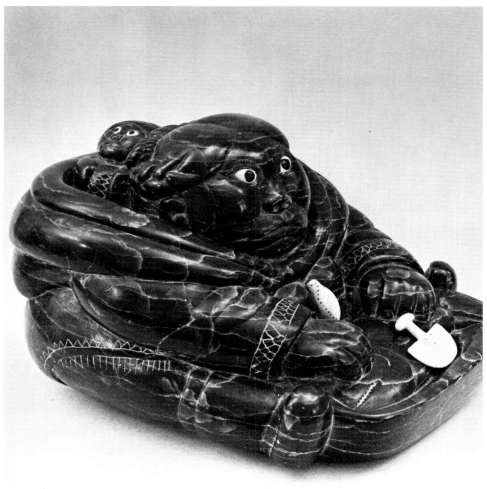

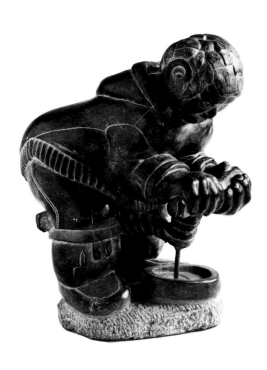

293/Unidentified artist
Inukjuak (Port Harrison) 1954 ?
Stone and soap inlay height 8¹/₂″

294/Abraham Nastapoka
(formerly Charlie Inukpuk)
Inukjuak (Port Harrison) c. 1960
Stone height 9¹/₂″
WAG G-72-237

295/Unidentified artist
Inukjuak (Port Harrison) 1954/5
Stone and ivory height 6¹/₂″

296/Unidentified artist
Inukjuak (Port Harrison) 1952/3
Stone height c. 4″

297/Sara Meeko Nastapoka ?
Inukjuak (Port Harrison) 1953
Stone height 12¹/₄″
CMC IV-B-1198

298/Eli Weetaluktuk
(Eli)
Inukjuak (Port Harrison) 1954
Stone height 5″
WAG G-60-65

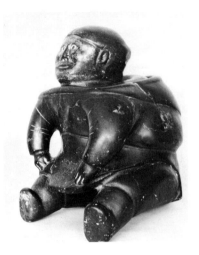
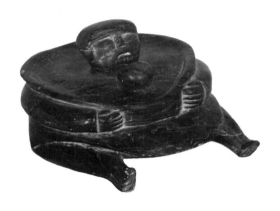
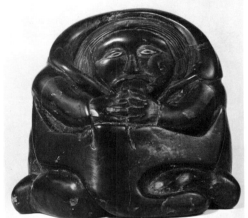
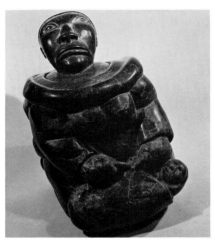
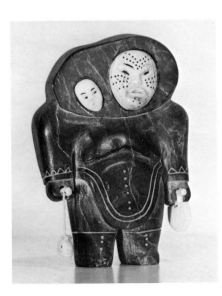
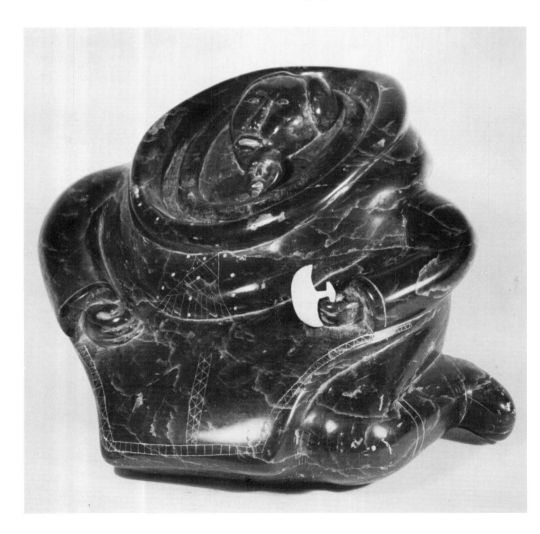

299/Syollie Weetaluktuk
(Sarollie/Syolee)
Inukjuak (Port Harrison) 1953 ?
Stone and ivory height 9³/₄″
CMC NA-519

300/Unidentified artist
(Philiposie Napartuk ?)
Inukjuak (Port Harrison) 1955
Stone with ivory inlay height 10¹/₂″
WAG G-60-40

301/Akeeaktashook ?
Inukjuak (Port Harrison) 1954
Stone height 7¹/₄″
WAG G-76-381

302/Unidentified artist
Inukjuak (Port Harrison) 1949
Stone and ivory height 6¹/₂″
TDB EC-72-66

303/Unidentified artist
Salluit (Sugluk) ? 1953
Stone and ivory height 6¹/₈″
TDB EC-72-71

304/Unidentified artist
Inukjuak (Port Harrison) 1954/5
Stone height 13¹/₄″
WAG G-60-41

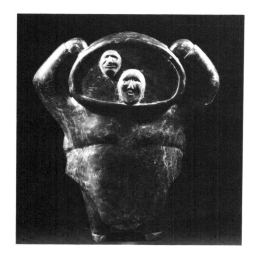

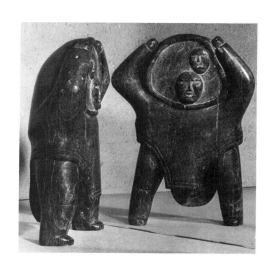

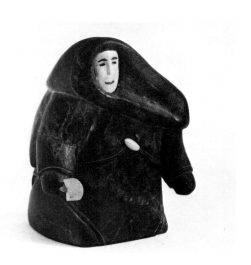

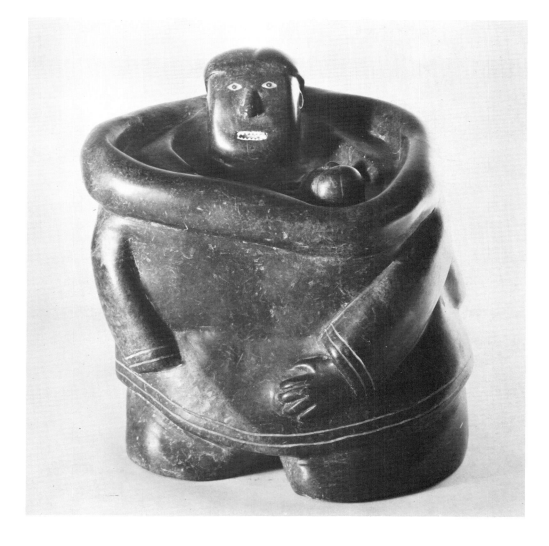

305/Elizabeth Tuki ?
(Elizabeth)
Inukjuak (Port Harrison) 1950
Stone height 2³/₈"

306/Unidentified artist
Inukjuak (Port Harrison) 1950 ?
Stone and ivory height 5¹/₄"
Avataq NA-615a-c

307/Pinnie Nuktialuk
Inukjuak (Port Harrison) 1954
Stone and ivory height 10¹/₂"
AGO 54/5

308/Unidentified artist
Inukjuak (Port Harrison) 1952
Stone with ivory height 7"
WAG G-60-49

309/Unidentified artist
Inukjuak (Port Harrison) 1952/3
Stone with ivory and inlay height 6¹/₂"
WAG G-60-140

162

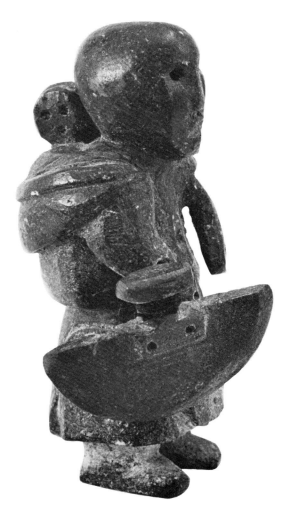

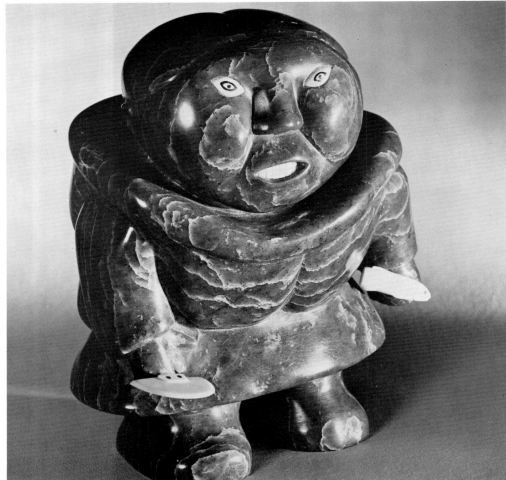

310/Unidentified artist
Inukjuak (Port Harrison) c. 1955
Stone height 8¹/₂"

311/Unidentified artist
Inukjuak (Port Harrison) 1949
Stone height 6³/₁₆"

312/Paulosie Sivuak
Povungnituk 1966
Stone height 5³/₈"
MCQ 66-293

313/Isah Qumalu Sivuarapi
(Isa Sheeg)
Povungnituk 1953 ?
Stone height 3³/₄"
CMC IV-B-1317

314/(Camp of) Akeeaktashook
(Philiposie Napartuk ?)
Inukjuak (Port Harrison) 1949/50
Stone and polychrome inlay height 4¹/₈"
(cf. 258 and 291)

315/Isapik Smith
(Isah Aullalu)
Povungnituk 1955 ?
Engraved stone height c. 6¹/₂"
Avataq NA-120

316/Pauloosie Kanaju
(Kenourak)
Povungnituk 1959 ?
Stone height c. 3¹/₂"

163

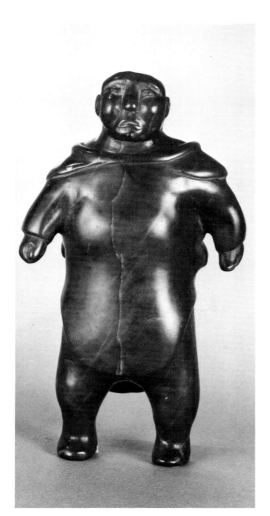

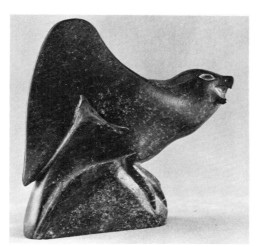

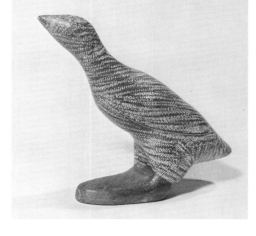

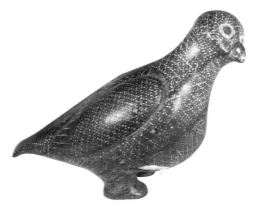

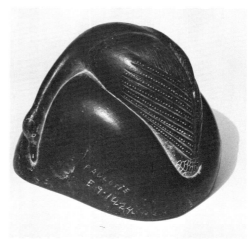

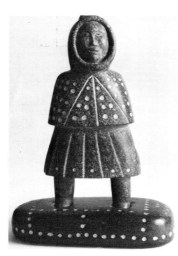

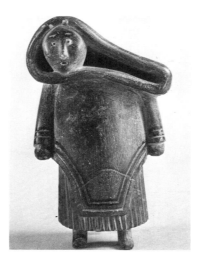

317/David Irqu Irqumia
(Davidee)
Povungnituk 1961
Stone height c. 11″

318/Josie Pamiutu Papialuk
(Paperk/Poppy)
Povungnituk 1967
Stone width 4⁵/₈″
(also 206)

319/Johnny Angutigulu Novalinga
(Johnny POV)
Povungnituk 1961
Stone and bone height 7″

320/Aisapik Quma Igauja
(Isapik)
Povungnituk 1962
Stone length 6¹/₂″
WAG 2019-71

321/Samisa Passauralu Ivilla
(Shamasha)
Povungnituk 1956/7
Stone with engraved lines length 5³/₄″
WAG G-60-134

322/Charlie Sivuarapik
(Arnaituk/Argnaituq))
Povungnituk 1958
Stone heights 6⁵/₈″ and 9¹/₂″
WAG 2006/7-71
(also 188)

323/Aisa Qupirualu Alasua
(Qupiraluk/Koperqualik/Koperqualook)
Povungnituk 1948
Stone, bone, and ivory height 3⁵/₈″

324/Aisa Qupirualu Alasua
(Koperqualook)
Povungnituk 1948
Stone, pigment, and bone length 4⁵/₈″

164

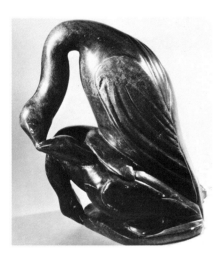
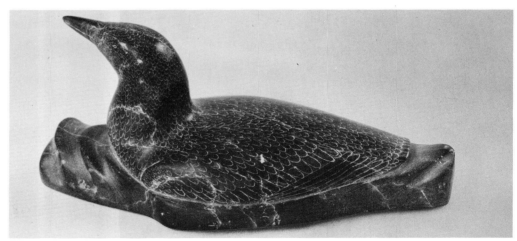
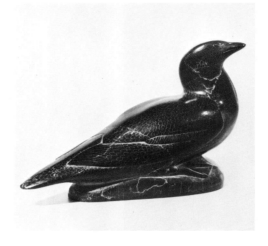
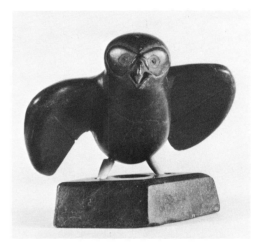

325/Isapik Smith
(Isah Aullalu)
Povungnituk 1962
Stone length 8½"
WAG 1979-71

326/Joanassie Smith
Povungnituk 1958
Stone length 13¾"
WAG 1988-71

327/Johnial Johmal
Povungnituk 1957
Stone length 8"
WAG G-60-114

328/Unidentified artist
Povungnituk 1953/4
Stone and ivory length 9"
WAG G-60-21

329/Unidentified artist
Povungnituk 1950
Stone, ivory, and bone width 3¹⁵/₁₆"

330/Unidentified artist
Povungnituk 1948?
Stone length 3½"

331/Josie Pamiutu Papialuk
(Josie Paperk/Poppy)
Povungnituk 1957
Stone length 7"
WAG G-60-112

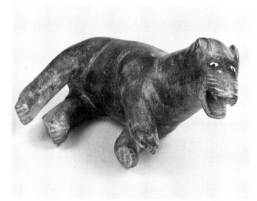
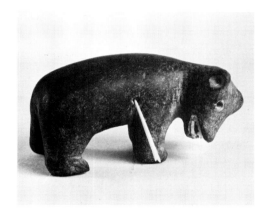
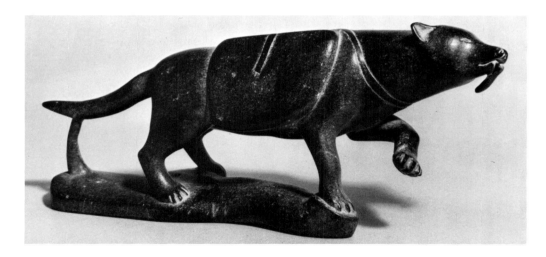
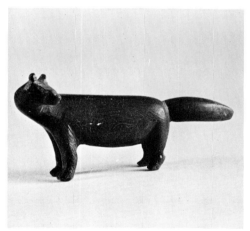
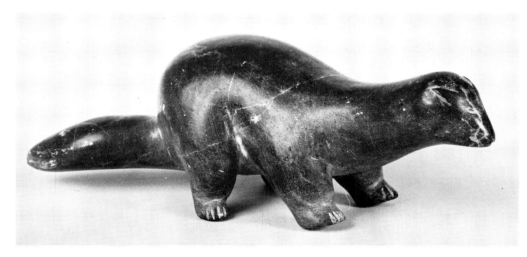
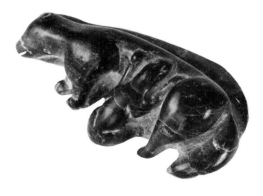

332/Levi Qumaluk
(Kumalik)
Povungnituk 1955
Stone length 12″
Avataq NA-120

333/Unidentified artist
Povungnituk 1948 ?
Stone and bone height 5″

334/Makusi Qalingo Angutikirq
(Kalingo)
Povungnituk 1955
Stone, ivory, and sinew height 5³/₄″
CMC NA-128

335/Juanisialu Irqumia
(Juanasialuk)
Povungnituk 1955
Stone, ivory, and leather height c. 5¹/₄″
Avataq NA-59a-d

336/Peesee Oshuitoq (re-a)
(Oshooweetook "A")
Cape Dorset 1955
Stone and ivory length c. 11″
ICI NA-60
(not Anautak from POV)

337/Unidentified artist
Povungnituk 1955
Stone length 6³/₄″
WAG G-60-136

338/Juanisi Irqumia Kuanana
(Johnassie)
Povungnituk 1955
Stone length 8″
CMC NA-269

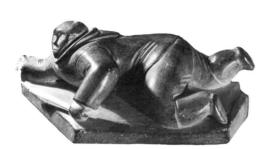
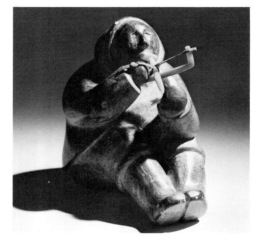
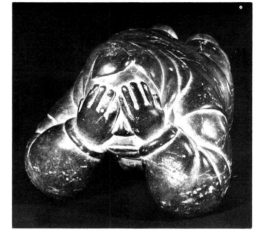
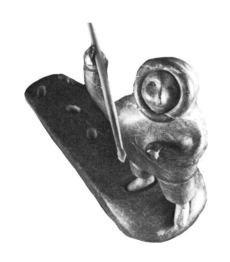
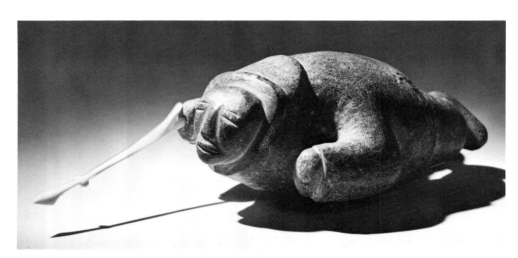
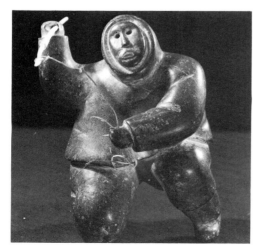
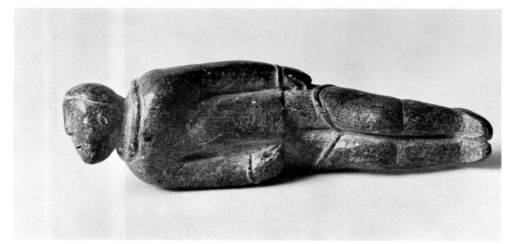

339/Simon Qissualu Aliqu
(Simon Qitsualuk)
Akulivik (Cape Smith) 1957
Stone height c. 4½″

340/Juanasialu Irqumia
(Juanasialuk)
Povungnituk 1956
Stone and ivory length 12½″
CMC IV-B-1279

341/Aisa Ajagutaina Tukala
(Arrogtaniak)
Povungnituk 1957
Stone, bone, and leather height 6½″
WAG G-60-159

342/Thomassiapik Sivuarapik
Povungnituk 1957
Stone length c. 7″
(Charlie's son, cf. 346; not Isah Sheeg)

343/Samisa Passauralu Ivilla
(Shamasha)
Povungnituk c. 1958
Stone and bone height 11½″
WAG G-72-194

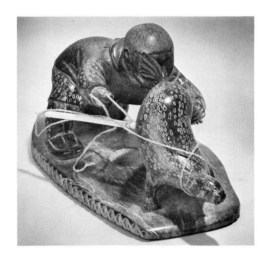

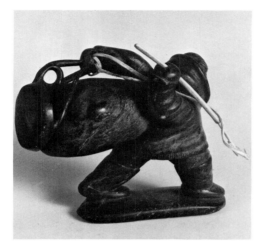

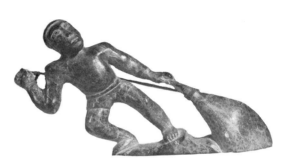

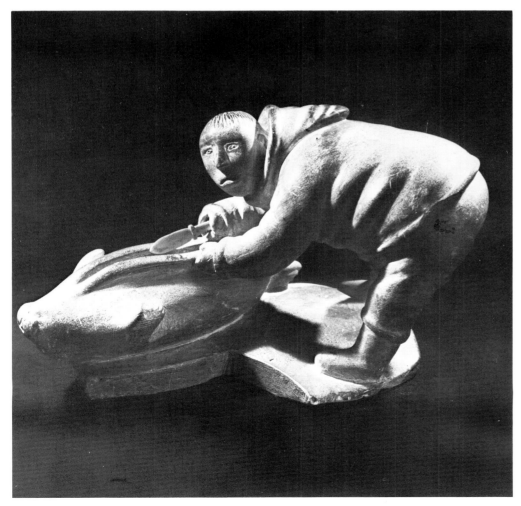

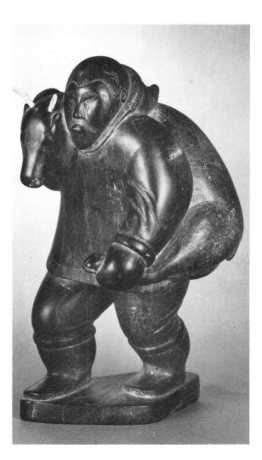

344/Peter Nauja Angiyu
(Peter Nowya)
Povungnituk 1961
Stone height 12½"
WAG G-62-3

345/Levi Qumaluk
Povungnituk no date
Stone height 11"
TDB EC-72-39

346/Charlie Sivuarapik
(Arnaituk/Argnaituk)
Povungnituk 1957
Stone and ivory height 6"
(cf. 342)

347/Unidentified artist
Povungnituk 1948
Stone and wood height 3"

348/Annie Niviaxie ?
Kuujjuaraapik (Great Whale River) 1966
Stone width 8"

349/Makusi Nunga Kuanana
(Quananak)
Povungnituk 1958
Stone length 8¾"
TDB EC-7

168

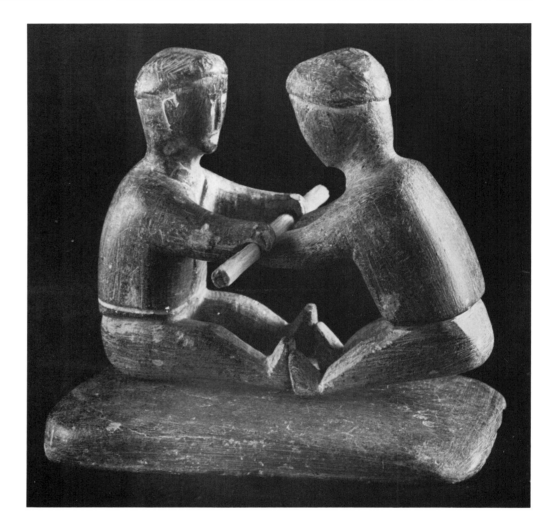

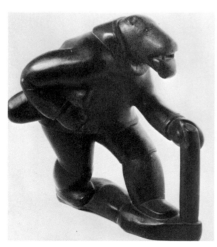

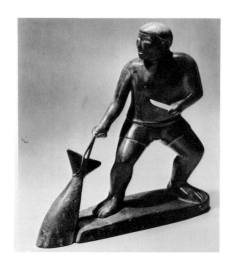

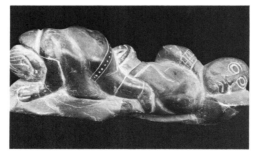

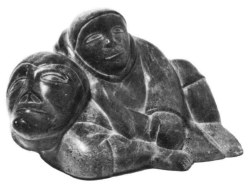

350/Davidialuk Alasua Amittu
(Davideealuk)
Povungnituk 1958
Stone length c. 15"
CMC IV-B-1352

351/Eliassieapik Napatu
(Ilisapi Aullalu)
Povungnituk 1959
Stone length 8½"
WAG G-76-409

352/Aisa Qupirualu Alasua
(Qupirqualuk/Koperqualook)
Povungnituk 1955
Stone and ivory length c. 11"
WAG G-60-70

353/Aisa Qupirualu Alasua
(Qupirqualuk/Koperqualook)
Povungnituk 1959?
Stone length c. 13"
AGO S1002

354/Juanisi Irqumia Kuanana
(Johnassie)
Povungnituk 1958/9
Stone length 10¾"
WAG G-76-403

355/Unidentified artist
Povungnituk 1958/9
Stone length 15"

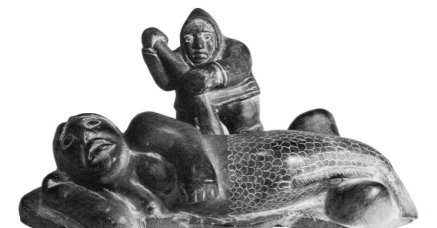

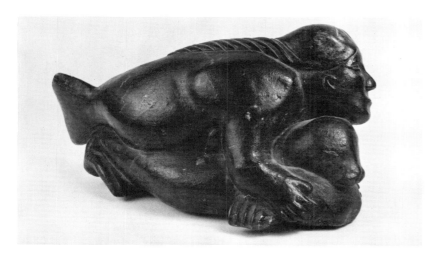

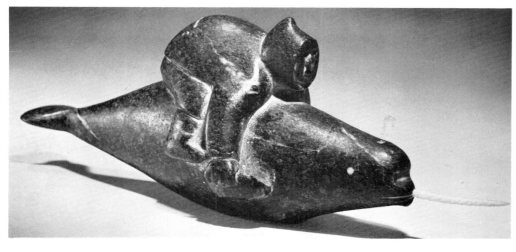

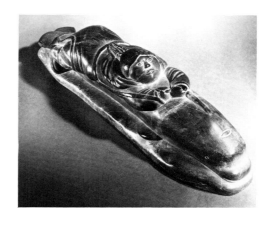

356/Pilipusi Tukai ?
(Pillipussie ?)
Povungnituk 1948
Stone, ivory, soap and cardboard height 2¾"

357/Matiusi Manukulu Qilugi
(Maliki)
Povungnituk 1953
Stone width 9¾"
WAG G-85-359

359/Joe Talirunili
Povungnituk 1965
Stone, ivory, wood, leather height 12"

358/Peter Iqallu Angutikirq
(Peter Angutik)
Povungnituk 1957
Stone height 13½"

360/Joe Talirunili
Povungnituk 1964
Stone height 6"

361/Joe Talirunili
Povungnituk 1966
Stone length 7¹⁄₁₆"
MCQ 66-374

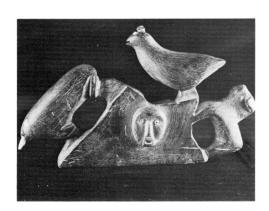

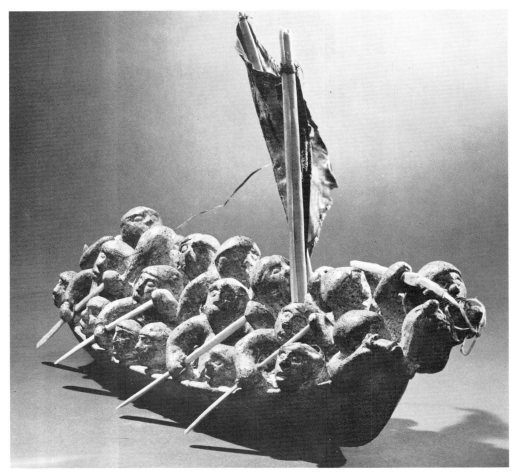

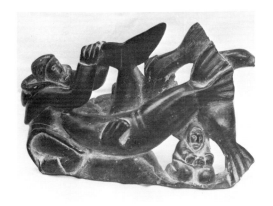

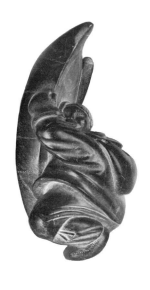

362/Davidialuk Alasua Amittu
(Davideealuk)
Povungnituk 1960 ?
Stone (detail) height 4″
EMC C68.14-1

363/Davidialuk Alasua Amittu
(Davideealuk)
Povungnituk 1959
Stone length 11³/₄″

364/(bottom view of 363)

365/Davidialuk Alasua Amittu
(Davideealuk)
Povungnituk 1959
Stone length 14″
CMC IV-C-1336

366/Davidialuk Alasua Amittu
(Davideealuk)
Povungnituk 1966
Stone height 6³/₄″
MCQ 66-358

367/Davidialuk Alasua Amittu
(Davideealuk)
Povungnituk 1963
Stone height 10¹/₄″
EMC C69.28-1

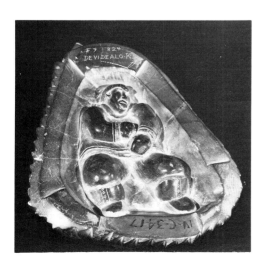

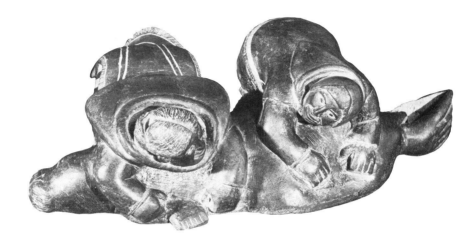

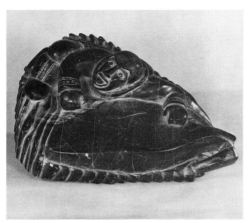

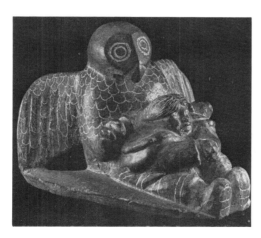

368/Davidialuk Alasua Amittu
(Davideealuk)
Povungnituk 1958
Stone height 16³/₄″
WAG 1953-71

369/Davidialuk Alasua Amittu
(Davideealuk)
Povungnituk 1959
Stone height 7″
TDB EC-82-629

370/Davidialuk Alasua Amittu
(Davideealuk)
Povungnituk 1968
Stone height 4¹/₂″
MCQ 68-3450 (cf. 204)

371/Davidialuk Alasua Amittu
(Davideealuk)
Povungnituk 1958
Stone height 6″

372/Davidialuk Alasua Amittu
(Davideealuk)
Povungnituk 1960/1
Stone lengths 3¹/₂″ and 5¹/₂″
WAG G-72-138 & 1959-71

373/Davidialuk Alasua Amittu
(Davideealuk)
Povungnituk 1958
Stone height 8″

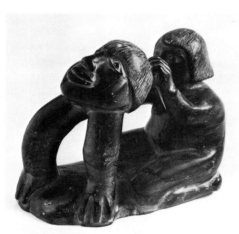

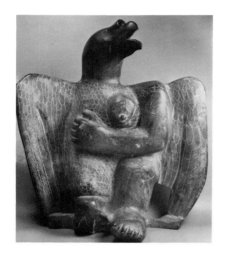

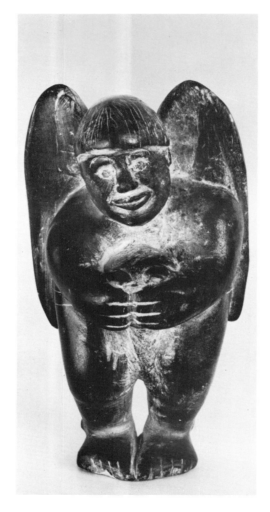

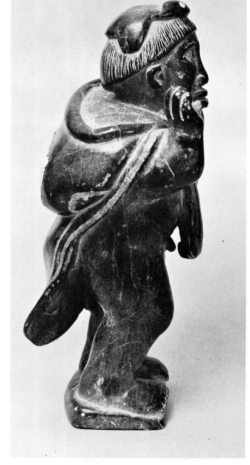

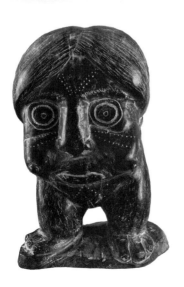

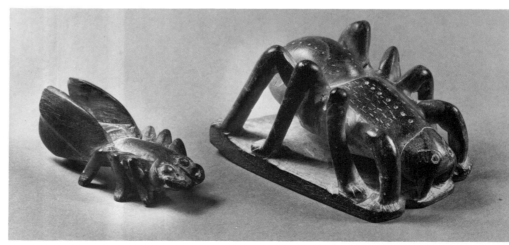

374/Eli Sallualu Qinuajua
(Eli Sallualuk)
Povungnituk 1963
Stone height 7″
WAG G-76-407

375/Eli Sallualu Qinuajua
(Eli Sallualuk)
Povungnituk 1969
Stone height 21″
AGO 89/657

376/Eli Sallualu Qinuajua
(Eli Sallualuk)
Povungnituk 1968
Stone height 5³/₄″
MCQ 69-354

377/Eli Sallualu Qinuajua
(Eli Sallualuk)
Povungnituk 1966
Stone height 2¹/₈″

378/Eli Sallualu Qinuajua
(Eli Sallualuk)
Povungnituk 1967
Stone height 2¹/₂″
WAG G-76-390

379/Levi Qumaluk
Povungnituk 1968
Stone height 4³/₄″
WAG G-76-399
(also 98)

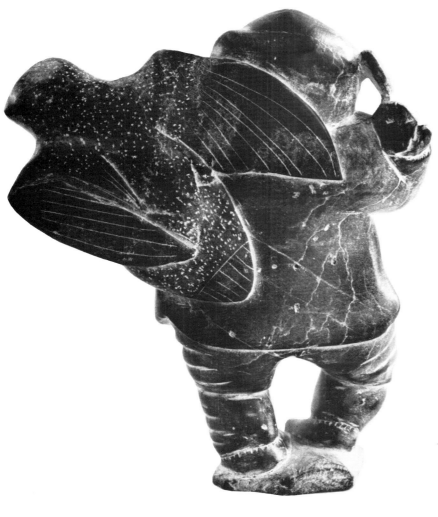

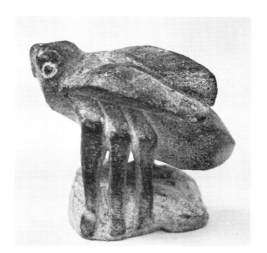

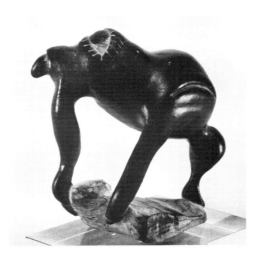

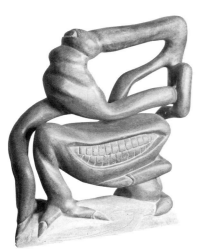

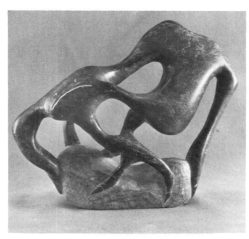

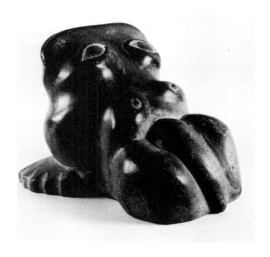

380/Peter Iqallu Angutikirq
(Peter Angutik)
Povungnituk 1968
Stone height 4⁷/₈″
CMC IV-B-1396

381/Juniapi Angutigulu Uqaitu
(Johnnieapik)
Povungnituk 1963
Stone height 8³/₈″
WAG 3034-71

382/Lukasi Passauralu Qinuajua
(Lucassie Sam, signature)
Akulivik (Cape Smith) 1968
Stone height 3¹/₂″
CMC IV-B-1412

383/Isah Qumalu Sivuarapi
(Isa Sivuarapik/Isah Sheeg)
Povungnituk 1968
Stone height 2³/₄″
WAG G-76-393
(also 191)

384/Peter Iqallu Angutikirq
(Peter Angutik)
Povungnituk 1964
Stone height 4¹/₄″

385/Leah Qumaluk
Povungnituk 1968
Stone height 3″
CMC IV-B-1405

386/Levi Alasua Pirti Smith
(Levi Smith)
Povungnituk 1968
Stone height 9″
(also 190)

387/Johnny Qaqutuq
Povungnituk 1969
Stone height 5¹/₄″

174

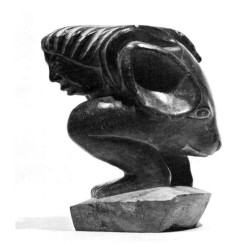
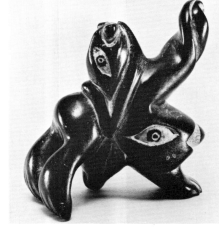
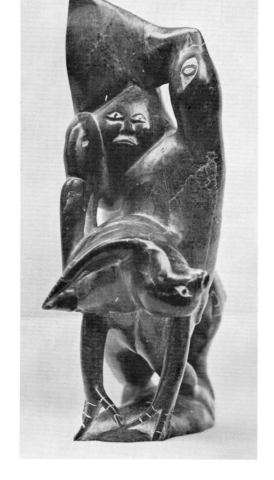
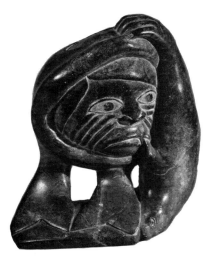
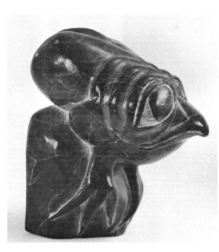
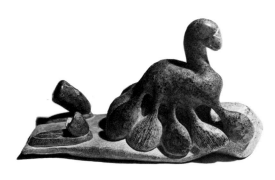
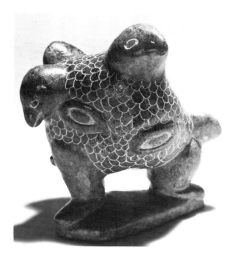
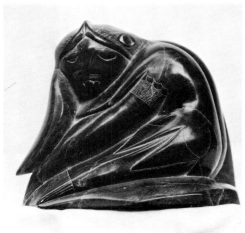

388/Aisa Qupirualu Alasua
(Qupirqualuk/Koperqualook)
Povungnituk 1953
Stone with inlaid eyes height 5¹/₄″
WAG G-60-52

389/Juniapi Angitigulu Uqaitu
(Johnnieapik)
Povungnituk 1960
Stone length 8⁷/₈″
WAG G-76-394

390/Daniel Quma Angiyu
(Qumak)
Povungnituk 1961
Stone height 8″

391/(Camp of) Johnny Inukpuk (re-a)
Inukjuak (Port Harrison) 1954 ?
Stone and ivory height 13¹/₂″
MMFA 1955, aa.1

392/Isah Qumalu Sivuarapi
(Isa Sivuarapik/Isah Sheeg)
Povungnituk 1967
Stone height 4⁵/₈″
(also 36)

393/Charlie Sivuarapik
(Arnaituk/Argnaituk)
Povungnituk 1958
Stone height 11″
CMC IV-B-1297

394/Charlie Sivuarapik
(Arnaituk/Argnaituk)
Povungnituk 1954 ?
Stone height 8¹/₄″
NGC 9609

395/Isah Qumalu Sivuarapi
(Isa Sivuarapik/Isah Sheeg)
Povungnituk 1968
Stone height 17¹/₂″
MCQ 71-99

175

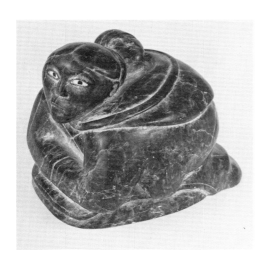
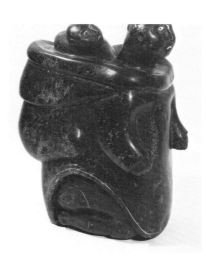
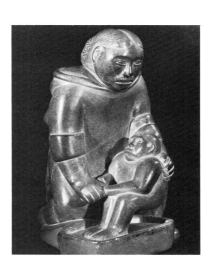
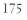

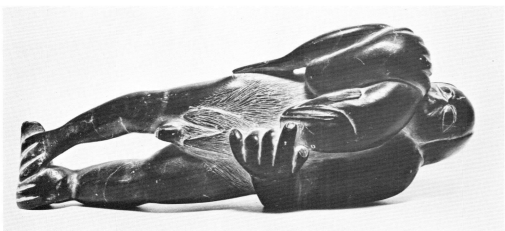

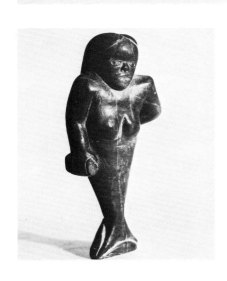
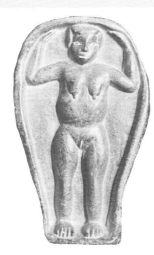
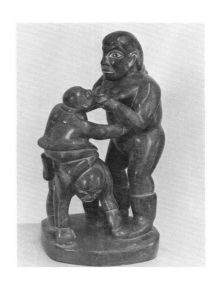

396/George Kopak Tayarak ?
(Kopak/Qupak)
Salluit (Kangiqsujuaq) 1963
Stone length 17″
TDB EC-75-480

397/Unidentified artist
Kangiqsujuaq (Wakeham Bay) 1969 ?
Stone height 6⅛″
EMC C69.44-1

398/Johnny Pakarti Qiisiq
(Kushuk)
Kangiqsujuaq (Wakeham Bay) 1965
Stone length 14″
WAG G-62-110

399/Elsie Emuk
(Empuk)
Kangiqsualujjuaq (Kangiqsujuaq) 1967
Stone length 7″
WAG G-76-639

400/Sammy Nassak
Kangirsuk (Payne Bay) 1966
Stone length 6⅝″
MCQ 66-178

401/Sammy Nassak
Kangirsuk (Payne Bay) 1966
Stone length 7″
MCQ 66-191

402/Unidentified artist
Kangirsuk (Payne Bay) 1960
Stone height 5½″

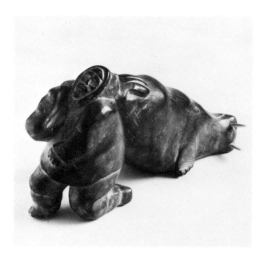

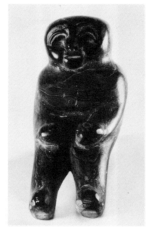

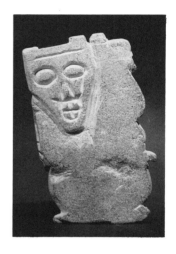

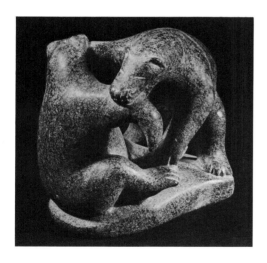

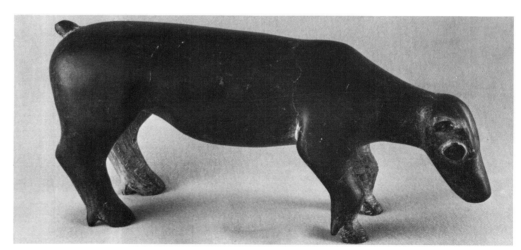

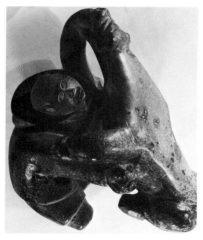

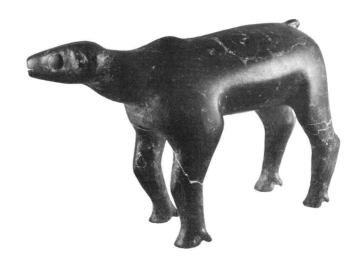

403/Manu Kanarjuak Qaunnaaluk
Ivujivik 1958
Stone height 4"
CMC NA-664

404/Unidentified artist
Ivujivik 1967 ?
Stone height 2⁷/₈"
ECM C67.11-1

405/Paulusi Qaunnaaluk
(Qaunaluk)
Ivujivik 1962
Stone height c. 7"
WAG 1648-71

406/Joanasi Audlak
(Aullak)
Ivujivik 1963/4
Stone length 6¹/₂"
WAG G-76-301

407/Johnny Cain
Kuujjuaq (Fort Chimo) 1966
(Baie aux Feuilles/Tasseujarq)
Stone height 5⁵/₈"
MCQ 66-162

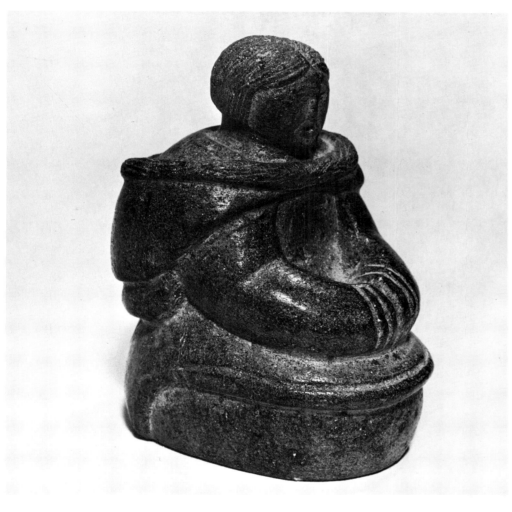

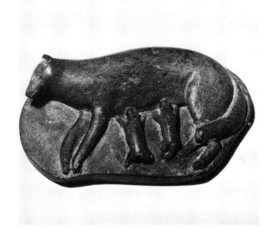

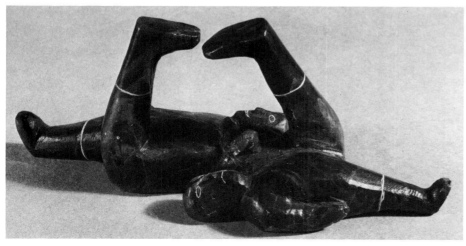

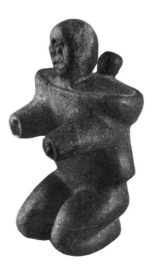

408/Maggie Ittunik Tayaraq
(Taiarak/Tyara)
Salluit (Sugluk) 1955 ?
Stone height 7″
Avataq NA-1386

409/Sarah Imadlak Tayaraq
(Imala)
Salluit (Sugluk) 1955
Stone height 11¼″
CMC NA-251

410/Unidentified artist
Salluit (Sugluk) c. 1956
Ivory engraved and polychromed height 4⅛″

411/Mary Irqiquq Sorosiluk
(Miaiji Iqikuk)
Salluit (Sugluk) 1953
Stone height 8½″
WAG G-60-630

412/Unidentified artist
Salluit (Sugluk) 1952/3
Stone, bone, and pencil height 14″
WAG G-60-43

413/Alacie Sakiagaq
(Alisi Taiarak)
Kangiqsujuaq (Salluit) 1954
Stone height 8½″

178

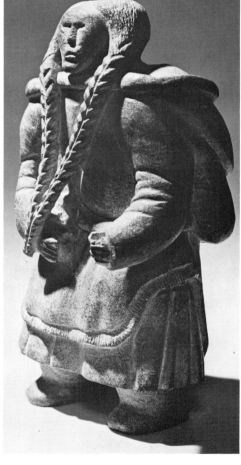

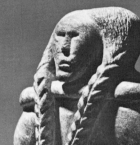

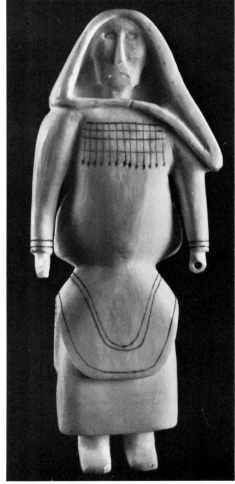

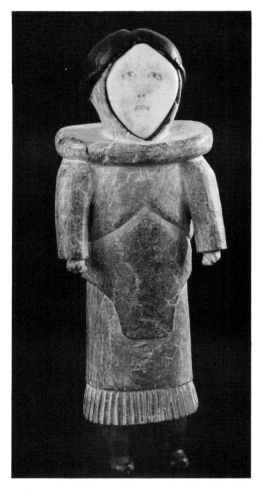

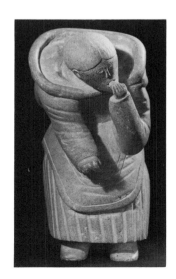

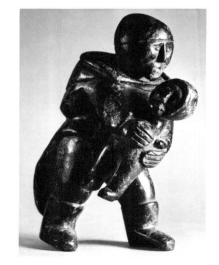

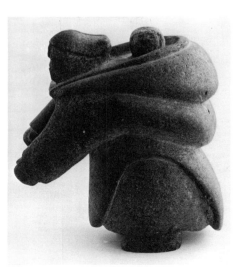

414/Unidentified artist
Salluit (Sugluk) 1952/3
Stone height c. 7″

415/Unidentified artist
Salluit (Sugluk) 1955
Stone length 5¼″

416/Mary Irqiquq Sorosiluk
(Miaiji Iqikuk)
Salluit (Sugluk) 1955
Stone height 7½″
WAG G-60-73

417/Mary Irqiquq Sorosiluk
(Miaiji Iqikuk)
Salluit (Sugluk) 1957
Stone height 8¼″
WAG G-60-68

418/Mark Kadyulik
(Kadjulik)
Salluit (Sugluk) 1959
Stone height 3″

419/Unidentified artist
Salluit (Sugluk) 1949 ?
Stone length 5⅛″

420/Unidentified artist
Salluit (Sugluk) 1957
Stone length 10¼″
WAG G-60-37

179

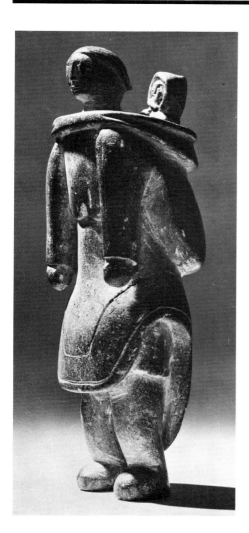
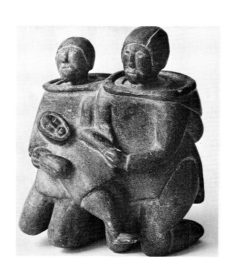

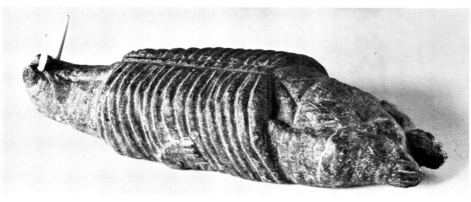
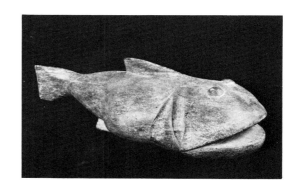

421/Unidentified artist
Salluit (Sugluk) 1955
Stone and bone width 3¾"

422/Willie Kulluajuk Papigatok
(Uili Kulluajuk)
Salluit (Sugluk) 1957
Stone height 4½"
WAG G-60-75

423/Unidentified artist
Hudson Straits (Salluit ?) 1949
Bone and ivory length 8½"

424/Thomasie Angutigirk
Salluit (Sugluk) 1958 ?
Stone height 13½"
TDB EC-75-307

425/Charlie Kalingoapik Angutigirk
Salluit (Sugluk) 1960
Stone length 9⅝"
WAG 3988-71

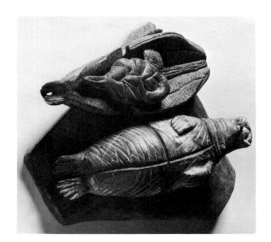

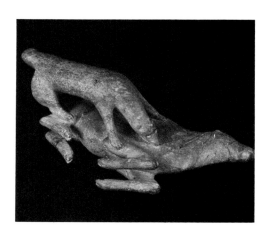

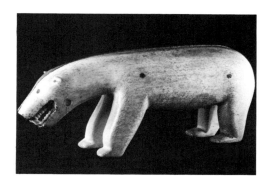

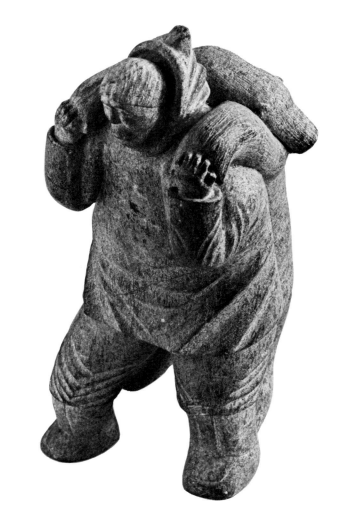

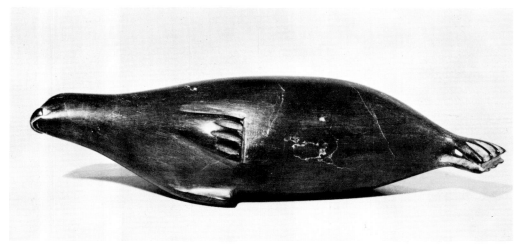

428/Kananginak Pootoogook
Cape Dorset 1956/7
Stone height 11¾″

429/Sheokjuq Oqutaq
(Sheeookjuk)
Cape Dorset 1964/5
Stone height 5¾″
MMFA 1966.aa.3

426/Iyola Kingwatsiaq
(Iola/Aiulaa)
Cape Dorset 1960
Stone height 8″
ICI NA-927

430/Niviaksiak
Cape Dorset 1959?
Stone height 14″
CMC NA-960

427/Niviaksiak
Cape Dorset 1957/8
Stone length 9½″
WAG G-60-101

431/Osuitok Ipeelee
(Oshooweetook "B")
Cape Dorset 1970
Stone and bone height c. 11¾″
CMC IV-C-4098 a-c

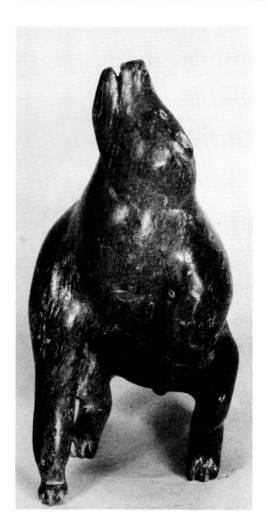

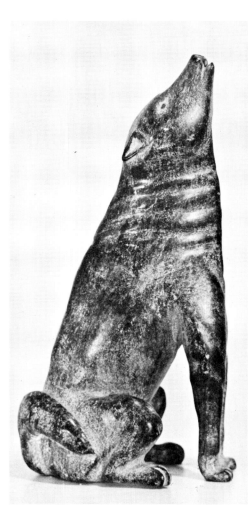

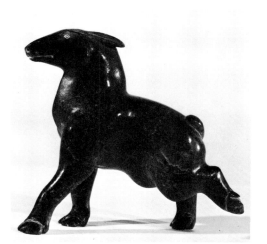

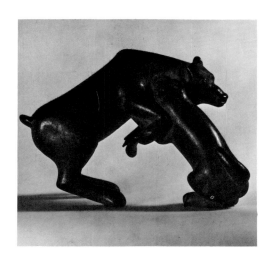

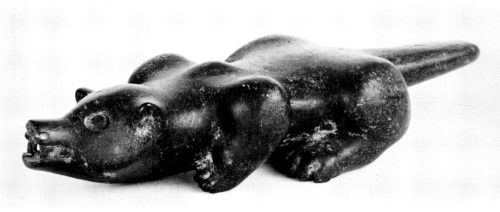

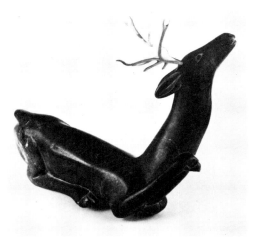

432/Sharky Noona
(Sarkee)
Cape Dorset 1968
Stone width 10″

433/Davidee Mannumi
(Tavitee)
Cape Dorset before 1953
Stone and ivory height 3″
MMFA 1955.aa.7

434/Kiawak Ashoona
(Kiawak)
Cape Dorset 1968
Stone height 20″
AGO 90/540

435/Timothy Ottochie
Cape Dorset 1965
Stone length 15″

436/Ningeosak Pudlat
(Ningoochiak)
Cape Dorset 1959 ?
Stone height 2⁷/₈″
(formerly attributed to Sheeookjuk)

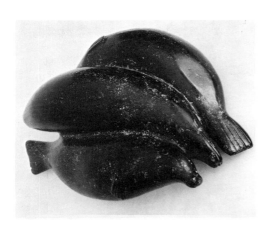

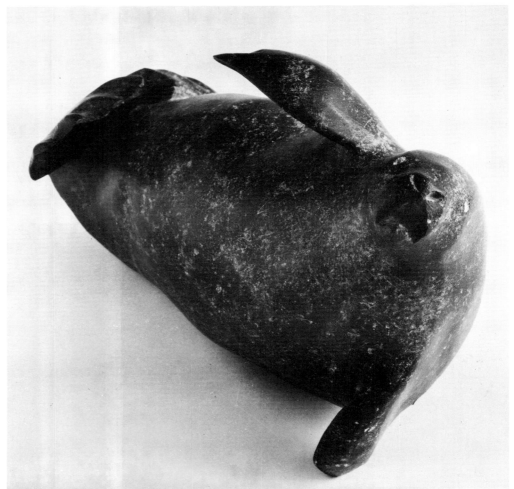

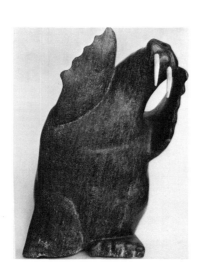

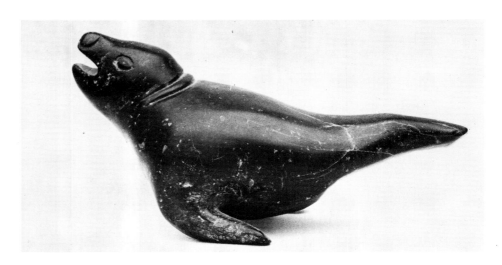

437/Kiakshuk
Cape Dorset 1959 ?
Whalebone height 5″
ICI NA-922

438/Abraham Etungat
(Eetungeet/Etungate)
Cape Dorset c. 1963
Stone height 10″

439/Kiakshuk
Cape Dorset 1959 ?
Whalebone with inset eyes width 2³/₄″
ICI NA-859

440/Unidentified artist
Cape Dorset 1968
Stone height 2¹/₄″

441/Tudlik
Cape Dorset 1960
Stone height 3³/₄″

442/Kuppapik Ragee
(Kopapik "B"/Kooparpik)
Cape Dorset 1962
Stone height 4¹/₄″

443/Lukta Qiatsuk
(Lukta/Qiatsuq)
Cape Dorset no date
Stone height 4″
CMC NA-8700

444/Pudlo Pudlat
(Pudlo)
Cape Dorset 1967
Stone height 12″

183

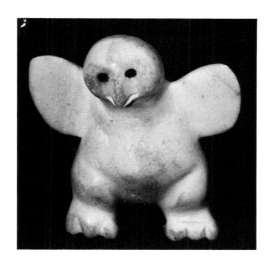

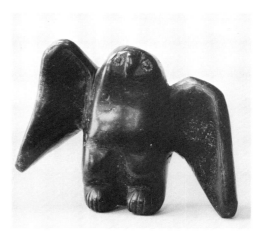

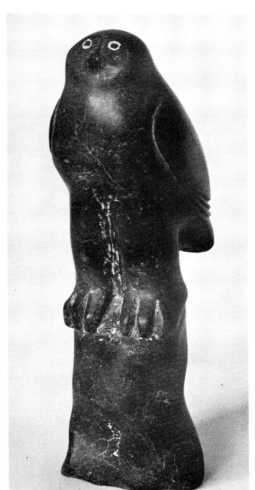

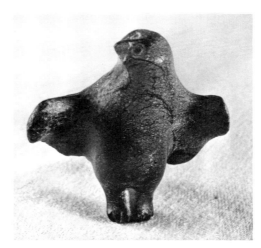

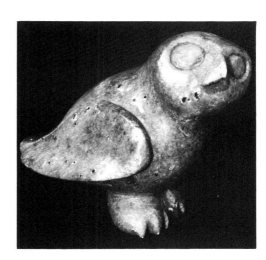

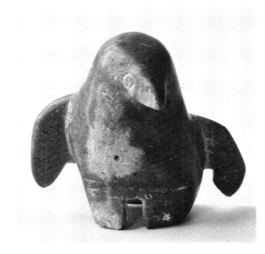

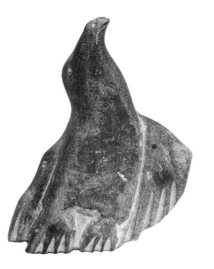

445/Tudlik
Cape Dorset 1961
Ivory height 6⅝″

446/Unidentified artist
Cape Dorset no date
Stone height 6″

447/Lukta Qiatsuk
(Lukta/Qiatsuq)
Cape Dorset c. 1954
Stone height 7⅝″
CMC NA-879

448/Iyola Kingwatsiak
(Iola/Aiulaa)
Cape Dorset 1962
Stone height 6¾″
WAG G-60-117

449/Niviaksiak
Cape Dorset 1954 ?
Stone height 9″
ICI NA-37

450/Kenojuak Ashevak
(Kenojuak)
Cape Dorset 1969
Stone height 17″

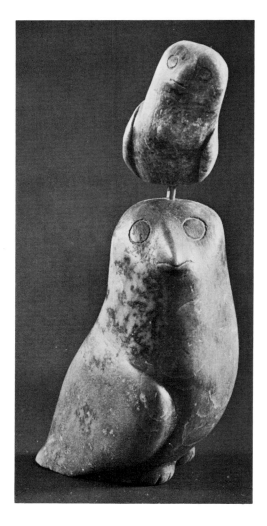

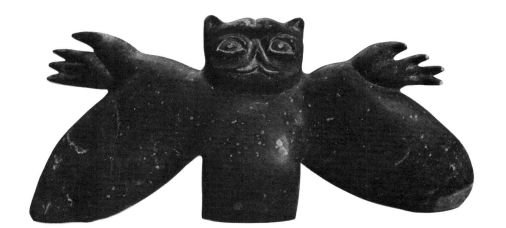

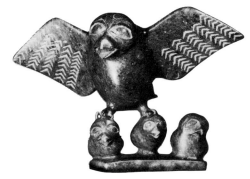

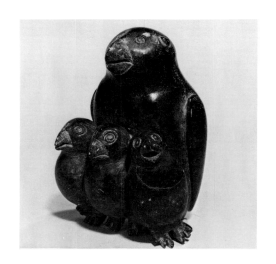

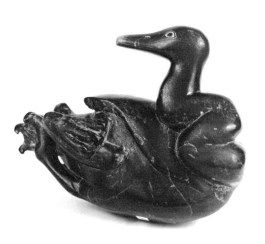

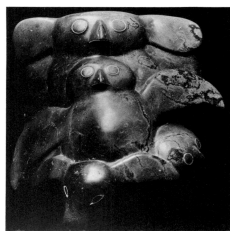

451/Tudlik
Cape Dorset 1960
Stone height 2⁵/₈″

452/Joanassie Qayuayuk
(Qukjurakjuk)
Cape Dorset 1960
Stone (engraved) height c. 2¹/₂″

453/Kiawak Ashoona
(Kiawak)
Cape Dorset 1965 ?
Stone length 20″

454/Peter Pitseolak
Cape Dorset 1965 ?
Stone height 10″
TDB EC-72-27

455/Pauta Saila
(Pauta)
Cape Dorset 1952
Stone height 11¹/₈″
(formerly attributed to Tudlik)

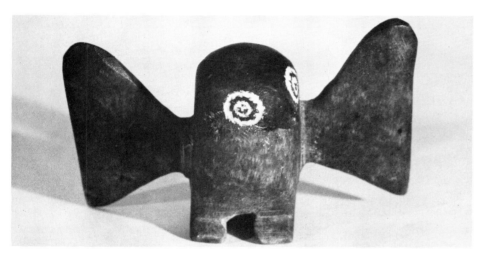

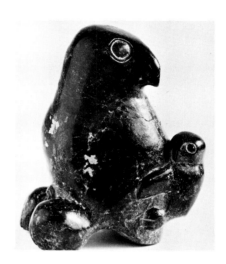

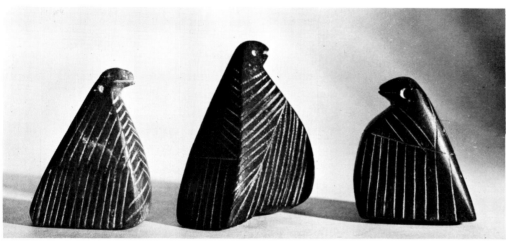

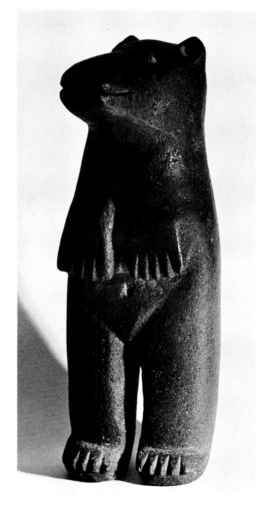

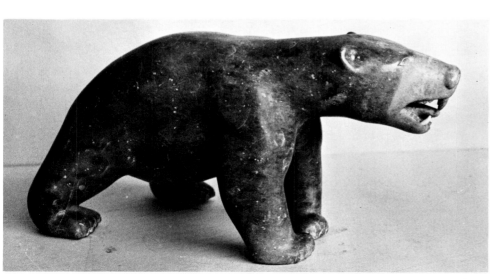

456/Peter Pitseolak
Cape Dorset 1955
Stone height 7¹/₁₆″

457/Tudlik
Cape Dorset 1959
Stone height 4⁷/₈″

458/Samuellie Tunnillie
Cape Dorset 1953
Stone and ivory heights 4¹/₂″ and 5¹/₈″
(l) --- (r) CGCM 247.

459/Kananginak Pootoogook
(Kananginak)
Cape Dorset 1968
Stone and ivory height c. 12″
TDB EC-82-601
(also 12)

460/Joe Jaw
(Jya/Yaw)
Cape Dorset 1967
Stone and bone height 4″

461/Pauta Saila
(Pauta)
Cape Dorset 1956/7
Stone height 8″

186

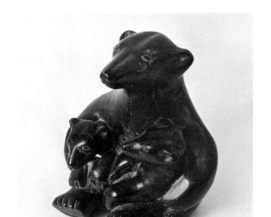

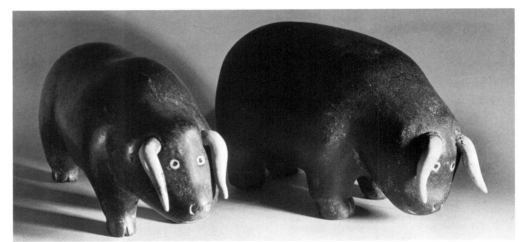

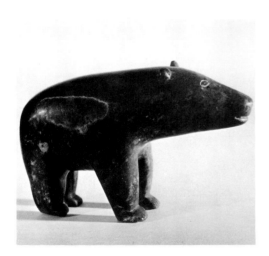

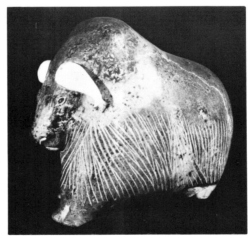

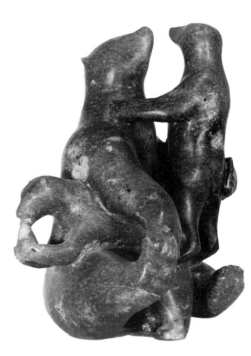

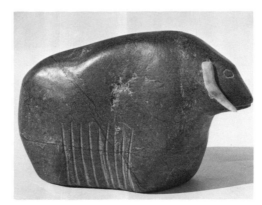

462/Pauta Saila
(Pauta)
Cape Dorset 1961/2
Stone height 16¼″
WAG 1042-71

463/Pauta Saila
(Pauta)
Cape Dorset 1963
Stone height 12½″

464/Pauta Saila
(Pauta)
Cape Dorset 1962 and 1963
Stone heights 16¼″ and 14″

465/Pauta Saila
(Pauta)
Cape Dorset 1966
Stone width 12″

466/Pauta Saila
(Pauta)
Cape Dorset 1964
Stone height 4⅜″
WAG 1042-71

467/Pauta Saila
(Pauta)
Cape Dorset 1963
Stone height 10¾″

468/Pudlat Pootoogook
(Pudlat "A")
Cape Dorset 1967
Stone height 13¼″
(another view of 60, formerly Pauta)

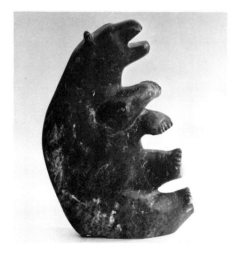

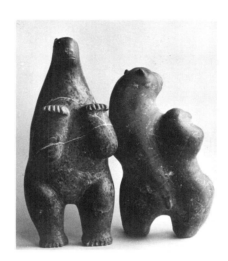

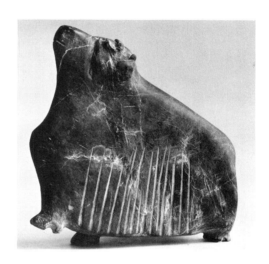

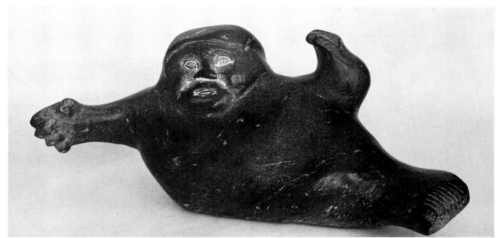

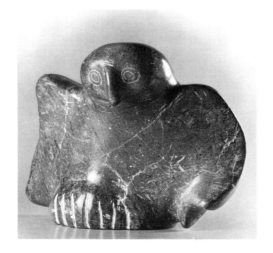

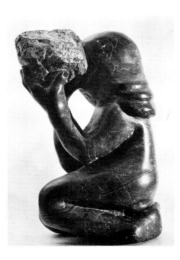

469/Latcholassie Akesuk
(Lassaulassi)
Cape Dorset 1969
Stone height c. 14″

470/ Latcholassie Akesuk
(Lassaulassi)
Cape Dorset 1962
Stone height 7″

471/Tudlik
Cape Dorset 1957/8
Stone height 3¾″

472/Latcholassie Akesuk
(Lassaulassi)
Cape Dorset 1967
Stone height 7⅝″

473/Latcholassie Akesuk
(Lassaulassi)
Cape Dorset 1962
Stone height 9¼″

474/Latcholassie Akesuk
(Lassaulassi)
Cape Dorset 1968
Stone height 14″
EAG 70.5

475/Latcholassie Akesuk
(Lassaulassi)
Cape Dorset 1966
Stone height 9½″
AGO S2651

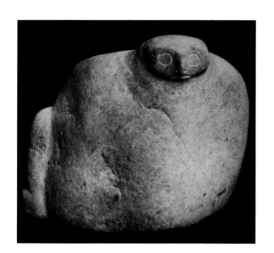

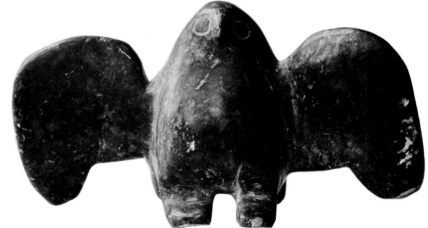

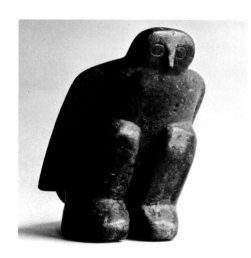

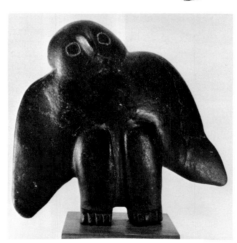

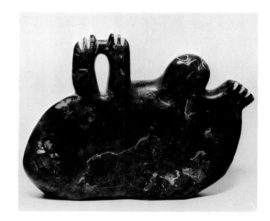

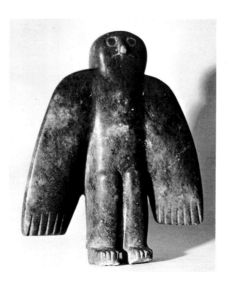

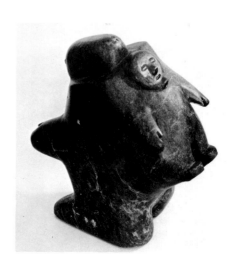

476/Aqjangajuk Shaa
(Axangayuk)
Cape Dorset 1963
Stone height 14½"
MMFA 1963.aa.4

477/Aqjangajuk Shaa
(Axangayuk)
Cape Dorset 1964
Engraved walrus tusk (detail) height c. 2½"
AGO S2099

478/Aqjangajuk Shaa
(Axangayuk)
Cape Dorset 1964?
Stone width 17½"
(frontal view of 4)

479/Aqjangajuk Shaa
(Axangayuk)
Cape Dorset 1963
Stone height 12½"

480/Aqjangajuk Shaa
(Axangayuk)
Cape Dorset 1966
Stone width 18½"
AGO 78/199

481/Kiawak Ashoona
(Kiawak)
Cape Dorset 1964?
Stone height 17"
MMFA 1965.aa.8

482/Kiawak Ashoona
(Kiawak)
Cape Dorset 1963?
Stone height 8¼"
(also 31)

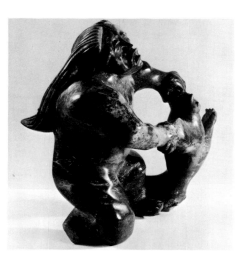

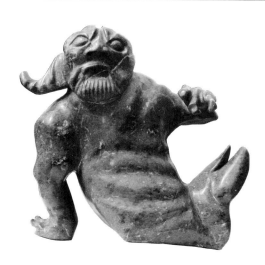

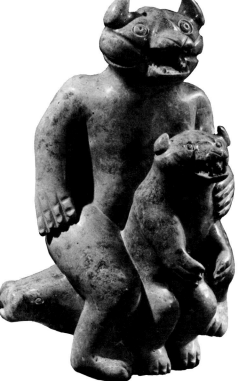

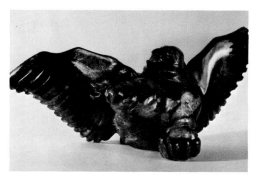

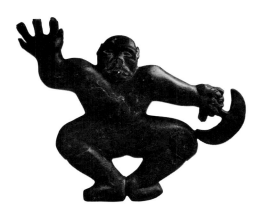

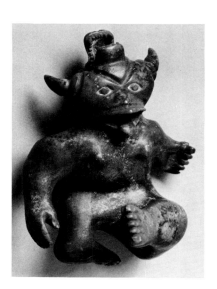

483/Aggeak Petaulassie
(Aggiak)
Cape Dorset 1963
Stone length 19˝
MMFA 1963.aa.3
(also 213)

484/Unidentified artist
Cape Dorset 1968
Stone height c. 16˝

485/Unidentified artist
Cape Dorset c. 1952
Stone height 6¾˝
WAG G-76-105

486/Qabaroak Qatsiya
(Kavagoak/Kabubawakota/Kabubuwa)
Cape Dorset 1968/9
Stone length 27¼˝
MMFA 1974.aa.10

487/Mikigak Kingwatsiak
Cape Dorset 1964/5
Stone length 12˝
WAG 1020.71

488/Osuituk Ipeelee
Cape Dorset 1963/4
Stone height 10˝
(former attribution: Eegyvudluk Pootoogook)

190

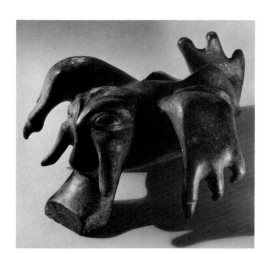
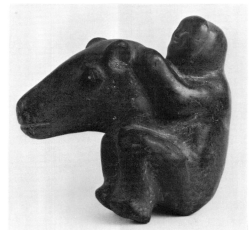
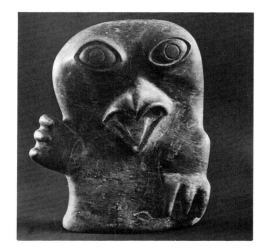
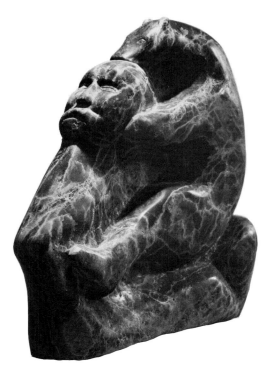
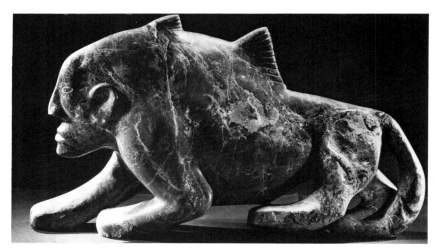
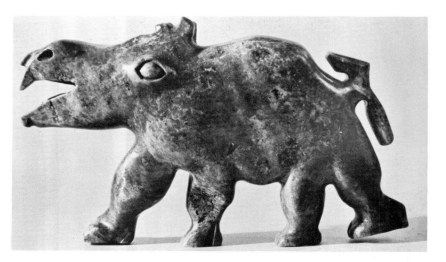

489/Unidentified artist
Cape Dorset no date
Stone width c. 8″

490/Latcholassie Akesuk
(Lassaulaasi)
Cape Dorset 1959
Stone length 8″
WAG G-76-135

491/Eli Simagaq
(Simigak)
Cape Dorset 1966
Stone width 8″
NGC 29306

492/Kiakshuk
Cape Dorset 1957
Stone length 6″
TDB EC-72-44

493/Saggiak
Cape Dorset 1963
Stone length 14″

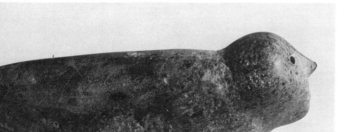

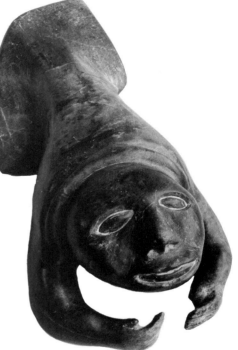

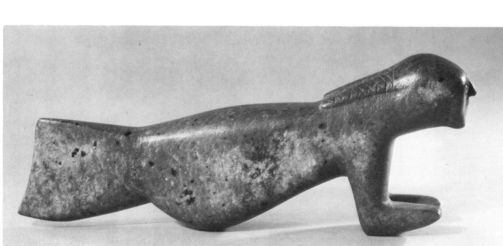

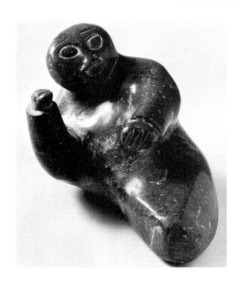

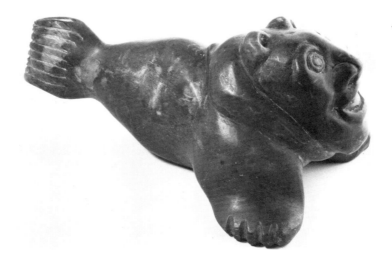

494/Unidentified artist
Cape Dorset 1954?
Stone height c. 3½"
EMC C54.6-2

495/Sheeokjuk Oqutaq?
(Sheeookjuk)
Cape Dorset 1956
Stone height 7¼"
WAG G-60-153

496/Tikituk Qinnuayak
Cape Dorset 1953
Stone height 4¼"
CGCM 090.
(formerly attributed to Oshooweetook "B")

497/Simayai Akesuk
(Shimayook)
Cape Dorset 1967
Stone height 6"
(Collaborated with husband Latcholassie)

498/Qavaroak Tunnillie
(Kavagoak)
Cape Dorset 1953?
Stone length 7½"
ECM C54.6-1

499/Eyeetsiak Peter
(Eechiak)
Cape Dorset 1970
Stone height c. 24"

500/Tudlik
Cape Dorset 1951
Stone height c. 2¼"

192

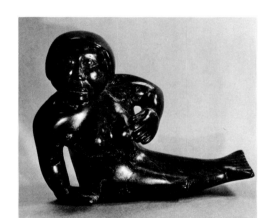
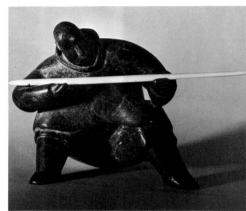
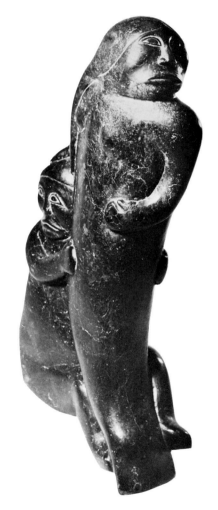
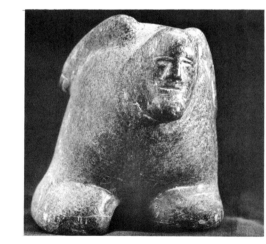
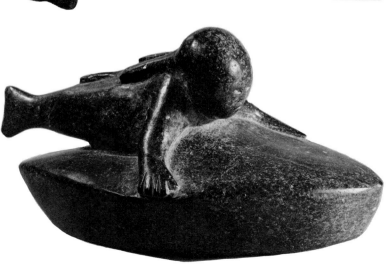
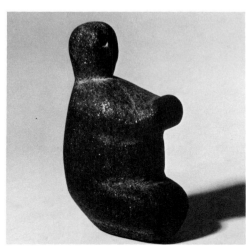

501/Kaka Ashoona
(Kaka/Hakkak)
Cape Dorset 1956
Stone height c. 9"
CMC NA-265

502/Eelee Shuvigar
(Shoovagar)
Iqaluit/Cape Dorset no date
Whalebone height 7"
ICI NA-177

503/Akeeaktashuk
(formerly attributed to Joe/Iya Yaw)
Inukjuak (Port Harrison) 1952
Stone and ivory height 4³/₈"
CGCM 084.

504/Kiawak Ashoona (re-a)
(Kiawak)
Cape Dorset 1960
Whalebone height c. 5"
MCM 1989.7.40
(previously attributed to Saggiak)

505/Kenojuak Ashevak
(Kenojuak)
Cape Dorset c. 1966
Stone height c. 16"
McMB

506/Peesee Oshuitoq
(Oshooweetook "A")
Cape Dorset 1955
Stone height 8³/₄"

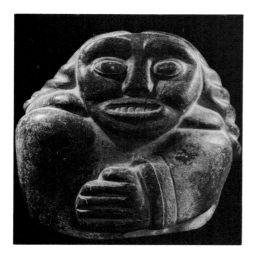

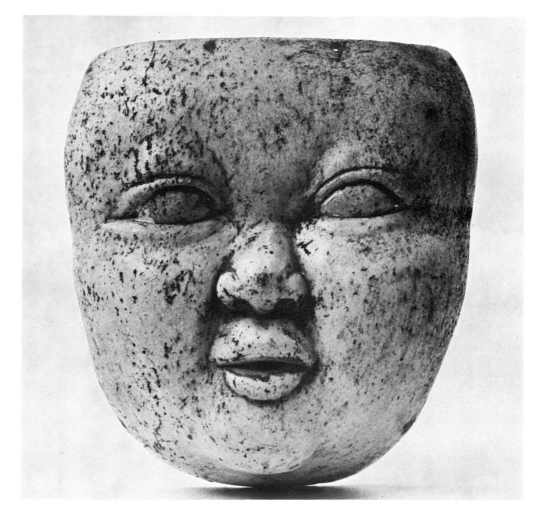

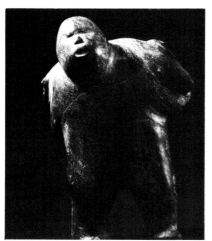

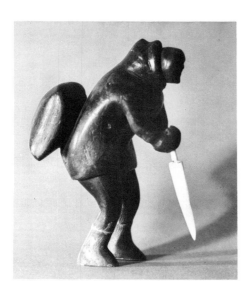

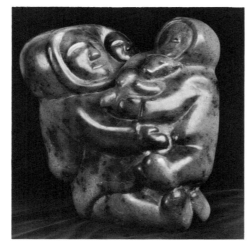

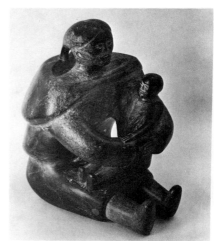

507/Eelee Shuvigar
(Shoovagar)
Iqaluit/Cape Dorset 1954
Stone height 6½"
CMC NA-7

508/Unidentified artist
Cape Dorset 1955 ?
Stone height 7½"
ICI NA-268

509/Peesee Oshuitoq (re-a)
(Oshooweetook "A" ?)
Cape Dorset 1954 ?
Stone height 9"
(formerly attributed to Oshooweetook "B")

510/Pudlat Pootoogook
(Pudlat "A")
Cape Dorset 1953
Stone height 4½"
CGCM 070.

511/Unidentified artist
Cape Dorset ? 1952/3
Stone height 14⅛"

512/Kumakuluk Saggiak
(Kumukulu)
Cape Dorset 1967 ?
Stone width 17½"
(Formerly attributed to Kaka)

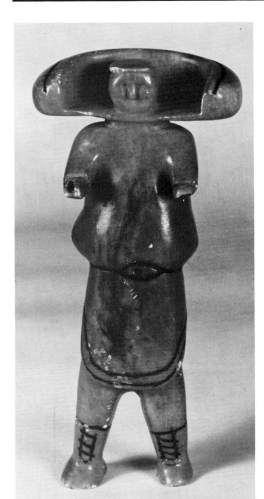

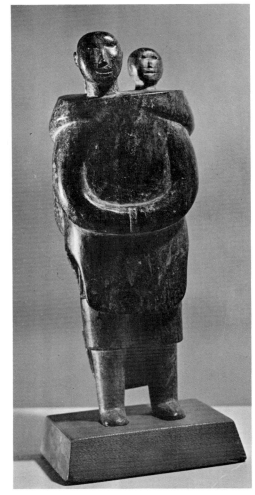

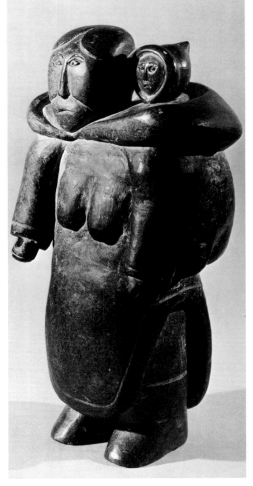

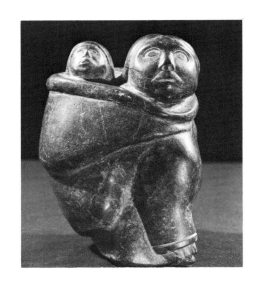

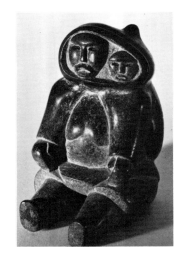

513/Kapik Kolola (ivory)
Paulosi Padluq (stone)
Lake Harbour no date
Ivory and stone height 1½"

514/Simonie Koojakaloo
(Kowjakalook)
Lake Harbour 1961
Stone height 5"
WAG G-72-242

515/Unidentified artist
Lake Harbour 1952/3
Stone height 3¾"

516/Noah Koughajuke
(Koojuajuk)
Lake Harbour 1966
Stone length 13"
(same as 33)

517/Nuyalliaq Qimirpik
(Newquilliak)
Lake Harbour c. 1968
Stone and ivory height 8"
UBC Na 1325 a-p
(similar to Shorty Kiliktee)

518/Unidentified artist
Lake Harbour 1956
Stone height 7"

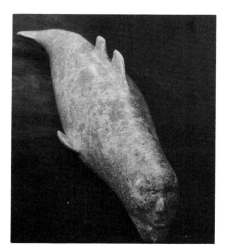

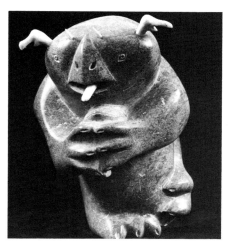

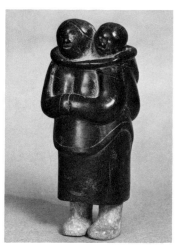

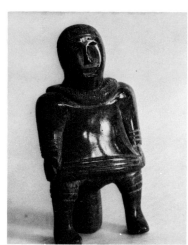

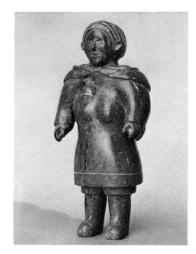

519/Tootalluk Etchuk ?
(Tootaluk)
Lake Harbour 1956/9
Stone height 3″
WAG G-72-180

520/Noah Koughajuke
(Koojuajuk)
Lake Harbour 1967/8
Stone height 8½″

521/Ennutsiak
(Inuksiak)
Iqaluit (Frobisher Bay) c. 1963
Stone and ivory width 9½″
EMC C 69.27-1
(also 45)

522/Sheokjuk Okutaq
(Sheeookjuk)
Cape Dorset/Lake Harbour 1958 ?
Ivory length 6½″
ICI NA-785

523/Unidentified artist
Lake Harbour 1956
Stone height 2″
ICI NA 217 a, b

524/Manno
Iqaluit (Frobisher Bay) no date
Stone and antler width 8″

525/Manno
Iqaluit (Frobisher Bay) no date
Stone width 6¾″

526/Davidee Ningeoak
(Nignuik)
Iqaluit (Frobisher Bay) 1925
Stone height 19⅞″
NGC 9941

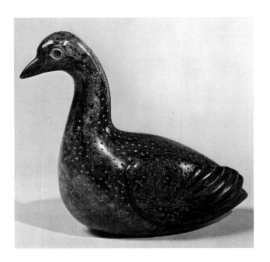
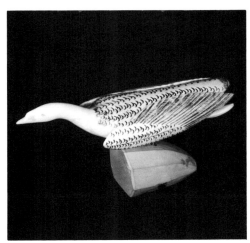
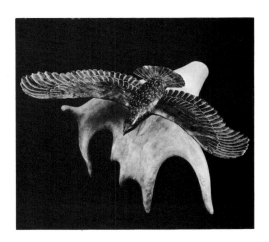

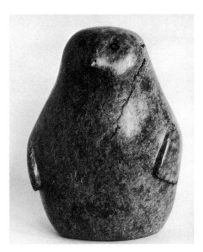
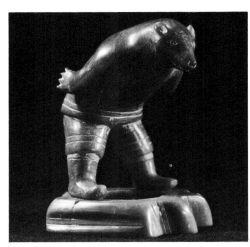
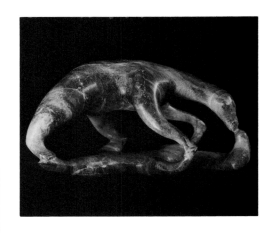

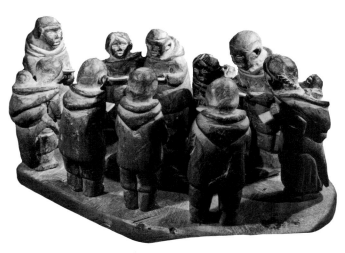
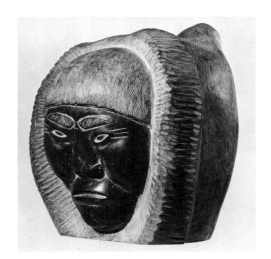

527/Enook Manomie
(Munamee)
Iqaluit (Frobisher Bay) 1963
Stone height 10¾"
CMC NA-993

528/Noah Nuna
Iqaluit (Frobisher Bay) 1964 ?
Stone height c. 12"
WAG 1594-71

529/Unidentified artist
Iqaluit (Frobisher Bay) 1963 ?
Stone height 7⅝"

530/Henry Evaluardjuk
(Henry)
Iqaluit (Frobisher Bay) 1962
Stone height 11¼"
CMC NA-1056

531/Unidentified artist
Iqaluit (Frobisher Bay) no date
Stone and ivory height 9½"

532/Unidentified artist
Clyde River, 1964
Stone height 6"

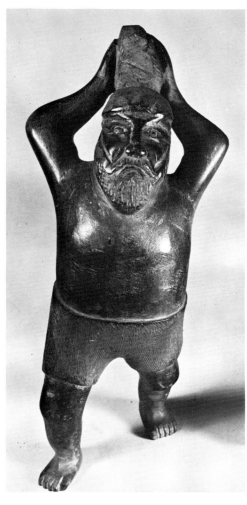
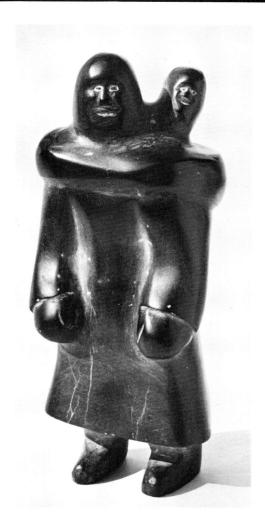
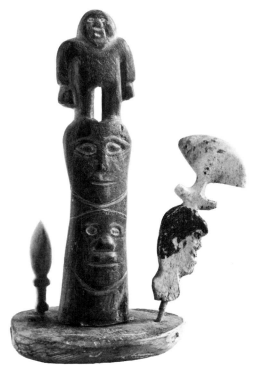
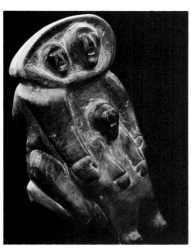
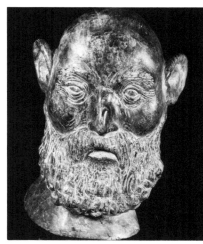
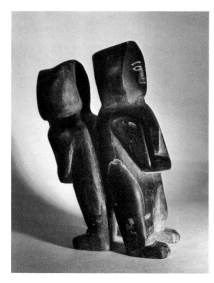

533/Unidentified artist
Pangnirtung 1968
Whalebone height c. 16"

534/Reepa Pappatsie
(Oleepa)
Pangnirtung c. 1965
Whalebone length 4½"

535/Unidentified artist
Pangnirtung 1968
Whalebone height c. 8"

536/Manasee Manniapik
(Manasie Maniapik)
Pangnirtung 1969
Whalebone width c. 32"
McMB

537/Unidentified artist
Pangnirtung 1968
Whalebone length 18"

538/Paylemonie Etuangat
(Payleemoonie)
Pangnirtung 1971
Whalebone height 22¼"
AGO 90/227

539/Mosesee Qiyuakyuk
(Keeokjuk)
Pangnirtung 1967
Whalebone height 9¾"

540/Unidentified artist
Pangnirtung 1967
Whalebone height 11½"

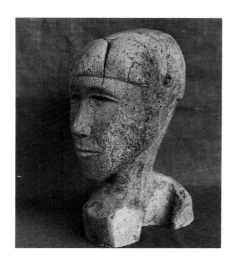

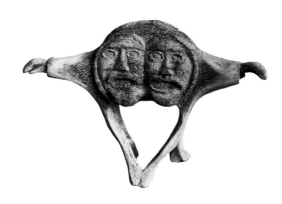

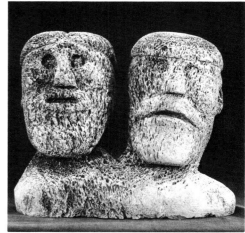

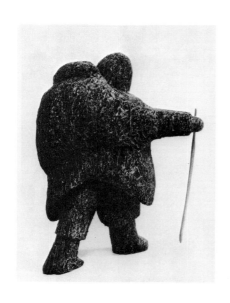

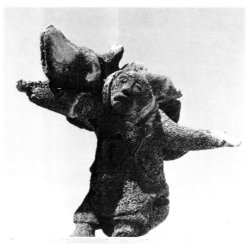

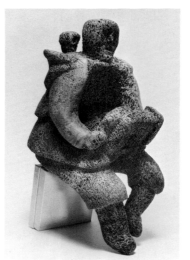

541/Jetaloo Akulukjuk
Pangnirtung 1963
Stone height 3⁵/₈"
TDB EC-82-647

542/Abraham Arnaquq
(Abraham)
Pangnirtung 1969
Bone height 4¹/₂"

543/Aksayook Etooangat
(Eetwanga/Etungat)
Pangnirtung 1951
Ivory heights 4³/₄" and 4¹/₄"
TDB EC-75-413

544/Markosee Joan Pitsiulak
Pangnirtung 1967
Whalebone height 8"

545/Josephee Angnako
(Agnako)
Pangnirtung 1964
Ivory height 3"

546/Josephee Angnako
(Agnako)
Pangnirtung 1965 ?
Stone and ivory height 8"
TDB EC-75-297

547/Peterosee Anilniliak
(Anigiliak)
Pangnirtung c. 1967
Whalebone height 17¹/₂"
McMB

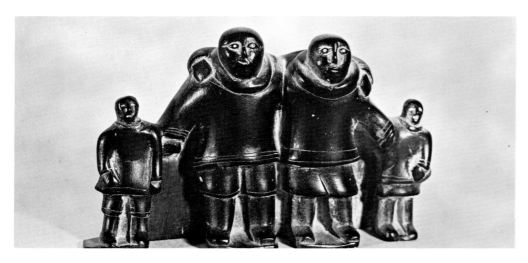

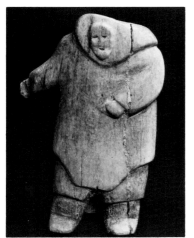

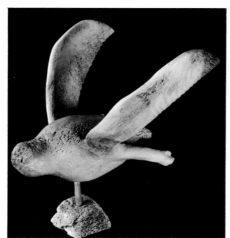

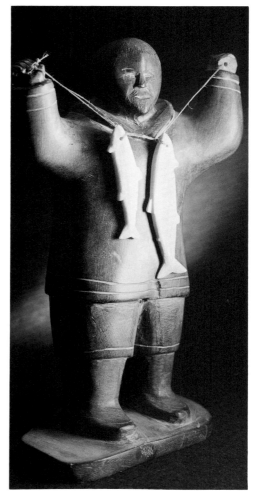

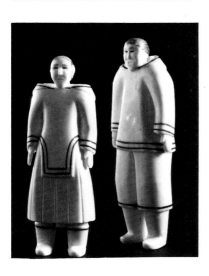

548/Qumangapik Muckpa
(Koomanapik)
Arctic Bay 1959
Whalebone height 5¹/₄"

549/Elisapee Kanangnaq Ahlooloo
(Elisapee Kanagna)
Arctic Bay 1960
Whalebone height 4³/₄"
WAG 579-71

550/Agluk Koonayook
Arctic Bay 1963
Walrus mandible and stone height 8¹/₂"

551/Elisapee Kanangnaq Ahlooloo
(Elisapee Kanagna)
Arctic Bay 1961
Whalebone height 5³/₄"
WAG 322-71

552/Imarnituq Taqtu
(Emalootee/Emaroeetok)
Arctic Bay 1960
Whalebone width 7"
WAG 397-71

553/Peesee Oshuitoq (re-a)
(Oshooweetook "A")
Cape Dorset/Arctic Bay c. 1958
Whalebone height 8¹/₄"

554/Philip Qaminirq
(Kominerk/Kaminerk)
Arctic Bay 1963
Stone width 6"
WAG 510-71

555/Pauloosee Akitirq
(Akiterk)
Arctic Bay 1961
Whalebone length 8³/₄"
WAG 351-71

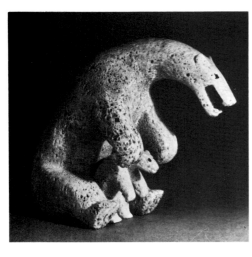
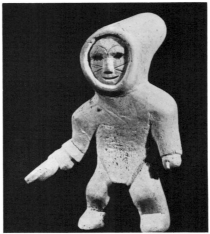

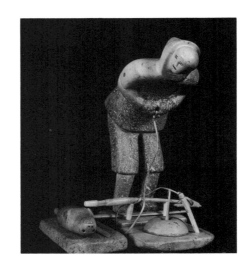
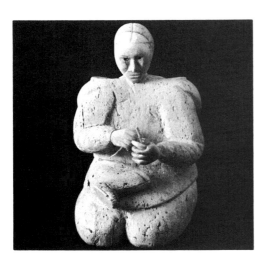

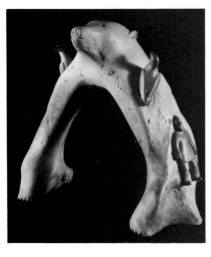

556/Toongalook
Arctic Bay 1966 ?
Whalebone, stone, and ivory length 8½″

557/Toongalook
Arctic Bay 1963 ?
Whalebone and ivory width 14″

558/Lew Phillip
(Lootee Lew)
Arctic Bay 1966
Whalebone height 4½″
WAG 487-71

559/Joseph Tassugat
(Josephine)
Clyde River 1968
Stone height 7¾″

560/Solomonie Tiqullaraq
(Teegodlerrak)
Clyde River 1963
Stone length 8″

561/Oqadla Panipak
(Ohadlak)
Clyde River, Nanook Group 1968
Stone length 8¼″

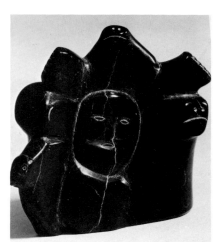

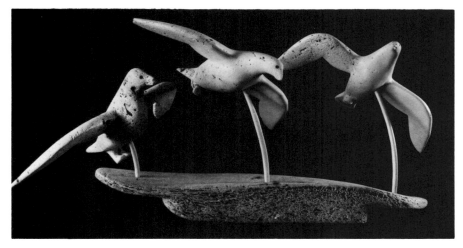

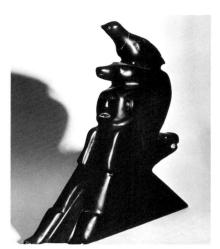

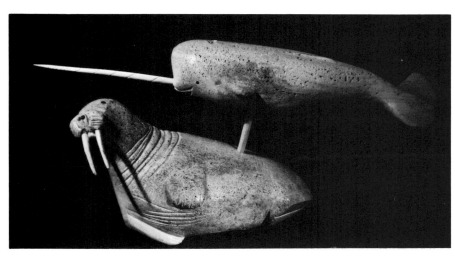

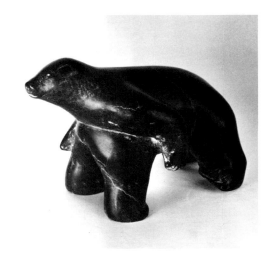

562/Bernard Ikkuma
Igloolik/Broughton Island no date
Stone height 4¹/₈″
NGC 1.78.6

563/Josephee Milkoalik
(or Qaurnirk ?)
Broughton Island 1969
Stone height 5¹/₄″

564/Koveyook Natsiapik
Broughton Island c. 1967
Stone height 9³/₄″
MMFA 1976.aa.1

565/Moses Paneloo Kasarnak
(Panelak)
Pond Inlet 1970
Stone and bone widths c. 13″ and 18¹/₂″
CMC IV-C-4399 a-c

566/Bernard Ikkuma
Igloolik/Broughton Island no date
Stone height 5″

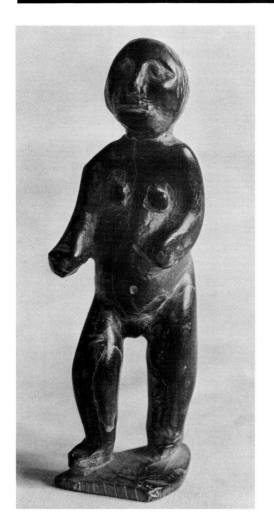

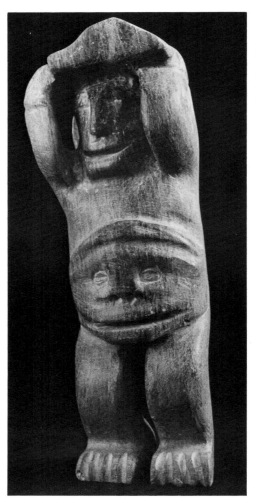

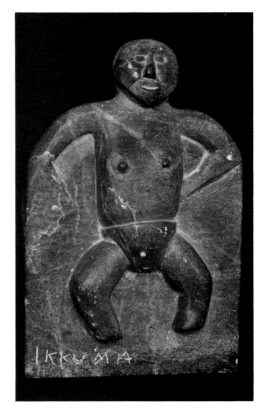

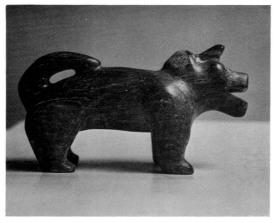

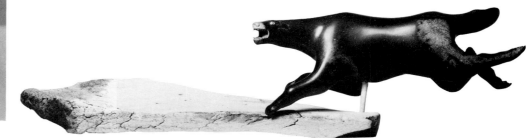

567/Philip Pitseolak
(Koonoo)
Pond Inlet c. 1965
Stone length 8⅝"

568/Philip Pitseolak
(Koonoo)
Pond Inlet no date
Stone and bone width 10"

569/Jacob Peterloosie
Pond Inlet 1969
Various materials width 19¼"

570/Noah Siakuluk
(Seakoluk)
Hall Beach 1970
Stone height c. 6"
PWNHC 970:3.22

571/Luke Equallaq
Gjoa Haven 1967
Bone height c. 7"

572/Unidentified artist
Craig Harbour (Grise Fiord) no date
Stone and bone width 6"

573/Alain Ijerak
Igloolik/Chesterfield Inlet
Whalebone height 8⅝"
WAG G-76-141

574/Joseph Saimut
(Shimout)
Coral Harbour 1967
Whalebone height 4¾"

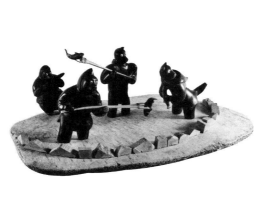
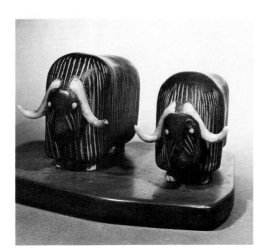
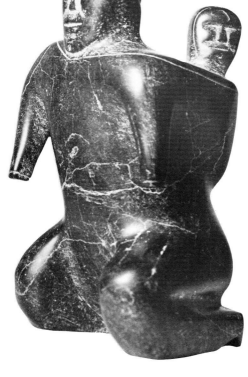

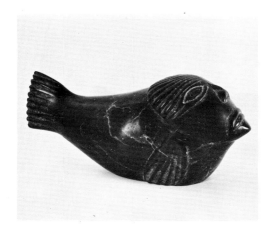
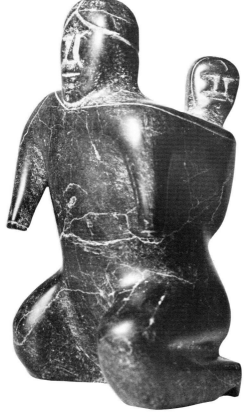

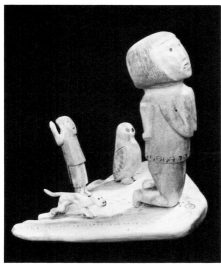

575/George Aggiaq
(Aggeak/Aggiar)
Igloolik c. 1959
Stone and ivory length 6¼"

576/George Aggiaq
(Aggeak/Aggiar)
Igloolik no date
Stone length 8"

577/Johnny Makkigak
Whale Cove 1969
Stone height 7¼"

578/Andy Miki
Arviat/Whale Cove 1968
Stone height 8"

579/George Aggiaq
(Aggeak/Aggiar)
Igloolik 1963
Stone length 6¾"
WAG G-76-297

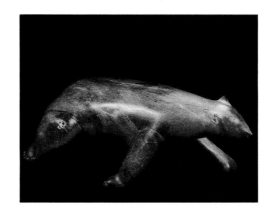

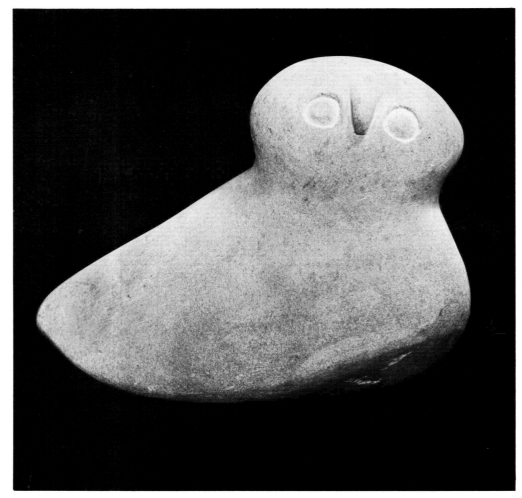

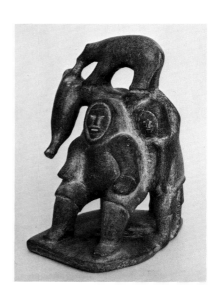

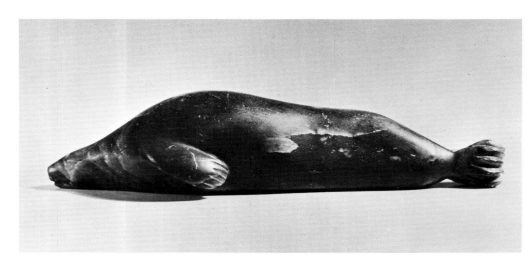

580/Eva Seuteruk Mamgark
(Suetakak)
Arviat (Eskimo Point) 1968
Stone height 8″

581/Eva Tarlooki Aliktiluk ?
(Tarlooki)
Arviat (Eskimo Point) 1967
Stone height 5¹/₈″
WAG G-76-235

582/Peter Komak
Arviat (Eskimo Point) 1970
Stone height 5¹/₄″
WAG G-76-173

583/Monique Kopanuak
(Kopinar)
Arviat (Eskimo Point) 1967
Stone height 8¹/₂″
CMC IV-C-3720

584/John Attok
(Atok)
Arviat (Eskimo Point) 1969
Stone height 6″

585/Mary Ottuk Oroluk
(Ottuk)
Arviat (Eskimo Point) 1966 ?
Stone and bone height 7¹/₂″

586/Andy Mamgark
(Mamgark)
Arviat (Eskimo Point) 1967
Stone length 6¹/₂″
CMC IV-C-3738

587/Susan Ootnooyuk
Arviat (Eskimo Point) 1968
Stone height c. 4¹/₂″
CMC IV-C-3852

588/Nicholas Ikkuti
(Eekootak/Erkootee)
Arviat (Eskimo Point) 1967
Stone length 4¹/₈″
WAG G-76-645

205

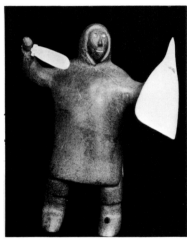
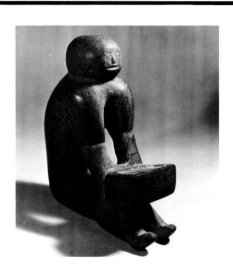
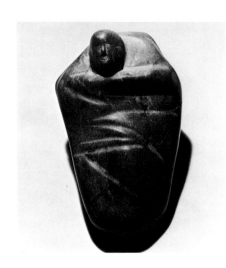
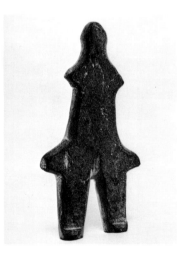
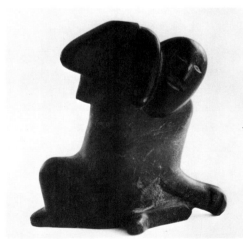
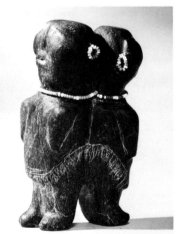
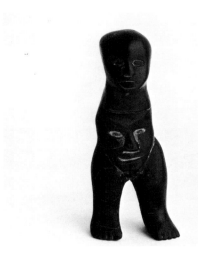
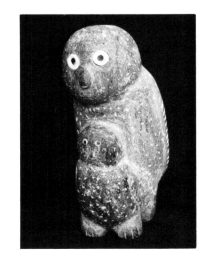
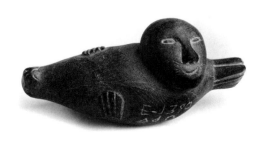

589/Jacob Irkok
Arviat (Eskimo Point) 1967
Whalebone and stone height 5"
VAG 67.25

590/Rev. Armand Tagoona
(Tagoonak)
Baker Lake/Arviat 1969
Bone height c. 2¼"
EMC C 69.9-1

591/Luke Oroluk
Arviat (Eskimo Point) 1968
Bone height 2⅞"

592/Luke Anowtalik
(Anowtelik)
Arviat (Eskimo Point) 1970
Caribou antler length 9¾"
WAG G-76-228

593/Margaret Uyauperq Aniksak
(Uyaoperk)
Arviat (Eskimo Point) 1968
Stone height c. 16"
WAG 1193-71

594/Eva Seuteruk Mamgark
(Suetakak)
Arviat (Eskimo Point) 1967/8
Stone height c. 6"

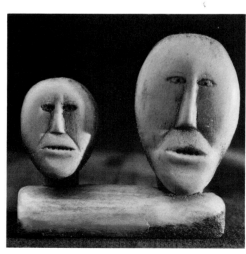

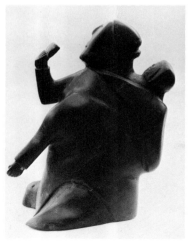

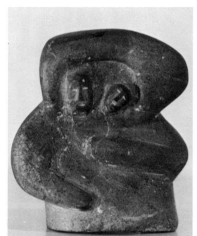

595/Eulalie Utuuyak Irkok
(Utuyak)
Arviat (Eskimo Point) 1967
Stone height 4″

596/Martine Pisuyui Anoee
(Pissuyui)
Arviat (Eskimo Point) 1967
Stone height 7″
CMC IV-C-3743

597/Michael Ivunirjuk
(Evunerdjuk)
Arviat (Eskimo Point) 1968
Stone height 5¹/₂″

598/Theresa Alunak Angmak
(Arlutnar)
Arviat (Eskimo Point) 1968
Stone height 3¹/₄″
WAG G-76-212

599/Martha Ikiperiak Eekerkik
(Ikiperiak)
Arviat (Eskimo Point) 1967
Stone height 6″

600/Elizabeth Nutaraluk Aulatjut
(Nootaraloo)
Arviat (Eskimo Point) 1967
Stone height 4³/₄″
WAG G-76-197

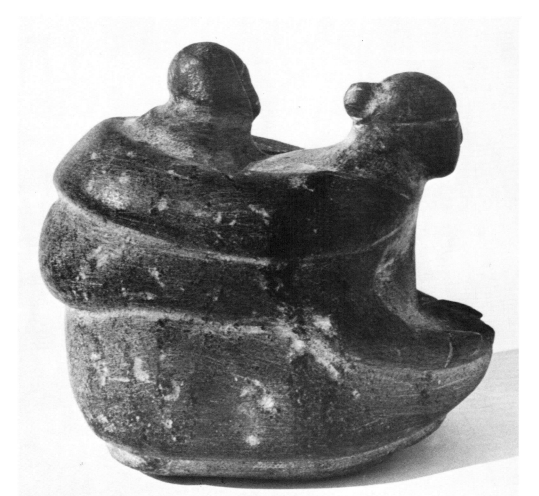

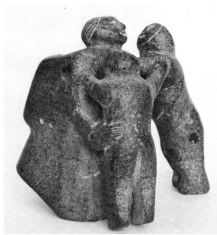

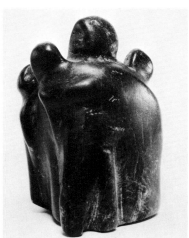

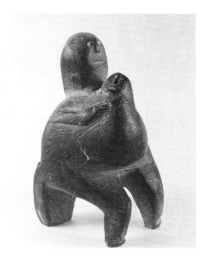

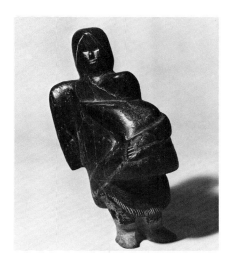

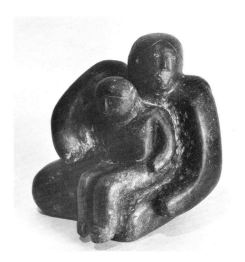

601/Mary Ayaq Anowtalik
(Akjar)
Arviat (Eskimo Point) 1969
Stone height 6³/₄"
(Another view of 145)

602/Theresa Alunak Angmak
(Arlutnar)
Arviat (Eskimo Point) 1968
Stone height 4¹/₂"
CMC IV-C-3967

603/Jacob Irkok
Arviat (Eskimo Point) 1968
Antler width 11"

604/Elizabeth Nutaraluk Aulatjut
(Nootaraloo)
Arviat (Eskimo Point) 1966
Antler bone length 11³/₄"
WAG 1493-71

605/John Polik
Arviat (Eskimo Point) 1969
Bone and ivory length c. 5"
AGO 90/36

606/John Attok
(Atok)
Arviat (Eskimo Point) 1969
Whalebone and ivory height 6³/₈"
WAG 1221-71

208

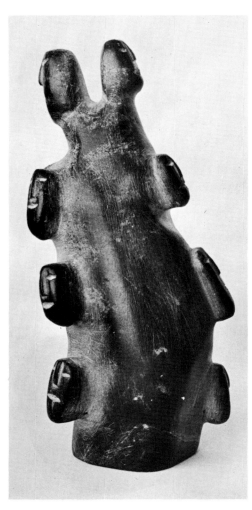
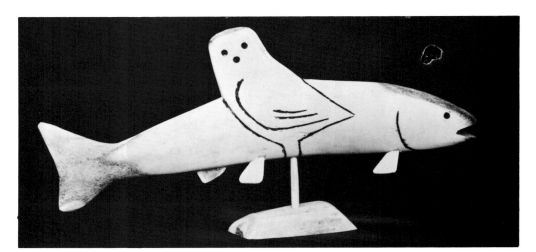
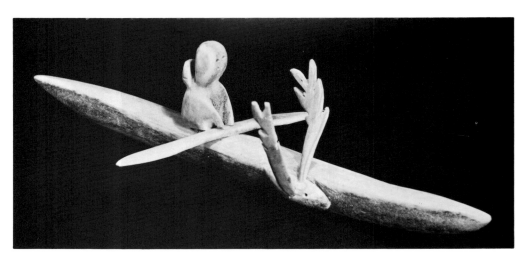

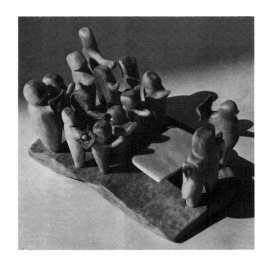

607/Lucy Tasseor Tutsweetok
(Tasseor)
Arviat (Eskimo Point) 1969
Stone height 3¹/₄"

608/Lucy Tasseor Tutsweetok
(Tasseor)
Arviat (Eskimo Point) 1967
Stone height 11³/₈"
WAG G-68-91
(also 118)

609/Lucy Tasseor Tutsweetok
(Tasseor)
Arviat (Eskimo Point) 1969
Stone height 4⁷/₈"

610/Mary Ayaq Anowtalik (re-a)
(Akjar)
Arviat (Eskimo Point) 1965/6
Stone height 2³/₄"
WAG G-76-258
(formerly attributed to Lucy Tasseor)

611/Lucy Tasseor Tutsweetok
(Tasseor)
Arviat (Eskimo Point) 1969
Stone width c. 7"
WAG G-76-254

612/Lucy Tasseor Tutsweetok
(Tasseor)
Arviat (Eskimo Point) 1968
Stone height c. 5³/₄"

613/Lucy Tasseor Tutsweetok
(Tasseor)
Arviat (Eskimo Point) 1969
Stone height 4¹/₈"

614/Lucy Tasseor Tutsweetok
(Tasseor)
Arviat (Eskimo Point) 1968
Stone height 5¹/₄"
CMC IV-C-4075

209

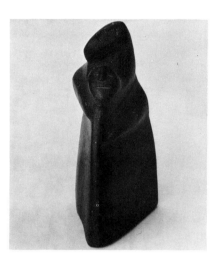

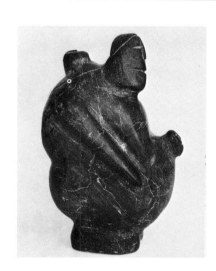

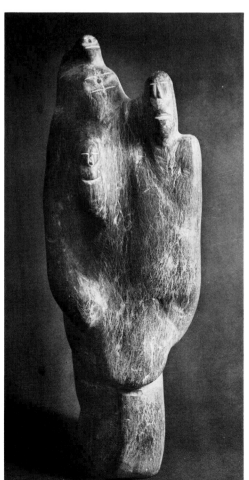

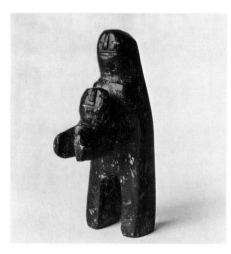

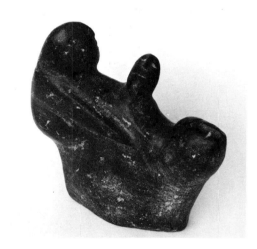

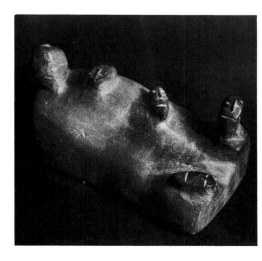

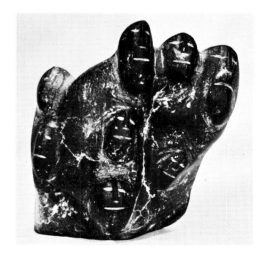

615/John Pangnark
Arviat (Eskimo Point) 1969
Stone height c. 4¹/₂"

616/John Pangnark
Arviat (Eskimo Point) 1967
Stone height c. 6"
WAG 1238-71

617/John Pangnark
Arviat (Eskimo Point) 1967
Stone height 4"
CMC IV-C-3845

618/John Pangnark
Arviat (Eskimo Point) 1968
Stone height 4"
CMC IV-C-3804

619/John Pangnark
Arviat (Eskimo Point) 1967
Stone height 3¹/₂"
WAG G-76-181

620/John Pangnark
Arviat (Eskimo Point) 1968
Stone height c. 5¹/₂"
CMC IV-C-3825

621/John Pangnark
Arviat (Eskimo Point) 1967/8
Stone height 3³/₈"

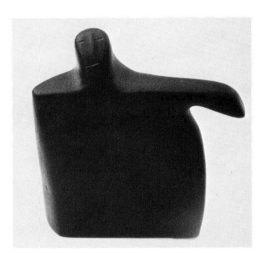
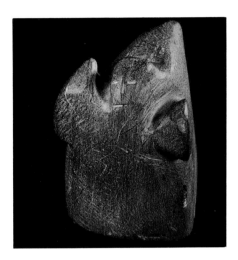
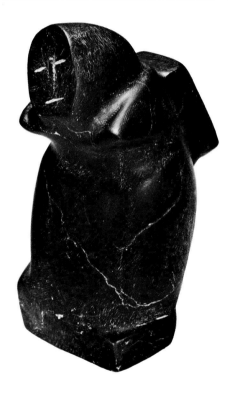

622/John Pangnark
Arviat (Eskimo Point) 1968
Stone height 4″
CMC IV-C-3801

623/John Pangnark
Arviat (Eskimo Point) 1968
Stone height 5″
CMC IV-C-3810

624/John Pangnark
Arviat (Eskimo Point) 1969
Stone width c. 8¹⁄₂″
WAG G-68-79

625/Eli Tikeayak
Rankin Inlet 1961
Stone height c. 6³⁄₄″
AGO 89/293

626/George Arluk
(Arlu)
Arviat/Rankin Inlet 1968
Stone height c. 4¹⁄₂″
WAG G-76

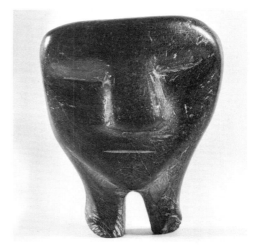

212

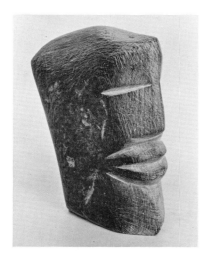

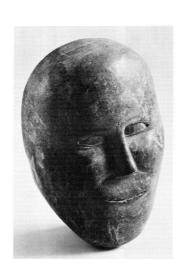

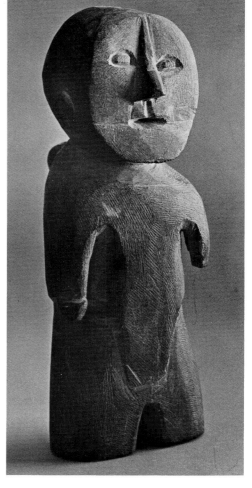

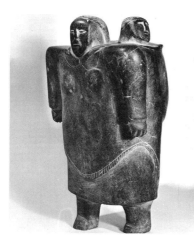

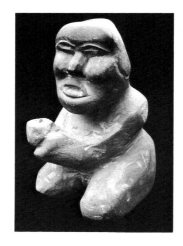

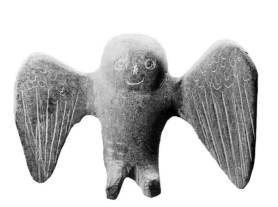

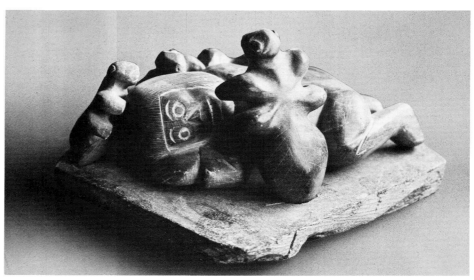

634/Eli Tikeayak
Rankin Inlet 1963
Stone height 4¹/₂″

635/Joseph Angatajuak
(Angataguak)
Rankin Inlet 1965
Stone height 3³/₄″
WAG G-76-36

636/Eugenie Tautoonie Kabluitok
(Tautungie)
Rankin Inlet 1963
Stone length 10″

637/Vital Okoktok
(Okotok)
Rankin Inlet 1963
Stone height 15″

638/John Okalik
(Ukalik)
Arviat/Rankin Inlet 1969
Stone length 11⁵/₈″
EMC C69.43-1

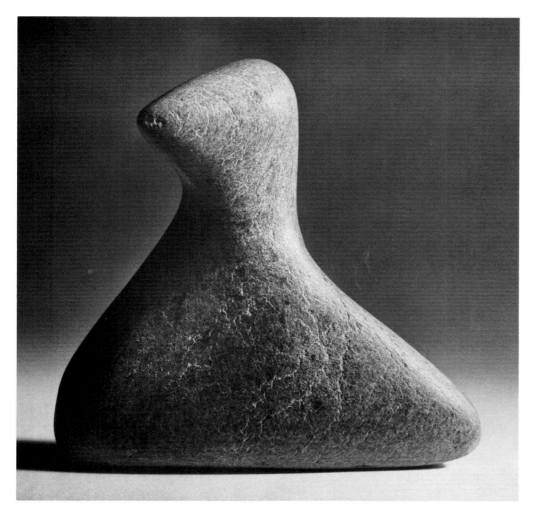

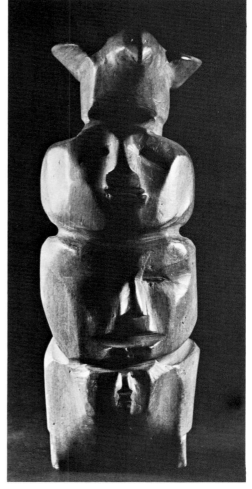

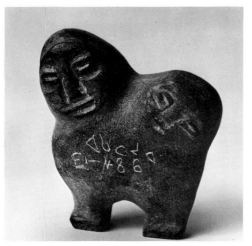

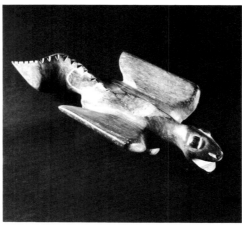

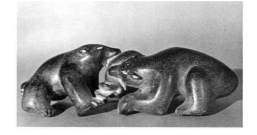

640/John Kavik
(Qavirq)
Rankin Inlet 1964
Stone height 9¹/₂″
WAG G-76-461

642/John Kavik
(Qavirq)
Rankin Inlet 1964
Stone height 6″

639/John Kavik
(Qavirq)
Rankin Inlet 1963/4
Stone height 5³/₈″
AGO 89/229

641/John Kavik
(Qavirq)
Rankin Inlet 1969
Stone height c. 5″

643/John Kavik
(Qavirq)
Rankin Inlet 1963
Stone height 3¹/₂″
WAG G-76-458

214

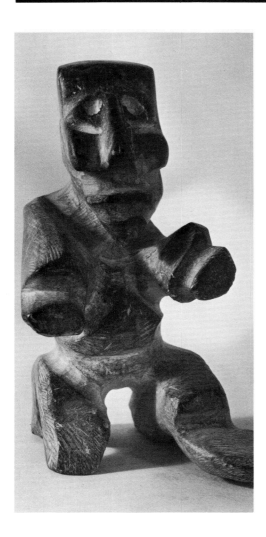

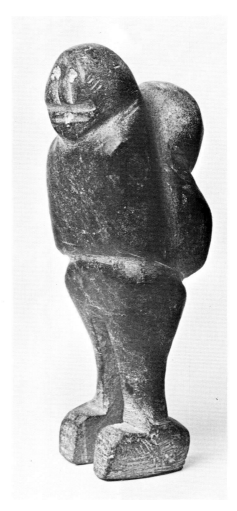

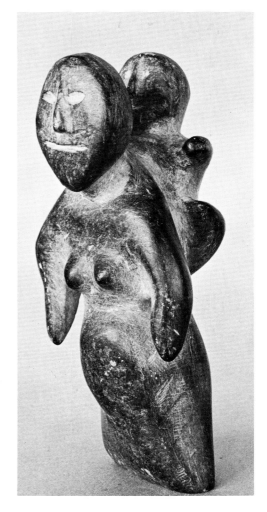

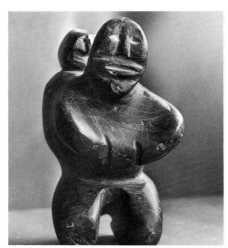

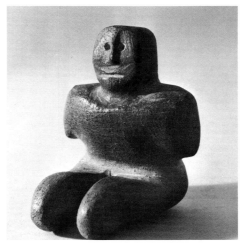

644/John Kavik
(Qavirq)
Rankin Inlet 1964
Stone height 7"

645/John Kavik
(Qavirq)
Rankin Inlet 1969
Stone height 4³/8" and length 5"
EMC C65.12-1

646/John Kavik
(Qavirq)
Rankin Inlet 1965
Stone height 3³/4"
AGO 89/239

647/John Kavik
(Qavirq)
Rankin Inlet 1965
Stone height 3³/4"
WAG G-76-450

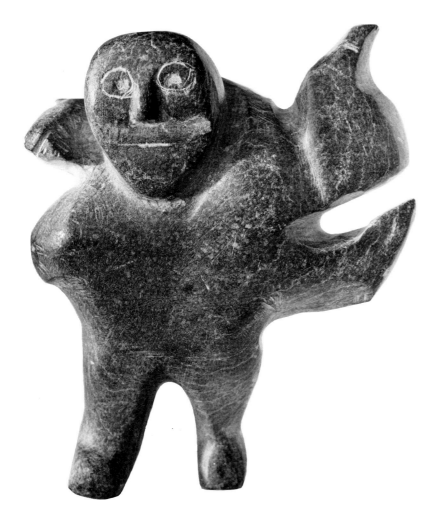

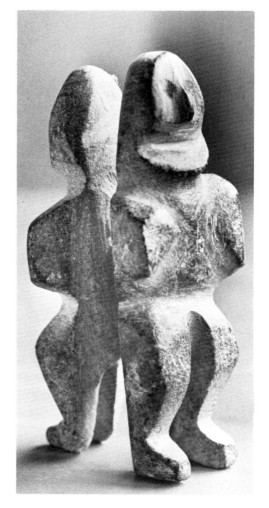

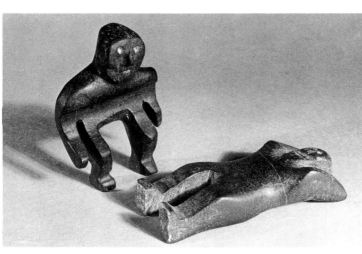

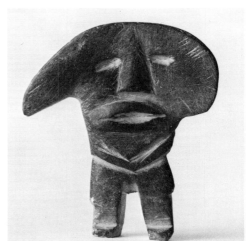

648/John Tiktak
Rankin Inlet 1964
Stone height 7³/₄″

649/John Tiktak
Rankin Inlet 1967/8
Stone height 16¹/₄″

650/John Tiktak
Rankin Inlet 1966/7
Stone height 21¹/₄″
McM 1980.11

651/John Tiktak
Rankin Inlet 1969
Stone height 11³/₈″
ICI 1.65.203

652/John Tiktak
Rankin Inlet 1961
Stone height 8″
AGO S2647

653/John Tiktak
Rankin Inlet 1963/4
Stone height 5¹/₄″
WAG 2061-71

216

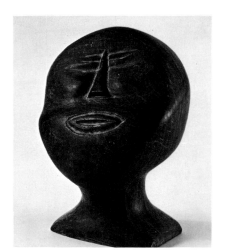
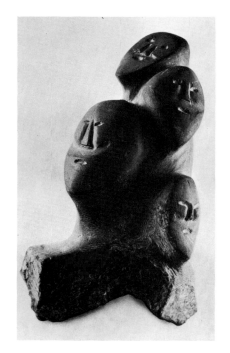
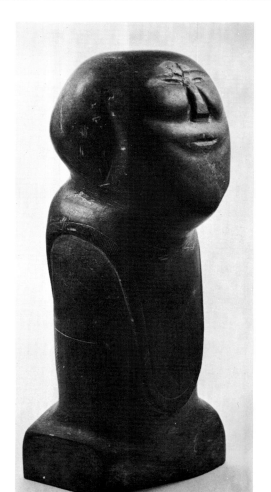
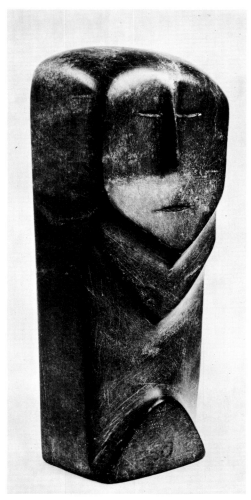
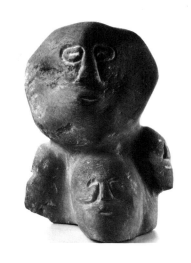
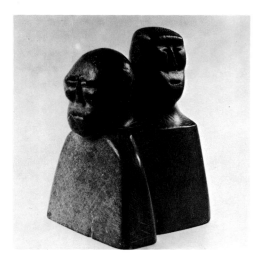

654/John Tiktak
Rankin Inlet 1962
Stone height 5″

655/John Tiktak
Rankin Inlet c. 1968
Stone length 27″
CMC IV-C-3771
(same as 146)

656/John Tiktak
Rankin Inlet 1967/8
Stone height 15¼″
VAG 70.7

657/John Tiktak
Rankin Inlet 1965
Stone height 7″

658/John Tiktak
Rankin Inlet 1968
Stone height 10″
EAG 70.3

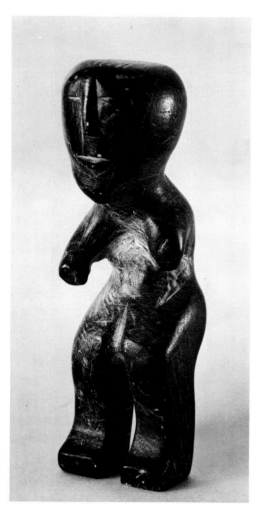
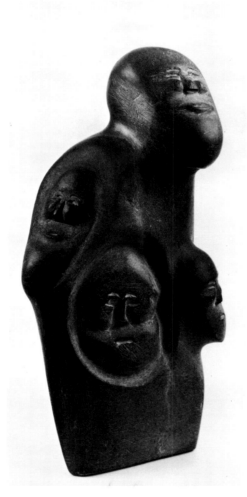
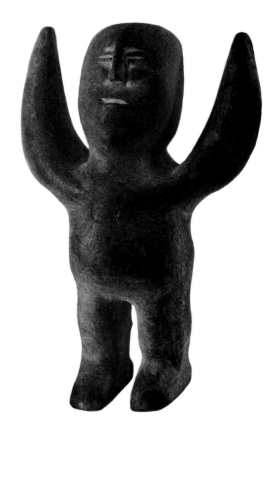
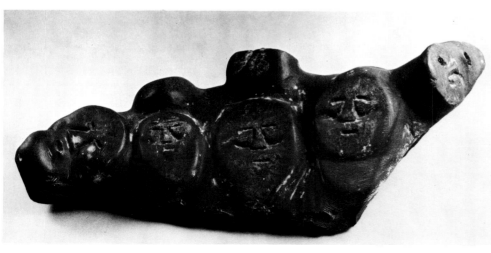
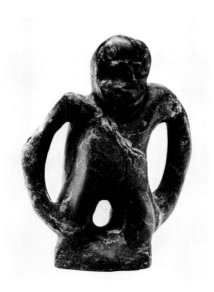

659/John Tiktak
Rankin Inlet 1965
Stone height 6³/₄″

660/John Tiktak
Rankin Inlet 1965
Stone height 5″

661/John Tiktak
Rankin Inlet 1963
Stone height 8¹/₄″

662/John Tiktak
Rankin Inlet 1964
Stone height 9¹/₄″

663/John Tiktak
Rankin Inlet 1962
Stone height 5″

664/John Tiktak
Rankin Inlet 1961
Stone height 5⁵/₈″
WAG G-76-429

665/John Tiktak
Rankin Inlet 1963
Stone height 7¹/₂″
WAG G-76-443

218

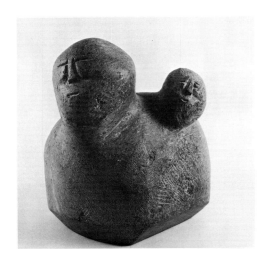

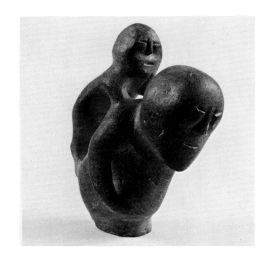

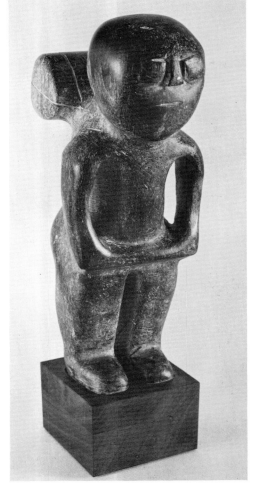

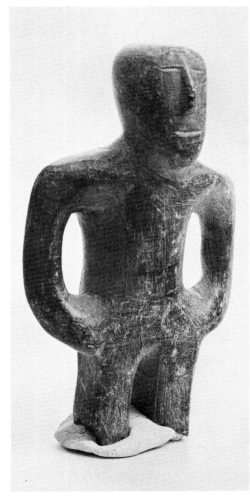

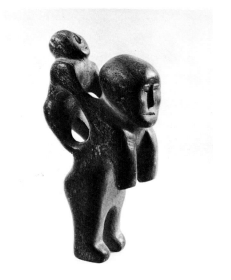

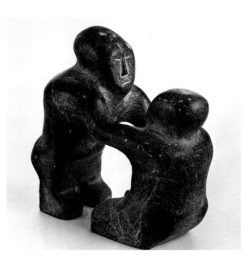

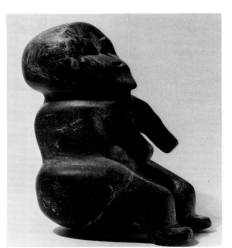

666/Tuna Iquliq
(Donat/Toona Erkolik)
Baker Lake 1963
Stone height 7¹/₂"
WAG G-64-95

667/Tuna Iquliq
(Donat/Toona Erkolik)
Baker Lake 1962
Stone height 4¹/₂"
WAG G-64-83

668/Tuna Iquliq
(Donat/Toona Erkolik)
Baker Lake/Rankin Inlet 1963
Stone length 7³/₈"
WAG G-76-652

669/Tuna Iquliq
(Donat/Toona Erkolik)
Baker Lake 1963
Stone height 7¹/₂"

670/Tuna Iquliq
(Donat/Toona Erkolik)
Baker Lake 1964
Stone length 4"

671/Tuna Iquliq
(Donat/Toona Erkolik)
Baker Lake/Rankin Inlet 1964
Stone height 4³/₄"

672/Tuna Iquliq
(Donat/Toona Erkolik)
Baker Lake/Rankin Inlet 1964
Stone height 6"
WAG G-76-650

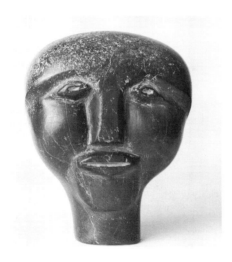

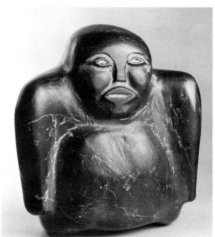

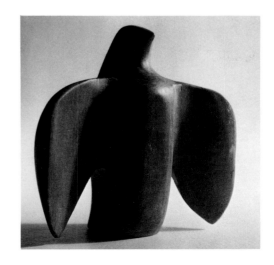

673/David Ikutaaq
(Ekoota)
Baker Lake 1963
Stone height c. 8½″

674/David Ikutaaq
(Ekoota)
Baker Lake 1964/5
Stone height 11″

675/David Ikutaaq
(Ekoota)
Baker Lake 1963
Stone height 8½″
WAG 711-71

676/David Ikutaaq
(Ekoota)
Baker Lake 1963
Stone height 8½″

677/David Ikutaaq
(Ekoota)
Baker Lake 1964
Stone height 8¾″
WAG G-76-75

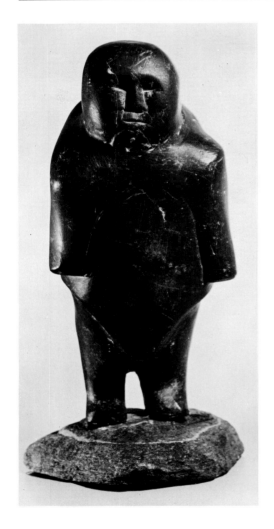

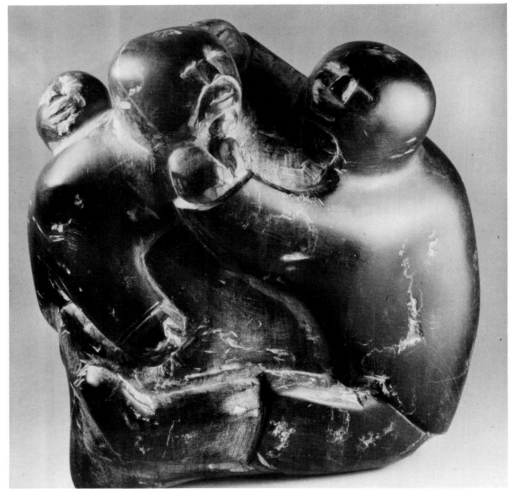

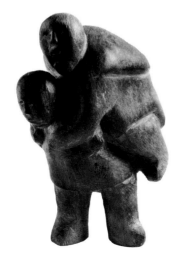

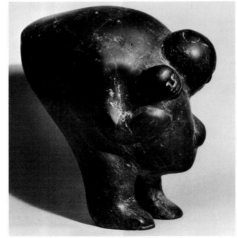

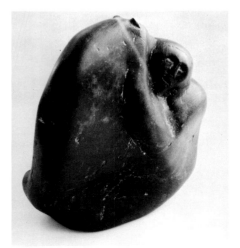

678/Moses Akilak
(Ukkeelak)
Baker Lake 1961
Stone height 5¹/₂″

679/Yvonne Kanayuk Arnakyuinak
(Kanayuk)
Baker Lake 1970
Stone height 4¹/₂″

680/David Ikutaaq
(Ekoota)
Baker Lake 1965
Stone height 12¹/₂″

681/George Tataniq
(Tattener)
Baker Lake (1967)
Stone height c. 10″

682/Mathew Aqigaaq
(Akeeah)
Baker Lake 1965
Stone height 12″

683/Victoria Mamnguqsualuk ?
(Mummookshoarluk)
Baker Lake 1964
Stone height 13¹/₂″

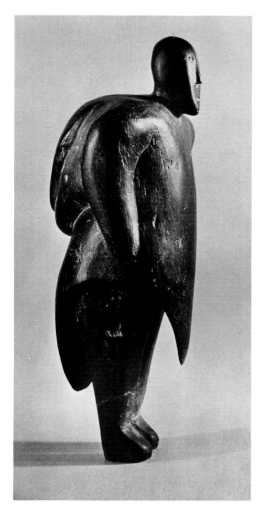

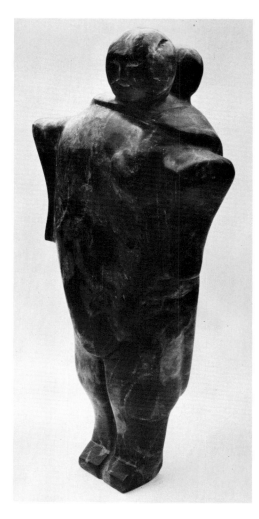

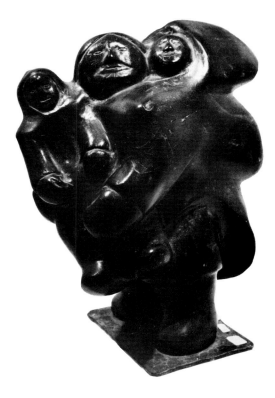

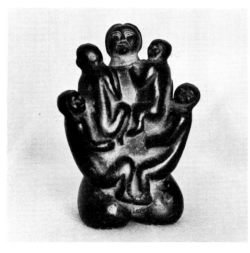

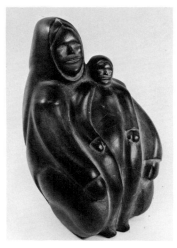

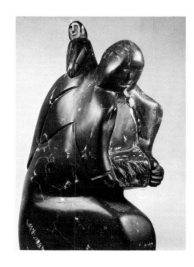

685/Michael Amarook
Baker Lake 1962
Stone height 10½"

684/Francis Kaluraq
(Kallooar)
Baker Lake 1963/4
Stone height 7½"
AGO 90/148

686/Silas Aittauq
(Itow)
Baker Lake 1969
Stone height 5"

687/Luke Iksitaaryuk
(Ikseetarkyuk)
Baker Lake 1969
Antler height 10"
EMC C68.13-1

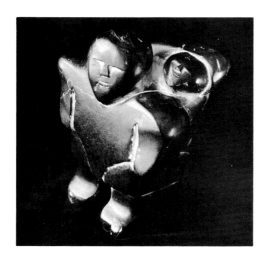

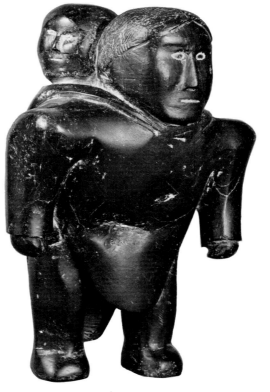

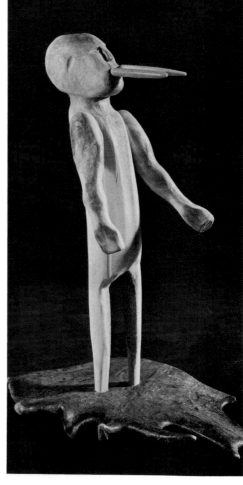

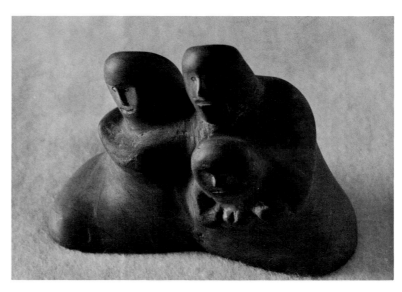

688/Peter Assivaaryuk
(Arseevaryou)
Baker Lake 1969
Antler and leather height 14″

689/Luke Iksitaaryuk
(Ikseetarkyuk)
Baker Lake 1968
Antler height c. 8³/₈″
AGO 90/115
(cf. 116)

690/Vital Makpaaq
(Makpa Arnasungnark)
Baker Lake 1970
Stone and ivory height 6¹/₂″

691/Moses Nagyugalik
(Nugyugalik)
Baker Lake 1967
Antler height 8″
WAG 641-71

692/Barnabus Arnasungaaq
(Akkanarshoonark/Barnabus)
Baker Lake 1969
Antler height 9¹/₂″

693/William Ukpatiku
(Ukpateeko)
Baker Lake 1970
Antler and sinew height 5³/₄″
WAG G-76-28

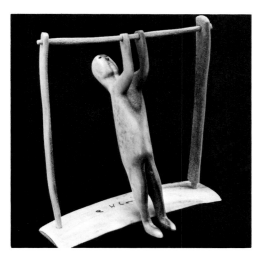

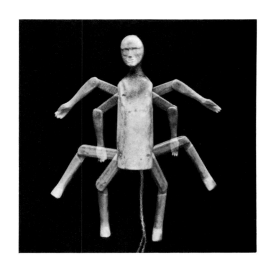

694/Vital Makpaaq
(Makpa Arnasungnark)
Baker Lake 1962
Stone and bone width 13¼"
WAG 605-71

695/James Kingilik
(Kingeelik)
Baker Lake 1963
Stone and bone length 8"
WAG G-76-79

696/Paul Toolooktook
Baker Lake 1964
Stone length 12¼"
WAG 636-71
(also 102)

697/Samson Kayuryuk, George Tataniq
(Kayoyok, Tattener)
Baker Lake 1963
Stone and bone lengths 10⅜" and 7⅜"
WAG 588-71/671-71

698/George Tataniq
(Tattener)
Baker Lake 1963
Stone and ivory height 6¼"
WAG 648-71

699/Eric Niuqtuk
(Irenee Neeooktook)
Baker Lake 1963
Stone and bone length 4½"
WAG 673-71

224

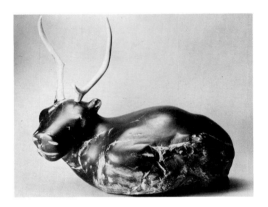

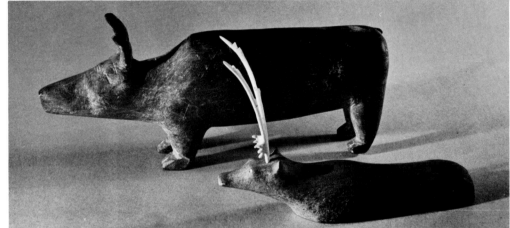

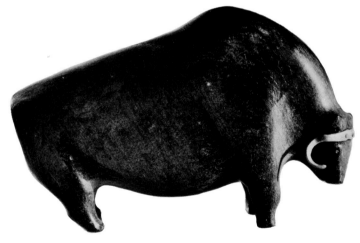

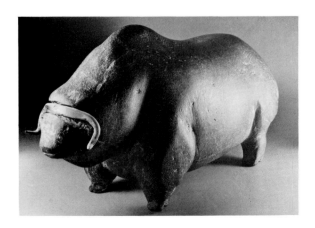

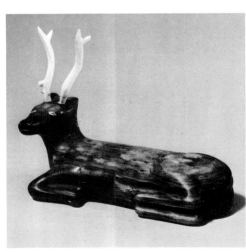

700/Michael Amarook
Baker Lake 1963
Stone and bone length 10½″
WAG G-64-81

701/Dominic Kingilik
(Kingalik)
Baker Lake 1963 ?
Stone length 8½″

702/David Tiktaalaaq
(Tiktala)
Baker Lake 1963
Stone and bone length c. 13½″

703/Josiah Nuilaalik
(Nooeelarlik)
Baker Lake 1963
Stone length 8½″

704/George Tataniq
(Tattener)
Baker Lake 1963
Stone length c. 5″

705/George Tataniq
(Tattener)
Baker Lake 1963
Stone length 10″
WAG G-72-232

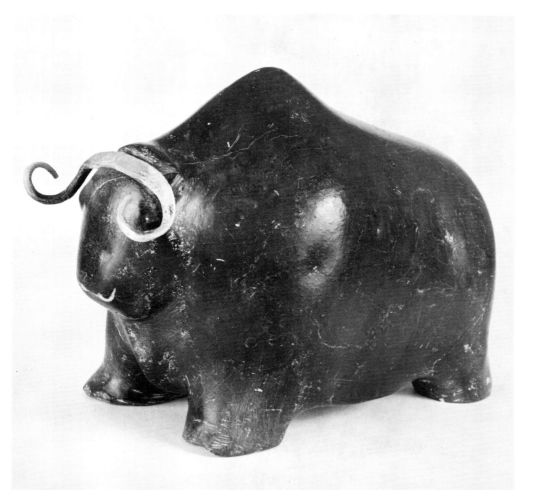

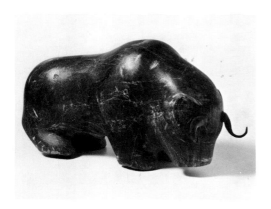

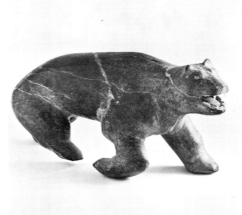

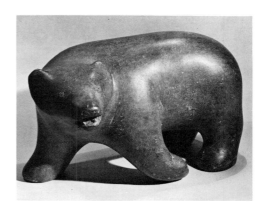

706/Vital Makpaaq
(Makpa Arnasungnark)
Baker Lake 1962
Stone height 8″
WAG G-64-87

707/Barnabus Arnasungaaq
(Barnabus Akkanarshoonark)
Baker Lake 1965
Stone height 15″

708/David Tiktaalaaq
(Tiktala)
Baker Lake 1963
Stone length 7″
WAG G-76-77

709/Dominic Kingilik
(Kingalik)
Baker Lake 1963
Stone height 7″

710/George Tataniq
(Tattener)
Baker Lake 1963
Stone length c. 9″
WAG 647-71

711/Francis Kaluraq
(Kallooar)
Baker Lake 1964
Bone height 4″
WAG G-76-60
(same as 209)

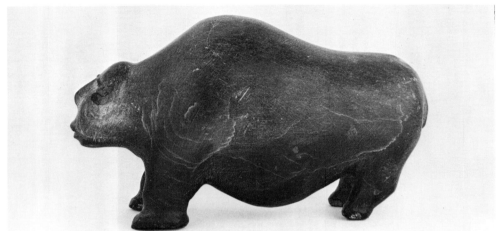
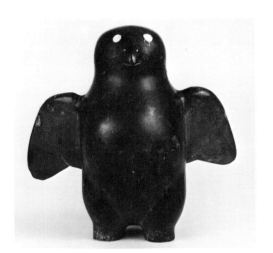
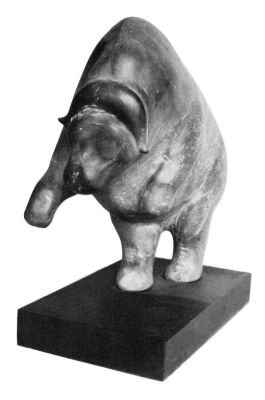
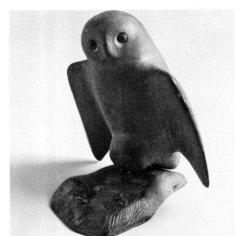
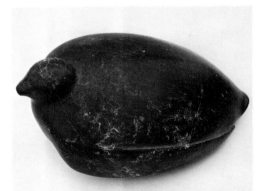
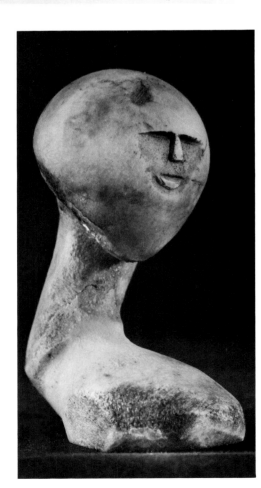

712/Robert Oolamik
Baker Lake 1964
Stone height 6½"

713/Dominic Kingilik
(Kingalik)
Baker Lake 1963/4
Stone height 10½"

714/Mathew Aqigaaq
(Akeeah)
Baker Lake 1964
Stone height 5¾"
AGO S387

715/Mathew Aqigaaq
(Akeeah)
Baker Lake 1967
Stone height 8"

716/Silas Aittauq
(Itow)
Baker Lake 1969 ?
Stone height 7"

717/Marjorie Esa
Baker Lake 1963
Stone height 10½"
WAG G-64-91

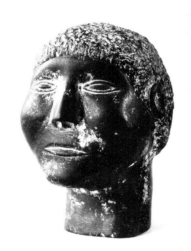

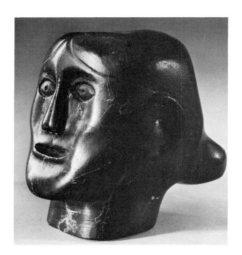

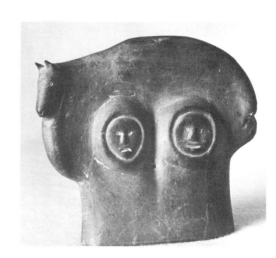

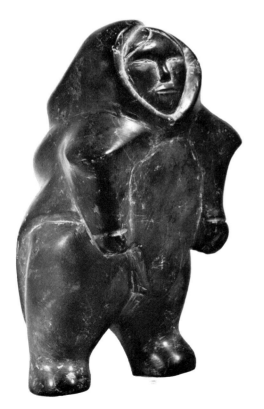

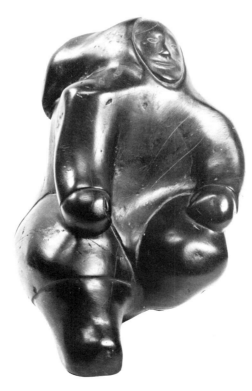

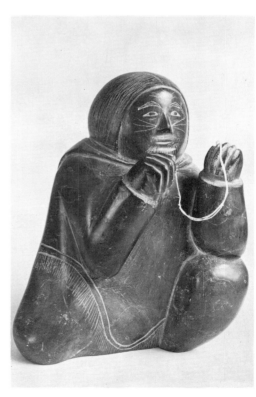

718/John Kaunak
Repulse Bay 1966
Stone and bone heights 6¹/₄″ and 9¹/₂″
TDB EC-75-298

719/Jean Mapsalak
Repulse Bay 1968/9
Stone and bone height 4″
EMC C68.9-1

720/Unidentified artist
Repulse Bay 1960
Stone height c. 5¹/₄″
EMC C60.9-1

721/Irene Kataq Angutitok
(Katak)
Repulse Bay c. 1960/62
Stone height 9⁵/₈″
EMC C69.8-1

722/Irene Kataq Angutitok
(Katak)
Repulse Bay c. 1960
Stone height 3³/₈″
EMC C60.8-1

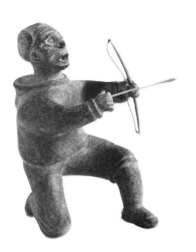
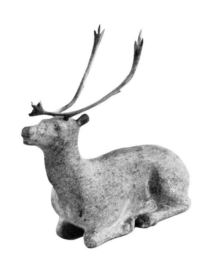
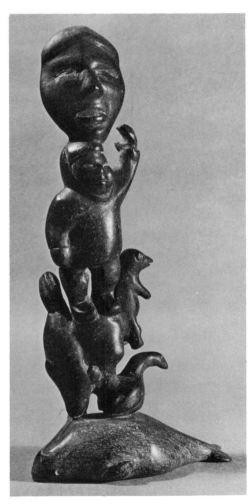
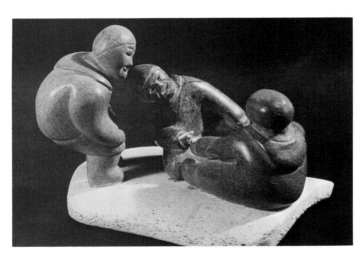
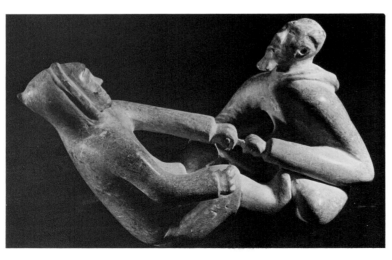
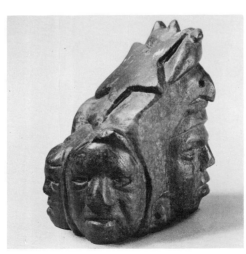

723/Mark Tungilik
(Tongikik)
Repulse Bay 1967
Stone and ivory width 5⁷/₈"
WAG 2312-71

724/Donat Milortok
Repulse Bay 1967
Stone and ivory length 8³/₄"

725/Letia Koonoo Tagornak
(Kunuk)
Repulse Bay 1968
Stone height 3"

726/Madeleine Isserkut Kringayark
(Isserkrut)
Repulse Bay 1967 ?
Stone and ivory height 6"

727/Louis Oksokitok
(Oksokirtok)
Repulse Bay 1966/7
Stone and ivory height 7"
EMC C67.21-1
(cf. 87)

728/Bernadette Ivalooarjuk Saumik
(Bernadette Ivalooarjuk)
Rankin Inlet/Repulse Bay 1968
Stone height c. 5¹/₂"

229

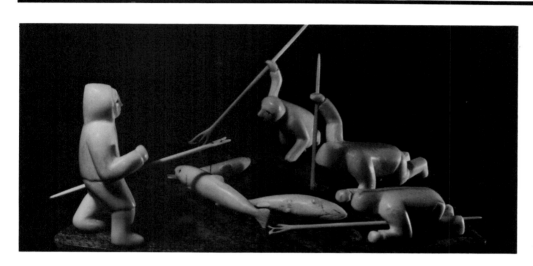

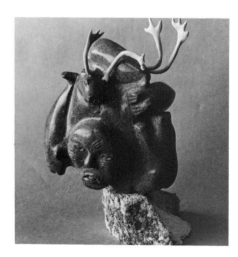

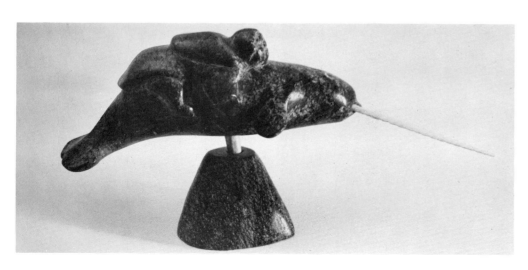

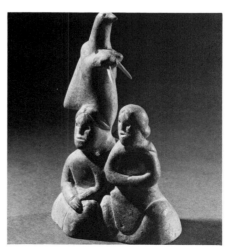

729/Irene Katak Angutitok
(Katak)
Repulse Bay 1959/60
Whalebone height 5″
WAG G-60-170

730/Lucie Angalakte Mapsalak
(Angalakte)
Repulse Bay 1958 and 1960
Various materials height 5″
WAG 2800-71, 2079-71

731/Christine Aaluk Sivanertok
(Christine Aaluk)
Repulse Bay 1959
Stone heights 2³/₄″ to 3⁷/₈″
WAG 3166/7/8-71, 3173-71

732/Irene Katak Angutitok
(Katak)
Repulse Bay 1959
Whalebone height 6¹/₂″
WAG 2370-71

733/Apollina Nobvak
(Nabvar)
Repulse Bay 1961
Stone and ivory height 3¹/₈″
WAG 3257-71

734/Louis Oksokitok
Repulse Bay 1967
Stone and ivory height 2″

735/Apollina Nobvak
(Nabvar)
Repulse Bay 1964
Stone and crayon height 5¹/₄″

736/Bernadette Iguptark Tongelik
(Iguptark)
Repulse Bay 1955
Stone height 4¹/₂″
WAG G-76-586

737/Unidentified artist
Repulse Bay 1965
Stone, whalebone, and antler height 3¹/₂″
WAG G-76-597

230

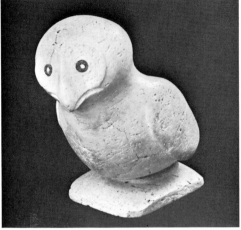
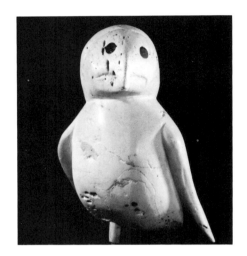
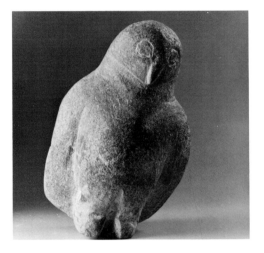

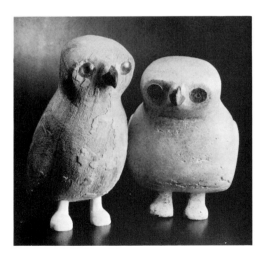

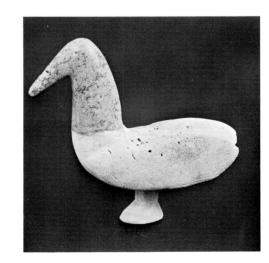

738/Mark Tungilik
(Tongikik)
Repulse Bay 1965
Stone and horn length 7″

739/Keelawajuk
(Piluardjuk)
Repulse Bay 1960/62
Ivory length c. 5½″
AGO 90/135

740/Athanase Ullikatar
(Ulikatark)
Repulse Bay 1958
Stone lengths 9⅞″ and 7″

741/Mark Tungilik
(Tongikik)
Repulse Bay 1969
Ivory and whalebone length 10½″

742/Keelawajuk
(Piluardjuk)
Repulse Bay 1960/62
Ivory length 4¾″
AGO 90/134

743/Marie Tullimar Aupilardjuk
(Tullimak)
Repulse Bay 1968
Stone and ivory width c. 7″
WAG G-90-934

744/Mark Tungilik
(Tongikik)
Repulse Bay 1968
Ivory height 2½″

745/Bernadette Ivalooarjuk Saumik
and Paul Siusangnark and
(Irene Katak ?)
Repulse Bay 1961
Stone lengths 6⅜″
WAG 2971-71 and 3739-71

746/Bernadette Iguptark Tongelik
(Iguptark)
Repulse Bay 1968/9
Stone, ivory, and antler width 9″
WAG G-90-933

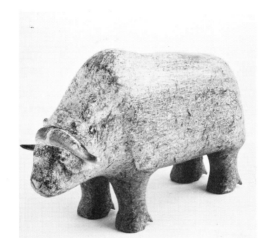

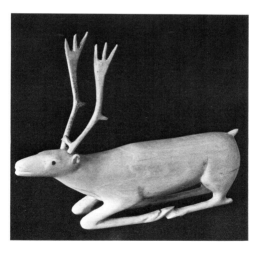
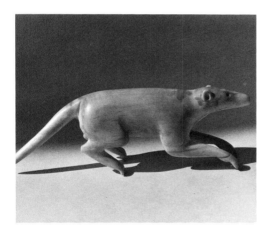
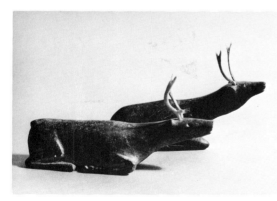
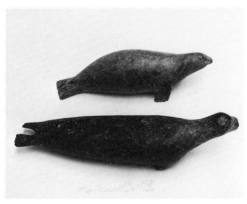
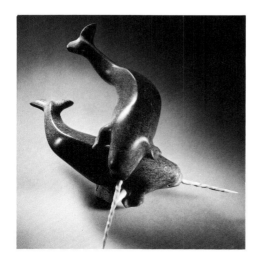
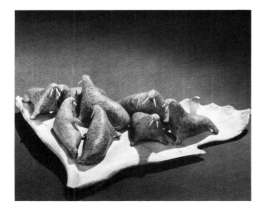

747/Lucie Angalakte Mapsalak
(Angalakte)
Repulse Bay 1954
Ivory length c. 4″
AGO 90/155

748/Mariano Aupillardjuk
(Aupilarjuk)
Rankin Inlet/Repulse Bay 1962/3
Stone height 6³/₈″
WAG G-76-551
(same as 38)

749/Paul Nivianian Sannertannu
(Nivianian)
Repulse Bay 1965
Stone and ivory height 5⁵/₈″
WAG G-76-470

750/Paul Siusangnark
Repulse Bay 1960
Stone length 5″

751/John Kaunak
Repulse Bay 1963
Stone length 10¹/₂″
WAG 3072-71

752/Keelawajuk
(Piluardjuk)
Repulse Bay 1964
Ivory length c. 12″
WAG 76-521

753/Anthonese Mablik
Repulse Bay 1962 ?
Stone length 6¹/₄″
TDB EC-75-340

232

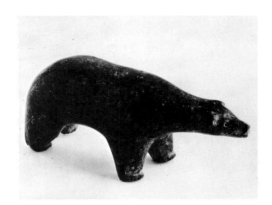

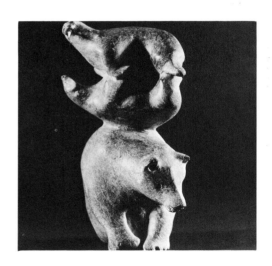
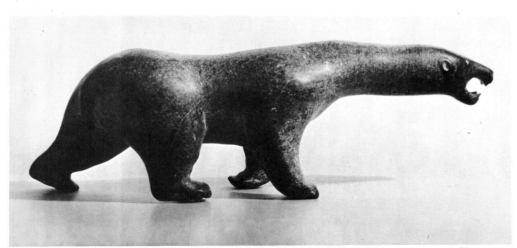

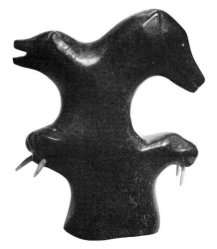

754/John Kaunak
Repulse Bay 1960 ?
Stone length 6³/₈"

755/Madeleine Isserkut Kringayark
(Isserkrut)
Repulse Bay 1962
Stone lengths 7"
WAG 2555-71 and 2554-71

756/Anthonese Mablik
Repulse Bay 1962
Stone lengths 5" and 4³/₄"

757/Marie Tullimar Aupillardjuk
(Tullimak)
Rankin Inlet/Repulse Bay 1964
Stone length 8¹/₂"
AGO S1068

758/Cecilia Angmadlok Angutialuk ?
(Angmadlok)
Repulse Bay 1954/5
Stone length 4¹/₂"
WAG G-76-471

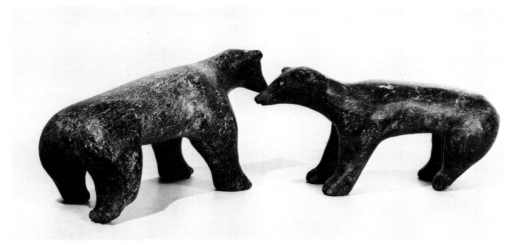

759/Christine Aaluk Sivanertok
(Aaluk)
Repulse Bay 1963
Stone width 4½"
WAG G-76-504

760/Christine Aaluk Sivanertok
(Aaluk)
Repulse Bay 1967
Whalebone height 4⅜"
WAG G-76-505

761/Christine Aaluk Sivanertok
(Aaluk)
Repulse Bay 1967
Stone height 4¾"
WAG G-76-507

762/Christine Aaluk Sivanertok
(Aaluk)
Repulse Bay 1965
Stone height 8"
WAG G-76-503

763/Christine Aaluk Sivanertok
(Aaluk)
Repulse Bay 1960/1
Stone height 5"

764/Christine Aaluk Sivanertok
(Aaluk)
Repulse Bay 1955/6
Stone height 5¾"
WAG G-76-506

765/Christine Aaluk Sivanertok
(Aaluk)
Repulse Bay 1963
Stone height 3½"
WAG G-76-508

234

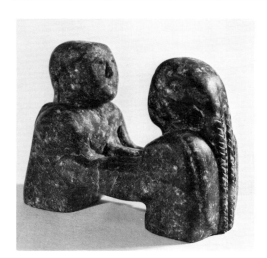
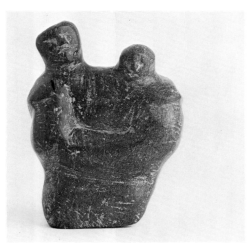
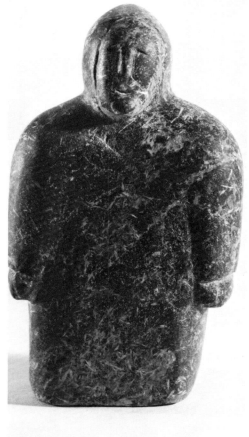
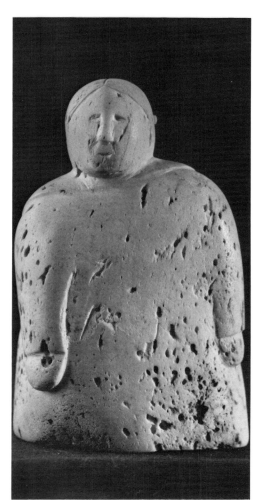

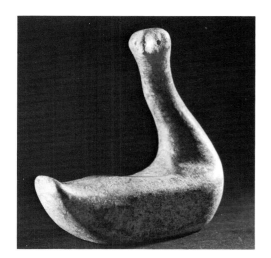

766/Madeleine Isserkut Kringayark
(Isserkrut)
Repulse Bay 1962
Stone and bone height 6⁵/₈″
WAG 2542-71

767/Mariano Aupillardjuk
(Aupilarjuk)
Repulse Bay 1970
Whalebone width c. 18″
PWNHC 970.3.18

768/Unidentified artist
Repulse Bay 1969
Stone height 7¹/₄″

769/Mark Tungilik
(Tongikik)
Repulse Bay 1967
Ivory and stone height 2¹/₄″

770/Therese Arnasivik Tabo
(Arnasibvik)
Repulse Bay 1968
Stone and ivory height 7″
ECM C68.8-1

771/Unidentified artist
(Isserkrut ?)
Repulse Bay 1969
Whalebone and stone height 7¹/₂″

772/Madeleine Isserkut Kringayark
(Isserkrut)
Repulse Bay 1961
Stone and bone height 9″
WAG 2516-71

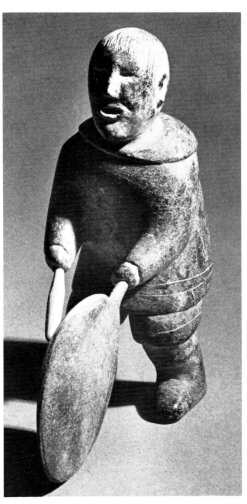
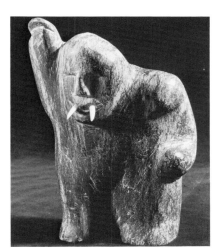
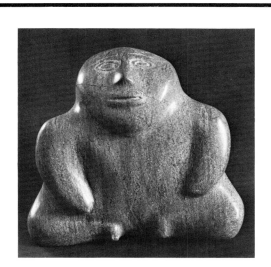
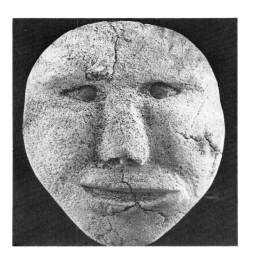
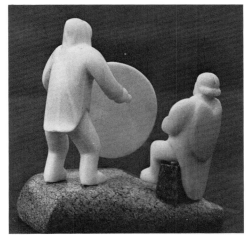
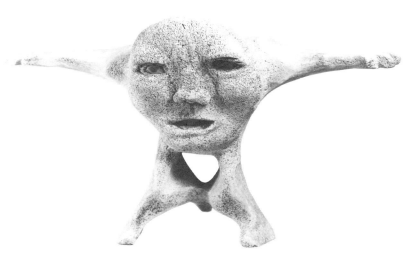
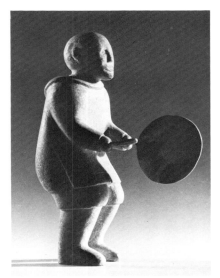

773/Lucie Angalakte Mapsalak
(Angalakte)
Repulse Bay 1966?
Stone height 5"
AGO 90/141

774/Alice Utakralak Nanorak
(Utakralak)
Repulse Bay 1965
Stone height 3¹/₄"

775/Paul Akkuardjuk
Repulse Bay 1963
Stone height 5"
WAG 3327-71
(cf. 198 right figure)

776/Celina Seeleenak Putulik ?
(Seeleenak)
Repulse Bay 1961
Stone height 4"

777/Celina Seeleenak Putulik
(Seeleenak)
Repulse Bay 1968
Stone height 11"

778/Bernadette Qattalik
(Kattalik)
Igloolik/Repulse Bay 1968
Stone height 3³/₈"
AGO 90/140

236

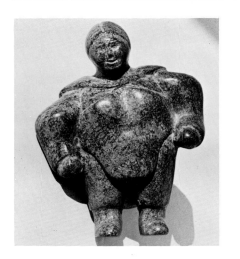
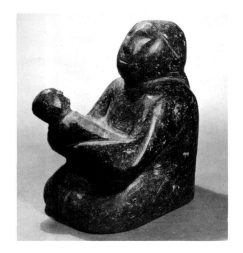
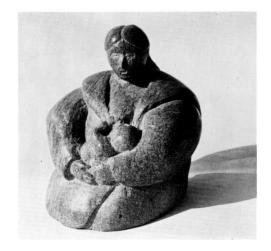
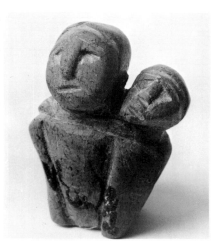
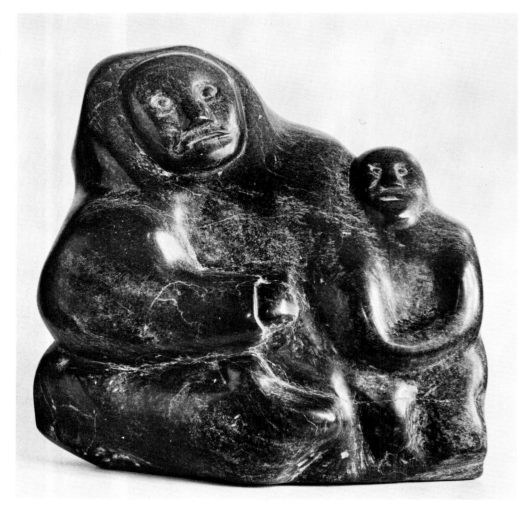
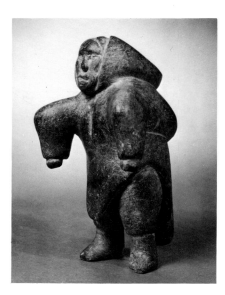

779/Suzanne Tupitnerk Mablik
(Tupitnerk)
Repulse Bay 1968
Stone height 5⁷/₈″

780/Suzanne Tupitnerk Mablik
(Tupitnerk)
Repulse Bay 1963/4
Stone height 3¹/₈″
AGO 90/133

781/Celina Seeleenak Putulik
(Seeleenak)
Repulse Bay 1959
Stone height 3³/₄″

782/Rosa Arnarudluk Kanayok
(Arnarudluk)
Repulse Bay 1968/9
Stone height 7″
EMC C68.2-1

783/Bernadette Ivalooarjuk Saumik ?
(Ivalooardjuk ?)
Rankin Inlet/Repulse Bay 1953 ?
Stone height 3″
WAG G-76-554

784/Bernadette Ivalooarjuk Saumik
(Ivalooardjuk)
Rankin Inlet/Repulse Bay 1965 ?
Stone height 3¹/₈″
WAG G-76-79

785/Unidentified artist
(Tupitnerk ?)
Repulse Bay 1962 ?
Stone height 3¹/₂″
WAG G-76-579

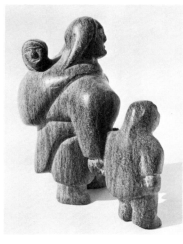

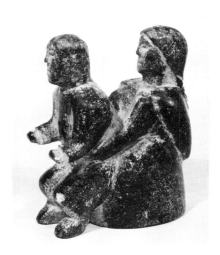

786/Fabien Oogaaq
(Oogark)
Pelly Bay 1954
Stone height 3⁵/₈"
EMC C54.9-1

787/Unidentified artist
Pelly Bay c. 1958
Stone height 2¹/₄"
WAG G-76-608

788/Unidentified artist
Pelly Bay 1954
Stone height 2³/₄"
EMC C54.9-1

789/Maria Tuitark ?
Pelly Bay 1966
Ivory and bone height 3¹/₂"

790/Fabien Oogaaq
(Oogark)
Pelly Bay 1955
Stone height 2³/₄"
EMC C55.20-1

791/Bernard Iqqugaqtuq
(Irkogaktok)
Pelly Bay 1954
Stone height 2⁷/₈"
EMC C54.11-1

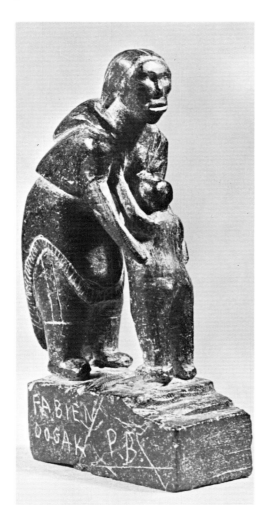

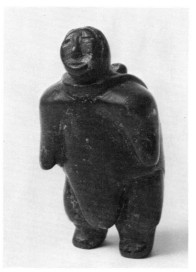

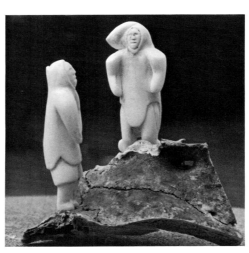

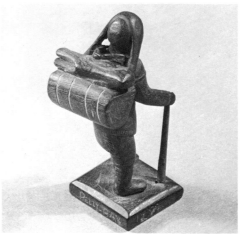

792/Antonin Attark
Pelly Bay c. 1954
Ivory length 10"
EMC C54.4-1

793/Antonin Attark
Pelly Bay c. 1954
Ivory length c. 8½"
EMC C54.2-1

794/Maria Tuituark
Pelly Bay c. 1963
Ivory and bone height c. 2¾"

795/Lee Aarlu Makittuq
(Aerluk)
Spence Bay c. 1960
Ivory height 2½"
WAG 1731-71

796/Fabien Oogaaq
(Oogark)
Pelly Bay c. 1959
Ivory height c. 4½"

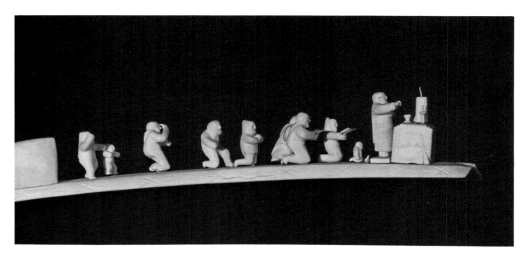

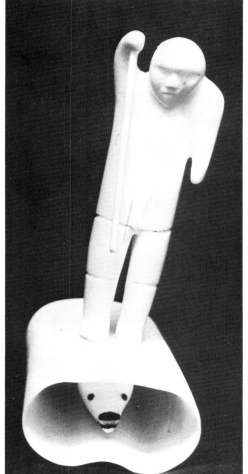

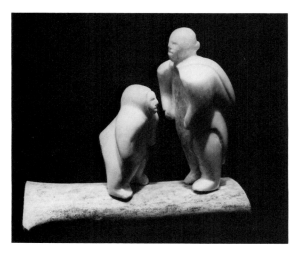

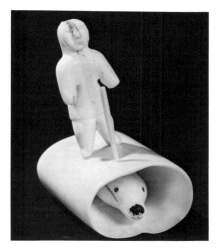

797/Fabien Oogaaq ?
(Oogark)
Pelly Bay 1958/9
Ivory height c. 3″

798/Unidentified artist
(Fabien Oogaaq ?)
Pelly Bay 1968
Ivory and bone height 1³/₈″

799/Unidentified artist
(Fabien Oogaaq ?)
Pelly Bay 1968
Ivory and bone height 3¹/₂″
(same artist as 798 and 801)

800/Fabien Oogaaq
(Oogark)
Pelly Bay c. 1966
Ivory and bone height 4⁵/₈″
EMC C66.6-1

801/Unidentified artist
(Fabien Oogaaq ?)
Pelly Bay c. 1956
Ivory height 1¹/₄″
EMC C62.10-1

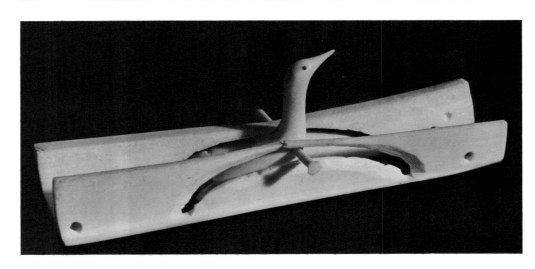

802/Unidentified artist
Repulse Bay c. 1955
Ivory length 7$\frac{1}{2}$"
EMC C55.7-1

803/Simon Inuksaq
(Inuksak)
Pelly Bay 1954
Ivory average length 4"
EMC C50.16-1a-d

804/Vital Makpaaq (re-a)
(Makpa Arnasungnark)
Baker Lake 1956
Ivory length c. 10"
EMC C.59.4-1

805/Unidentified artist
Pelly Bay c. 1966
Ivory and antler length 7$\frac{1}{4}$"
TDB EC-75-267

806/Fabien Oogaaq
(Oogark)
Pelly Bay c. 1966
Ivory length 4"

807/Fabien Oogaaq
(Oogark)
Pelly Bay c. 1960
Ivory and stone length c. 3"

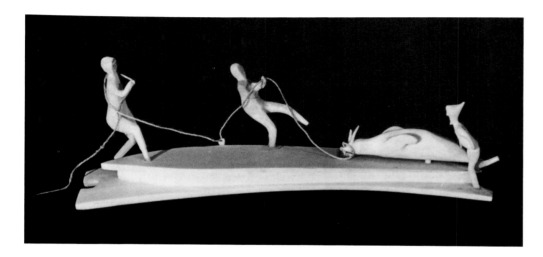

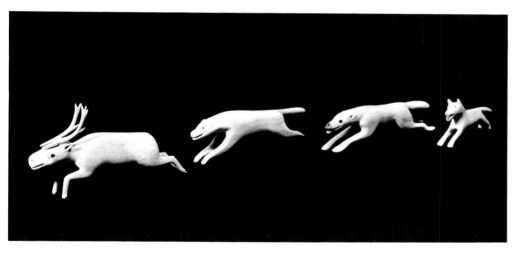

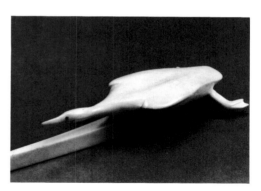

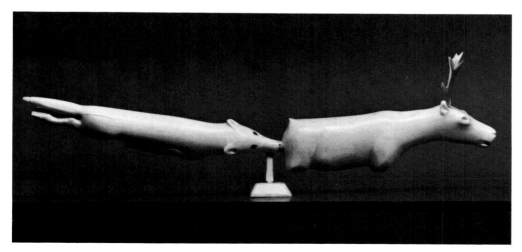

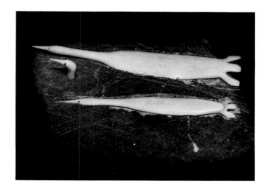

808/Sakkiassee Anaija
(Anaija)
Spence Bay 1969
Whalebone width 3³/₄″
WAG G-76-808

809/Eli Inukpaluk
(Igjukuvak/Igjookhuak)
Spence Bay 1969
Whalebone height 22⁵/₈″
U of M 69.415

810/Karoo Ashevak
Spence Bay 1970
Whalebone height c. 10″
PWNHC 970.3.64 a-c

811/Sakkiassee Anaija
(Anaija)
Spence Bay 1969
Whalebone height 11″

812/Unidentified artist
Spence Bay 1969
Whalebone height c. 20″

813/Gideon Qauqjaq
(Gideon/Kadojuak)
Spence Bay 1969
Whalebone height c. 19″

814/Sakkiassee Anaija
(Anaija)
Spence Bay 1969
Whalebone height c. 18″
York 69.

815/Karoo Ashevak
Spence Bay 1969
Whalebone heights c. 18″

816/Unidentified artist
Spence Bay 1969
Whalebone height 21″
CAG 70.9

242

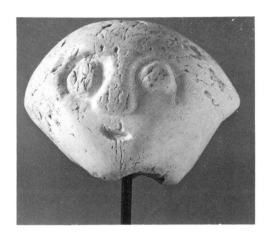
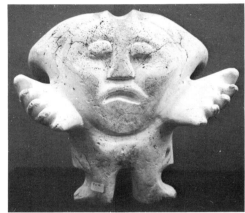
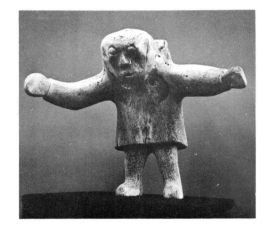

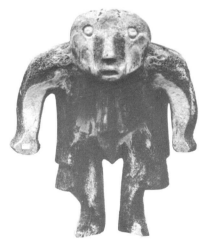
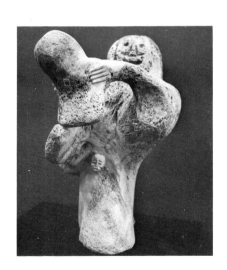
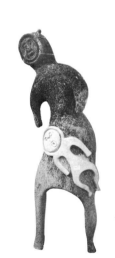

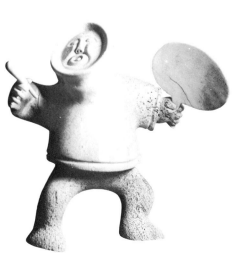
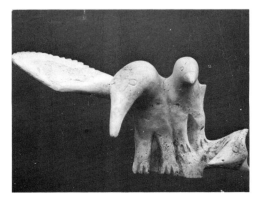
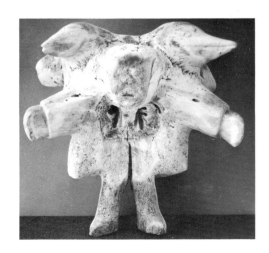

817/Unidentified artist
Coppermine before 1920
Stone and various materials height 4″

818/Bessie Kakagon
Coppermine 1955
Stone height c. 4″
CMC NA-122

819/Unidentified artist
Bathurst Inlet c. 1968
Stone, ivory, and copper height 5½″

820/Doris Hagiolok
Coppermine 1966
Stone height 2¾″

821/Peggy Ekagina
Coppermine 1970
Stone and various materials width c. 11″
PWNHC 970.3.58 a-n

822/May Mogena
(Mareena)
Coppermine 1965
Stone height 5½″
WAG 1181.71

823/Andrew Klengenbergh
Coppermine 1970
Stone and various materials width c. 7″
PWNHC 970.3.24

824/Ada Suzanne Kayogena ?
(Kayitok)
Coppermine 1969
Stone length 13″

825/Unidentified artist
Coppermine c. 1969
Stone height c. 3½″
WAG G-90-919

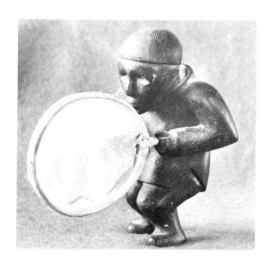
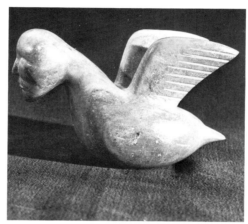
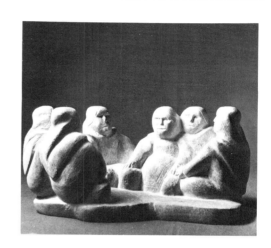

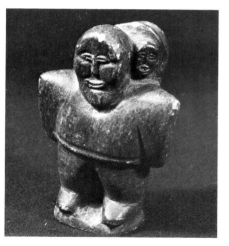
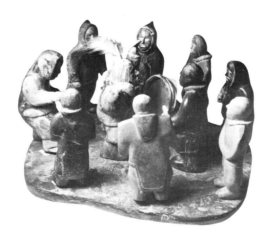
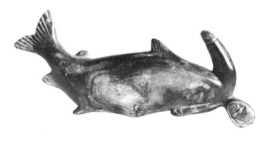

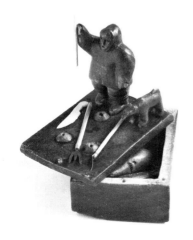
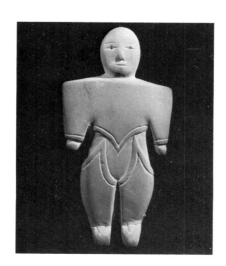
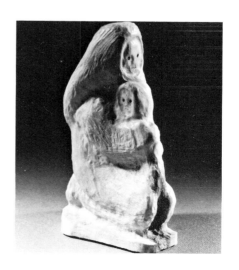

In retrospect, I am pleased that a great number of pieces have come into public collections. There were in play circumstances that caused those acquisitions – though intrinsic to the nature of the book and my intentions – to have achieved a paradoxical effect. Originally it was my plan to show only good quality carvings, which also expressed the great variety typical of Inuit concepts of life and nature. Yet I had neglected to emphasize that there were considerable quality differences. Such hard facts are, of course, true of most art produced anywhere but are less true in the context of what Nelson Graburn refers to as "ethnic art," often misnomered as art of indigenous people or worse, as "primitive" or "naive," or simply as "native" art.

To be sure, art of the later historical and of the contemporary Inuit can hardly be called "primitive art" (as one could say of most cave and rock art, although the mural-like paintings of Altamira and Lascaux are highly sophisticated). On the other hand, even as late as the seventies, much Inuit art, while sometimes disarmingly naive, has been mostly primary and elemental yet only seldom primitive. And when one takes into consideration the economic motivation of almost all "Inuit art" since 1948-49 (cf. pp. 23-24 and 131) the word "primitive" is not applicable and reeks of inane promotion attempts.

But there are quality differences. While the good is usually rare, the not so good is not. In the art of the Inuit of the 1950s the quality differences were minimal. Today, the very opposite obtains. These differences can be equated to two ziggurats (pyramids in which succeeding steps or stories become progressively smaller). In terms of a quality equation, the good (and smaller) is on top; the lesser (but larger) lies below. In the 1950s the stories of the metaphorical ziggurat were almost equal in dimensions and, therefore, quality divergences not always evident.* Today the base story is very extensive but the top is consequently higher. Art then was not a conscious process; today the consciousness of it separates the top from the bottom a great deal.

Expressed differently, in the early days it was possible to speak of Inuit art or "Eskimo Art." It is no longer possible to speak of Inuit art as an undifferentiated ethnic art form. In its beginning stages there was a remarkable unity of form and content, but rapid acculturation forces (discussed in chapters 6 and 7) together with the ensuing consciousness of art making have created highly differentiated forms and content as well as quality differences. While these changes were noticeable in the mid-sixties, there existed a directness of narration, i.e., of visual interpretation of things seen, experienced, or imagined. Today much of this directness has been replaced by more or less technical skills and by daring in subject matter. Narration has often become more complex and less straightforward. Yet there are new and truly remarkable accomplishments. However, due to differences in talents and skills, the consciousness of having to make "art" has created such great disparities that "Inuit art" is more of a geographically ethnic designation than a culturally singular art form. At best it is true art, created by artists who are Inuit. However, art that is not good can never become (Inuit) art as such even when the makers are genuine Inuit carvers but not artists in the positive sense of that word.

On the other hand, the number of *good* Inuit artists is a much, much greater proportion of their population than exists in Western cultures. But a distinction must be made between what can be called art and what cannot. As artist (and perhaps epicure) I look for the good and tend to bypass the mediocre. Quality almost automatically raises responses in me; the absence of quality I ignore or, at least, avoid. Only when served up *en masse*, or promoted embarrassingly, does inferior art grab my attention and reaction. But what I love and collect is that which evokes responses in me. Such was the case with "Eskimo art" and still is with that which, to this day, is authentic art.

For over forty years my concern was always with what I felt was art and which I saw and still see and find. That concern has not changed in updating this book. In fact, it has increased while its focus has become sharper. I only wish that it were possible to publish more of the good I found and savoured. But we *are* beginning. However we must not give the impression that we are "covering the territory." What most of us try to do is to point to some of the good that is so conspicuous. It is therefore hoped that the reader has enjoyed and found useful the great variety of art shown so far. More good – no, more very good – is to come.

* I don't think it was merely due to James Houston who says that often at night he carried inferior works into a boat and then sank them into the waters.

Musings

826/Father Projet, o.m.i.
Chesterfield Inlet c. 1920
Photo (PA 43157)
NAC 1936-271
("Ivory carving by Eskimos")

Having written so emphatically on quality differences, I must also admit that there are in souvenir shops a good many important but hidden values and occasionally excellent work. While most collectors disregard these, it is significant that this kind of work is treasured by a majority of people who buy it for a variety of reasons (souvenirs, gifts, and pleasing *objets d'art*). As "products," these objects achieve entirely new meanings beside the obvious pleasure they give to consumers. They become a mainstay of the Inuit economy inasmuch as some 70 per cent of all Inuit wage earners (or more than 3,000 people – both male and female) produce "art" for the markets. Economic motivation is a major impetus for art making in the North. But it certainly is not the only one.

Historically, the souvenir items will become recognized with age as *antiques* or *collectibles*. Carvings of the first five to ten years (e.g., 245 to 254 or 750 to 757) – the "Classic Phase" – have already become valuable. The carvings displayed on this page being earlier work, are even more valuable and are being recognized as *cultural artifacts*.

While agreeing that masterpieces do occur, I am suspicious of the current abuse of the ubiquitous "masterwork" phrase. At the same time, I believe in the need to differentiate between the important and the indifferent. In the past twenty years about a million carvings have been produced but in this revision I have restricted myself to about thirty additional pages and less than ninety new illustrations. And, considering that I see every year several thousand carvings, I selected from only those carvings that indicate the trends I wish to illustrate.

I no longer arrange the artists by area (as in the *Catalogue of Artists*) but by content and form. The earlier arrangement was necessary as a great many artists had not been identified, and the names of locations, where the carvings originated, were essential for identification. I have never used the designation "anon" or "unknown" which I considered insulting. Artists were never anonymous, we simply didn't know their names. But now it has become possible to identify a few more, as well as plausible to attribute and re-attribute some pieces to artists whose names and work we do know. Wherever I received identifications by early collectors who had lived in the North I have let the names stand although, at times I could not find their names listed anywhere else (cf. 305 and 314).

The other problem with names we encountered is not only the new orthography but the making of indices of artists. On page 28 I mentioned the example of Osuitok Ipellie whom, since 1963, I called Oshooweetook, as his name was spelled phonetically. Now it is used as his alternate name only. In fact, most of the artists I know were known by only one name. Hence my having to cross-index them.

One more major difficulty was posed by the increasing need to use titles. In the original edition, I abstained from using any. But now, because of the more sophisticated, more complex, and more content-conscious character of art, the use of titles is necessary. The question is: which title? Or, rather whose? Those given by collecting or purchasing institutions? Or those given by the artists? The answer unquestionably is: the artists'! But, alas, only few artists give titles; the majority of titles are given by institutions, wholesalers, and auction houses. While these titles are always more or less acceptable, they often fail to identify the highly complex *raisons d'être* of the pieces. I have put the latter titles in brackets in contrast to those few titles given by artists.

827/Mark Tungilik
(Tongikik)
Repulse Bay c. 1982
Stone, ivory, baleen, copper, pigment
width 13¼″
AGO S2713

828/Manasie Akpaliapik
(Manasie)
Toronto, Ont. 1989
Whalebone, ivory, stone, antler, horn
width 28⅛″
AGO S561
"Respecting the Circle"

247

This amazing NAC double-portrait (opposite) was drawn to my attention in 1979 by Gabriel Gély. It is a double exposure, probably taken by Father Projet himself, in the early days of the Roman Catholic Mission at Chesterfield Inlet. It substantiates the existence and type of ivory carvings flourishing on the west coast of Hudson Bay and on Baffin Island in the Historical Period (p. 119-22); however, it was surprising to me to see the use of vertebrae and bone carvings.

The similarity of carvings produced in the Contemporary Period with those in the photo is simply too fascinating not to be noted (cf. 543, 734, 747, 797, and 803).

In the same spirit, Mark Tungilik has described Arctic people and wild life for more than forty years. In his "Scene" he "bridges" Inuit life style and the range of his own earlier work.

And then, looking at Manasie Akpaliapik's huge "Respecting the Circle" that is so knowingly and painstakingly carved, we enter the world of art itself. Manasie's carving is juxtaposed with Mark Tungilik's in order to introduce what may be classified as the post-Contemporary* phase of Inuit art. While both are based on Inuit themes of existence, the technical means and the formal attitudes (or style) are altogether different.

"Respecting the Circle" displays some of the new period's characteristics: large, skilfully carved, complex, and ingenious. Manasie explores and exploits the sculpture's several materials without ever losing touch with their subtleties or the whalebone's monumentality.

* My use of "post-Contemporary Inuit art" refers to that art which so clearly separates itself in the early 1980s from that of the previous three decades, which had become known as the "Contemporary Period" (cf. pp. 123-236).

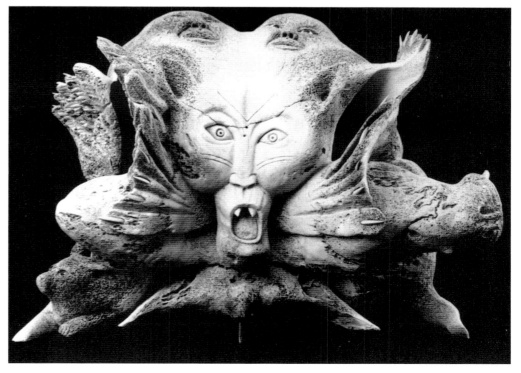

829/Nick Sikkuark
Gjoa Haven 1989
Whalebone, bone, antler, hide, fur, pigment
height 7⅝"
AGO S1029
("Spirit Swallowing Animal")

830/Emily Pangnerk Illuitok
Pelly Bay 1991
Bone, hair, horn, bird claws height 15⅜"
WAG G-91-2
("Spirit")

831/Tukiki Manomie
(Tukiki Munamee)
Cape Dorset no date
Stone height c. 25½"
AEF A40.1a-b
("Life's Fantasy")

248

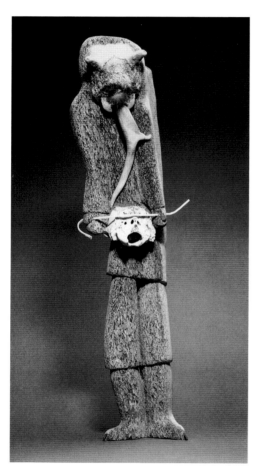

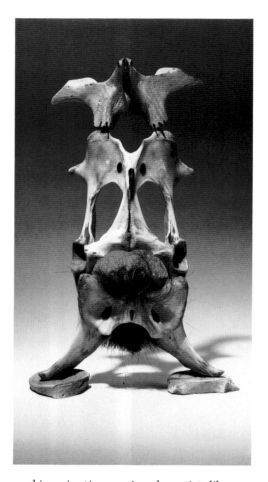

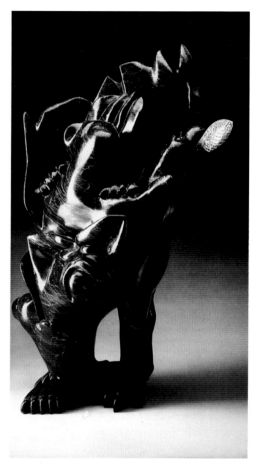

When I first went north in 1957, I had definite notions what "Eskimo art" was supposed to look like. After a few days in Povungnituk, my hunches about the "collectivity of anonymous Eskimo Art" were not only confirmed but expanded (cf. pp. 18-19). While there were carvers who created "tourist" subjects, one could readily see who were the "artists." Also those who worked beyond the clichés and those who had retained a sense of nearly raw ("primitive") art impulses without any consciousness of them (cf. 119 and 143).

Looking back at my original writings, I can see my predilection was for art that was straightforward and evocative. On the other hand, I learned to find the fantastic

and imaginative carvings by artists like Davideealuk and Eli Sallualuk (pp. 172-73) with their inventive configurations. Together with the fantasy artists of Cape Dorset (pp. 190-91) and Karoo Ashevak (832) they were the forerunners of the unconventional artists of the late eighties and nineties.

These latter have come onto the stage of Inuit sculpture with great impact. When they first arrived, they reminded me of the phrase *épater le bourgeois*, except that they not only astounded the Philistines (and most early collectors) but they also amazed and influenced many of the "Kitikmeot" artists (cf. p. 256) including Nick Sikkuark (829), who moved from

Gjoa Haven to Pelly Bay and Emily Pangnerk Illuitok (830).

Tukiki Manomie's art (831), however, is different. Most of his complex stone sculptures are abstract shapes based on concepts of form rather than on narration, on sensitive stone carving technique, on fertile imagination, and on vision (hallmarks of good Cape Dorset art).

Such praises apply even more emphatically to Karoo Ashevak who had the greatest impact, particularly in the "Kitikmeot" regions (cf. p. 256). He started out in a narrative sense (810 and 817), yet was conspicuously conscious of the whalebone's inherent chimerical possibilities. By extending that material (adding antler,

249

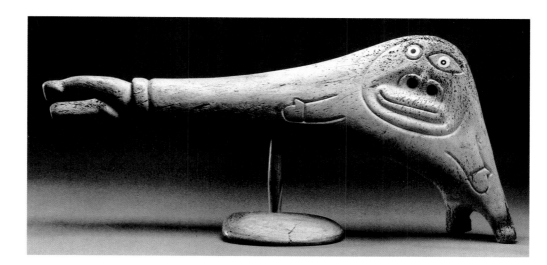

ivory, and various other substances), he became a true "multi-media" artist. And it was in this regard – precipitated by a flood of catalogues, magazine articles, and reviews of his work – that his influence became so enormous.

Karoo's uncle, Charlie Ugyuk, of Spence Bay, whose carving (835)* shows a remarkable affinity with the fantastic carvings of Cape Dorset and Povungnituk is an artist of vision. And like Davideealuk, he often is robust and jocose – Rabelaisian – as are most other Kitikmeot artists.

As to the other two sculptures – so different in their minimal, pure, severely curvilinear, and abstracted form – they are equally communicative. Ovilu Tunnillie's "Football Player" (833) is precisely that: an astutely conceived, powerful, threatening gridiron giant. Tuqiqi Osuitok's "Two Figures" (834) are abstractly conceived as firm yet elegantly expressed idealization of an intertwined, inseparable couple. Tuqiqi, by the way, is Osuitok Ipeelee's son and clearly has inherited his father's great talents and skills (cf. 12, 94, 431, and 898). In 1975 he said to me "I like Henry Moore best of all, I want to be an artist as good as he."

The seven works on these pages are art: good sculpture, not just carvings. They are far removed from the concept "tourist."

* Charlie Ugyuk's title "Devil after Birth Holding Young Devil" is both literal and narrative, in keeping with old Inuit oral traditions. As such the carving has mytho-poeic nuances which it would not have without the title.

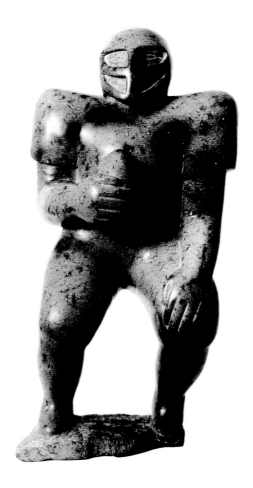

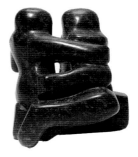

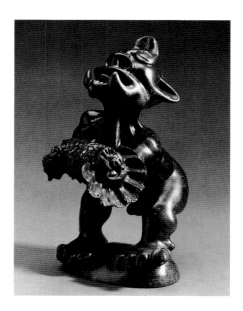

836/George Arluk
(Arlu)
Arviat/Rankin Inlet 1969
Stone length 8⁵/₈"
AGO 90/110
("Man on Skidoo")

837/Lazaroossee Akpaliapik
Arctic Bay 1975
Stone length 4¹/₂"
AGO 90/212
(harpoon head bought as a pendent)

838/Niaqunnuaq Ukuqtunnuaq
Spence Bay 1989
Stone, antler, graphite length 6⁷/₈"
AGO GS292
("Skidoo Hunting")

250

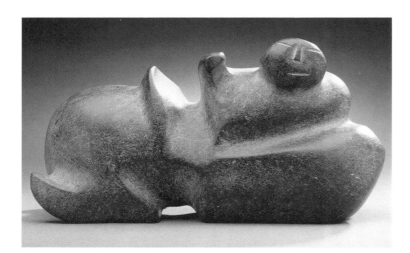

As different, stylistically and in subject matter, as the carvings* on these two pages might feel, a common ground is hunting magic in Inuit cultures. And, particularly, in the art of the Dorset culture (pp. 114-15).

George Arluk's "Man on a Skidoo" (836) is very close to Tuqiqi's stylized couple but its subject matter has additional content: the skidoo is also a telling symbol of acculturation. Skidoos have now largely replaced dog teams for travel and transportation and are indispensable in hunting activities.

Niaqunnuaq Ukuqtunnuaq's "Skidoo Hunting" (838) is explicit and unequivocal about the skidoo's major function. Underneath the skidoo, on the carving's antler base, is drawn a bear similar to Akeeaktashook's (153), but with legs stretched forward. Since Dorset times (or

even before) a great variety of bear effigies (cf. 152) and of more or less abstracted pendents (cf. 151 and 157) have been symbols (or insignia) of propitiatory hunting magic. In that sense, Niaqunnuaq's skidoo is designated as a helper in the hunt of which it is the signifier.

In both carvings the symbolic content is an essential element, which added to their sensory (aesthetic) appeal. To a connoisseur (not to be confused with specialist or scholar), the aesthetic form and the symbolic content combined are greater than the sum of the parts and cannot be separated.

So it was also with Lazaroossee Akpaliapik's harpoon head (837) sold as a pendent. Among its prominent features are the extended barbs so reminiscent of the basal spurs of Dorset culture harpoon heads (cf. 150). The latter, with the addi-

tion of lozenge-shaped stone points, are evidently the prototypes of Lazaroossee's pendent. And, compare that "pendent" with the frontal view of the famous ivory bear from Alarnerk (152): the relationships between the two become clearly visible. Lazaroossee's large basal spurs were in fact the bear's hind legs (with strongly expressed paws) and the lozenge-shaped harpoon point the bear's head! And his pendent, turned around, became the bear's body!

Similar, visually significant, symbolic parallels exist between the Alarnerk bear and Dorset harpoon heads and their symbolic magic: the bear as spirit helper facilitates through the harpoon head, resembling the bear, in taking quarry.

A few years earlier, I had seen a carving of a bird with outstretched wings perched atop a swimming bear (839). I was told,

839/Mark Kadyulik
(Kadjulik)
Salluit (Sugluk) c. 1963
Stone length c. 12¹/₄"
AGO GS323
("Spirit Flight")

840/Akeeaktashuk ?
Inukjuak (Port Harrison) 1953
Stone, ivory, feathers, sinew length 9¹/₄"
WAG G-60-135
("Shaman Riding a Bear" cf. 153)

841/Unidentified artist
Arviat (Eskimo Point) 20th century
Leather, sinew, thread length c. 4¹/₂"
AGO 90/236
(shaman's ? parka pendent)

there never are birds on polar bears, the carving was "obviously a mistake" and, therefore, on sale. Liking it purely as "work of art," I took advantage of the opportunity, also sensing somehow the carving's kinship with the supernatural. As I learned more about shamanism I recognized that this carving represented a shaman's eternal "spirit journey"!

Ten years earlier, I had already seen Akeeaktashook's carving (840). When viewed with Kadyulik's carving, the posture of the bears (with front legs folded to the sides and hind legs extended), shows the bears are floating or flying through space. In Kadyulik's carving the bird symbolizes flight and the bear a shaman transformed or a helping spirit's flight. Akeeaktashook's bear, as helping spirit, has on its limbs the same magic joint marks as the "flying bear" of Alarnerk.

The final bear sculpture in this series is a leather pendent (841) which may have come from a shaman's costume or a parka's amulet, with the propitiatory implications of the bear. All three bears, not incidentally I believe, have their hind legs extended and spread out like a harpoon head's basal spurs! Furthermore, the leather bear is particularly elucidative for its very carefully sewn open jaws, similar to the open-ended tips (the jaws) of a harpoon head that holds the death-dealing harpoon point! But it might also indicate breathing, soul, or spirit, *aninirq* in Inuktitut, which (through its root *an-*) relates to *angakoq*, the shaman "who on his spirit journey has assumed the soul form – the permanent form of being" (Taylor and Swinton, 1967).

* Personally I am inclined to use "carving" for a small sculpture and "sculpture" for a large carving, but this is merely an idiosyncrasy of mine.

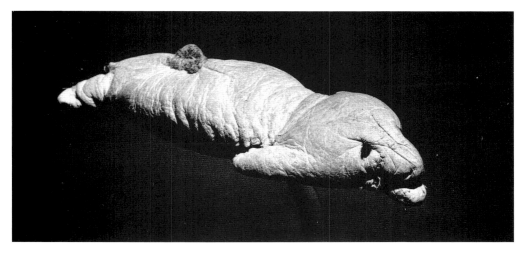

842/Abraham Anghik
(Abe Anghik)
Salt Spring Island, B.C. 1984
Brazilian soapstone, African wonderstone,
ivory height 18½″
WAG G-90-508
"Shaman's Apprentice"

843/David Ruben Piqtoukun
(David Ruben)
Toronto, Ont. 1982
Brazilian soapstone and ivory height 12″
AGO GS330
"Bear Spirit Possessing Man's Soul"

844/Unidentified artist
Clyde River c. 1968
Stone height 3¾″
("Shaman Transformed" ?)

845/ (another view of 844)

846/Qavaroak Tunnillie
(Kabubuwakotak/Kabubuwa)
Cape Dorset no date
Stone height c. 22″
AEF A70.2
("My Seal")

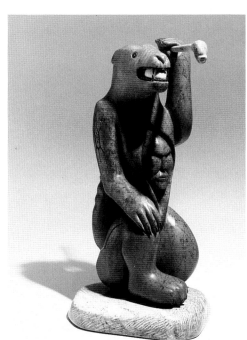

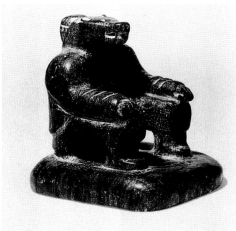

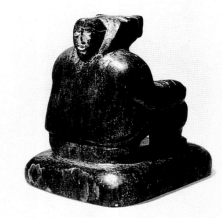

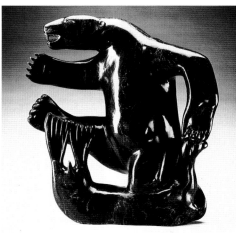

The two views (844 and 845) of a transformed shaman are of a powerful but small sculpture only 3¾″ high. It shows a great shaman who has changed into the form of his helping spirit (with the characteristic joint marks on his *arms*). The shaman has become his other self – his spirit form – enabling him to perform the tasks to which he had consecrated himself, fulfilling in a secular world the sacred mission to the people he serves – and often controls.

Related to it are two recent bear sculptures, one with a head, the other with a figure, enclosed in the bears' excised abdomens. They refer to the shamans' ability to change form; to their apprenticeship, which confirms being called; and to their mastery over themselves and others. These two pieces came from the remarkable "Out of Tradition" exhibition at the Winnipeg Art Gallery in early 1989. In her catalogue captions, Darlene Wight used the titles and succinct statements given her by the two brothers.

Abe Anghik said about his "Shaman's Apprentice" (842):

"Often the shaman would be chosen, as a child, for certain gifts he or she exhibited early in life or certain events that would cause an individual to get great powers. This would be followed by many years of apprenticeship under a shaman. It would include mastery of the language, its myths and legends, healing and medicine, clairvoyant and clairaudient powers, and acting as mediator between the worlds of animals, spirits and men."

About his carving "Bear Spirit Possessing Man's Soul" (843) Anghik's brother David Ruben says:

"A powerful shaman in the form of a bear has taken possession of his enemy's soul. His enemy will now die." (Wight, 1989)

847/Levi Alashuak
(Alasua)
Akulivik (Cape Smith) no date
Stone c. 15″
AEF A2.1
("Listening Bear and Seal")

848/Jimmy Inaruli Arnamissak
(Jimmy Smith)
Inukjuak (Port Harrison) no date
Stone, sinew, ivory height c. 18″
AEF A6.1
("Seasons of the Hunter")

849/Judas Ullulaq
(Ooloolak)
Gjoa Haven no date
Stone, ivory, bone, sinew height c. 15″
AEF A71.1a-b
("Inukshuk Comes to Life")

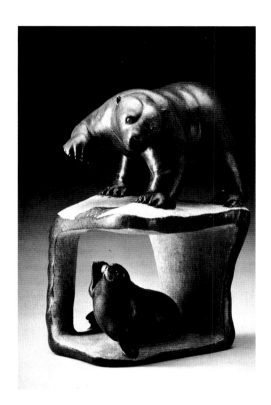

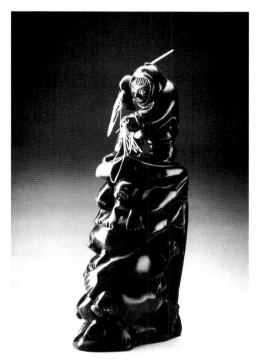

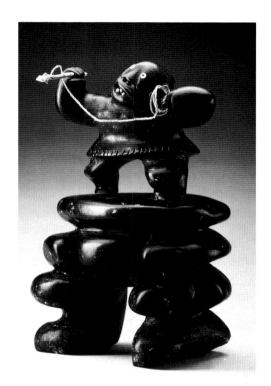

In contrast stand four hunting images. They were selected for their interesting, message-bearing reasons.

The high-standing *inuuk* (the Inuktitut expression for *two* men) are ready to hurl their harpoons. Jimmy Smith's hunter (848) does so with visible delight, standing on the floe edge of the ice under which seals frolic unsuspecting: the very image of "Shrewd Hunter Outsmarting Dim-witted Quarry." Furthermore, the carving is typical for past and present Inukjuak sculptures: large and complex (cf. 91) and now even more narrative and detailed as the artists became more skilful. Alas, so much of contemporary carving is polished, waxed, or even varnished, in order to achieve a detailed finish with a high gloss.

Judas Ullulaq's sculpture (849) presents less of his great technical skill than his constant amusement, with which he faces

life and art. As mentioned (p. 248), the "Kitikmeot" artists delight in jesting about their own foibles and heroics. Judas's hunter, standing on an *inukshuk*,* is aiming his harpoon. But at what? Seals? Surely not at caribous? This is obviously some kind of banter, but at whose expense? The Inuit hunter's? The gullible white men? Seals are, of course, not hunted from atop an *inukshuk*, nor caribous with a harpoon: it is a typical example of Inuit fondness for trick playing.

Levi Alashuak's meticulously carved sculpture (847) – also combines hunt and humour. A mighty bear, scraping the ice over a seal hole attempts to grab a prankish seal who raises his flipper to hear better. As does the bear his paw. Maybe to strike, or perhaps, to hear better?

Qavaroak Tunnillie's triumphant bear with "his" seal (846) is another expression of Inuit acuity: somewhat caustic, cagily

realistic, not malevolent. This sculpture, so elegantly carved in the manner of a heraldic device, proclaims the archetypal exultation of winner and the absolute defeat of loser.

These eight carvings are related via hunting. They show a range from the supernatural to the very skilful, to the humorous, to the symbolic. Ultimately they all are part of the ambivalent but not paradoxical ways of traditional Inuit rationality.

* The ubiquitous Inuit stone cairns or figures of man, now used as markers, were originally lined up in a row and employed to direct *caribous* into an ambush.

850/Tookikalook Pootoogook
(Tukakikalook)
Iqaluit/Cape Dorset 1973 ?
Stone c. 7¹/₂″
WAG G-76-128
("Two Birds")

851/Mina Inuktalik
(Mina Crow)
Sanikiluaq (Belcher Islands) 1980
Stone (pale and dark green) width c. 9¹/₂″
NGC 1.80.14
("Sea Bed")

852/Miriam Marealik Qiyuk
(Marealik)
Baker Lake 1979
Stone length 7¹/₂″
AGO 90/113
("Coupling")

254

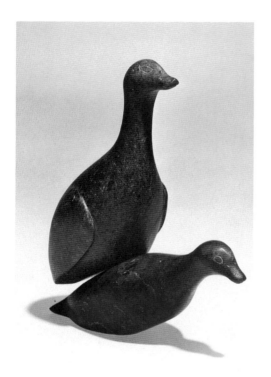

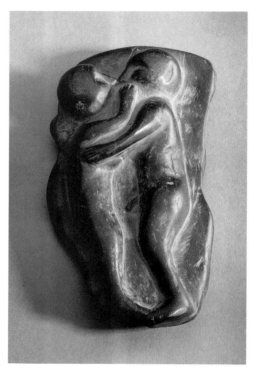

Further to my comments on sexuality in Inuit sculpture (pp. 21-22) – what I then called "propagation as part of nature" – eroticism *has* bloomed in the Arctic as was to be expected. This happened because of the influence of girlie magazines and blue movies, part of the all-pervading acculturation processes.

On the other hand, the appearance of carvings with more "feminist" attitudes is becoming increasingly noticeable. This affirms visually and symbolically the emergence of contemporary Inuit women within the worldwide feminist movement. A more sensitive concern for family and nature is manifested, one quite different from the greater energy and matter-of-factness seen in the carvings like those on page 22 and 260, conspicuously produced by male artists.

This difference becomes obvious in comparing the carving by Tookikalook (850) to Miriam Qiyuk's (852). His ducks are stolidly involved in propagative copulation. The matter-of-factness of this process is evidenced by the ducks' solemn forms and placid features. A candid sculptural accomplishment.

Miriam's bas-relief on the other hand exudes tenderness with delicately carved shapes and gently pliable forms. Nonmechanical. Instinctive. Innocently sensuous.

Mina Crow's "Sea Bed" (851) appears to be less pragmatic, more design oriented, the result of aesthetic appreciation of (sea shell) forms and patterns as subject matter.

Changes 1971-1999

853/Augustin Anaittuq
(Annaitok)
Pelly Bay 1975
Ivory and stone height c. 7/8″
AGO 88/621
("Dog with Animal Skeleton")

854/Augustin Anaittuq
(Annaitok)
Pelly Bay 1989
Whalebone and antler height 5⅝″
WAG G-90-510
("Untitled/Inukshuk and Skull")

855/Bernadette Iguptark Tongelik
(Bernadette Iguptark)
Repulse Bay c. 1973
Ivory, sinew and whalebone height c. 6¾″
AGO S2076
("Transformed Shaman and Walrus")

256

During the past twenty years substantial changes in styles and attitudes occurred. The most radical changes occurred in the western regions of the central Arctic and, particularly, at the once predominantly Netsilikmiut-inhabited locations of Spence Bay, Gjoa Haven, and, eventually, Pelly Bay.

One should note that the population is no longer purely Netsilik because many families from Baffin Island (Cape Dorset), Pangnirtung, and Pond Inlet) moved there before World War II and stayed. The area is now called "Kitikmeot," which means land of the middle (or centre), i.e., in the centre of the Arctic or, more idiomatically, central to the area where Inuit live. The name derives from *kitik* (or *qitiq*) – the Inuktitut word for middle (or centre). "Kitikemeot" now, is also known and publicized as "Land of the Spirits" as a result of typecasting the area's sculptural innovations.

The most authentic Inuit word for spirit as soul (or vice versa) is *aninirq* as already mentioned (p. 251). The word *inua* is also used which, especially in Alaska, implies an unspecific but compelling essence which persons (or anything in general) *possess* and that hence becomes the "spirit" (or soul) in the sense of a being beyond existence. It also relates to persona and anima. We are apt not to use the word "spirit" in that "soul" sense. For us, especially in titles, it usually denotes a super-natural – often malicious or even demonical – being, which is not accessible to our conventional interpretations.

Furthermore, I believe that the so gargoyle-like sculptures of the past twenty-five years or so – and particularly those of the last ten – have "spook" and not "spirit" connotations. The carvings are made with fun and fury rather than with solemn or sacred vision. They are neither *inua* nor *aninirq*, yet they have a great deal of character (persona) and emotional appeal (anima) and, when not repetitious, they often are inventive, astounding, and exciting works of art. Also, as is commonly recognized in this regard, all Eskimoid peoples across the Arctic from Siberia to Greenland were known for their animistic beliefs: almost anything and everything had soul and spirit (their *inua*). But *inua* is something quite different from the way this term is used in the generalized "spirit" designation of so many carvings. Many of the "spirit" carvings of the last decade or so have become increasingly sensational, irreverent, and derisive. They seem to be produced to amuse the artists, to amaze colleagues, and to attract the sensation-seeking art market. Again, there exist innovative major pieces among them. But innovation exists no longer when repeated. The implications of the "spirit" carvings have therefore several underlying meanings, which serve to illustrate some of the changes in Inuit life and art.

856/Mark Tungilik
(Tongelik)
Repulse Bay 1982
Ivory and stone height c. 4⁷/₈″
ICI 1.82.29
("Totem")

857/Mark Tungilik
(Tongelik)
Repulse Bay 1976
Ivory and stone height (incl. container) 1³/₁₆″
AGO GS261
("Seal Hunt on Container")

257

I had indicated at several instances that myths and traditions were essential parts of Inuit existence. Despite – or, perhaps because! – of acculturation, they represent the remarkable paradox of contemporary Inuit culture. Some fifty years after the conversion of the population to mostly Christian beliefs, some of the churches began to indigenize their services. Some of the younger people have started to look at religious services with skepticism. Some of the older people, especially when ill, still believe, at least partially, in the effectiveness of shamans. And while neglected earlier (because of Christianity), shamanism itself became part of the increased recognition of the need to revive old traditions and legends in order to substantiate ethnic and economic self-affirmation.

I have always stressed that Inuit artists in general do not deny commercial motivation in their art making, and I have also acknowledged their frequent concern for quality (cf. pp. 23-24). Yet because of their often incredible facility, and the talent of so relatively large a number of good artists (who get paid considerable amounts of money), a triple threat to art making started to evolve in the past two decades: repetition, copying, and over- if not assembly line-production. Here again I refer to my analogy of a quality pyramid (p. 244) and re-emphasize that no mass of indifferent work really detracts from the good that stands out.

Further changes which took place were less sensational in terms of motivation. They included the extension of skills and the use of new and mixed materials. On the other hand, there arose as well a consciousness of art making. Manasie Akpaliapik told me once that he thought that "younger people think of carving as art" and of the profession, and of the materials of art making. These, he said, "had meaning for the younger people and not the old." That loss of innocence is an extraordinarily significant and somewhat ominous factor in contemporary art production. It implies intentional and deliberate rather than intuitive and creative processes of art making, which are part of the genius of great artists but also of danger to, and the downfall of, the lesser.

Finally, further components of the changing Inuit art scene (equally auspicious and inauspicious) will be illustrated where it will become appropriate. Meanwhile I wish to let three artists from geographically, stylistically, and technically related areas show a now much neglected but once considerably respected attitude.

Augustin Ainaittuq, though not born there, lives at Pelly Bay; Mark Tungilik (now dead) was born in Pelly Bay but lived most of his creative life at Repulse Bay, as did Bernadette Iguptark (Toungelik), also dead. Their skill is renowned and their ingenuity as individual creative artists is equally recognized: for instance, Augustin and Mark as masters of narrative miniatures (853 and 857); Augustin also as master of exquisitely carved allusive imagery (854); as are Mark and Iguptark as artists of traditional themes (855 and 856). These small sculptures (except for Augustin's "Inukshuk and Skull") are, generally speaking, also the most underrated as art. Maybe they are not big enough?

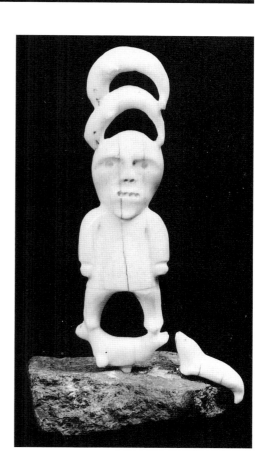

858/Simon Hiqiniq
(Sikkinik)
Gjoa Haven 1981
Stone height 8½"
NGC 29124
("Men and Seals")

859/George Arluk
(Arlu)
Arviat (Rankin Inlet) 1975 ?
Stone height c. 22½"
ICI 1.76.16
("Composition")

860/Luke Iksiktaaryuk
(Ikseetarkyuk)
Baker Lake 1971
Antler, bone, metal, wood, gut width 15¾"
WAG G-76-24
("Untitled/Drum Dance")

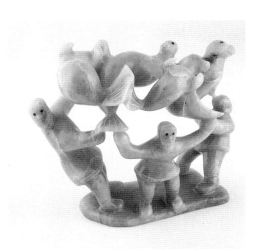 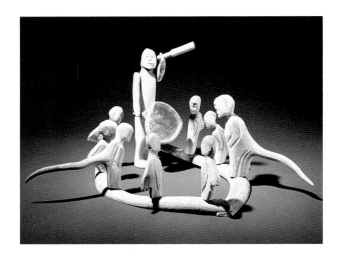

Another, in many ways traditional, theme of group images exists not only in sculpture but in all other mediums as well; on pages 112-13 I hinted at it through illustrations. This type of image has been in existence all over the Arctic in various cultures from Siberia to Greenland for some two thousand years with the exception that no such images have been recovered from the times of Thule culture (pp. 111-16).

Possible interpretations of group imagery range from shamanism to kin and group affirmations. As to the former, a good case can be made because of variously sized masks attached to shamanic costumes (recovered as late as the mid-1920s in Siberia) and because of faces carved or painted on ceremonial masks all along the Northwest Coast. The other interpretation relates to the close bonding of Inuit families and comparable groups,

astounding in our age of nuclear and single-parent families. Those ties result in great coherence (but, to a certain degree now also in nepotism). Kin and group relationships extend to playing, visiting, travelling, and hunting as well as to celebrations, ceremonies, and commerce.

The sculptures by Simon Hiqiniq (858) and George Arluk (859) show such relationships unequivocally well. Hiqiniq's open yet connected and Arluk's intimate, curvilinear shapes speak plainly for themselves.

Luke Ikseetarkyuk's "Drum Dancer" (860) is quite obvious in its imagery and title. Drum dancing has other implications: largely performances[1] as well as shamanic imagery.[2]

Luke Anowtalik's "Acrobats" (863)[3] relates in technique and materials (predominantly antler) to Ikseetarkyuk's, but not in its subject matter. Anowtalik deals with companions playing, Ikseetarkyuk with a performance or a séance. Both carvings are among the best of their kind (cf. also 605) and are far removed from the familiar concepts about "Eskimo Art" carved solidly out of dark stone.

861/Eva Talooki Aliktiluk
(Tarlooki)
Arviat (Eskimo Point) 1986
Stone, beads, string height c. 4¹/₈″
("Head Cluster")

862/(another view 861)

863/Luke Anowtalik
(Anowtelik)
Arviat (Eskimo Point) 1975
Antler and sinew width c. 14¹/₈″
NGC 1.75.58
("Acrobats")

864/Irene Avaalaaqiaq
(Ahvalakiak)
Baker Lake 1981
Stone height and width 10¹/₄″
NGC 1.82.3
("Group of Figures")

865/(another view of 864)

259

Yet the other two carvings (861 and 864) are just that: dark stone and carved solidly. They come from the very same Keewatin localities as the two so free antler compositions. They show groupings not too unsimilar to George Arluk's (859), also a Keewatin artist. They relate stylistically to many carvings, especially from Arviat (like 598-99 and 601) and from other areas as well (cf. 61-62, 359, 521, 541, 649, 659, and 779-80). But these two carvings stand out from others (and even from the artists' past usual work).

Eva Tarlooki's carvings used to have a two-dimensional or profile character, but have become more and more three-dimensional. This is evident in the "Head Cluster" (861 and 862) which demands at least two views to fully show it in the round. Its strong form is emphasized by the delightful strings of beads meandering between the heads. Hers and similar carvings (602 and 614) are amazingly small but *feel* disproportionately large.[4]

Avaalaaqiaq's "Group of Figures" (864 and 865) displays the same kind of three-dimensionality. Like Tarlooki's, it is massively structured, totally in the Baker Lake manner of carving. In addition, the strong tattoo marks on the principal head (female? male?), together with the other heads carved in relief, are reminiscent of supernatural presences, showing strong shamanic leanings often visible in other Baker Lake art including her own wall-hangings, for which she is famous.

1) The dancer also sings (cf. 119 and 766).
2) The shaman drumming, dancing and chanting puts himself into a trance (cf. back cover, 690 and 770).
3) Really children swinging acrobatically on the high bars of Arviat.
4) Several works when "blown up" have lost their monumentality!

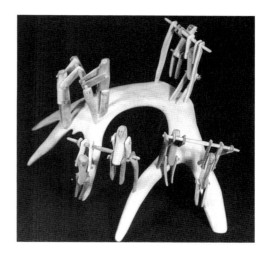

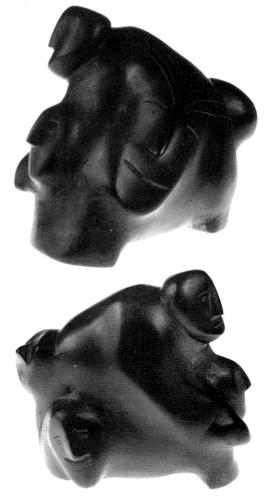

866/Matiusie Iyaituk
(Mattiusi)
Ivujivik 1980
Stone, antler, leather, black pigment
height c. 8½"
AGO 89/606
"This woman is happy to see that her son is
becoming a good hunter"

867/Peter Sevoga
Baker Lake 1973
Stone stained black height 14¾"
AGO 89/441
("Mother and Child")

868/Mathew Aqigaaq
(Akeeah)
Baker Lake no date
Stone height c. 8"
AEF A5.2
("Mother and Children")

869/Barnabus Arnasungaaq
(Akkanarshoonark)
Baker Lake 1974
Stone height 9⅜"
AGO S314
("Mother and Sons")

260

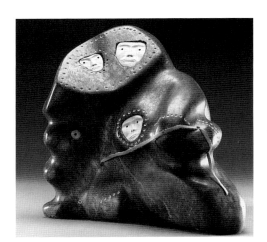

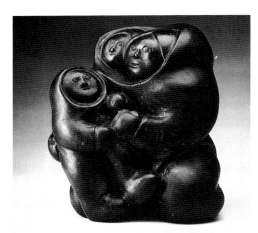

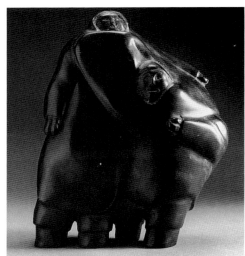

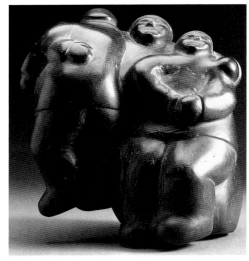

Not far off the "group carvings" stand the massive family carvings from Baker Lake and from a few other areas. Prominent among the latter is Matiusie Iyaituk from Ivujivik (866) whose sculptures have tended to become more and more abstract in recent times. This prosperity, notice-able in his earlier work, permitted him to retain the suggestive shapes of the stone. Without his inlaid faces of antler, and without his use of dot ornamentation, his

sense for the naked beauty of the stone resembled that of Pangnark's (cf. 622) from Arviat who had always utilized the primary, unembellished nature of his materials. Matiusie used yet another fea-ture – a hidden content he disclosed in the title. Without that title, the sculpture

maybe says no more than "family compo-sition." But with *his* title attached, the carving receives a new and I believe pro-found entity (cf. p. 246). In this particular case Matiusie's has become an expression of anticipation characteristically Inuit.

Mathew Aqigaaq's "Mother and Chil-dren" (868) might have intended to convey a similar meaning but contents itself in representing a familiar and conventional concept of family. This type of highly popular but somewhat sentimental depic-tion is not as characteristic for Baker Lake as it might be for say Inukjuak. On the other hand, and in keeping with his earlier vigorous work (682 and 714-15), he still employed the distinguished and distinc-tively bulging Baker Lake style.

Opposite to it stand the next two carv-ings of the same subject matter which, to me, typify in every regard the threatened survival of the eloquently powerful Baker Lake sculptures of the sixties (cf. 62, 102, and 119) and of the early seventies. Those power-packed carvings exuded a vitality that, I believe, has never been surpassed and bloomed into the early eighties. Peter Sevoga's sculpture (867) and Barnabus Arnasungaaq's (869) give striking evidence of that. These artists are, however, aging. The younger generation of Baker Lake has not yet found the spark.

Miriam Marealik Qiyuk's (870) is, like all her work, subtle and tender (cf. 147 and 852) and, whether consciously or not, displays mostly birds and people (largely female) in prone positions. The carving combines those unusually positioned heads in a cozy, tranquil bas-relief: the young women not only sleeping but seem-ingly dream, as might the birds. It all amounts to a singularly romantic and feminine work of art.

870/Miriam Marealik Qiyuk
(Marealik)
Baker Lake 1978 ?
Stone width c. 11"
NGC 1.85.9
(7 girls and 3 birds, sleeping)

871/Silas Aittauq
(Itow)
Baker Lake 1975/6
Stone width 26½"
AGO S495
("Head Cluster" cf. 143-147)

872/Abraham Anghik
(Abe Anghik)
Salt Spring Island, B.C. 1983
Limestone and stone height c. 13¾"
AGO 89/639
"Mother and Child/Polar Bear"

873/Tutuyea Ikkidluak
(Tutueja)
Cape Dorset 1989
Stone height c. 11"
("Mother and Child")

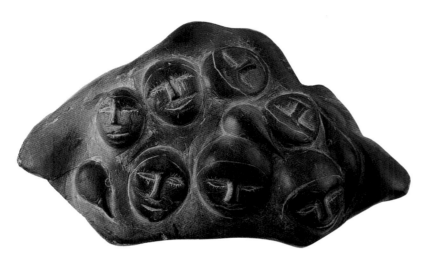

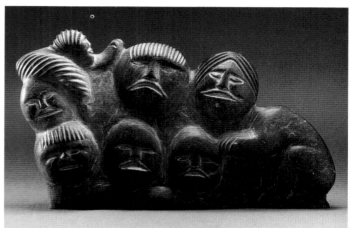

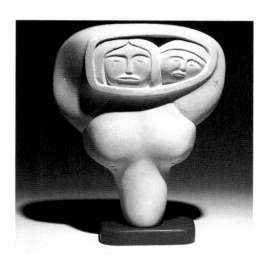

Silas Aittauq's half-relief (871), in contrast to Miriam Qiyuk's, is more than twice as large. Like the Dorset culture face clusters (143-44) it is aggressively carved, deeply and assertively furrowed by decisive and harsh marks of a firmly held file. This sculpture, so energetic in technique and fierce in appearance, tellingly represents a macho prototype regularly found in Inuit myth and legends. It is an impressive example.

The next two carvings, so different from the Baker Lake sculptures, are indicative not only of changes having taken place during the past decade but also of the vitality of the younger artists born since 1950. One of the most imaginative and skilful of them, Tutuyea Ikkidluak of Cape Dorset, lived only from 1962 to 1989. He committed suicide. When he worked from his intense world of fantasy and invention, he could create imaginative carvings and the most sensitively narrative compositions. His unique, wistful "Mother and Child," (873) was one of his last works. Wishing . . . Yearning . . . Desperately? Hopefully?

Abraham Anghik, born 1951 near Paulatuk, has now settled after much travel on Salt Spring Island, B.C. Like his older brother David Ruben, he is of the generation that lives more in the South than in the North and which, like Manasie Akpaliapik, believes in art making as a profession and consciously thinks of art as process and product. While he was strongly influenced by Northwest Coast Indian art, his style development manifests itself in various ways. His ingeniously designed "Mother and Child/Bear" (872) of 1983 is totally his own. About it he said:

"I have used the form of a bear's head to make the outline of a woman's torso. She is carrying a child in her amautee."* (Wight, 1989)

Abe, with his great skill, artistic imagination, and drive has gone a long way toward becoming a significant Canadian artist who also is an Inuk. Most of the sculptures to follow, also originated during the eighties, and exemplify the changes during that time.

* The pouch of the women's parka (*amautik*)

874/Manasie Akpaliapik
(Manasie)
Toronto, Ont. 1989
Whalebone and narwhal ivory
height c. 17¹/₄″
WAG G-90-506
"Shaman Summoning Taleelayuk to Release Animals"

875/Abraham Anghik
(Abe Anghik)
Salt Spring Island, B.C. 1988
Brazilian soapstone and African
wonderstone length/depth c. 17″
"Shaman/Sedna with Raven Familiar"

262

As subject matter for their art, the world of the supernatural – the mysterious and frantic "spirit" world – has become the most favoured by better Inuit artists. Unfortunately, the lesser like it too, but they can only seldom cope with it sculpturally. Yet that world is haunting many, particularly the older; the younger take it up as part of "the old traditions," passed on by their parents, grandparents, and elders. Their commitment to those traditions (despite their Euro-Canadian school education) generally raised their self-esteem and stimulated their interests in reading about them.

The supernatural world is not a part of their religion but thrives because it is so closely attached to their profound and unsentimental feelings for nature. As part of this identification many traditions deal with propitiating the natural forces. I prefer to call these forces "deities" – personified essences of that over which only they

have the power to exculpate – rather than spirits.

Before going further, Manasie Akpaliapik's sculpture "Shaman Summoning Taleelayuk* to Release Animals" (874) will give an insight into a propitiation process. Darlene Wight comments on the sculpture "Taleelayuk's Life" that is describing exactly what Manasie's sculpture and title imply:

"the sea goddess, Taleelayuk, moved between the people on the land and her home at the bottom of the ocean. The shaman summons her, *through the drum dance*, to release animals for the hunt. It might be necessary for him to visit her in her ocean home and comb and braid her hair to appease her so that his people will no longer starve." (Wight, 1990, italics mine)

As far as Abe Anghik's "Shaman/Sedna with Raven Familiar" (875) is concerned, Abe explained:

"This piece represents the duality man/woman. The raven represents the mythological husband of Sedna and the spirit helper of the Shaman. The face of a man below represents mankind. The seal represents the animal world." (Wight, 1989)

The word "familiar" in this context describes the "spirit" (the Raven) which is associated with the mythological creature (Sedna). The younger artists are certainly up on their traditions.

876/Kiawak Ashoona
(Kiawak)
Cape Dorset 1990
Stone height c. 19¼″
NGC 35529
("Bird Creature")

877/Tutuyea Ikkidluak
(Tutueja)
Cape Dorset/Lake Harbour late 1980s
Stone height 17½″
AEF A22.2
("Becoming Falcon")

878/(another view of 876)

879/Lukta Qiatsuk
(Lukta/Qiatsuq)
Cape Dorset 1979
Stone height 25¾″
ICI 1.81.7
("Spirit")

Kiawak Ashoona is another artist who accepts both supernatural worlds; his "Bird Creature" (876 and 878) is aptly named. Kiawak has extraordinary technical control and very fertile imagination, well able to visualize a creature as a force to be feared. The other illustrations of his work in this book (31, 434, 453-54, 482, and 504) show part of his range, which extends also to demonic and religious imagery, drum dancing, hunting, and animals. He and his brother Haka (31, 124, 501, and 512) are two of the very best artists from Cape Dorset, the most art-productive area in the Arctic. Two others are Lukta Qiatsuk and the already cited Tutuyea Ikkidluak.

Lukta's "Spirit" (879) is characteristic of his imaginative work, featured recently in a solo exhibition in Germany. A very accomplished and bold artist, he has changed from his whimsical bird compositions (cf. 443 and 447), to droll and specter-like creatures, which tend to be called "spirits" but actually are phantasmagoric beings. Tutuyea Ikkidluak's "Becoming Falcon" (877) looks like a being, halfway between Lukta's "Spirit" and Kiawak's "Bird Creature" but, in fact, represents a shaman transforming into his helping spirit. Iconographically it resembles heraldic griffins and allegoric gargoyles. Yet it is truly Inuit and is close to Kiawak's creature but differs in that it is discharging positive signals rather than instilling fear: it is more champion than demon.

* Taleelayuk is one of several Baffin Island names for the "goddess of the sea" who is more familiar to us as Sedna and who, incidentally, has various names in different Eskimoan areas (cf. N. Swinton, 1980).

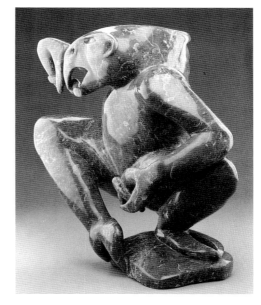

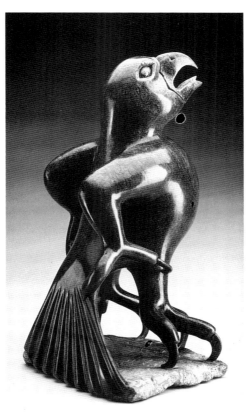

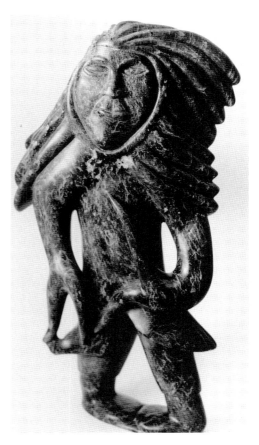

880/Tutuyea Ikkidluak
(Tutueja)
Cape Dorset 1986
Stone height c. 13¼″
AGO 90/98
"Ta Da" (Fox with Spirit)

881/Eegyvudluk Pootoogook
(Eejyvudluk)
Cape Dorset no date
Stone and antler height c. 11½″
AEF (number not accessible)
("Bird Spirit")

882/Aqjangajuk Shaa
(Axangayuk)
Cape Dorset 1984
Stone and antler height 25⅜″
AGO S2512
(cf. 894)

883/Latcholassie Akesuk
(Lassaulaasi)
Cape Dorset 1980
Stone height c. 12⅞″
ICI 1.80.4
("Bird")

264

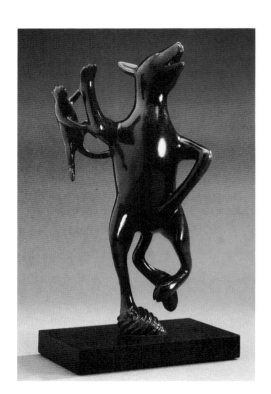

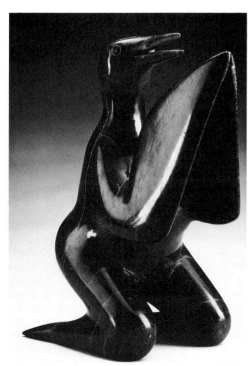

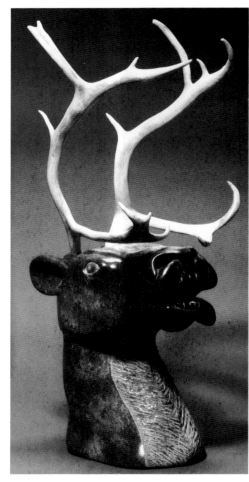

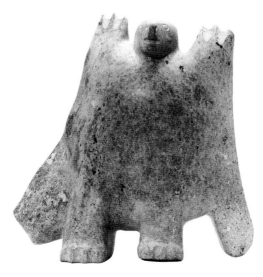

Having just observed style *comparisons* in subject matter, style *variations* can best be illustrated by Cape Dorset. Tutuyea Ikkidluak will further help to exemplify several important Cape Dorset characteristics. After his "Ta Da," (Fox with Spirit) (880) was completed the artist was asked for a title: "Ta-da, ta-da" he casually said, "it's finished!" (courtesy of Norman Zepp). The sculpture abounds in superior skills and daring expected from good Cape Dorset artists. It follows the type of earlier fantastic carvings (pp. 189-90) but is less bizarre, more severe. It represents a culmination rather than merely a type.

Aqjangajuk Shaa (882), who in the original text was known as Axangayuk (4, 25, 68, 476-80), illustrates the Cape Dorset curvilinear style with its baroque intensifications. The major quality of this style – and potentially a danger – is swirling involvement in fugue-like curves and countercurves. Aqjangajuk's carving delights in sensuously carved details, like the caribou's nostrils and mouth in relation to the curving neck and ornamental antlers, virtues of flamboyance and skill, features of Cape Dorset sculpture.

Eegyvudluk's and Latcholassie's carvings (881 and 883) have ostensibly opposite styles. Their abstracted forms are two ways of dramatizing content: Eegyvudluk in a simplifying direction (cf. 488) and Latcholassie's as a continued search for more structural, less playful form (cf. 469-475*).

Even further in contrasts and similarities, are the next two sets of illustrations which function both horizontally and vertically. Horizontally as birds and combatants, and vertically as ornate and complex forms versus plain and primal shapes.

884/Pootoogook Qiatsuk
(Pootoogook Kiakshuk)
Cape Dorset 1983
Stone height 9⅝"
ICI 1.83.8
("Owl")

885/Joanassee Kuniliusee
(Joanasee Kooneeliusee)
Broughton Island 1980
Stone width c. 11"
ICI 1.81.15
("Two Men Wrestling")

886/Andy Miki
Arviat (Eskimo Point) c. 1972
Stone height c. 7½"
("Bird")

887/Thomassie Kudluk
Kangirsuk (Payne Bay) 1979
Stained stone height c. 5⅜"
AGO GS306
("Arguing")

Miki's "Bird" (886) is an equally simple and sophisticated shape in its astounding concept of "pure vision" as Norman Zepp observed (1986). In its purity it has a nobleness which is startlingly tranquil, completely devoid of falseness. Unhesitating. Intuitive. Totally sure.

Pootoogook Qiatsuk in his meticulously carved "Owl" (884) also shows sureness of technique and skill by which he overcomes the great hardness of the stone and its tendency to crack. At the same time he manages to achieve a decoratively enriched surface and an amazing translucency of the owl's wings. Delicacy had always been a feature of ivory carvings but has now become characteristic of Cape Dorset carvings in hard stone.

In Joanassee Kuniliusee's "Two Men Wrestling" (885) the detailing on the intertwined shapes is enriched by the coil-patterned clothing. Those reiterated coils create a rhythmic design. In juxtaposition, Thomassie Kudluk's "Arguing" (887) exudes raw sculptural strength. However similar in subject matter and similar in the outstretched arms, the techniques and styles are as opposite as they can be. Thomasssie's sense for story telling and chronicling in stone (and on paper) was his major reason for art making, which he reinforced by explaining his "stories" in syllabics on each work. Here, translated freely, it reads: "This one man visited the other man's daughter without letting him know" (i.e., without permission) "and now they are arguing." Thomassie Kudluk was the last of the great Arctic Quebec story tellers (with Joe Talirunili and Davidialuk Alasua Amittu).

* Except 471 which is by Tudlik, Latcholassie's father.

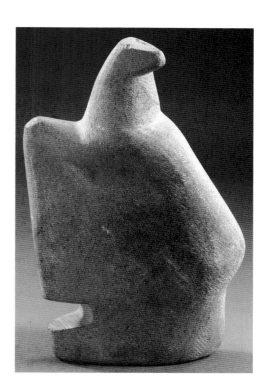

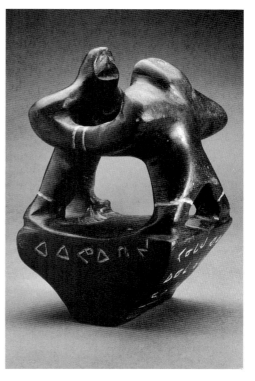

888/Simon Kernerk
(Simon Kirnik)
Gjoa Haven c. 1974
Stone, wood, ivory height c. 5⁷/₈"
NGC 1.79.1
("Head with Goggles")

889/Donat Anawak
(Anaruak)
Rankin Inlet 1966
Bisque width c. 6"
AGO 90/276
("Vase")

890/Nelson Takkiruq
Gjoa Haven 1988
Stone, whalebone, ivory, antler height c. 9"
("Drumdancer")

891/Joe Tikivik
(Tukavik)
Iqaluit (Frobisher Bay) 1981
Whalebone, stone, bone, ivory
width c. 25⁵/₈"
NGC 1.82.19
("Untitled")

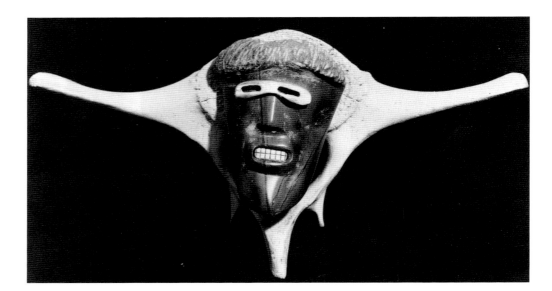

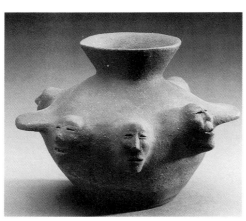

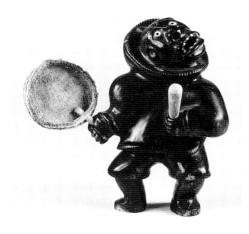

Faces and masks, distinctly carved or incised both naturalistically and stylistically, have existed for at least twenty-five hundred years (cf. pp. 112-18). However, almost all Canadian Thule faces during that culture's odd five hundred years were featureless. In the later phases of the Historic Period (mainly in Alaska) faces and masks gradually reappeared, mostly in connection with various aspects of spirit (*inua*) magic.

In contemporary art since 1949 two major types stand out: (1) the shamanic transformation or "spirit" images and (2) the doll faces as well as the expressive heads used as interesting subject matter. There are over fifty illustrations in this book – too numerous to discuss individually or even to list. The reader/viewers are urged to explore this subject on their own starting with illustration 5.

Donat Anawak (cf. his portrait and his insights p. 23) now comes first with his bisque "Vase" of 1966 (889). Thematically, his circle of faces is reminiscent of "group" carvings (especially of 145-46) and, stylistically, of the Tyara maskette (148) and the Pelly Bay comb (166). To me they have another symbolic meaning: they

are Inuit "looking all around in all directions" at the struggling, acculturating new world of Rankin Inlet (inhabited then for less than ten years) and the ceramics project which, in short time, was to die.

Next, two faces with snow goggles of which two earlier examples have already been illustrated (104 and 272). The 1974 "Head with Goggles" (888) by Simon Kernerk is significant in two ways. First, it is so primal like some of the early carvings (cf. 176, 269, and 347) at a time when carving techniques in most other areas had become quite complex. Second, and in retrospect, the simultaneous use of several mediums heralded the "Kitikmeot" multimedia developments of the eighties (cf. 832) and Nelson Takkiruq's "Drum Dancer" (890) in particular.

However, Joe Tikivik's snow goggles and assemblage carving "Untitled" (891) needs to be discussed first. This sculpture is striking in its clever and innovative use of materials and, in its conspicuous technical and imagistic audacity. Only a few years earlier a carving such as this would have been inconceivable. Yet it is hardly as sensational as those from Spence Bay and Gjoa Haven.

892/Pauta Saila
(Pauta)
Cape Dorset no date
Stone and ivory height c. 11″
AEF A59.1
("Dancing Bear")

893/Nalenik Temela
(Nawleenik/Nalerik)
Lake Harbour no date
Stone height c. 22″
AEF A67.4
("Dancing to my Spirit")

894/Aqjangajuk Shaa
(Axangayuk)
Cape Dorset 1983
Stone height c. 14¹/₈″
ICI 1.84.2
("Dancing Caribou" cf. 882)

895/Shorty Killiktee
Cape Dorset/Lake Harbour no date
Stone and antler height c. 33″
AEF A33.5a-c
("Becoming Caribou")

267

There, Nelson Takkiruq is one of the most skilful artists. His drum dancer (890), singing and dancing, proclaims braggadociously the prevailing "Kitikmeot" aesthetics through its image and form. See the dancer's face on the defiantly raised head emerging from the protective hood. The open mouth with its inserted gleaming ivory teeth, the widely open inlaid eyes, and the arched opening of the nose became the earmark of Kitikmeot art making. Those intense features have often led to fanciful innovations including coarse humour as well as florid imagery.

The other four sculptures illustrate a related rage (by artists and collectors) for dancing and prancing creatures, especially for dancing bears. It all may have started with Iyola Kingwatsiak's "Dancing Bear" (95) first illustrated in the 1967 centennial issue of "The Beaver" and reproduced frequently. In Pauta Saila's bear (892), of which he has produced many versions, its mouth, teeth, and neck are identical to the features of his superb sculptures of some twenty years earlier (78). Unhappily, a southern confidence man produced (and sold) fakes of them. Unfortunately as well, Pauta's and Iyola's bears have also influenced Inuit imitators.

The two caribous, in contrast, are different and also typical of Cape Dorset mastery of materials and techniques. Shorty Killiktee's sculpture (895) is expertly carved but does not quite have the stylistic elegance – almost baroque mannerism – of Aqjangajuk's caribou (894). Shorty's primarily "stands" in contrast to Aqjangajuk's which virtually "prances" off the base, its neck and head spiritedly launching forward.

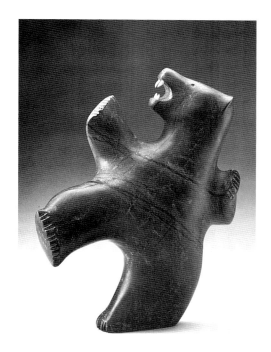

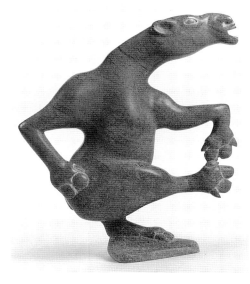

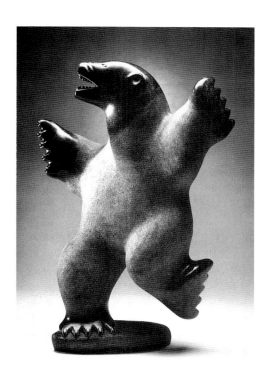

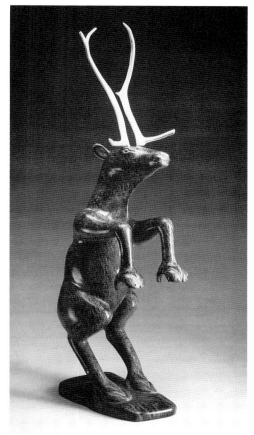

896/Barnabus Arnasungaaq
(Barnabus Akkanarshoonark)
Baker Lake no date
Stone length c. 18"
AEF A7.2
("Musk Ox and Man")

897/Lucassie Ikkidluak
Lake Harbour no date
Stone and antler length c. 21"
AEF A21.1
("Musk Ox")

898/Osuitok Ipeelee
(Oshooweetook "B")
Cape Dorset 1977
Stone and bone height c. 8³/₄"
AGO S351
"Caribou"

899/Judas Ullulaq
(Ooloolah)
Gjoa Haven no date
Stone and ivory length c. 23"
AEF A71.3
("Musk Ox")

268

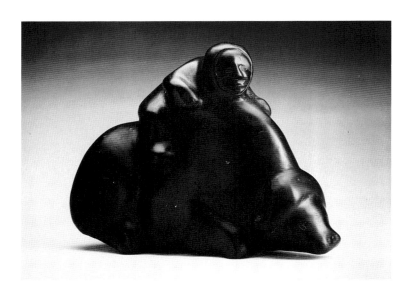

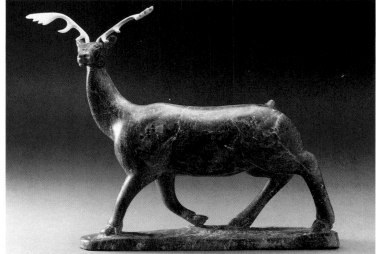

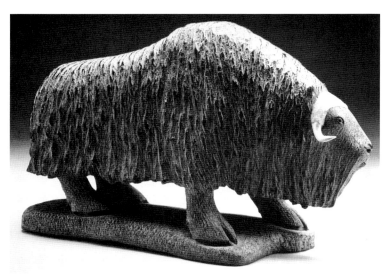

Three further comparisons in relation to style, form, and content (cf. pp. 16-17). It is in their sense that the caribou and musk ox carvings are compared.

The alerted, striding "Caribou" by Osuitok Ipeelee (898) is a striking example of Cape Dorset *savoir faire* at its best. It is a relatively small sculpture, though, feeling considerably larger than it is (we always perceive size as it relates to head and body in a reversed proportion). Osuitok's cari-bou feels absolutely majestic. Its form is as serene as Miki's "Animal Plaque" (903) and as descriptive as Lucassie Ikkidluak's "Musk Ox" (897). It synthesizes form and content, and is not merely subject matter.

In opposite ways, Augustin Anaittuq's "Caribou" (901), twice the size of Osuitok's, feels larger because of its sheer bulk, its massiveness accentuated by spindly legs; were it not for those, the small hoofs, and the caribou pelvis as head, the identification of the creature as cari-bou would be next to impossible. The body's bulkiness and texture are certainly closer to a musk ox. Its fanciful manner-ism is close to Ullulaq's "Inukshuk Comes to Life" (849), part of the whimsical "Kitik-meot" image vocabulary. It also represents one of the features of "post-Contempo-rary" Inuit art (p. 247). Obviously, Augus-tin has been influenced, too, by Nick Sikkuark's move to Pelly Bay (cf. pp. 248-49)

900/Lazalusie Ishulutaq
Pangnirtung 1989
Whalebone and antler height c. 16³/₈"
AGO GS43
("Fantastic Flying Caribou")

901/Augustin Anaittuq
(Annaitok)
Pelly Bay 1990
Whalebone and antler height 19³/₄"
width c. 24³/₈"
AGO S339
("Caribou")

Still in the realm of fantasy is Lazalusie Ishulutaq's "Fantastic Flying Caribou" (900). It may have started out as spirited fun to create such a fabulous creature, but ended up as a highly lyrical and inventive image. A caribou's *inua*?

Judas Ullulaq's "Musk Ox" (899) is whimsical as well. That incredibly powerful sculpture of a windblown musk ox is typical of his jocular manner (849) and is unusual because of the sensitive, aesthetic handling of not only the beast but also of its droppings.

Lucassie Ikkudluak's "Musk Ox" (897), on the other hand, is a representationally carved likeness of a musk ox. In making precisely what he wanted and knew to make, it couldn't be better, but it doesn't go beyond that. As art, its content is its skill. It is successful as a model wild life sculpture but in the sense of the previous four sculptures, which gave meaning beyond subject matter, it lags behind. Its finely detailed "naturalism" lacks *élan vital – inua*.

Less skilful but more soulful is Barnabus Arnasungaaq's "Musk Ox and Man" (896). It is the type that used to be called "legend" or "spirit carving," particularly in Povungnituk (cf. 352-55). In approach it is similar to Mark Kadyulik's "Spirit Flight" (839). In Barnabus' own form (and in typical Baker Lake style), the shapes of man and beast merge as on a spirit journey or in totemic interaction, no longer merely man and musk ox. Art, as distinguished from skill.

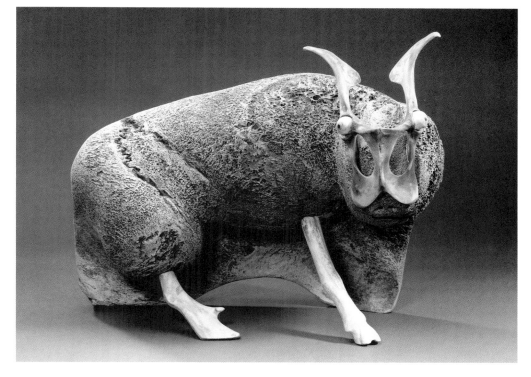

902/John Kavik
(Qavirq)
Rankin Inlet 1981
Stone width c. 8³/₈″
("Musk Ox Spirit Image")

903/Andy Miki
Arviat (Eskimo Point) c. 1969
Stone width c. 10¹/₂″
("Animal Plaque")

270

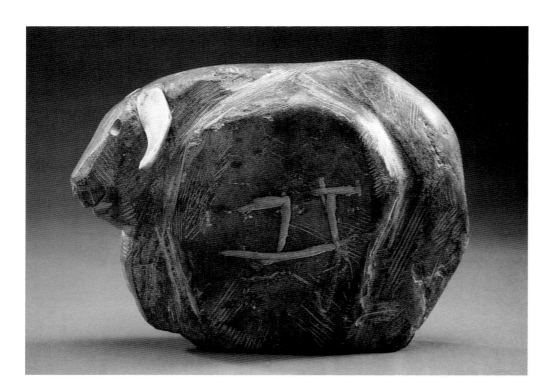

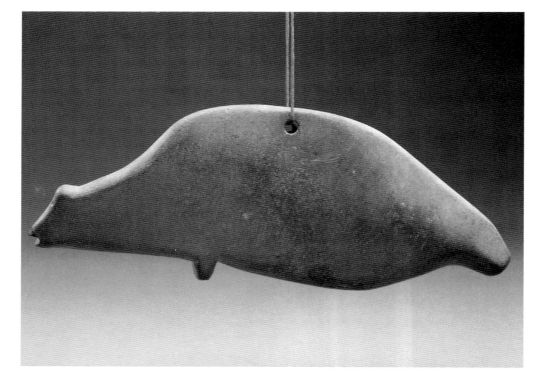

On the past two pages we have finally arrived (in words) at what the entire book is all about: on Inuit art as art, art as distinguished from mere skill, art that goes beyond stereotyped ideas and ideals. If it weren't for this distinction – which is more easily made between the very good and the indifferent – the word "art" could be applied condescendingly to everything that is carved, drawn, painted, printed, sewn, stitched, woven, etc. And that, in a way, is justifiable as we in our own culture are inclined to make the same hypocritical pronouncements, except that we, even less sagaciously, make a distinction between the arts and crafts.* To me that distinction is wrong. The bad or lesser artist is very seldom a good craftsman. But there are exceptions: the "primitive" prehistoric artists, as well as the folk and "self-taught" artists of today (often called "innocent").

Many of the older generation of Inuit artists were obviously self-taught, but only a small proportion remained innocent (end of the Classic Phase). Those who did turned out to be really good artists simply because they had talent, they did not succumb to commercialism, nor to the often disastrous advice from well-meaning advisers. Some of the advisers, however, were important supporters (cf. p. 129) who encouraged the self-taught as well as unfashionable other artists and their productions. Such artists as Kavik, Miki, Pangnark, and even Tiktak could not have survived without such support.

* That word is regularly misapplied to indicate disparagingly the superiority of art vis-à-vis such handwork as the fiber arts, ceramics, jewelry, etc. It implies a supremacy of the "creative" artist over the "skilful" artisan or, even worse, over the "repetitive" craftsman. Neither artists nor crafts people can ever be good if their work is repetitious or merely skilful, that is, if it lacks vision and is without soul.

905/Kavavau Pootoogook
Cape Dorset 1984
Stone, antler, wood height c. 8¹/₄"
AGO 90/107
("Sea Goddess")

904/George Arluk
(Arlu)
Arviat/Rankin Inlet c. 1973
Stone height c. 5"
AGO 89/497
("Figure")

906/Eric Niuqtuk
(Ireenee Neeooktook)
Baker Lake 1974/5
Stone and bone height c. 7³/₈"
AGO 89/556
("Shaman")

271

John Kavik (902) is the self-taught artist *par excellence*. To me he also is one of the most exciting and, generally, most inconspicuous artists whose work I had admired for nearly thirty years (103, 639-647). Born in 1897, he carved until recently. His form is unique and would often be described as primitive and crude. Having known him since 1963, I know the opposite to be true. His knowledge, while not schooled, is profound, his manners gentle, his technique is intelligent, interesting, forceful and to the point. His major skill is the uninhibited and guileless ability to communicate visually. In this regard his technique is neither awkward nor incompetent but, in fact, is efficient and accomplished; highly sophisticated "pure vision." His "Musk Ox Spirit" is *inuk* personified: man and *his* musk ox spirit as much as the musk ox spirit and *its* man.

George Arluk (904), whose work I also have followed for almost thirty years (he carved since he was twelve years old), is a wonderful but also inconsistent artist. He is very productive but he simply carves too much. His work, at his best (like 836 and 859, and his "Figure" of 1973 when he was only twenty-four years old), is extraordinarily simple, delicately proportioned, and subtly carved. Arluk's elegance and Kavik's elementariness stand in stylistic polarity as do their contents.

In similar relationships, the next three sculptures further explore the abstruse realm of form and content. Andy Miki's "Animal Plaque" (903) is mysteriously suspended like his cousin Pangnark's "Spirit" (624). These two artists not only have family relationships but also kinship in abstraction (cf. 886 and 619). Miki, furthermore, has a close affinity with Kavik: utterly unartificial form, however different in appearance, is analogous in the singleness of their approaches.

Kavavau Pootoogook's "Sea Goddess"* (905) is very beautiful (the first and only time that I am using this much too used, capricious, and inscrutable term). Again not large in size, it stands out for its fascinating quality of floating elegantly through space (or water) heightened by the stunning, ornamental, oversize tail. Eric Niuqtuk's austere Batman-like "Shaman" (906) relates in its supernatural function to Kavavau's sea goddess and Kavik's musk ox spirit.

The major point revealed by all these juxtapositions is of great importance to a clearer understanding of the changes that have taken place in the past twenty years. The earlier, unself-conscious artists were more concerned with content in the sense of stories and illustration. The generation of artists who came to the forefront thereafter (right into the eighties) became more concerned with sculptural form than with narration. It became important *how* sculpture looked rather than *what* it said. In "post-Contemporary" sculpture the latest emphasis is on accentuation and hyperbole of form *and* content.

* Taleelayuk (or Sedna) sculptures have either a beluga or a fish tail, equivalent to what Davidialuk once called "half-fish" – *Iqalunappaa* (350-51).

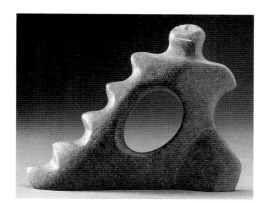

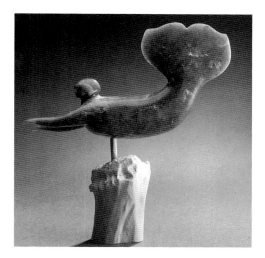

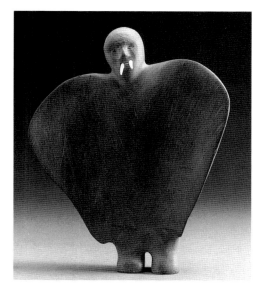

907/Manasie Akpaliapik
(Manasie)
Toronto 1989
Whalebone, stone, ivory width c. 14⅞″
"Drum Dancer"

908/David Ruben Piqtoukun
(David Ruben)
Toronto, Ont. 1986
Brazilian soapstone, antler, caribou
fur height c. 22½″
AGO 89/670
"Caribou-man Drummer"

909/David Ruben Piqtoukun
(David Ruben)
Toronto, Ont. 1984
Brazilian soapstone, sinew, Italian
alabaster height 13″
McM 1986.47
"Shaman Returns from the Moon"

272

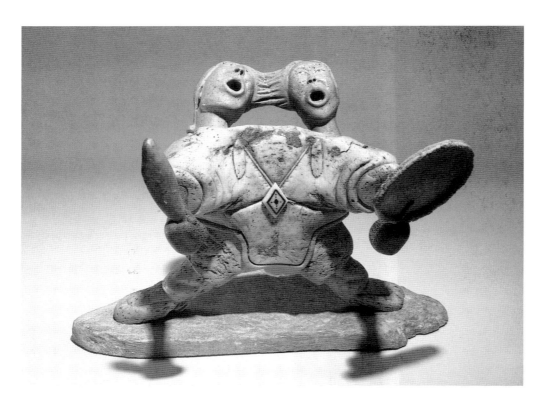

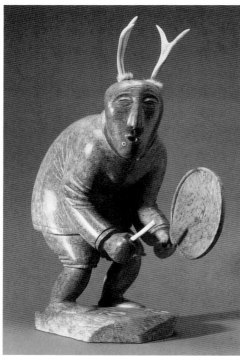

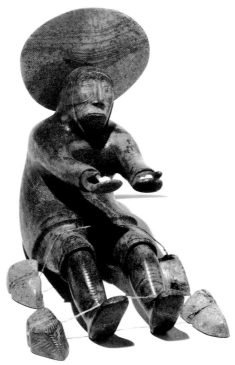

The last three illustrations have in common supernatural relevance in which drum dance(r)s and the shaman play the most important roles. Kitikmeot artists have taken the most radical stand with emphasis on bizarre form and whimsical allegoric content. Together they give Inuit art a new and unexpected look.

The main reason for this development is that Inuit artists and Inuit society had need and capacity to affirm their identity. The artists had become very conscious of making art by which could be achieved individual self-actualization as artists and collective (ethnic) self-assertion as Inuit. In many conversations with younger artists across the country that point came up both directly and parenthetically. Art no longer was merely an "easy" way to earn money but had become a profession and a very tangible means for earning self-esteem.

From the anthropological point of view, the "typically traditional collectivity of the Eskimo" has changed into acculturated "untypical individualism" of Inuit. In terms of art it meant that the real artists could, and often did, depart from the expected clichés (cf. p. 131 and Trafford, 1961) out of which evolved the dramatic form changes of the two past decades.

Art always reflects contemporaneous culture patterns. Stages of Inuit art evolution are no exception: thematic bravura and technical showmanship in this context indicate confident, ethnic consciousness in contrast to indifferent repetitiousness that reflects some of the adverse implications of acculturation.

In the early Classic Phase, (pp. 131-32) "carving" was *intended* to be "a cottage industry (solely) to provide economic benefits to the *hunters and native people*"

(italics mine). That purpose remains for those who *still* carve as a cottage industry. And with unemployment being over 70 per cent, most Inuit need money to pay for their daily needs.

Not unrelated to economics, one of the several characteristics of post-Contemporary Inuit sculpture is larger size and greater complexity. Earlier carvings were much smaller and less complicated. Artists like Manasie Akpaliapik, Abraham Anghik, and David Ruben, more than others, affirm the trend toward larger size, greater sophistication, complexity, and use of a variety of different and even imported materials.

These innovations, part of the new professionalism, will likely produce greater status/distinctions among artists and categories of art. From the point of view of cultural history, the conscious professionalism of the artists will demand entirely new marketing structures, quite the opposite of current co-op, wholesaler, and dealer practices. Hopefully, they won't destroy the large cottage industry production, which is so great an economic necessity for so many.

Manasie Akpaliapik is one of the three professionals I named. He and the other two like to live as their forefathers did, as hunters. In his "Drum Dancer" (907) – as in his more than double-the-size "Respecting the Circle" (828) – his highly personal and complex ideas on traditional life are expressed in powerful, sophisticated imagery. The drum dancer/singer's ecstatic feelings are expressed in the doubled head swinging to and fro in contrast to the massive body and the repeated triangular composition of the spread legs and the *amautik* clasp and straps. Manasie's sensuous sculpture stands in sharp contrast to David Ruben's unembellished

"Caribou Drum Dancer" (908). He says about it:

"This carving depicts a caribou-man transformation drumming in a ceremony to become one and the same as a caribou. In order to track the caribou, he has to be like one. This is the sign of a great hunter." (Wight, 1990)

In the Canadian Arctic drum dancing/ singing is not a uniquely shamanic property but it was the most authentic means to express oneself as keeper of ancestral heritage as well as to assist a shaman in changing form. David's title and his specific reference to "transformation" indicate shamanic ceremonial means. The antlers and the labret are shamanic earmarks as well.

In "Shaman Returns from the Moon" (909), as on the back cover's "Shaman Transformation" (formerly called "Shaman Chanting"), further important aspects of shamanic activities are affirmed, visually and narratively. Here are David's own captions.

Shaman Returns from the Moon
"The shaman has returned from the moon, frosted and holding white translucent stones to prove he has been there. He tells people that the moon is a cold, barren place and that no human life exists on it. The people in the village hold him in high esteem, and feed him well after his long journey."

and *Shaman Chanting*
"One reason why this sculpture is so powerful is that my brother gave me claws from a crazy, rabid bear which he killed – and used for the teeth of the transforming shaman." (Wight, 1989)

Shamanic carvings have been illustrated throughout the book. They, together with the more abstract and intricate compositions of recent years and the fantastic "Kitikmeot" carvings, are indicators of the extraordinary changes: superior technical skills and thematic innovations; a greater emphasis on ethnicity and traditions; frequent references to the supernatural; and the conscious efforts to produce art.

Nevertheless, the miracles of contemporary Inuit sculpture are its continuous, albeit changed, existence; so much of it is so good; and it defies typological definition. It has become an art not in search but in affirmation of identity. It may very well be one of the few art forms of today that has selfness, for it still exists outside the maelstrom of international art in the challenging and often hostile realities of the Inuit world.

Yet, with experience and undisputed integrity, Abraham Anghik said not so long ago (Inuit Art Quarterly, Spring 1991) that it is ". . . more important than ever for young Inuit to produce works using a broader range of materials, styles and technique than their parents did." And, indeed, why not? Yet, the Inuit component in his (and similar artists') art is still strong and very attractive. If and when it ceases to be, then they simply will become known as artists, as all other Canadian artists of different ethnic extractions. But I believe the Inuit's perennial pragmatism will again adopt and adapt. In their world – as in Abe's – tradition and change do indeed co-exist.

910/Showroom of North West Company
Inuit Art Marketing Service
Rexdale, Ontario

Since the last edition of *Sculpture of the Inuit* was published in 1992, many of the ideas and readings concerning Inuit art have changed a great deal. In the 1992 edition, I attempted to illustrate and discuss some of the more obvious changes from the previous forty years (1950 to 1990). This applied particularly to the new chapters "Musings" and "Changes 1971–1992." During the past decade, the formal changes have been relatively minor, dealing mainly with size and the mixing of media. Therefore, I shall add on the following pages only a few of the newer type of carvings; the examples presented earlier in this chapter and in the "Musings" chapter suffice to give an initial feeling of the nature of current trends.

On the other hand, the increasing presence of a marked and justifiable ethnocentric awareness – avoiding the term "nationalism" – has become a truly significant factor in many aspects of making, promoting, and distributing Inuit art. For this reason, it is necessary to take a close look at just what the terms "art" and "Inuit art" do mean – or are often understood to mean – to the general public and to Inuit artists alike. In that sense, Chapter 8, "Aesthetics – Inuit vs. Kablunait" (pp. 129-34), must be further examined and its implications considered in the light of the recent ethnocentric concepts.

Since this book was first published, a great many of the sculptures illustrated here have been transferred from private to public Inuit art collections, including major art galleries and museums. They were acquired by public institutions because they were considered at that point "excellent and most important examples of Inuit art." This, by itself, would not be so noteworthy – what else but the best and most distinctive of its kind should be preserved in public institutions? – yet various questions were raised when ethnic (native) art, or what Nelson Graburn calls Fourth World art, was placed into public institutions.

And new questions, mostly dealing with empowerment, arose when these institutions were owned and administered by First Nations and Inuit peoples alike.

While these questions (mostly dealing with repatriation) had precursors in those frequently asked about the "Mona Lisa," the Elgin marbles, and Egyptian treasures looted by Napoleon, they did not arise significantly in the case of Inuit art until the late 1970s and early 1980s, with the gradual ascent of the notions known as the New Art History. What, above all, the New Art historians attempted to do was to question the pertinence of traditional art history's overemphasis on quality, authenticity, attributions, dating, and meanings, instead of taking "account of the realities of the social world in which art is produced."* In this way, beside feminism, Marxism, gender issues, and other social-science perspectives, New Art historians became increasingly concerned with ethnic issues, a major factor causing public institutions – as well as ethnic artists and advocates – to question what to put into collections, why, how, and who to do it.

When I started on my first book – and even well before then, when I first went north to prepare a report for the Hudson's Bay Company on the artistic and commercial viability of "Eskimo Art" – I did so purely from an "art" point of view. It was in July and August 1957 when I went to Puvirnituq (then still Povungnituk) and Inukjuak (then Port Harrison) to observe Inuit carving activities (for details see Wight, 1987, pp. 7-19). But even then, I was astonished at the so casual use of the term "art" in "Eskimo art." In an article for *The Beaver* I had no hesitation to write, therefore, that "no longer can we talk of Eskimo *art* when we see Eskimo sculpture,

for some have become [largely] handicraft – skillful and 'charming' as it may be – [but] some of the inferior pieces are just Eskimo souvenirs. If we do not make these classifications time will do it anyhow." (Swinton, 1958).

This is an important point, which I stressed again and again, and in *Eskimo Sculpture* of 1965, *Sculpture of the Eskimo* of 1972, and in its update of 1992, the texts and illustrations were carefully chosen from that all-overriding "art" point of view. It is in this regard that I take the liberty of quoting from my own introduction from 1972, in which I wrote that "while carving and other techniques are practised by many Eskimos, art is by no means a collective activity, and the notion that all Eskimos carve or that all those who carve are artists is simply absurd. . . . Still it is true that there is an unusually high percentage of good artists among the contemporary Eskimos. This fact is even more extraordinary since these artists are able to create in the cultural vacuum resulting from the white man's intrusion on their land and culture." Obviously, then, my use of the term "art" based on Western art traditions needs proper clarification.

Let me start by confessing, yet also affirming, that in the past two centuries, the Western concept of art has become mostly judgemental and elitist as, in the first place, it was intended to be. It tried to denote highest quality and to exclude everything that was not. It could include excellence in any activity from making love (Ovid's original use of the term in *Ars Amatoria*) to cooking, from painting to printing books, from poetry to piano playing, and even from forging cheques to forging art. The concept of mastery (with its so much misused terms "masterwork" and "masterpiece"), related to the German concept of *Meister*, best expresses the idealistic notion of quality that the term "art" is supposed to entail. And indeed they are "artists" who can aspire to have

achieved mastery in their respective fields. In such an exclusive definition, however, art is obviously not an egalitarian concept and, correspondingly, offends non-judgemental, social-science-oriented art concepts of universality and equality.

Within that latter non-judgemental understanding of art, which is as close to the concepts of the New Art historians as it is to the idea of *sananguaq* (the generally used Inuktitut term for sculpture), all art-making activities and their products, rather than merely masterpieces, have equal significance. In that sense all Inuit carvings, and not merely those judged to be the better or the most outstanding, should be and are considered Inuit art. Yet it is precisely the latter that attracts the interests and preferences of art museums and, in fact, of the art market.

When looking at the photo of the salesroom of the North West Company in Toronto (910), two principal points become obvious: (1) the great quantity of apparent Inuit art objects, and (2) their equally evident variety of styles – though despite their quantity and variety, they retain their Inuit character. Every piece is designated as art by the bilingual "Igloo tag" (911), which identifies all Inuit art objects sold everywhere as both Inuit-made and art. What concerns me is that while many of these objects would fall into my category of good to excellent art (as do most items in this book), a much, much greater number does not. Due to

* This phrase was first employed, descriptively, as a title for a one-day conference organized in 1982 titled "The New Art History?" (Rees and Borcello, 1988)

912/Josie Unarluk
Sanikiluaq/Puvirnituq 1958
Stone length c. 6″
WAG G-76-94

inevitable overuse and overproduction, they drift into lesser statements of the banal or unimaginative commonplace.

When I speak of the commonplace and overproduction, I really am not as critical as I might appear to be, for I frequently think of the carvers as victims of their living conditions and of the excessive demands and the false promises – opportunities? – of the worldwide art market. The issue here revolves around the Inuit's economic necessities and the fact that the differing qualities of art have values beyond economic gratification. And also at work are the set, egalitarian principles and customs that are the foundations of Inuit social functioning and traditions.

In that context, quality differences, with their corresponding value judgements, were, and (as far as the older generation is concerned) still are, not part of Inuit ways of life. Anything made (carved) was expected to be made as well as possible, or as circumstances demanded, but certainly was never subject to judgement by others. But due to the growing pressures of daily living brought on by Western civilization's intrusions, and due to the increasing demands of the Inuit art market (another form of intrusion!), even the best carvers have been unable to maintain the quality of their work. This applies equally to producers of "art" and to the lower-end souvenir carvers, often leading to overproduction and loss of inventiveness. It

also leads to the overuse of the word "art" as part of the now principally accepted notion of Inuit art, by the artists and by the art market alike.

In Chapter 8, "Aesthetics – Inuit vs. Kablunait," on pages 129-30, the Inuktitut term for carving, *sananguaq*, is explained in detail, referring to the carving process – the act of making – rather than to the product as in Western thinking. By *sananguaq*, the Inuit thought of the act of sculpting rather than of the objects produced by the process. It is only since the 1970s that some Inuit artists started to think consciously about art in the sense of aesthetics, or what I call form; that is, of the how instead of the what. Unfortunately, most carvers still do not fully consider form, and in fact neither does the art market at large! Luckily, however, the producers of good art (the artists) have acted instinctively and sensitively, with their innate sense of aesthetics, by their sensuous responses to the challenges and opportunities of the materials they carved (cf. paras. 6 and 7, p. 142).

In this respect, it is useful to remember the derivation of the word "aesthetics" from the Greek *aisthetikos*, meaning "perceiver through the senses" (that is, one who knows and understands through his senses), which is far removed from feeble concepts of the pretty or of being in good taste. It is the artist's aesthetic sense that gives the subject matter what I like to call form. And form is the most important factor in transforming subject matter into sculpture, thereby giving it meaning as art. It is the tangibly sensuous form of the earlier carvings that brought such immediate recognition to Inuit art.

It is the absence of aesthetic sensibility, on the other hand, that makes the lower-end carvings mere repetitious Inuit souvenirs. What else could they be? They are the result of marginal carvers who, due to the economic conditions in communities where there is as much as 60 per cent unemployment, produce those borderline

carvings in order to secure enough money to keep their families from the indignity of welfare handouts and even from starving. The Inuit art industry is now an important economic and cultural feature of contemporary Inuit society without which the Nunavut economy might not be able to function without considerable difficulty, at least not for the time being. To produce those carvings is often their only opportunity to make money. That the results often seem to lack soul merely reflects the reality of the carvers' living conditions. It has always amazed me that, despite these conditions and the carvers' lack of aesthetic interests, they have the courage to carve. It is even more amazing that *often* I have been able to find real treasures among them, truly sensitive works, such as the exquisite little carving by Josie Unarluk (912), which certainly belongs to my category of art. It is doubly rewarding to find such a work among an assortment of "lower-end" carvings under which category it was wholesaled.

In connection with souvenir art, two points about size and technique are important to note, particularly in relation to that exceptional little work of art by Josie Unarluk. Not all carvings that might be designated as souvenirs and only sparingly represented in this book (cf. 228 and 798) are small or lower end. I am also inclined to designate fairly large carvings, costing several hundred or even several thousand dollars, as souvenir-type work. I am thinking here of the prowling and dancing bears, and the vapid, insipidly posing hunter or family figurines, usually dark and highly polished, which are promoted and appreciated as art by gift-shop dealers, gullible journalists, and naive Inuit art collectors. These carvings are often well carved, but all they show is shrewd skill, craftiness but not craft, and may be pretty but are inevitably artless. Most patrons of such art are usually buying it for sentimental reasons only.

277

Since all carvings are designated by the ubiquitous Igloo tag, obvious questions then arise. Should these tags differentiate between art and souvenirs? Should they not? Do they merely state simplistically that Inuit art is art? Or even more simplistically – not to say halfwittedly – that Inuit art simply is Inuit art? Wouldn't it be better to use terms that equate with *sananguaq*, like carving or sculpture, wall hanging, or print, indicating processes or techniques?

In view of the dominant souvenir production, the use of the current Igloo tag for all "Inuit art" appears to be pretentious and misleading. Most New Art historians and advocates of that general "Inuit art" term will disagree with this opinion, as would the worldwide interests in the tourist art or souvenir trade. But, as pointed out earlier, the misinterpretations by many of the carvers and by the uninitiated public do lead to naive assumptions and self-deceptions that there do not exist real differences between art and souvenirs. In turn, these erroneous notions have always led to financial disappointments and painful retrospections. On the other hand, it was the Canadian art world's aspiring misinterpretations of Inuit art as a very desirable, authentic, anonymous, primitive art form that led to its almost immediate public recognition, especially by those who felt they had found the genuine article. Yet, these misinterpretations eventually brought to many collectors considerable financial advantages.

One has to agree with the New Art historians, to a certain extent, that souvenir carvings, beyond their obvious meaning of economic self-gratification, not only have cultural significance as indicators of social conditions and status – like gospel singing and popular music – but also exhibit ethnic perceptions and prevailing attitudes of conscience which, as such, point to general, cultural manifestations. For these reasons alone, I cannot completely object to the use of the generic term "Inuit art."

Even worse, there are times when I cannot avoid using it, albeit reluctantly.

When looking at and trying to understand the full impact of "Inuit art" in all its amazing stylistic variety but apparent ethnic uniformity, particularly in the use of materials and techniques, one's first thoughts may turn automatically to the idea of the Arctic and its environment(s). During thirty years of many sporadic visits to the Arctic, I always had a clear concept of "Arctic." Wherever I was, the environmental and purely visual realities were always different, but felt to me uniformly one. And, similarly, I relate my perception of the whole of Inuit art to that single reality, despite the obvious differences I observe and the individual characteristics I inevitably recognize.

The concepts of environment and acculturation discussed in chapters 1 and 2 (pp. 107-10), symbolized here by the two views of Cape Dorset, in 1958 and 1995 (913, 914), relate not only to the changes in life styles and environment that have taken place, but also to the total circumstances of Inuit existence and, therefore, of art making. The birth of Nunavut – which we are celebrating with the new edition of this book – is the most visible and significant evidence of these changes. However, this event is unlikely to have a significant influence on art making itself, other than that it might open up new, symbolic approaches of self-affirmation and of ostensible pride. Such approaches might avoid a mere political posturing about our having patronized and neglected their traumatic past, or even angrily and justifiably censuring it.

It is, of course, not possible to anticipate the consequences of this elemental change from colonial conditions to homeland, from Ottawa and Yellowknife administration to Nunavut self-government. The term "Nunavut" itself embraces the idea of the land that is ours, but concepts of "land" and "ours" are for the Inuit very

much more open than the English terms indicate. "Land" is all-inclusive, the vast, almost unlimited areas of the Arctic from the North Pole to the tree line, where "we," the Inuit, have lived since "time immemorial," and which has provided "us" with food and shelter and clothing and all the other necessary means for survival, owned by nobody privately but "ours" collectively. That land was sacred, and included all the fauna and flora, all of which had soul and was therefore respected, but also feared.

The "we" in this world view is the Inuit, not Qallunaat, nor Amerindians, nor the governments, nor anyone else. And now all this has changed, Nunavut has become a geographical and political entity, owned and administered by Inuit: an empirical understanding of place has given way to a formal understanding. That is the way Inuit learned to think from the white man. Now both will be living together as part of the political and geographical land that is Canada. But Inuit have distinctive souls and traditions, and Nunavut is not only a physical land but, predominantly, a state of mind. What is called "Inuit art" should always hope to express this distinctiveness. And while the production of lower-end souvenir carvings will continue, many of the younger artists are now conscious of their art as both a personal and cultural expression.

When I used the term "younger artists," I meant that they were younger than most of the earlier carvers – the first generation – who had originated "Eskimo art" and many of whom were dead by the late 1970s, when consciousness of art as such started to rise. These younger artists were then already in their early forties, some even older, and should rightfully be called the second generation in terms of both their age and styles. They started to feel like artists in their own right – as now does the third generation – not merely because they

were Inuit. I know several of them – far too many to quote individually – who in many conversations not only affirmed their belief in themselves but who, with typically Inuit egalitarian magnanimity, never berated souvenir makers or their products. Even though all of them based their own work on Inuit subjects and traditions, their art-making interests were based on being good artists rather than on consciously producing Inuit art.

The next question which needs to be asked is whether Inuit art could, as the term implies, be considered to be indigenous. It was first asked by social scientists, puristic writers, and art critics (cf. p. 27) in relation to the earlier term "Eskimo Art," which was widely publicized by the government to be indigenous. While I never considered it such – or, at most, considered it to be "art of the *new* Eskimo" – I had no doubt that the acculturating people of the contemporary Arctic continued to be "true Eskimos," even though their life styles had changed so much. In fact, I believe that the diverse productions of arts and crafts called, perhaps inexpediently, "Inuit art" truly represent the changed ways of life and the economic reality of Nunavut today. While I would not be able to call it indigenous art, it certainly is an authentic and significant part of contemporary Inuit culture. Why not, therefore, think of the best of it as being indigenous?

However, in complete contrast, it is equally important to note that in the first two decades of the new Eskimo art production phase, outside influences did have a considerable impact on the production of sculpture and other artistic activities, particularly on printmaking and wall hangings. While such input may have at first been thought to be beneficial, it did remove at once the possibility of speaking of the "indigenousness" of Inuit art. It also removed its art historical credibility

for most of the international art museums. But it did not shake the confidence of the believers who continued to collect and exhibit with undiminished enthusiasm and foresight.

One must also think here of both the negative and positive aspects of these influences on art making itself. On the positive side, there are the strong personalities of Gabriel Gély in 1964-65 at Baker Lake, of Jack and Sheila Butler, also at Baker Lake in 1969-75, and the gentle yet effective guidance of Terry Ryan in Cape Dorset since the 1960s to the beginning of the new millennium. The same applies to the peripatetic James Houston, who gave Inuit art its initial impetus, settling in Cape Dorset during the 1950s, where he also launched the successful Inuit print program (as the Butlers did ten years later in Baker Lake), and who still produces his many Inuit-inspired stories and films, as well as his colourful memoirs.

On the often negative side, one could mention several others, but they, too, always had in mind the important objective of assisting Inuit artists and craftspeople to become commercially successful. That they succeeded more often than not is evidenced by the many art co-operatives in the Eastern Arctic. In the Central Arctic, the co-operatives provided the same important economic stimulus, but their success in supporting artists was due less to the co-operatives than to the stronger artists themselves, who exercised considerable influence in their communities.

As far as the earlier, more primary, and unsophisticated art of the 1950s and the early 1960s (further west) is concerned, it succeeded on its own because external influences, despite several attempts, were less intrusive or did not succeed at all (cf. p. 131). Its primary character remained intact for some time, leading to the widely held, mistaken belief that "Eskimo art" was primitive.

915/Manasie Akpaliapik
Toronto/Arctic Bay 1992
Whalebone, ivory, stone
width 46½″
WAG G-93-254

Now, however, there has risen all across the Arctic the previously mentioned awareness of art, which, increasingly, has become individual in kind and style. I shall show, therefore, a few examples from various areas to illustrate the diversity as well as the, at times, amazing similarity of new technical approaches. Ideally, I would have wished to produce a new image bank, such as appears on pages 145-243, but for a variety of reasons this is not possible nor entirely necessary. I hope the following survey not only has the merit of brevity, but also provides a candid overview, which image banks sometimes fail to do.

Some of the disadvantages of visual data banks are the misleading proportions of actual works within the nearly equal size of reproductions. Small pieces appear relatively larger, large pieces smaller, particularly when printed on separate pages. It is difficult for the casual observer not to be influenced by the disproportionate dimensions of the photos. For instance, Manasie Akpaliapik's "untitled carving" of an over forty-five-inch-wide whale vertebra (915) is actually close to eight times larger than Josie Unarluk's loon (912). But as different as these two carvings are in size, they are quite equal in the manner in which they have transformed subject matter into art through detailed and sensitive handling of their specific materials. Furthermore, that Manasie's carving would symbolize a shaman and his helpers, or that Josie's portrays a loon, is really not relevant to the context of their juxtaposition. Its sole purpose was to underline the aesthetic experience of these two carvings, not their explicit identifications.

This kind of aesthetic experience was part of the initial appreciation of the early, primary – not primitive! – phases of "Eskimo art." Without this specific type of experience, no appreciation of art is ever complete. And, incidentally, some form of aesthetic experience – rather than

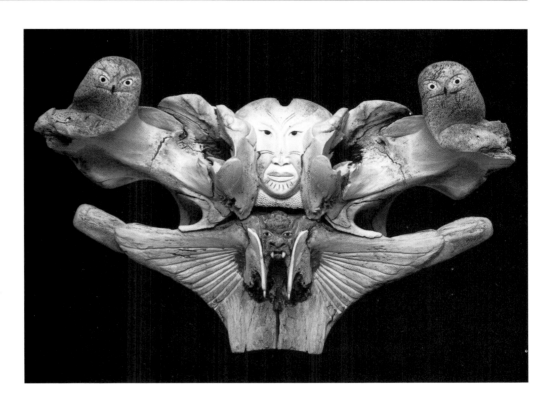

ethnographic appreciation – is still the most widely held perspective by which Inuit art is generally understood and collected by the public at large (as is, in fact, most of the world's art). I, too, have to confess that ever since closely researching various aspects of Inuit art and my intense ethnographic interests, my art-collecting instinct still influenced me to give precedence to aesthetic considerations. Yet in retrospect, I find it increasingly difficult to divide aesthetic, ethnographic, and human predilections. If that is called subjective connoisseurship, then so be it. But might it not also explain why I am so cautious about New Art historical methods and evaluations of Inuit art?

David Ruben Piqtoukun's "Aura" (916) stands in apparent direct contrast to Manasie's work. Coming out of his widely shown solo exhibition "Between Two Worlds," his sculpture is knowingly titled

and also subtitled and described by him in specific detail:

"The metal circle represents the technology of the outside world and the aura of the spirit world. An abstract owl's mask hovers over the shaman's mask. Can the old knowledge find a place among the new ways? Can the shaman and his spirit helper break out from the new circle of understanding?"

His comments have thus become an essential part of his work, and as Darlene Wight, the exhibition's curator, notes, since 1994 David has created "sculpture that interprets some of the non-Inuit influences that had altered his traditional culture." David's new, totally different attitude indicates his recent aesthetics. They include the artist's comments as an essential part of his work, as does the use of non-Inuit materials and

916/David Ruben Piqtouqun
Toronto/Paulatuk 1996
Brazilian soapstone, welded steel
height 28⅔″
WAG G-97-5

917/Judas Ullulaq
Gjoa Haven 1988
Muskox horn, walrus tusk, caribou antler,
stone, sinew, ivory, whalebone
height 44.3″
WAG G-92-47

280

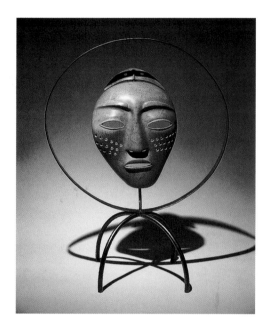

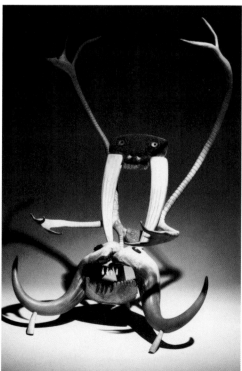

techniques. Both Manasie's and David's pieces have symbolic implications, but in stylistic contrast to Manasie's expressionist representationalism, David's sculpture has pure, almost abstract characteristics. Strangely enough, both artists, though born in the north and remaining totally committed to the north, live in the south – near and in Toronto. Despite their technical and domestic leanings to the south, they are *inumarit*, truly Inuit as men and artists.

The use of non-Inuit visual art techniques, including videotaping and performance art, is becoming more and more general in all parts of the Arctic. Among them prevails the extensive use of mixed media and assemblage techniques, such as Judas Ullulaq's striking untitled assemblage subsequently labelled "Inuruutuq (Shaman's Transformation)" (917). While such techniques have been used in the Kitikmeot area for some time (cf. 829, 830, 874 and 901), Judas's "Inuruutuq" exemplifies the extent to which he used great varieties of materials with stunning effects throughout the 1980s. Another characteristic of Kitikmeot sculpture in general, and Judas Ullulaq's and Charlie Ugyuk's in particular, is their unconventional, often caustic sense of humour (cf. pp. 248 and 253). His "Inuruutuq" very subtly illustrates this curious mixture of aesthetic sensibility combined with visual punning, of which Augustin Anaittuq's "Caribou" (901) is such an intriguing example. In my Arctic travels I seldom failed to be impressed by the profound sense and expression of Inuit humour that included their undisguised poking fun at our credulity in general and, especially, about the making, titling, and our buying of their art.

Their sense of humour, plus their pride in being Inuit, are now even more evident in their consciousness of finally and officially owning Nunavut, their homeland. It is important to remember that a great

deal of true Inuit art often gives tacit witness to this pride, as can be observed from the previous three sculptures and the following two. The latter are open affirmations of ancient shamanic traditions that survived the incursions of secular and Christian acculturation. While officially these assaults of acculturation were diminishing in intensity, the traditions continued underground as parallels to Western medical and religious practices. The traditions were openly reappearing from the very beginning of the contemporary phase of Inuit art, often encouraged by art advisors and favoured by private and institutional collectors, as were other traditional and mythological notions. It is difficult, however, to determine if the production of such art is the result of economic or aesthetic, spiritual, and cultural motivations. I venture to guess that the proportions between the different motivations are about even (some carvers occasionally being unsure themselves of the impetus). Among the real or good artists, however, the integrity of their objectives appears to be mostly beyond doubt.

Josiah Nuilaalik's "Shaman" (918) is witness to its maker's abiding affirmation of the survival of traditional shamanism. In contrast to those carvers who certainly are known to have produced for economic reasons, and despite his constant financial difficulties, Josiah produces only little, but whatever he has carved shows the integrity of his beliefs and craft, as well as of his visionary imagination. It is a hallmark of his family, he being one of Jessie Oonark's many progeny, all of whom have become significant artists. His sculpture oozes power and otherwordly flight: shamanic strengths and daring; supreme confidence in spirit flights; the antlers as traditional designation of shaman with spirit helper. These are the allusions of Josiah's sumptuous form, which elevates his carving to a profound, archetypal image of shamanism

918/Josiah Nuilaalik
Baker Lake c. 1996
Stone, caribou antler
height 16"

919/Charlie Ugyuk
Taloyoak 1994
Whalebone, stone, bone
height 26"

920/Luke Airut
Igloolik 1991
Stone height 8⅞"
WAG G-91-125

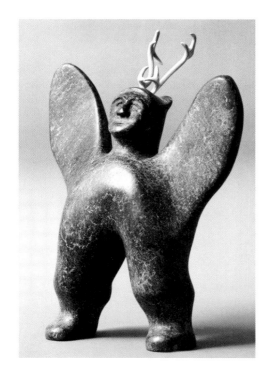

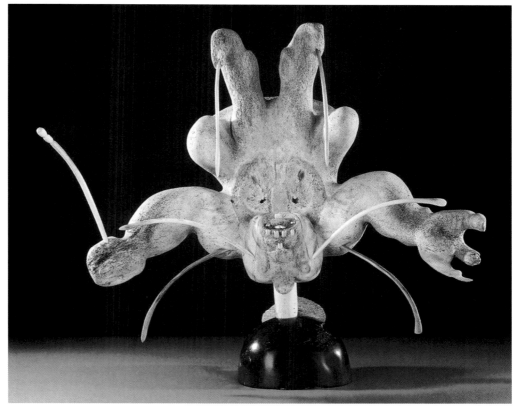

and a masterpiece to boot.

Charlie "Big Charlie" Ugyuk's "Shaman" (919), on the other hand, is a highly personal, individualistic sculpture interpreting an otherwise traditional subject. It is more of an Ugyuk-type work of art, a very powerful, fantastic image and showpiece, than it is a mere representation of a shaman. Ugyuk's "Shaman" relates to me an often heard explanation of what shamanism meant to many Inuit: colossal power and great fears, the supernatural having become real. It does not *say* shaman, but it is. It is a typical Kitikmeot image of both horror and satire, perhaps in protest against and contempt of Western religious shallowness about Inuit spiritual values. It is a very daring and satiric work of art of great aesthetic and communicative impact. Totally different from Josiah's, it, too, is in fact a masterpiece.

Luke Airut's formally retitled "Eagle Shaman" (920) is thematically a typical

work of the late 1980s, often called "transformations," "shamanic transformations," or "shamans with their helping spirit," which enjoyed great popularity with artists and public alike. Usually these carvings were not as well executed as is Luke's. His imaginative manner of handling such standard subject matter, combined with his superior craftsmanship, clearly indicates why it is possible to think of his carvings as art and of Luke as a good, indeed a very good, artist.

Luke Anowtalik's impressive "Composition" (921) is an expression of how much mysterious traits meant at one time to the Inuit. Shamans gather their powers, as well as their reputations and positions, from the people with whom, and over whom, they serve. Luke's monolithic sculpture captures

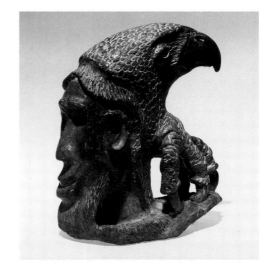

921/Luke Anowtalik
Arviat 1998
Stone, caribou antler
height 30˝

such properties and their symbolism with great simplicity in a single, massive block of stone, with a caribou's head and its antlers crowning the composition. This powerful and obviously meaningful carving is like a symbolic tribute to the powers of the caribou. Its mysterious gifts of itself – like a shaman's – benefit inland Inuit and Inuit elsewhere, too. In that sense, Luke's inspired "Composition" also has archetypal implications as an image of unexplainable power.

Adamie Anautak's sculpture of a woman and a thieving dwarf (922) is, stylistically, very much a Nunavik carving. Fully representational, it is *sulijuk*, a "true and honest" (cf. pp. 131-32), almost literal conversion of a local narrative into carefully and delicately carved stone. It tells of a woman trying to dry a seal skin to make clothing for her family, but which is stolen by a dwarf, with whom she lives thereafter "peacefully as a neighbour."

Story-telling was a great tradition among all Inuit everywhere, and such tales were not only told but also sung, often as personal or family property as much as part of the common oral tradition. However, such detailed carvings as Adamie's were a special feature of Nunavik art, especially of Povungnituk (now Puvirnituk) and also of Akulivik (cf. pp. 169-74). Its representational technique has always been highly popular with the general art market – in terms of its aesthetics and of its obviously literal or symbolic meaning – even when the meaning (metaphor or cultural practice) was not always quite clear.

The aesthetics of this carving remind me – in a contrary way – of the famous statement by the Nabis painter Maurice Denis over a hundred years ago (in 1890) and which became the widely accepted battle cry of twentieth-century modernism (including mine): "Remember that a painting – before being a battle horse, a nude woman or some anecdote – is essentially a

922/Adamie Anautak
Akulivik 1989
Stone height 11¾₁₀˝

923/Oviloo Tunnillie
Cape Dorset 1995
Stone height 27½˝

flat surface covered with colours arranged in a certain order." This is not always true, particularly as it relates to Adamie's sculpture. While I am impressed by its intricacies and well-carved naturalism, I am more fascinated by the frank ethnography of what we now call the storyline.

The next piece, which is likewise totally representational, has special meaning to me on several levels, but my appreciation of it is more difficult to describe. I am referring to Oviloo Tunnillie's "Dancer" (924), one of the most remarkable and, at the same time, most atypical pieces of Inuit art. The sculpture is nevertheless quite typical of Oviloo's own conspicuous affinity for Western art in terms of design, configuration, and technique. Oviloo's work stands out, at least for the time being, among that of Inuit artists, "Dancer" perhaps more so than any other of her sculptures – which include nurses, angels, daughters, fathers, nudes, torsos and also many Sednas, as well as additional Inuit subject matter. I have selected it because it is so superb a sculpture, without any ethnic connotations or implications. Oviloo is an outstanding sculptress by any standard, especially of female figures. The photograph speaks for itself and does not need further comment, except for expanding on my reasons for including it as a significant

924/Matiusie Iyaituk
Ivujivik 1989
Stone, caribou antler
height 12˝

925/David Ruben Piqtoukun
Toronto/Paulatuk 1996
Brazilian soapstone, slate
length c. 30˝

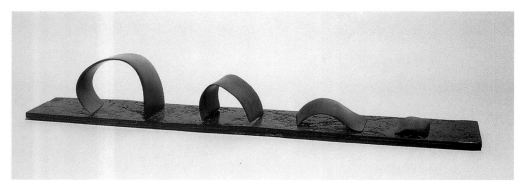

example of *Inuit* art, although being atypical of it. One wonders whether good art is ever typical. If quality were typical of all Inuit art, that question would never have come to be asked in the first place. A masterpiece obviously speaks for itself, and "Dancer" certainly is one.

Matiusie Iyaituk, who has been working with semi-abstract and wholly abstract form for a decade, is not only an accomplished and knowledgeable artist in his own right, but also a successful workshop leader to several communities in Nunavik and across the Arctic, as well as in Ottawa and the United States. His "Mother and Child" (924) both contrasts with and complements Oviloo's "Dancer." They are both images of feminine attributes: dancer and mother, charm and affection, grace and strength. The forms of his imagery speak for themselves. Matiusie's imagery has existed for some time (cf. 866), but

its communicative strength remains strong, and abstraction as such appears to be perhaps the lesser element. In contrast to Matiusie's semi-abstractions, David Ruben Piqtoukun's "Tradition Lost" (925) strikes one at first as true abstraction until one reads the title and text, essential parts of most of David's recent sculptures and their intended meaning:

"Like waves that die out and leave no trace, something important is being lost. Our minds were hard like stone – solid, in touch with nature and ready for any challenge. Now they have been bent out of shape, made useless in the new society."

Obviously, like Oviloo's "Dancer," David's "Tradition Lost" points to his affinity for Western ideas and techniques, yet his Inuit philosophy remains uniquely intact. In fact, its metaphoric sparseness is reminiscent of Inuit resourcefulness in dealing with ever-recurrent austerities. Visually, the tops of the arches remind me of the windblown snow on the tundra. Good art always invites the viewer to participate in the work's intent and then to let his or her imagination wander beyond.

As to the question of what difference there is in the ability of abstraction or realism to permit a viewer to give free rein to these possibilities, the answer is unequivocally none. Mark Nakoolak's whimsical,

untitled skull with animals (926) is a perfect example of letting a viewer's imagination run wild in the fantastic rockscape of a segmented walrus skull. It also is a wonderful example of how art lets fantasy become reality, "howsoever, strange and admirable" (cf. p. 17).

Similar miracles occur in Nick Sikkuark's "Woman Buried in the Snow" (927), except that this is not a fantasy. It is *equally* strange and admirable for Nick to have his creative visualization transformed into a sculpture of such delicacy. It is a tiny sculpture, but it exudes a frightening yet fascinating presence, like Monet's "Camille on her Deathbed" – a painting more than ten times the size of the carving. But then, size alone is not the major factor in achieving great effects. And Nick's exquisite little carving truly is great, as are many of his very small carvings. Unfortunately, however, the conspicuously higher prices paid for larger pieces have reinforced the idea of many artists that – as on the Western art markets – quality and size are synonymous.

Osuituk Ipeelee – definitely not Ipeelee Osuitok, nor Oshooweetook 'B' (cf. p. 28) – is a special case of a steady and excellent artist who has effectively produced major, unusual, and often very beautiful work for over fifty years, since even before the very beginnings of contemporary art making in Cape Dorset. His fantastic bird figures

926/Mark Nakoolak
Coral Harbour 1991
Walrus skull, ivory, black inlay
height 7″
WAG G-91-127

927/Nick Sikkuark
Pelly Bay 1996
Ivory, antler, whalebone, muskox hair
width c. 4″
WAG G-98-359

928/Osuitok Ipeelee
Cape Dorset
Stone height 19⅔″
WAG G-92-46

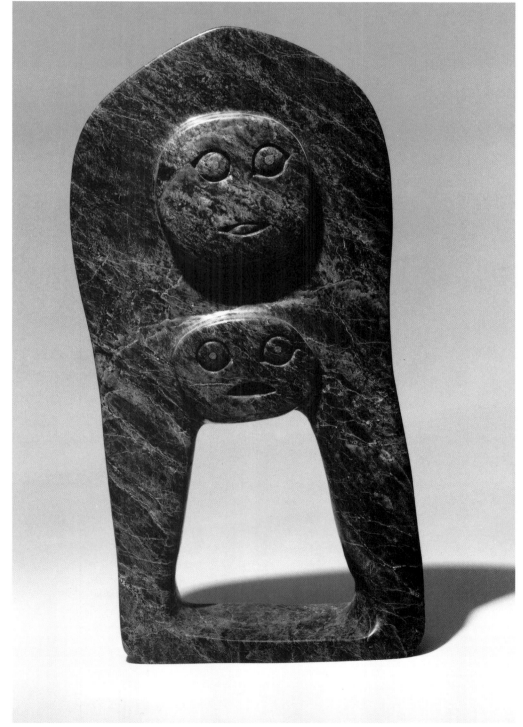

929/Bill Nasogaluak
Yellowknife 1999
Stone, moose antler, sinew, caribou antler,
height 16˝

(94 and 488) and sinuous caribous (431 and 898) particularly have made him and his art renowned. Being a consummate, inventive, and prolific craftsman, he is equally at home with naturalism and symbolic imagery, which he treated more or less abstractly. His "Two Owls" (928) functions on several levels if one insists on "deconstructing" them – a procedure which was prominent in the past decade and a half but in which this book never intended to involve itself or its artists.

Our final illustration is "Calling the Animals Back" (929) by Bill Nasogaluak. Bill first attracted my attention when I saw an illustrated interview with him in an issue of *Inuit Art Quarterly* in 1996. In it, he answered the interviewing editor, Marybelle Mitchell, with unequivocal simplicity, while also reflecting on Inuit art in

general: "I know that a lot of people from the South look at me as an Inuit artist, but I have never given it much thought because, to me, I simply am an artist. My subject matter happens to be very much drawn from my culture because I'm portraying what I know best. . . . Whether I continue to make a living from it is irrelevant. I am going to do art regardless." Bill, who also paints, meant precisely that when he called himself an artist, inclusive of what I call its Western elitist sense. As to souvenir makers, he modestly abstained, saying, "I find Inuit are better at producing than appraising their own work. . . . When it comes to our own work, we tend to be reserved." These few words mark him as a true "modern," a contemporary Inuk, utterly typical of forward-thinking Inuit ideas and changed life styles. Bill explains about his

new sculpture "Calling the Animals Back" that "through the song of the drum this man is calling back the animals to their familiar hunting grounds. The sinew attaching the animals and the stones also echoes the music through the drum."

As in David Ruben's work, the meaning of Bill's sculpture – despite its highly representational elements – is for the most part metaphorical. Which, in turn, closely relates to the Inuit love for story-telling. That so much of good Inuit sculpture of the past dozen years has that strong metaphoric imagery is a clear signal of the presence of traditional, ethnocentric awareness in and through art. May that actually and symbolically herald good hopes for the future of Nunavut. Eventually then, their art may truly become "Inuit art" and not merely be a geographical designation.

A Bibliography of Eskimo Art, Archaeology, & Ethnography

These works were chosen to cover the entire range of the above field and to introduce the reader to further studies in the field of Eskimo art and culture. For an extensive bibliography on every other aspect of the Arctic, the "Arctic Bibliography" published by the Arctic Institute of North America is recommended.

Works are referred to in the text of this book by author's name and year of publication.

Abbreviations

AA – American Anthropologist, Menasha
AINA – Arctic Institute of North America, Montreal and Washington, D.C.
AMNH – American Museum of Natural History, New York
APUA – Anthropological Papers of the University of Alaska, College
BAE – Bureau of American Ethnology, Washington, D.C.
BE – Bureau of Ethnology (earlier designation of BAE), Washington, D.C.
CA – Current Anthropology, Chicago
Fifth Thule – Report of the Fifth Thule Expedition 1921-24, Copenhagen
MoG – Meddelelser om Gronland, Copenhagen
NMC – National Museum of Canada, Ottawa
Smithsonian – Report of the Smithsonian Institution, Washington, D.C.
The Beaver – The Beaver, Hudson's Bay House, Winnipeg
T.P. 11 – *Prehistoric Cultural Relations between the Arctic and Temperate Zones of North America*, ed. John M. Campbell. Technical Paper No. 11, Arctic Institute of North America, 1962.
USNM – United States National Museum, Washington, D.C.

Additional Abbreviations

AGO – Art Gallery of Ontario
CAP – Canadian Arctic Producers
IGEA – Innuit Gallery of Eskimo Art
IGM – Inuit Galerie, Mannheim
IGV – Inuit Gallery of Vancouver
INA – Department of Indian and Northern Affairs
MMFA – Montreal Museum of Fine Arts
NMAG – Norman Mackenzie Art Gallery, University of Regina
SAP – Society for Art Publications
WAG – Winnipeg Art Gallery

ACKERMAN, ROBERT E.
1962 "Culture Contacts in the Bering Sea: Birnirk-Punuk Period," *T.P. 11*, AINA, pp. 27-34.
1967 "Prehistoric Art of the Western Eskimo," *The Beaver*, Autumn, pp. 67-71.

ALASKA, UNIVERSITY OF
1963 *Early Man in the Western American Arctic*. A symposium. APUA, Vol. X, No. 2.

ANDERSON, J. W.
1956 "Eskimo Handicrafts," *Moccasin Telegraph*, Vol. XV, No. 2, Break-up, Winnipeg, pp. 1-2.
1961 *Fur Trader's Story*. Toronto: Ryerson Press, Chap. XXIV, "The Eskimo and his Carving," pp. 217-222.

ANDREE, K.T.
1891 "Die Skulpturen der Eskimos," *Globus*, Vol. LIX:348.

BAIRD, IRENE
1957 "Anoutoaloak," *Canadian Geographical Journal*, Vol. LVII, September, Ottawa, pp. 120-123.

BALIKCI, ASEN
1959 "Two Attempts at Community Organization among the Eastern Hudson Bay Eskimos," *Anthropologica*, Vol. I, Nos. 1 & 2, Ottawa, pp. 122-135.
1970 *The Netsilik Eskimo*. New York: Natural History Press.

BANDI, HANS-GEORG
1969 *Eskimo Prehistory*. Translated from *Urgeschichte der Eskimo*, Stuttgart, 1964. University of Alaska Press, dist. by University of Washington Press, Seattle.

BARZ, SANDRA (ed.)
1976-1984 *Arts and Culture of the North*. (A quarterly) New York.

BELCHER, E.
1861 "On the Manufacture of Works of Art by the Esquimaux," *Transactions of the Ethnological Society*, N.S. Vol. I, London, pp. 129-146.

BIHALJI-MERIN, OTO
1971 *Modern Primitives* (Naive Painting from the Late Seventeenth Century until the Present Day), translated from the German by Russell M. Stockman. London: Thames and Hudson.

BIRD, J. B.
1945 *Archaeology of the Hopedale Area, Labrador*. Anthrop. Papers, AMNH, Vol. XXXIX, Part 2.

BIRKET-SMITH, KAJ
1929 *The Caribou Eskimos*. Fifth Thule, Vol. V.
1930 "The Question of the Origin of Eskimo Culture: A Rejoinder," AA, N.S., Vol. XXXII, Oct.-Dec., pp. 608-624.
1937 "Eskimo Cultures and Their Bearing Upon the Prehistoric Cultures of North America and Eurasia," in *Early Man*, ed. G. G. MacCurdy. Philadelphia and New York, pp. 293-302.

1940 *Anthropological Observations on the Central Eskimos*. Fifth Thule, Vol. III.
1945 *Ethnographical Collections from the Northwest Passage*. Fifth Thule, Vol. VI, No. 2.
1952 "Present Status of the Eskimo Problems," *Proceed. 29th Internat. Congress Americanists*, Vol. III, Chicago.
1958 "The Significance of Eskimology," *Proceed. 32nd Internat. Congress Americanists*, Copenhagen.
1959 *The Eskimos*. London: Methuen.

BLODGETT, JEAN
1977 *Karoo Ashevak*. Winnipeg: WAG.
1978 "The Historic Period in Canadian Eskimo Art," *The Beaver*, Autumn 1979.
1979 *The Coming and Going of the Shaman*. Winnipeg: WAG.
1982 "Whale Bone," *The Beaver*, Autumn 1982.
1983a "Christianity and Inuit Art," *The Beaver*, Autumn 1984.
1983b *Grasp Tight the Old Ways: Selections from the Klama Family Collection of Inuit Art*. Toronto: AGO. (See also: Winnipeg Art Gallery)
1985 "Osuitok Ipeelee," *Inuit Art: An Anthology*, Alma Houston (intro.). Winnipeg: Watson & Dwyer Publishing.

BLOORE, RONALD L.
1971 "to gain a sense of presence – to find a sense of urgency," *artscanada*, no. 162/163, Dec. 1971/Jan. 1972, Toronto, pp. 48-67.

BOAS, FRANZ
1888 "The Central Eskimo," *6th Annual Report*, BE; and University of Nebraska Press, Lincoln, 1964.
1900 "Religious Beliefs of the Central Eskimo," *Popular Science Monthly*, Vol. LVII, October, New York, pp. 624-631.
1901 *The Eskimo of Baffin Land and Hudson Bay*. Bulletin, AMNH, Vol. XV, Part 1, and 1907 Part 2.
1927 *Primitive Art*. New York: Dover Publications, 1955; and Irvington-on-Hudson: Capital Pub. Co., 1951.

BORDEN, CHARLES E.
1962 "West Coast Crossties with Alaska," *T.P. 11*, AINA, pp. 9-19.

BREUIL, H.
1939 "L'art des populations arctiques américaines," *Annuaire*, xxxix, Collège de France, Paris, pp. 138-144.

BRODZKY, ANN (ed.)
1972 "The Eskimo World," *artscanada*, Vol. 162/163, Toronto: SAP.
1974 "Stones, Blood and Skin," *artscanada*, Vol. 184/5/6/7, Toronto: SAP.

BRUEMMER, FRED
1971 *Seasons of the Eskimo: A Vanishing Way of Life*. Toronto: McClelland and Stewart.

BURGESS, HELEN
1965 "A Talent to Carve," *north*, Vol. XII, No. 2, March-April, Ottawa, pp. 19-27.

BURNHAM, JACK
1971 *The Structure of Art*. New York: George Braziller.

BUSHNELL, G., & MCBURNEY, C.
1959 "New World Origins Seen from the Old World," *Antiquity*, Vol. XXXIII, Cambridge, pp. 93-101.

CALDER, RITCHIE
1957 *Men Against the Frozen North*. London: George Allen & Unwin Ltd.

CAMPBELL, JOHN M.
1962 (ed.) *Prehistoric Cultural Relations between the Arctic and Temperate Zones of North America*. T.P. 11, AINA.
1963 "Ancient Alaska and Paleolithic Europe," *APUA*, Vol. X, No. 2, pp. 29-49.

CANADA, DEPT. OF EXTERNAL AFFAIRS
1954 *The Eskimos*. Information Division Reference Paper No. 71, Ottawa, March.

CANADA, DEPT. OF NORTHERN AFFAIRS
1954 *Canadian Eskimo Art*. Ottawa: Queen's Printer.
1964 *Q-Book*. Welfare Division, Northern Administration Branch, D.N.A., Ottawa.

CANADA, DOMINION BUREAU OF STATISTICS
1964 *Canada Year Book 1964*. Ottawa: Queen's Printer.
1971 *Canada 1971*. The annual handbook of present conditions and recent progress. Information Canada, Ottawa.

CANADIAN ARCTIC PRODUCERS LTD.
1974 *From the Bottom of the Kudlik: Carvings and Artifacts from Gjoa Haven*. Ottawa: CAP.
1979 onward, Individual artists' *Exhibition Catalogues*. Ottawa and Winnipeg: CAP.
1984 *Biographies of Inuit Artists* (2nd edition). Ottawa: CAP.

CANADIAN HANDICRAFTS GUILD
n.d. *Canadian Handicrafts Guild*. Montreal.
n.d. *Eskimo Art*. Montreal.

CARPENTER, EDMUND S.
1952 "The Future of the Eskimos," *Canadian Forum*, Vol. XXXII, Toronto, pp. 54-55.
1955a "Space Concepts of the Aivilik Eskimos," *Explorations No. 5*, University of Toronto Press, pp. 131-145.
1955b "Changes in the Sedna Myth among the Aivilik," *APUA*, Vol. III, pp. 69-73.
1956 "The Timeless Present in the Mythology of the Aivilik Eskimos," *Anthropologica*, Vol. III, Ottawa, pp. 1-4.
1959 *Eskimo*. (With Robert Flaherty and Frederick Varley.) Toronto: University of Toronto Press.
1962 "Artists of the North," *Natural History*, February, AMNH, pp. 8-15.
1964a "Eskimo Masks: The Audience as Artists," *Varsity Graduate*, Vol. XI, No. 2, University of Toronto Press, pp. 53-55.
1964b *Man and Art in the Arctic*. Museum of the Plains Indian, Browning, Montana.
1967 "Image Making in the Arctic," in *Sign Image Symbol*, ed. G. Kepes. New York: George Braziller, pp. 206-225.

CARPENTER, EDMUND S. & MCLUHAN, MARSHALL
1960 "Acoustic Space," in *Explorations in Communication*. Boston: Beacon Press (BP-218), 1966, pp. 65-70.

CHANDLER, JOHN NOEL
1971 "Janus in Baffinland," *artscanada*, no. 162/163, Dec. 1971/Jan. 1972, Toronto, pp. 104-112.

CHARD, CHESTER S.
1955 "Eskimo Archaeology in Siberia," *Southwestern Journal of Anthropology*, Vol. XI, No. 2, Albuquerque, pp. 150-177.
1958 "New World Migration Routes," *APUA*, Vol. VII, No. 1, pp. 23-26.
1959a "New World Origins: A Reappraisal," *Antiquity*, Vol. XXXIII, Cambridge, pp. 44-49.
1959b "The Western Roots of Eskimo Culture," *Actas del 33 Congreso internacional de Americanistas*, Vol. II, San José, pp. 81-87.
1963 "The Old World Roots: Review and Speculations," *APUA*, Vol. X, No. 2, pp. 115-121.

CLAERHOUT, ADRIAAN G. H., and others
1965 "The Concept of Primitive Applied to Art," *CA*, Vol. VI, No. 4, October, pp. 432-438.

COLLINS, HENRY B., JR.
1929 *Prehistoric Art of the Alaskan Eskimos*. Misc. Coll., Smithsonian Institution, Vol. LXXXI, No. 14.
1935 "Archaeology of the Bering Sea Region," *Report*, Smithsonian 1933, pp. 453-468.
1940 *Outline of Eskimo Prehistory*. Misc. Coll., Smithsonian Institution, Vol. C.
1943 "Eskimo Archaeology and its Bearing on the Problem of Man's Antiquity in America," *Proceed. of the American Philosophical Society*, Vol. LXXXVI, No. 2, Philadelphia.
1951 "The Origin and Antiquity of the Eskimo," *Report*, Smithsonian 1950, pp. 423-467.
1953 "Recent Developments in the Dorset Culture Area," *Memoirs of the Society for American Archaeology*, No. 9, Salt Lake City, pp. 32-39.
1954a "Archaeological Research in the North American Arctic," *Arctic*, Vol. VII, Nos. 3-4, Montreal, pp. 296-306.
1954c "The Position of Ipiutak in Eskimo Culture – Reply," *AA*, Vol. XX, No. 1, pp. 79-84.
1955a "Archaeological Work on Southampton and Walrus Islands, Hudson Bay," *Year Book of the American Philosophical Society*, Philadelphia, pp. 341-344.
1955b "Excavations of Thule and Dorset Culture Sites at Resolute, Cornwallis Island, N.W.T." *Bulletin 136*, Annual Report NMC 1953-4, pp. 22-35.
1956a "Archaeological Investigations on Southampton and Coast Islands, N.W.T." *Bulletin 142*, Annual Report NMC 1954-5, pp. 82-113.
1956b "Vanished Mystery Men of Hudson Bay," *National Geographic*, Vol. CX, No. 5, November, pp. 669-688.
1957 "Archaeological Work in Arctic Canada," *Annual Report*, Smithsonian 1956.
1958a "Archaeological Investigations on Southampton and Walrus Islands, N.W.T." *Bulletin 147*, Annual Report NMC 1955-6, pp. 22-61.
1958b "Present Status of the Dorset Problem," *Proceed. 32nd Internat. Congress Americanists*, Copenhagen.
1959 "An Okvik Artifact from Southwest Alaska and Stylistic Resemblance between Early Eskimo and Paleolithic Art," *Polar Notes*, No. I, Dartmouth College, Hanover.
1961 "Eskimo Cultures," *Encyclopedia of World Art*. New York: McGraw Hill, Vol. V.
1962 "Bering Strait to Greenland," *T.P. 11*, AINA, pp. 126-139.
1964 "The Arctic and Subarctic," in *Prehistoric Man in the New World*, ed. J. D. Jennings and E. Norbeck. Chicago: University of Chicago Press, pp. 85-116.
1967 "Diamond Jenness and Arctic Archaeology," *The Beaver*, Autumn, pp. 78-79.

COLLINSON, R. (ed.)
1867 *The Three Voyages of Martin Frobisher*. London: Hakluyt Society.

COMMISSIONER OF THE NORTHWEST TERRITORIES
1963-4 *Annual Report*. Ottawa: Queen's Printer.
1965-6 *Annual Report*. Ottawa: Queen's Printer.

COPLAND, ALFRED
1954 "Men of the Barrens," in *North of 55°*, ed. Clifford Wilson. Toronto: Ryerson Press.

CROWE, KEITH J.
1969 *A Cultural Geography of Northern Foxe Basin, N.W.T.* Northern Science Research Group, Dept. of Indian Affairs and Northern Development, Ottawa, 1970.

DALL, WILLIAM H.
1884 "On Masks, Labrets and Certain Aboriginal Customs," *3rd Annual Report*, BE, 1881-2.
1913 "An Eskimo Artist," *The Nation*, Vol. XCVII, p. 121.

D'ANGLURE, BERNARD SALADIN
1962 "Découverte de Pétroglyphes à Qajartalik sur l'Ile de Qikertaaluk," *north*, Vol. IX, No. 6, Nov.-Dec., Ottawa.
1963 "Discovery of Petroglyphs near Wakeham Bay," *Arctic Circular*, Vol. XV, No. 1, January, Ottawa, pp. 6-13.

DE COURVAL, MICHEL
1968 "Les nouvelles sculptures de Povungnituk," *north*, Vol. XV, Nov.-Dec., Ottawa, pp. 14-17.

DE LAGUNA, FREDERICA
1932-3 "A Comparison of Eskimo and Paleolithic Art," *American Journal of Archaeology*, Vol. XXXVI, No. 4 and Vol. XXXVII, No. 1, New York.
1933a "Eskimo Lamps and Pots," *Journal de la Société des Américanistes*, N.S., Vol. XXV, Paris.
1933b "Peintures rupestres Eskimo," *Journal de la Société des Américanistes*, N.S., Vol. XXXV, Paris, pp. 17-30.
1946 "The Importance of the Eskimo in Northeastern Archaeology," in *Man in Northeastern North America*, ed. Frederick Johnson. Phillips Academy, Andover, Mass.
1962 "Intemperate Reflections on Arctic and Subarctic Archaeology," *T.P. 11*, AINA, pp. 164-169.

DE LORM, A. J.
1945 *Kunstzin der Eskimo's*. The Hague: A. A. M. Stols.

DE PONCINS, GONTRAN
1941 *Kabloona*. New York: Reynal & Co.; and Bantam Books, 1971.

DESGOFFES, CLAUDE
1955 "Le Cas des Esquimaux des Iles Belcher," *Anthropologica*, Vol. I, Ottawa.

DE SOLIER, RENE
1971 "Povungnituk," *Vie des Arts*, no. 63, été, Montreal, pp. 60-65; English translation, pp. 95-96.

DOCKSTADER, FREDERICK J.
1961 *Indian Art in America*, Greenwich, Conn.: New York Graphic Society.

DOZIER, EDWARD P.
1956 "The Concepts of 'Primitive' and 'Native' in Anthropology," in *Current Anthropology*, ed. William L. Thomas. Chicago: University of Chicago Press, pp. 187-202.

DRISCOLL, BERNADETTE
1981 *The Inuit Amautik: I Like My Hood to Be Full*. Winnipeg: WAG.
1985 *Uumajut: Animal Imagery in Inuit Art*. Winnipeg: WAG.
(see also: Winnipeg Art Gallery)

EHRENZWEIG, ANTON
1967 *The Hidden Order of Art*. London: Weidenfeld and Nicholson; and Paladin, 1970.

ELLIOTT, LAWRENCE
1962 "The Remarkable Eskimo Artists of Baffin Land," *Reader's Digest*, Vol. LXXXI, No. 485, September, pp. 29-34.

FIDLER, VERA
1965 "The Unique Art of the Eskimo," *Art Voices*, Spring, New York, pp. 122-125.

FIRTH, RAYMOND
1951 "The Social Framework of Primitive Art," in *Elements of Social Organization*. London: Watts & Co., pp. 155-182.

FITZHUGH, WILLIAM W. AND SUSAN A. KAPLAN
1982 *Inua: Spirit World of the Bering Sea Eskimo*. Washington: Smithsonian Institution Press.

FLAHERTY, R. J.
1924 *My Eskimo Friends*. London.

FRASER, DOUGLAS
1966 *The Many Faces of Primitive Art*. Englewood Cliffs, N.J.: Prentice-Hall.

FREUCHEN, PETER
1961 *Book of the Eskimos*, ed. Dagmar Freuchen. New York: World Pub. Co.; and Fawcett Crest Books, 1965.

FRY, JACQUELINE DELANGE
1971 "Contemporary arts in non-western societies," *artscanada*, no. 162/163, Dec. 1971/Jan. 1972, Toronto, pp. 96-101.

FURNEAUX, J.D.
1964 "The Eskimo speaks to us through his pictures and sculptures," in *Povungnituk 1964*. Québec: Povungnituk Cooperative Society, p. 3.

GAGNON, LOUIS
1991 *Charlie Inukpuk: étude sémiotique d'un cas en art inuit*. (Mémoire de maîtrise en histoire de l'art) Québec: Université Laval, Département d'Histoire de l'art (hiver).
1995 "Gift of the Caribou," *Inuit Art Quarterly*, Vol. 10, No. 2, Summer. Ottawa: Inuit Art Foundation.
1996 "L'intromission des légendes dans la sculpture des Inuit du Nunavik," *Transferts culturels et métissages Amérique/Europe, XVIe-XXe siècle = Cultural Transfer, America and Europe: 500 years of Interculturation*. Québec: Les Presses de l'Université Laval.
1999 "La sculpture contemporaine des Inuits du Nunavik," *Cap-aux-diamants*, No. 56, hiver.

GATHORN-HARDY, G. M.
1922 "A Recent Journey to Northern Labrador," *Geographical Journal*, Vol. LIX, London, pp. 153-169.

GEIST, OTTO & RAINEY, FROELICH
1936 *Archaeological Excavations at Kukulik*. Misc. publications of the University of Alaska, Vol. II.

GERBRANDS, A.
1957 "Art as an Element of Culture, with Specific Reference to African Sculpture," *Mededeelingen Van Leiden Rijksmuseum, Volkenk.*, Leiden.

GESSAIN, ROBERT
1952 "L'ajagaq, Bilboquet Eskimo," *Journal de la Société des Américanistes*, N.S., Vol. XLI, Paris.
1959 "L'Art squelettique des Eskimos," *Journal de la Société des Américanistes*, N.S., Vol. XLVIII, Paris.

GIDDINGS, J. L.
1950 *Early Man on the North Bering Sea Coast*. University of Pennsylvania Museum Bulletin, Vol. XIV, No. 4, Philadelphia.
1960 "The Archaeology of Bering Strait," *CA*, Vol. I, No. 2, March, pp. 121-137 (with CA comments).
1961 "Cultural Continuities of Eskimos," *American Antiquity*, Vol. XXVII, No. 2, Menasha.

1967 *Ancient Men of the Arctic*. New York: Alfred A. Knopf.

GIMPEL, CHARLES
1967 "A Collector's View," *The Beaver*, Autumn, pp. 72-75.

GRABURN, NELSON H. H.
1963 *Lake Harbour, Baffin Island*. Northern Co-ordination and Research Centre, Ottawa.
1966 "Eskimo Soapstone Carving: Innovation and Acculturation." Paper read at the 65th Annual Meeting of the American Anthropological Assoc., Pittsburgh, November 18. Mimeographed text.
1967a "The Eskimos and Airport Art," *Trans-Action*, Vol. IV, No. 10, October, Washington University, St. Louis, pp. 28-33.
1967b "Eskimo Carvers and Art in the Eastern Canadian Arctic." Unpublished report.
1969a *Eskimos without Igloos*. Boston: Little, Brown & Co.
1969b "Anthropological Investigation of Contemporary Canadian Eskimo Art." Unpublished report.
1969c "The Marketing of Eskimo Art." Unpublished report.
1969d "Art and acculturative processes," *International Social Science Journal*, Vol. XXI, No. 3, UNESCO, New York and Paris, pp. 457-468.
1971 "Takursunaituk – Imaginative Carvings," in *The Art of the Eskimo*. Burnaby: The Simon Fraser Gallery.

HALLOWELL, A. IRVING
1926 "Bear Ceremonialism in the Northern Hemisphere," *AA*, N.S., Vol. XXVIII, pp. 1-175.

HAMMERICH, L. L.
1958 "The Origin of the Eskimo," *Proceed. 32nd Internat. Congress Americanists*, Copenhagen, pp. 640-644.

HARINGTON, C. R.
1962 "A Bear Fable," *The Beaver*, Winter.

HARP, ELMER, JR.
1960 "Archaeological Evidence Bearing on the Origin of the Caribou Eskimos," *Actes du VIe Congrès Int. des Sciences Anthr. et Ethnol.*, Vol. II, Paris, pp. 409-413.
1961 "The Archaeology of the Lower and Middle Thelon, Northwest Territories," *Technical Paper No. 8*, AINA, December.
1962 "The Culture History of the Central Barren Grounds," *T.P. 11*, AINA, pp. 69-75.
1964 "The Cultural Affinities of the Newfoundland Dorset Eskimo," *Bulletin 200*, Anthrop. Series No. 67, NMC.
1969 "Late Dorset Eskimo Art from Newfoundland," *Folk*, Vol. XI/XII, Copenhagen, pp. 109-124.

HARP, ELMER, JR. & HUGHES, DAVID R.
1968 "Five Prehistoric Burials from Port-aux-Choix, Newfoundland," *Polar Notes*, No. VIII, June, Dartmouth College, Hanover.

HARRINGTON, RICHARD
1959 "Eskimo Stone Carvings," *Canadian Geographical Journal*, Vol. LIX, No. 2, Ottawa, pp. 38-47.
1963 "Eskimo Carvings of Eskimo Killings," *Weekend Magazine*, No. 14, Toronto, pp. 38-43.

HASELBERGER, HERTA
1961 "Method of Studying Ethnological Art," *CA*, Vol. II, No. 4, October (with CA comments).

HAWKES, E. W.
1916 *The Labrador Eskimo*. Memoir 91, No. 14 Anthrop. Series, Dept. of Mines, Geological Survey, Ottawa.

HEINRICH, ALBERT
1950 "Some Present-Day Acculturative Innovations in a Non-literate Society," *AA*, Vol. LII, No. 2, pp. 235-242.

HERSKOVITS, MELVILLE J.
1959 "Art and Value," in *Aspects of Primitive Art*. New York: Museum of Primitive Art.

HESSEL, INGO
1991 "Contemporary Inuit Art" in *Visions of Power*, Toronto: The Earth Spirit Festival.
1998 *Inuit Art: An Introduction*. Vancouver: Douglas & McIntyre.

HIMMELHEBER, HANS
1938 *Eskimokünstler*. Stuttgart: Strecker & Schröder. 2nd ed. 1953.

HOFFMAN, WALTER JAMES
1897 "The Graphic Art of the Eskimos," *Annual Report*, USNM 1895, pp. 739-968.

HOLM, BILL
1965 *Northwest Coast Indian Art: An Analysis of Form*. Seattle and London: University of Washington Press.

HOLM, GUSTAV
1914 "Ethnological Sketch of the Angmassalik Eskimo," *MoG*, Vol. XXXIX.

HOLTVED, ERIC
1944 "Archaeological Investigations in the Thule District," *MoG*, Vol. CXLI, Nos. 1 & 2.
1947 *Eskimokunst*. Copenhagen: Alverdens Kunst IV, Foreningen for ung Dansk Kunst. (With an English Summary, pp. 29-31.)
n.d. "Eskimo Shamanism," in *Studies in Shamanism*, ed. Carl-Martin Edsman. Based on papers read at a symposium held at Abo, September 1962. Stockholm: Almquist & Wiksell.

HOUSTON, ALMA (intro.)
1988 *Inuit Art: An Anthology*. Winnipeg: Watson & Dwyer Publishing.

HOUSTON, JAMES A.
1951a "Eskimo Sculptors," *The Beaver*, June, pp. 34-39.
1951b *Sanayasak*. (Eskimo Handicrafts – trans. by S. Ford and F. Woodrow), Department of Resources and Development, Ottawa, and Canadian Handicrafts Guild.
1952 "In Search of Contemporary Eskimo Art," *Canadian Art*, Vol. IX, No. 3, Spring, Ottawa, pp. 99-104.

1954a *Canadian Eskimo Art*. Dept. of Northern Affairs, Ottawa: Queen's Printer.
1954b "Contemporary Art of the Eskimo," *Studio*, Vol. CXLVII, February, London.
1954c "Eskimo Carvings," *Craft Horizons*, April, New York, pp. 10-15.
1954d "Eskimo Carvings," *Royal Architectural Institute of Canada Journal*, Vol. XXXI, April, Toronto.
1955 "The Creation of Anoutoaloak," *The Beaver*, Winter.
1960 "Eskimo Graphic Art," *Canadian Art*, Vol. XVII, January, Ottawa, pp. 8-15.
1962 "Eskimo Artists," *Geographical Magazine*, Vol. XXXIV, No. 11, London, pp. 639-650.
1967 *Eskimo Prints*. Barre, Mass.: Barre Pub. Co.; and Toronto: Burns & MacEachern.
1971 "To Find Life in the Stone," in *Sculpture/Inuit: Masterworks of the Canadian Arctic*. Toronto: University of Toronto Press, pp. 52-63.

HSU, FRANCIS L. K.
1964 "Rethinking the Concept 'Primitive,'" *CA*, Vol. V, No. 3, June, pp. 169-178.

HUGHES, C. C.
1965 "Under Four Flags: Recent Culture Change among the Eskimos," *CA*, Vol. VI, No. 1, February (with CA comments).

HUME, ROBERT M.
1963 "Eskimo Carver or Canadian Sculptor?" *north*, Vol. X. No. 1, Jan.-Feb., Ottawa, pp. 2-5.

HUTTON, SAMUEL KING
1912 *Among the Eskimos of Labrador*. London: Seeley & Co.

IGLAUER, EDITH
1964 "A Striking New Discovery in Eskimo Sculpture," *Maclean's Magazine*, Vol. LXXVII, No. 13, July.
1966 *The New People*. New York: Doubleday & Co.

ILLUSTRATED LONDON NEWS
1956 "Eskimo Carvings: Striking Sculptures by the Rodins of the Arctic," *Illustrated London News*, Vol. CCXXIX, August 11, pp. 278-279.

INNUIT GALLERY OF ESKIMO ART
1974 onward, *Exhibition Catalogues*. Toronto: IGEA.

INUIT GALERIE
1979 onward, Künstlerkataloge. Mannheim: IGM.

INUIT GALLERY OF VANCOUVER
1979 onward, *Exhibition Catalogues*. Vancouver: IGV.
1989 *Kitikmeot*. Vancouver: IGV.
1991 *Kitikmeot. Land of the Spirits*. Vancouver: IGV.

JENNESS, DIAMOND
1922 "Eskimo Art," *Geographical Review*, Vol. XII, April, New York, pp. 161-174.
1923 "Origin of the Copper Eskimo and their Copper Culture," *Geographical Review*, Vol. XIII, New York, pp. 540-551.

1925 "A New Eskimo Culture in Hudson Bay," *Geographical Review*, Vol. XV, New York, pp. 428-437.
1928a "Archaeological Investigations in Bering Strait," *Bulletin 50*, Annual Report NMC 1926.
1928b *The People of the Twilight*. New York: Macmillan Co.; and Chicago: University of Chicago Press, 1959.
1946 "Material Culture of the Copper Eskimo," *Canadian Arctic Expedition 1913-18*. Vol. XVI, Ottawa: King's Printer, p. 145.
1962 *Eskimo Administration: I. Alaska. Technical Paper No. 10*, AINA.
1964 *Eskimo Administration: II. Canada. Technical Paper No. 14*, AINA.
1965 *Eskimo Administration: III. Labrador. Technical Paper No. 16*, AINA.
1967 *Eskimo Administration: IV. Greenland. Technical Paper No. 19*, AINA.
1968 *Eskimo Administration: V. Analysis and Reflections. Technical Paper No. 21*, AINA.

JOPLING, CAROL F.
1965 *Art and Aesthetics in Primitive Societies*. New York: E. P. Dutton & Co., and Toronto and Vancouver: Clarke Irwin & Co.

KARDOSH, ROBERT
1996 *Oviloo*. Vancouver: Marion Scott Gallery.
1999 *Two Great Image Makers from Baker Lake*. Vancouver: Marion Scott Gallery.

KING, RICHARD
1836 *A Narrative of a Journey to the Shores of the Arctic Ocean*, Vol. II. London: Richard Bentley.

KIRWAN, JOHN
1961 "Belcher Islands, N.W.T." *Canadian Geographical Journal*, Vol. LXIII, No. 3, September, Ottawa.

KNUTH, EIGIL
1958 "Archaeology of the Farthest North," *Proceed. 32nd Internat. Congress Americanists*, Copenhagen, pp. 561-573.

LANTIS, MARGARET
1947 *Alaskan Eskimo Ceremonialism*. New York: J. J. Augustin; and Seattle: University of Washington Press, 1967.
n.d. "The Religion of the Eskimos," in V.T.A. Ferm, *Forgotten Religions*, pp. 311-339.
1950 "Mme Eskimo Proves Herself an Artist," *Natural History*, Vol. LIX, AMNH, pp. 68-71.

LARMOUR, W. T.
1964 "Carvers of Keewatin." Introduction to Winnipeg Art Gallery Catalogue, pp. 5-15.
1967 *Keewatin Eskimo Ceramics '67*. Exhibition Catalogue, February, Toronto City Hall.
1968 *Inunnit – The Art of the Canadian Eskimo*. Ottawa: Queen's Printer.

LARSEN, HELGE
1954 "The Position of Ipiutak in Eskimo Culture," *AA*, Vol XX, No. 1, pp. 74-79.

1969 "Some Examples of Bear Cult among Eskimo and Other Northern Peoples," *Folk*, Vol. XI/XII, Copenhagen, pp. 27-42.

LARSEN, HELGE & MELDGAARD, JORGEN
1958 "Paleo-Eskimo Cultures in Disko Bugt, West Greenland," *MoG*, Vol. CLXI, No. 2.

LARSEN, HELGE & RAINEY, FROELICH
1948 *Ipiutak and the Arctic Whale Hunting Culture*. Anthrop. Papers, AMNH, Vol. XLII.

LAUGHLIN, WILLIAM S.
1962 "Bering Strait to Puget Sound: Dichotomy and Affinity between Eskimo-Aleuts and American Indians," *T.P. 11*, AINA, pp. 113-125.
1936a "Eskimo and Aleuts: Their Origins and Evolution," *Science*, Vol. CXLII, No. 3593, Washington, pp. 633-645.
1963b "Primitive Theory of Medicine: Empirical Knowledge," in *Man's Image in Medicine and Anthropology*. New York: International Universities Press, pp. 116-140.

LAUGHLIN, W. S. & TAYLOR, W., JR.
1960 "A Cape Dorset Culture Site on the West Coast of Ungava Bay," *Bulletin 167*, NMC, pp. 1-28.

LEACH, E. R.
1961 "Art in Cultural Context," in *Cultural and Social Anthropology*. Selected Readings, ed. P. B. Hammond. New York: Macmillan Co., pp. 344-350.

LEECHMAN, DOUGLAS
1943 "Two New Cape Dorset Sites," *AA*, Vol. VIII, No. 4, pp. 363-375.
1954 "Eskimo Sculpture in Stone," *Canadian Geographical Journal*, Vol. XLIX, September, Ottawa, pp. 90-99.

LEVINE, MORTON H.
1957 "Prehistoric Art and Ideology," *AA*, Vol. LIX, pp. 946-962.

LEWIS, PHILLIP H.
1961 "A Definition of Primitive Art," *Fieldiana, Anthropology*, Vol. XXXVI, No. 10, October 20, Chicago Natural History Museum, pp. 221-241.

LEWIS, RICHARD (ed.)
1971 *I Breathe a New Song: Poems of the Eskimo*, illustrated by Oonark, with an introduction by Edmund Carpenter. New York: Simon and Schuster.

LIPTON, BARBARA
1984 *Arctic Vision: Art of Canadian Inuit*. Ottawa: CAP.

LOMMEL, ANDREAS
1967 SHAMANISM – *The Beginnings of Art*. New York: McGraw-Hill.

LOT-FALCK, E.
1957 "Les Masques Eskimo et Aléoutes de la Collection Pinart," *Journal de la Société des Américanistes*, N.S., Vol. XLVI, Paris, pp. 5-43.

LOTZ, JIM
1970 *Northern Realities*. Toronto: New Press.

LYON, G. F.
1825 *A Brief Narrative of an Unsuccessful Attempt to Reach Repulse Bay*. London: John Murray.

MACCURDY, G. G.
1921 "An Example of Eskimo Art," *AA*, N.S., Vol. XXIII, pp. 384-385.

MACNEISH, RICHARD S.
1959 "A Speculative Framework of North American Prehistory as of April 1959," *Anthropologica*, Vol. I, Nos. 1 & 2, Ottawa.

MACPHERSON, DOROTHY
1958 "Eskimo Handicrafts," *Encyclopaedia Canadiana*, Toronto, pp. 42-45.

MALAURIE, JEAN
1958a "L'Art Esquimau," *Annales de Géographie*, T. 67, No. 354, Nov.-Déc., Paris.
1958b "Remarques sur des formes différentes d'acculturation chez les Esquimaux et les Lapons," *Annales de Géographie*, T. 67, No. 354, Nov-Déc., Paris.

MANNING, T. H.
1946 "Ruins of Eskimo Stone Houses on the East Side of Hudson Bay," *American Antiquity*, Vol. XI, Menasha.

MARKHAM, ALBERT H. (ed.)
1880 *The Voyages and Works of John Davis*. London: Hakluyt Society.

MARKHAM, CLEMENT (ed.)
1881 *The Voyages of William Baffin, 1612-1622*. London: Hakluyt Society.

MARSH, GORDON H.
1954 "A Comparative Survey of Eskimo-Aleut Religion," *APUA*, Vol. III, pp. 21-36.

MARTIJN, CHARLES A.
1964 "Canadian Eskimo Carving in Historical Perspective," *Anthropos*, Vol. LIX, St. Augustin, Germany, pp. 546-596.
1967 "A Retrospective Glance at Canadian Eskimo Carving," *The Beaver*, Autumn, pp. 4-19.

MARTIN, PETER
1962 "Prosperous Eskimo Print Makers," *The Canadian Banker*, Vol. LXIX, No. 3, Toronto, pp. 32-41.

MARY-ROUSSELIERE, FR. GUY, O.M.I.
1960a "A Remarkable Specimen of Prehistoric Eskimo Art," *Eskimo*, Vol. LIV, March, Churchill, pp. 10-14.
1960b "Editorial," *Eskimo*, Vol. LVI, September, Churchill, p. 2.
1962a "For an Authentic Eskimo Art," *Eskimo*, Vol. LXII, Fall, Churchill, pp. 16-17.
1962b "Something New in Eskimo Archaeology," *Eskimo*, Vol. LXII, Fall, Churchill, p. 19.
1963 "Paleo-Eskimo Remains in the Pelly Bay Region," *Bulletin 193*, NMC.
1969 "Les Jeux de ficelle des Arviliqjuarmiut," *Bulletin 233*, NMC.
1970 "An Important Archaeological Discovery," *Eskimo*, Vol. LXXXIV, Fall-Winter, Churchill, pp. 19-24.

1971 "New Discovery of Masks at Button Point," *Eskimo*, Vol. XXVIII, N.S. No. 2, Churchill, pp. 19-20.

MATHIASSEN, THERKEL
1927 *Archaeology of the Central Eskimos*. Fifth Thule, Vol. IV, Parts 1 and 2.
1928 *Material Culture of the Iglulik Eskimos*. Fifth Thule, Vol. VI.
1930 "The Question of the Origin of Eskimo Culture," *AA*, N.S., Vol. XXXII, No. 4, Oct.-Dec., pp. 591-607.
1933 "Prehistory of the Angmagssalik Eskimos," *MoG*, Vol. XCII, No. 4.

MAXWELL, MOREAU S.
1960a "An Archaeological Analysis of Eastern Grant Land, Ellesmere Island, Northwest Territories," *Bulletin 170*, NMC.
1960b "Movements of Cultures in the Canadian High Arctic," *Anthropologica*, Vol. II, No. 2, Ottawa, pp. 177-189.
1962 "Pre-Dorset and Dorset Sites in the Vicinity of Lake Harbour, Baffin Island, N.W.T." *Bulletin 180*, Part 1, NMC.

MCGHEE, ROBERT
1977 "Ivory for the Sea Woman" in *Canadian Journal of Archaeology*, no. 1:141-149.
1978 *Canadian Arctic Prehistory*. National Museum of Man, Canadian Prehistory Series, Toronto: Van Nostrand Reinhold Ltd.
1996 *Ancient People of the Arctic*. Vancouver: UBC Press.

MELDGAARD, JORGEN
1952 "A Paleo-Eskimo Culture in West Greenland," *AA*, Vol. XVII, No. 3, pp. 222-230.
1955 "Dorset kulturen," with English summary, *Kuml*, Aarbog for Jysk Arkaeologisk Selskab, pp. 158-177.
1960a "Origin and Evolution of Eskimo Cultures in the Eastern Arctic," *Canadian Geographical Journal*, Vol. LX, February, Ottawa.
1960b *Eskimo Sculpture*. London: Methuen; and New York: Clarkson N. Potter Inc.
1960c "Prehistoric Culture Sequences in the Eastern Arctic as Elucidated by Stratified Sites at Igloolik," *Proceed. 5th Internat. Congress Anthrop. and Ethnol. Sciences*, Philadelphia.
1962 "On the Formative Period of the Dorset Culture," *T.P. 11*, AINA, pp. 92-95.
1967a "Greenland Art," *Danish Foreign Office Journal*, No. 58, Copenhagen, pp. 43-47.
1967b "Traditional Sculpture in Greenland," *The Beaver*, Autumn, pp. 54-59.

MELDGAARD, JORGEN & ROBERTSON, JOHN K. B.
1968 "Carving – It Runs in Families," *Northian*, Vol. V, No. 2, February, Saskatoon, pp. 24-25.

MILES, CHARLES
1963 *Indian and Eskimo Artifacts of North America*. Chicago: Henry Regnery.

MIRSKY, JEANNETTE
1970 *To the Arctic!* Chicago and London: University of Chicago Press.
MITCHELL, MARYBELLE
1986 onward (ed.), *Inuit Art Quarterly.* Ottawa: Inuit Art Foundation.
1996 "Bill Nasogaluak: Getting Past the Oral Tradition," *Inuit Art Quarterly*, Vol. 11, No. 3, Autumn, Ottawa: Inuit Art Foundation.
M'KEEVOR, THOMAS
1819 *A Voyage to Hudson's Bay During the Summer of 1812.* London: Phillips & Co.
MURDOCH, JOHN
1892 "Ethnological Results of the Point Barrow Expedition," *9th Annual Report*, BE, 1887-8.
MURIE, M. E.
1939 "Modern Eskimo Art," *Natural History*, Vol. XLIV, June AMNH, pp. 49-52.
NAGY, HENDRIKA G.
1967 "Pottery in Keewatin," *The Beaver*, Autumn, pp. 60-66.
NASH, RONALD
1969 *The Arctic Small Tool Tradition in Manitoba.* Occasional Paper No. 2, Dept. of Anthropology, University of Manitoba.
NATIONAL FILM BOARD OF CANADA
1958 "The Living Stone." Documentary film.
1960 (?) "Eskimo Sculpture." Manual for filmstrip "Eskimo Sculpture."
1963 "Kenojuak." Documentary film.
1963 (?) "Eskimo Prints." Manual for filmstrip "Eskimo Prints."
NELSON, EDWARD WILLIAM
1899 "The Eskimo about Bering Strait," *18th Annual Report*, BAE.
NEVINS, J. B.
1847 *A Narrative of Two Voyages to Hudson's Bay with Traditions of the North American Indians.* London: R. Clay.
NEW YORK TIMES
1930 "Eskimo Art Shown," *New York Times*, December 14, p. 6E.
1954 "Art of the Arctic," *New York Times*, Magazine Section, January 17.
NOREC
1965 *The Development of Indian and Eskimo Art and Crafts in the Far North.* Report of the NOREC Conference, May 3, 1965, at the O'Keefe Centre, Toronto, sponsored by the Northern Regional Committee of the Indian-Eskimo Association of Canada, Toronto.
NULIGAK
1966 *I, Nuligak*, edited and translated by Maurice Metayer, OMI, illustrated by Ekootak. Toronto: Peter Martin Assoc.
NUNGAK, ZEBEDEE & ARIMA, EUGENE
1969 "eskimo stories – unikkaatuat," *Bulletin 235*, Anthrop. Series No. 90, NMC.

O'BRYAN, D.
1953 "Excavation of a Cape Dorset Eskimo Site, Mill Island, West Hudson Strait," *Bulletin 128*, Annual Report NMC 1951-52, pp. 40-57.
OSCHINSKY, L.
1964 *The Most Ancient Eskimos.* Ottawa: The Canadian Research Center for Anthropology.
OSWALT, WENDELL
1961 "Eskimo Ingenuity," *north*, Vol. VIII, No. 6, Nov.-Dec., Ottawa, pp. 28-33.
OTTO, EBERHARD
1971 "The Eskimo World." Photographs and photographic essays, in *artscanada*, no. 162/163, Dec. 1971/Jan. 1972, Toronto.
PARRY, W. E.
1821 *Journal of a Voyage for the Discovery of a Northwest Passage.* London.
1824 *Journal of a Second Voyage for the Discovery of a Northwest Passage.* London.
PECK, W.
1961 "Eskimo Art," *Bulletin 41*, No. 1, Autumn, Detroit Institute of Arts, pp. 12-13.
PHILLIPS, R. A. J.
1967 *Canada's North.* Toronto: Macmillan Co.
PHILLIPS, R. A. J. & PARSONS, G. F.
1958 "Eskimo Sculpture," in *This is the Arctic*, pp. 21-22. Dept. of Northern and Natural Resources, Ottawa.
PITSEOLAK
1971 *Pitseolak: Pictures out of my life*, edited from tape-recorded interviews by Dorothy Eber, illustrated by Pitseolak. Montreal: Design Collaborative Books and Oxford University Press, Toronto.
POOL, BEEKMAN H.
1964 *Contemporary Canadian Eskimo Art.* Boston: The Club of Odd Volumes.
PRYDE, DUNCAN
1971 *Nunaga: My Land, My Country.* Edmonton: M. G. Hurtig Ltd.
PURDY, AL
1971 "Lament for the Dorsets," "Arctic Romance," and "Tent Rings," *artscanada*, no. 162/163, Dec. 1971/Jan. 1972, Toronto, pp. 30-31, 68, 84.
QUIMBY, GEORGE I., JR.
1940 "The Manitunik Eskimo Culture of East Hudson's Bay," *American Antiquity*, Vol. VI, No. 2, October, Menasha, pp. 148-165.
1962 "The Old Copper Culture and the Copper Eskimos, an Hypothesis," *T.P. 11*, AINA, pp. 76-79.
RAINEY, FROELICH G.
1941 *Eskimo Prehistory: The Okvik Site on the Punuk Islands.* Anthrop. Papers, AMNH, Vol. XXXVII, Part 4.
RASMUSSEN, KNUD
1929 *Intellectual Culture of the Iglulik Eskimos.* Fifth Thule, Vol. VII, No. 1.
1930 *Intellectual Culture of the Caribou Eskimos.* Fifth Thule, Vol. VI, Nos. 2 and 3.
1931 *The Netsilik Eskimos: Social Life and Spiritual Culture.* Fifth Thule, Vol. VIII.

1932 *Intellectual Culture of the Copper Eskimos.* Fifth Thule, Vol. IX.
RAY, DOROTHY JEAN
1961 *Artists of the Tundra and the Sea.* Seattle: University of Washington Press.
1967a *Eskimo Masks: Art and Ceremony.* Seattle: University of Washington Press; and Toronto: McClelland and Stewart.
1967b "Alaskan Eskimo Arts and Crafts," *The Beaver*, Autumn, pp. 80-91.
1969 "Graphic Arts of the Alaskan Eskimo," *Native American Arts 2.* U.S. Department of the Interior, Indian Arts and Crafts Board, Washington, D.C.
REDFIELD, ROBERT
1959 "Art and Icon," in *Aspects of Primitive Art.* New York: Museum of Primitive Art.
RINK, HINRICH J.
1875 *Tales and Traditions of the Eskimo.* Edinburgh and London: Blackwood.
ROBERTSON, R. GORDON
1960 "The Carving Industry of Arctic Canada," *The Commerce Journal*, Spring, University of Toronto, pp. 49-54.
ROSS, J.
1819 *A Voyage of Discovery for the Purpose of Exploring Baffin's Bay.* London: J. Murray.
ROTHENBERG, JEROME
1972 *Shaking the Pumpkin.* New York: Doubleday & Co. Inc.
ROUSSEAU, JACQUES
1964 "La guilde de Povungnituk, dynamique et diversifiée . . ." in *Povungnituk 1964.* Québec: Povungnituk Cooperative Society, p. 2.
ROUTLEDGE, MARIE
1979 *Inuit Art in the 1970/L'art inuit actuel: 1970-79.* Kingston: The Agnes Etherington Art Centre.
ROWLEY, GRAHAM W.
1940 "The Dorset Culture of the Eastern Arctic," *AA*, N.S., Vol. XLII.
1950 "An Unusual Archaeological Specimen from Foxe Basin," *Arctic*, Vol. III, No. 1, Montreal, pp. 63-65.
1971 "Notes on the Cambridge University Collection: Some unique pieces," *artscanada*, no. 162/163, Dec. 1971/Jan. 1972, Toronto, pp. 116-120.
RUDENKO, S. I.
1961 *The Ancient Culture of the Bering Sea and the Eskimo Problem.* Trans. by Paul Tolstoy for AINA. Toronto: University of Toronto Press.
SCHAEFER-SIMMERN, HENRY
1958 *Eskimo-Plastik aus Kanada.* Kassel: Friedrich Lometsch.
SCHAPIRO, MEYER
1953 "Style," in *Anthropology Today.* Chicago: University of Chicago Press, 1953 and 1962, pp. 278-303.
SCHNEIDER, LUCIEN, O.M.I.
1966 *Dictionnaire Alphabético-Syllabique du Langage Esquimau de l'Ungava.* Québec: Les presses de l'université Laval.

SCHUSTER, CARL
1951 "Joint-Marks: A Possible Index of Cultural Contact between America, Oceania and the Far East," *Royal Tropical Institute, Mededeling*, Vol. XCIV, Amsterdam.
1952 "A Survival of the Eurasiatic Animal Style in Modern Alaskan Eskimo Art," *Indian Tribes*. Selected Papers of the 29th International Congress Americanists, University of Chicago Press.
1964 "Pendants in the Form of Inverted Human Figures from Paleolithic to Modern Times." *7th International Congress of Anthrop. and Ethnol. Sciences*, Moscow, August 3-10 (MS).

SIEBER, ROY
1968 "The Art of Primitive Arts," *Art News*, Vol. LXVI, No. 9, January, New York, p. 28.

SIMPSON, R. DE E.
1948 "Eskimo Art in Ivory," *Masterkey*, Vol. XXII, Los Angeles, pp. 813-888.

SMITH, I. NORMAN (ed.)
1964 *The Unbelievable Land*. Ottawa: Queen's Printer.

SMITH, MARION W. (ed.)
1961 *The Artist in Tribal Society*. New York: Free Press of Glencoe; and London: Routledge & Kegan Paul.

SOLLAS, W. J.
1911 *Ancient Hunters and their Modern Representatives*. London.

SONTAG, SUSAN
1969 "On Style," in *Against Interpretation*. Laurel Edition. New York: Dell Publishing Co., pp. 24-45.

SPALDING, ALEX.
1971 "Our Lady of the Snows" and "Doctor Faust and the Woman in the Sea," *artscanada*, no. 162/163, Dec. 1971/Jan. 1972, Toronto, pp. 95, 102-103.

SPECK, FRANK C.
1924 "Eskimo Collections from Baffin Land and Ellesmere Land," *Indian Notes*, Vol. I, Heye Foundation, Museum of the American Indian, New York.
1925 "Central Eskimo and Indian Dot Ornamentation," *Indian Notes*, Vol. II.
1927 "Eskimo Carved Ivories from Northern Labrador," *Indian Notes*, Vol. IV.
1935 "Labrador Eskimo Mask and Clown," *The General Magazine and Historical Chronicle*, University of Pennsylvania, Vol. XXXVII, Philadelphia, pp. 159-173.

SPENCER, ROBERT
1959 "The North Alaskan Eskimo," *Bulletin No. 171*, BAE.

STEENSBY, H. P.
1916 "An Anthropogeographical Study of the Origin of Eskimo Culture," *MoG*, Vol. LIII.

STEFANSSON, VILHJALMUR
1914a "Prehistoric and Present Commerce among the Arctic Coast Eskimos," *Museum Bulletin No. 6*, Anthrop. Series, Dept. of Mines, Geological Survey, Ottawa.

1914b *The Stefànsson-Anderson Arctic Expedition*. Anthrop. Papers, AMNH, Vol. XIV, Part 1.
1921 *The Friendly Arctic*. New York: Macmillan Co. (republished 1943).

STRONG, W. D.
1930 "Stone-Age Culture from Northern Labrador and its Relation to the Eskimo-like Cultures of the Northeast," *AA*, N.S., Vol. XXXII.

SWINTON, GEORGE
1958 "Eskimo Carving Today," *The Beaver*, Spring, pp. 40-47.
1963 "Eskimo Art Can't Really Be Called Primitive," *Winnipeg Free Press*, November 28.
1964 "Eskimo Art Deserves Recognition," *Winnipeg Free Press*, November 21.
1965 *Eskimo Sculpture*. Toronto: McClelland and Stewart.
1966a "Artists from the Keewatin," *Canadian Art*, Vol. XXIII, April, Toronto, pp. 32-34.
1966b "Our 'Underdeveloped' Canadians," *The Alumni Journal*, University of Manitoba, Vol. XXVI, No. 3, Spring, pp. 9-13.
1967 "The Magico-Religious Basis" in "Prehistoric Dorset Art," by William E. Taylor, Jr. and George Swinton, *The Beaver*, Autumn, pp. 32-47.
1970a *Tiktak – Sculptor from Rankin Inlet, N.W.T.* Winnipeg: University of Manitoba Press.
1970b "the sculptor Tiktak," *artscanada*, no. 144/145, June, Toronto, p. 47.
1971a "Contemporary Canadian Eskimo Sculpture," in *Sculpture/Inuit: Masterworks of the Canadian Arctic*. Toronto: University of Toronto Press, pp. 36-51.
1971b "Eskimo art reconsidered," *artscanada*, no. 162/163, Dec. 1971/Jan. 1972, Toronto, pp. 85-94.
1971c "The Eskimo Museum at Churchill, Manitoba," *artscanada*, no. 162/163, Dec. 1971/Jan. 1972. Toronto, pp. 113-115.
1972 *Eskimo Fantastic Art*. Winnipeg: University of Manitoba Gallery 1.1.1.
1978 "Touch and the Real" in *Art and Society*, Michael Greenhalgh and Vincent Megaw (eds.), New York: St. Martin's Press.
1997 "Who Makes Inuit Art? Confessions of a Para-Anthropologist," *Fifty Years of Arctic Research*. Copenhagen: Publications of the National Museum of Denmark, Department of Ethnography, Vol. 18.

SWINTON, NELDA
1980 *La déesse inuite de la mer/The Inuit Sea Goddess*. Montreal: MMFA.
1993 *La faune de l'arctique: L'art des Inuit/Arctic Wildlife: The Art of the Inuit*, exhib. cat. Montreal: Musée des beaux arts de Montréal/Montreal Museum of Fine Arts.

TAYLOR, WILLIAM E., JR.
1959 "Review and Assessment of the Dorset Problem," *Anthropologica*, Vol. I, Nos. 1 & 2, Ottawa, pp. 24-46.

1960 "Description of Sadlermiut Houses Excavated at Native Point, Southampton Island, N.W.T." *Bulletin 162*, NMC, pp. 53-100.
1962a "Archaeological Collections from the Joy Bay Region, Ungava Peninsula," *Arctic Circular*, Vol. XV, No. 2, Ottawa.
1962b "Comments on the Nature and Origin of the Dorset Culture," *Problems of the Pleistocene and Arctic*. Publications of McGill University Museums, Vol. II, Montreal.
1963 "Hypotheses on the Origin of Canadian Thule Culture," *American Antiquity*, Vol. XXVIII, No. 4, April, Menasha, pp. 456-464.
1965 "The Fragments of Eskimo Prehistory," *The Beaver*, Spring, pp. 4-17.
1966 "An Archaeological Perspective on Eskimo Economy," *Antiquity*, Vol. XL, June, Cambridge, pp. 114-120.
1967 "The Silent Echoes of Culture," in "Prehistoric Dorset Art," by William E. Taylor, Jr. and George Swinton, *The Beaver*, Autumn, pp. 32-47.
1968 "The Arnapik and Tyara Sites: A Contribution to the Study of Dorset Culture Origins," *Memoirs of the Soc. for American Archaeology*, No. 22, Salt Lake City. (*American Antiquity*, Vol. XXXIII, No. 4, Part 2.)
1969 "Prehistoric Canadian Eskimo Art" in *masterpieces of indian and eskimo art from Canada*. Paris: société des amis du musée de l'homme.
1971a "Taisumanialuk – Prehistoric Canadian Eskimo Art," in *Sculpture/Inuit: Masterworks of the Canadian Arctic*. Toronto: University of Toronto Press, pp. 23-35.
1971b "found art – and frozen," *artscanada*, no. 162/163, Dec. 1971/Jan. 1972, Toronto, pp. 32-47.

THALBITZER, WILLIAM
1928 "Die Kultischen Gottheiten der Eskimos," *Archiv f. Religionswissenschaft*, Vol. XXVI, Leipzig, pp. 364-430.
1952 "Possible Early Contacts between Eskimo and Old World Cultures," in "Indian Tribes in Aboriginal America," *Proceed. 29th Internat. Congress Americanists*, Vol. III, Chicago, pp. 50-54.

THIEBERT, ARTHUR, O.M.I.
1958 *English-Eskimo Eskimo-English Dictionary*. Research Center for Amerindian Anthropology, University of Ottawa.

THOMPSON, STITH
1929 *Tales of North American Indians*. Cambridge, Mass.: Harvard University Press.

TIME MAGAZINE
1953 "Masters from the Arctic," *Time*, Vol. LXII, No. 3, July 20, Can. Ed., pp. 46-47.
1960 "Land of the Bear," *Time*, Vol. LXXV, No. 8, Feb. 20, Can. Ed., pp. 56-58.

1964a "Fantasy from the North," *Time*, Vol. LXXXIII, No. 1, Jan. 3, Can. Ed., pp. 8-10.
1964b "Brancusis of the Barren Ground," *Time*, Vol. LXXXIV, No. 22, Nov. 27, Can. Ed., pp. 19-20.
1965 "From the World of Squirrels, Owls & Bear-Hunting Dogs," *Time*, Vol. LXXXVI, No. 22, Nov. 26, Can. Ed., pp. 17-18.

TRAFFORD, DIANA
1968 "Takushurnaituk: Povungnituk Art," *north*, Vol. XV, March-April, Ottawa, pp. 52-55.
n.d. *Canadian Eskimo Artists – A Biographical Dictionary – Keewatin* (in manuscript).

TURNER, EVAN
1963a "Canadian Eskimo Graphic Art," *Graphis*, Vol. 108, Zurich.
1963b "Problems Confronting the Eskimo Artist," *Canadian Art*, Vol. XX, No. 4, July-August, Ottawa.

TURNER, LUCIEN
1894 "Ethnology of the Ungava District," *11th Annual Report*, BE.

TURQUETIL, MOST REV. A.
1926 "Notes sur les Esquimaux de Baie Hudson," *Anthropos*, Vol. XXI, St. Augustin, Germany, pp. 419-434.
1936 "Have the Eskimo the Concept of a Supreme Being?" *Primitive Man*, Vol. IX, No. 3, July, Washington.

TWOMEY, ARTHUR & HERRICK, NIGEL
1942 *Needle to the North*. Boston: Houghton Mifflin Co.

VALLEE, FRANK C.
1962 *Kabloona and Eskimo in the Central Keewatin*. Northern Co-ordination and Research Centre, Ottawa; and Can. Research Center for Anthropology, St. Paul's University, 1967.
1967 *Povungnituk*. Northern Co-ordination and Research Centre, Ottawa.

VAN DE VELDE, FR. FRANZ, O.M.I.
1970a *Canadian Eskimo Artists – A Biographical Dictionary – Pelly Bay*. Govt. of the Northwest Territories, Yellowknife.
1970b *Canadian Eskimo Artifacts*. Ottawa: Canadian Arctic Producers.

VAN STEENSEL, MAJA (ed.)
1966 *People of Light and Dark*. Foreword by H.R.H. Prince Philip. Introduction by R. Gordon Robertson. Department of Indian Affairs and Northern Development, Ottawa.

VANSTONE, JAMES W.
1962 *An Archaeological Collection from Somerset Island and Boothia Peninsula*. Occasional Paper No. 4, Arts and Archaeology Division, Royal Ontario Museum, Toronto.

VASTOKAS, JOAN M.
1967 "The Relation of Form to Iconography in Eskimo Masks," *The Beaver*, Autumn, pp. 26-31.

1971 "Continuities in Eskimo graphic style," *artscanada*, no. 162/163, Dec. 1971/Jan. 1972, Toronto, pp. 69-83.

WEYER, EDWARD M., JR.
1932 *The Eskimos*. New Haven: Yale University Press.
1960 "Art of the Eskimo," *Natural History*, February, AMNH.

WIGHT, DARLENE
1987 *The Swinton Collection of Inuit Art*. Winnipeg: WAG
1989 *Out of Tradition: Abraham Anghik/David Ruben Piqtoukun*. Winnipeg: WAG.
1990a "Inuit Tradition and Beyond: New Attitudes to Art-Making in the 1980s," *Inuit Art Quarterly*, Spring 1991.
1990b *Manasie: The Art of Manasie-Akpaliapik*. Winnipeg: WAG.
1991 *The First Passionate Collector: The Ian Lindsay Collection of Inuit Art*. Winnipeg: WAG.

WILKINSON, DOUGLAS
1955 *Land of the Long Day*. Toronto: Clarke, Irwin & Co.

WILLIAMSON, ROBERT G.
1965 "The Spirit of Keewatin," *The Beaver*, Summer, pp. 4-13.
1968 "The Canadian Arctic, Sociocultural Change," *Archives of Environmental Health*, Vol. XVII, October, Chicago, pp. 484-491.

WILLMOTT, WILLIAM
1961 *The Eskimo Community at Port Harrison, P.Q.* Northern Co-ordination and Research Centre, Ottawa.

WINGERT, PAUL S.
1962 *Primitive Art Its Traditions and Styles*. Cleveland and New York: World Pub. Co.; and Meridian Books (M-185), 1965.

WINNIPEG ART GALLERY
1964 *Eskimo Carvers of Keewatin, N.W.T.* Introductions by Dr. F. Eckhardt and W. T. Larmour. Exhibition Catalogue.
1967 *Eskimo Sculpture*. Illi-Maria Harff and George Swinton, foreword by Dr. F. Eckhardt. Centennial Exhibition Catalogue.
1977 *Port Harrison/Inoucdjouac*. (J. Blodgett, ed.)
1977 *Povungnituk*. (J. Blodgett, ed.)
1978 *Repulse Bay*. (J. Blodgett, ed.)
1979 *Cape Dorset*. (J. Blodgett, ed.)
1980 *Rankin Inlet/Kangirlliniq*. (B. Driscoll, ed.)
1981 *Belcher Islands/Sanikiluaq*. (B. Driscoll, ed.)
1982 *Eskimo Point/Arviat*. (B. Driscoll, ed.)
1983 *Baffin Island*. (B. Driscoll, ed.)
Winnipeg: WAG

WINTEMBERG, W. J.
1939 "Eskimo Sites of the Dorset Culture in Newfoundland," Parts 1 and 2, *AA*, Vol. V, No. 2, pp. 83-102; and Vol. V, No. 4, pp. 309-333.

WINTER, GEORGE
1958 "Arctic Art: Carving and the Eskimo," *Connoisseur*, Vol. CXLI, April, London.

WONDERS, WILLIAM C. (ed.)
1971 *Canada's Changing North*. The Carleton Library No. 55. Toronto: McClelland and Stewart.

YATES, MAYA
1966 "The Art of Travel, Eskimo Style," *Venture*, Vol. III, No. 3, June-July, New York, pp. 64-67.

ZEPP, NORMAN
1986 *Pure Vision: The Keewatin Spirit*. Regina: NMAG.
1987 *The Williamson Collection of Inuit Art*. Regina: NMAG
1995 *Inspiration: Four Decades of Sculpture by Canadian Inuit*. Vancouver: Marion Scott Gallery.

General Index

296

Index of Artists

Numbers in this index refer to the illustration numbers.

Unidentified artists

Prehistoric works

Photo Credits

Photographs are listed by number. Those photographs not included are from the author's archives. Every reasonable effort has been made to ascertain the ownership of illustrations used. Information would be welcomed that would enable the publisher to rectify any error.

American Museum of Natural History, New York, 148, 186
Amway Environmental Foundation, 831, 846-849, 868, 877, 881, 892-897, 899
Art Gallery of Ontario, Toronto, 307, 827-29, 832, 835-39, 843, 853, 855, 857, 866-67, 869, 871, 880, 882, 887, 889, 898, 900-01, 904-06, 908
Tim Atherton, 929
Brigdens Winnipeg, Photographers, 253
K.J. Butler, 688, 690, 692
Confederation Art Gallery and Museum, Charlottetown, 816
Fédération des Cooperatives du Nouveau-Québec, 924
Government of the North West Territories, 46, 565, 570, 767, 810, 821, 823
Richard Harrington, 301, 353
Courtesy of Hudson's Bay Company, 16, 20, 40, 44, 88, 90, 95, 127, 253, 286, 323, 339, 346, 355, 359, 511, 513, 728, 743, 746, 825
Indian and Northern Affairs, Ottawa, 859, 863, 870, 884, 891
Louise LeBlanc, 922
Marion Scott Gallery, 918, 919, 923
H. Martin (I.N.A.), 833, 879
Ernie Mayer (W.A.G.), 4, 830, 834, 837, 840, 841, 842, 844, 845, 850, 852, 860, 872, 874, 875, 907, 909, 912, 915, 916, 917, 920, 925, 926, 927, front and back jacket
M. Mitchell (I.N.A.), 861, 862, 885, 888
Montreal Museum of Fine Arts, 213, 391, 429, 433, 476, 481, 483, 486
National Archives of Canada, 826
National Film Board, 67, 99, 257, 335, 403, 406, 408, 449
National Gallery of Canada, Ottawa, 394, 526, 858, 876, 878
National Museum of Canada, Ottawa, 14, 32, 143, 149, 154, 179, 187, 218, 229, 243, 251, 254, 258, 265, 274, 280, 288, 290, 297, 299, 313, 315, 332, 334, 336, 338, 340, 350, 363, 365, 380, 382, 385, 393, 414, 426, 430, 437, 439, 443, 447, 501, 502, 507, 508, 522, 525, 527, 530, 583, 586, 587, 596, 614, 617, 618, 620, 622, 623, 818
Michael Neill (I.N.A.), 883
North West Company, 910
Northern Affairs Photo, 255, 306
Eberhard Otto, commissioned by artscanada magazine, 163, 166, 167, 168, 217
Tom Prescott, Winnipeg, 6-9, 26, 35, 45, 47, 48, 53, 54, 61, 66, 73-77, 79, 80, 83, 84, 91, 110, 112-117, 126, 147, 153, 178, 189, 190, 192, 195, 199-201, 204, 205, 207, 210, 214, 223, 235, 245, 247, 249, 266, 267, 270, 272, 275, 277, 279, 294, 298, 304, 309, 310, 321, 327, 329, 331, 337, 341, 343, 344, 368, 388, 402, 412, 416, 417, 422, 427, 485, 495, 514, 518, 521, 551, 553-555, 558, 573, 588, 606, 629, 647-649, 651, 656, 660, 675, 683, 694, 696, 700, 705, 706, 717, 723, 729-731, 733, 735, 737, 757, 763, 774-776, 781, 783-785, 787, 795, 822
Terry Ryan, 913, 914
Harold Seidelman, Toronto, 873, 890
Frances K. Smith, 293
Sheila Spence (I.N.A.), 854
TDF Artists Limited, Toronto, 18, 49-52, 55, 81, 82, 105-108, 111, 177, 178, 228, 252, 292, 302, 303, 345, 349, 369, 396, 415, 418, 420, 421, 424, 435, 454, 531, 543, 545, 630, 674, 701, 702, 709, 718, 738, 750, 753, 754, 805, 806, 819
Vancouver Art Gallery, 559, 574
Sandra Vincent, 921
P. von Baich (I.N.A.), 856, 864, 865
Waddington Fine Arts Limited, Montreal, 484
Winnipeg Art Gallery, 300, 398

Donors

More than half of the illustrated sculptures in public collections were acquired through donations. We regret that, due to lack of space, we are not able to list these many gifts and their individual donors.